Black River
Country Club
Men's Invitational

1991

This book is dedicated to:
Arnold Palmer ...
who has inspired so many to play,
and to:
Mother Teresa ...
who has taught so many to love.

T.S.

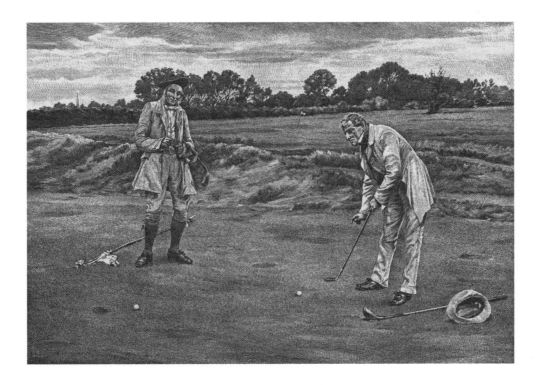

So I ask ye first, why does golf bring out so much in a man, so many sides o' his personality? Why is the game such an X-ray o' the soul?

Yes, a Rorrshock, that's what a golf links is. On some days I love these links of ours, on others I hate them. And it *looks* different dependin' on my mood.

Michael Murphy

THE STYMIE
by W. Dendy Sadler, 1915

THE MYSTERY OF GOLF

by Arnold Haultain

Golf is a game in which attitude of mind counts for incomparably more than mightiness of muscle. Given an equality of strength and skill, the victory in golf will be to him who is Captain of his Soul. Give me a clear eye, a healthy liver, a strong will, a collected mind, and a conscience void of offence both toward God and toward men, and I will back the pygmy against the giant. Golf is a test, not so much of the muscle, or even of the brain and nerves of a man, as it is a test of his inmost veriest self; of his soul and spirit; of his whole character and disposition; of his temperament; of his habit of mind; of the entire content of his mental and moral nature as handed down to him by unnumbered multitudes of ancestors.

A LITTLE PRACTICE
by W. Dendy Sadler, 1915

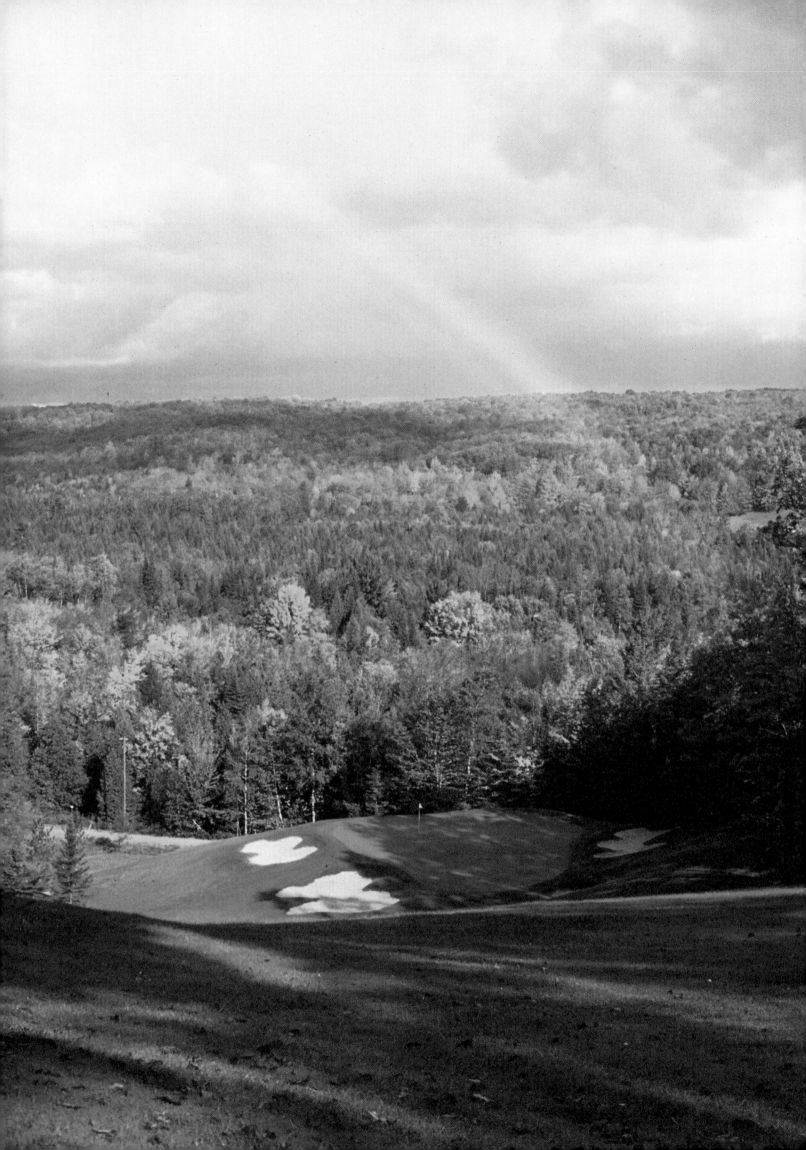

A TRIBUTE TO GOLF

◆

A CELEBRATION IN ART, PHOTOGRAPHY AND LITERATURE

COMPILED AND EDITED BY THOMAS P. STEWART

INTRODUCTION BY ARNOLD PALMER

DESIGNED BY
SANDRA ELLIS LANGAN

◆

STEWART, HUNTER & ASSOCIATES, PUBLISHERS
Harbor Springs, Michigan, U.S.A.

ACKNOWLEDGMENTS

I would like to thank the following for their help in creating this book: Jim Olman and Joe Ranney of The Golf Shop Collection; Sandra Langan, Meghan Pionk, Anne Berry Daugherty, Manuela DiGiovanni and Tim Barrett of The Quarton Group; Ray Davis of the PGA/World Golf Hall of Fame; Janet Siegl of the USGA Museum; Colman McCarthy of the *Washington Post*; Mort and John Olman of Olman Enterprises; Jack Berry of *The Detroit News*; Michael Murphy; and The Quarton Group, including Bob Vincent, Tom Morrisey, Bill Gray, Dave Buffington, Tracey Rekar and Kevin Hogan. Also, Al Barkow of *Golf Illustrated*, and Ben Wright. Another thanks to photographers par excellence: Jim Moriarty, Lawrence Levy, Tom Doak and Brian Morgan. Also, the facilities who have made photography available: Boyne USA, Elk River, Bay Valley, Sugarloaf, Treetops, Aberdeen, and Sentry World. Also, a hearty thanks to my personal friends and family, including: Bob and Nan Vincent, Mr. and Mrs. Tom Murphy, Hillery Knecht, Doc Giffin, Henry Martin, Fred Muller, Bill Yahne, Ted Frey, Chuck Hogan, Tom Keiswetter, Jan VandenBrink, Margaret Tvedton, Perry Hewitt, Don Reinhard, Jeff Lowe, Joe Krantz, William Nowak, Audrey Collins, Tony Morse, and the entire extended Stewart clan, including John, Anna Mae, Bob, Chris, David, Pat, Gerry, Katie, Kirsten, Dick, Jess, Jessie, Lizzie, Molly, Merf, Glen, Sagebrush and Windy.

Permission for the John Updike essay, "The Pro," is granted by *The New Yorker* and is from "MUSEUMS AND WOMEN AND OTHER STORIES" (Knopf), copyright 1966, John Updike. Originally in *The New Yorker*.

The Joe Dey piece, "A Course to Try Men's Souls," is reprinted courtesy of *Sports Illustrated*, from the July 10, 1978, issue. Copyright 1978, Time, Inc. All rights reserved.

Permission for the Herbert Warren Wind essay, "The Call of the Masters," is granted by *The New Yorker*, from the April 28, 1962, issue. From FOLLOWING THROUGH (Ticknor and Fields). Copyright 1962, Herbert Warren Wind. Originally in *The New Yorker*.

ISBN 0-9625276-0-2
Library of Congress Cataloging in Publication Data
Card Number: 90-90032
Main entry under title: Golf, A Celebration in Art, Literature, and Photography.

1. Golf in art. 2. Golf-Literary collections.
3. Golf-Photographic essays.

I. Stewart, Thomas P.
Published in 1990 by Thomas P. Stewart, Harbor Springs, Michigan 49740
For distribution information call 1-800-338-8211

Printed in U.S.A

TREETOPS #6 GAYLORD, MI
by Brian Morgan
(preceding page)

MIXED FOURSOME
by A. J. Keller, 1900

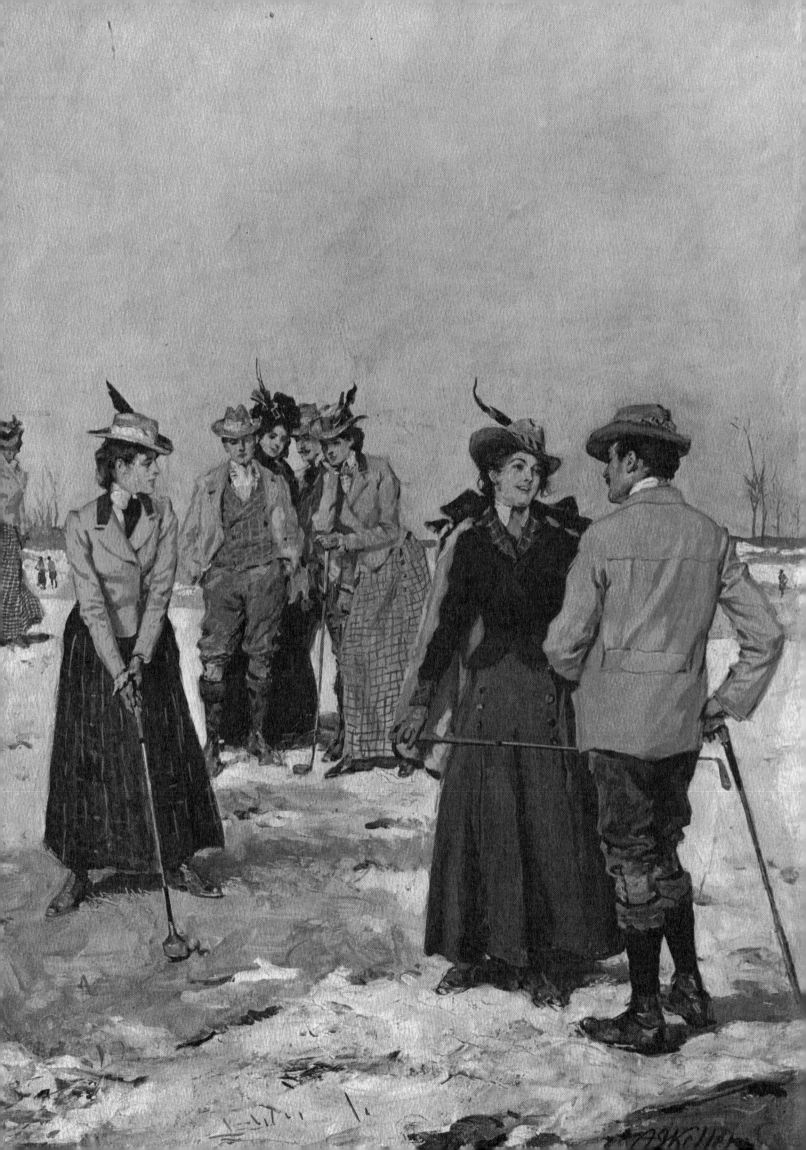

CONTENTS

3 THE MYSTERY OF GOLF *by Arnold Haultain*
A Little Practice *by W. Dendy Sadler*

12 FOREWORD *by Tom Stewart*
Autumn At Muirfield *by James Peter Cost*

15 INTRODUCTION *by Arnold Palmer*

16 GOLF LINKS *by W.C. Bitting*
The Triumvirate *by Clement Fowler*

JOYS OF GOLF
Stymie — St. Andrews *by Thomas Hodge*

20 THE JOY OF GOLF *The Times of London*
St. Andrews, 1891 *by John Blair*

22 PHOTO ESSAY *by Arnold Haultain*
Royal County Down *by Lawrence N. Levy*
Sentry World #6 *Artist Unknown*
Teeth Of The Dog #16 *by Brian Morgan*
Strange, U.S. Open *by Jim Moriarty*
Ian Woosnam *by Lawrence N. Levy*
Untitled *by Jim Moriarty*

24 THE PRAISE OF GOLF *by Sir W.G. Simpson*
Elk River #8 *by Brian Morgan*

28 GOLF *Anonymous*
8th Hole Pebble Beach
by James Peter Cost

31 IF THE BEASTS PLAYED GOLF
by Gerald Batchelor
Caught In The Rough *by Ken Smith*

32 GOLF: THE ESPERANTO OF SPORT
by Lorne Rubenstein
French Open, 1983 *by Lawrence N. Levy*
Swiss Open, 1983 *by Lawrence N. Levy*
Spanish Open, 1987 *by Lawrence N. Levy*

37 A GOLF SONG *by Rose Champion de Crespigny*
Sunrise Golfer *by Shed*

38 THE BEST GAME *by Frank Poxon*

39 GOLFER'S HYMN *by E.W. Stansbury*
In Clover *Artist Unknown*

THE SOUL OF GOLF
Grant of Glenmorrison *by R.R. McIan*

43 FAVETE LINGUIS *by Arnold Haultain*
Par Shooter *by Ralph Furmanski*

44 THE GAME'S HIDDEN BUT
ACCESSIBLE MEANING *by Michael Murphy*

48 THE STORY OF A TEE-CLUB *by Thomas March*
Untitled *by Bart Forbes*

50 THE SONG OF THE IRON *by Joshua Taylor*
The Bag *by Karin Boinet*

52 FUN, FRIENDS AND PLAY *by Tom Stewart*
The Fishing Hole *by R.A. Finlayson*

55 THE SOUL OF GOLF *by P.A. Vaile*
Golf *by Frank Gude*

56 ZEN GOLF *by Gordon Weaver*
Heather Hole *Artist Unknown*

62 MY BETTER SELF *by Robert Browning*
Untitled *by A.B. Frost*

64 THE GREAT MYSTERY *by Henry Leach*
Boyne Highlands Heather #5
by Brian Morgan
Disgusted Caddie *by Norman Orr*

66 PAR FOUR, DOGLEG LEFT
by William A. Nowak
The Bogey Man *by L. Earle*

69 FASCINATION *by Frank J. Bonnelle*
Cypress Pt. #16 *by Jim Moriarty*

71 HEY, FLYTRAP *by Al Barkow*
 Playing Through *by Karen Boinet*

72 THE DRAMA OF GOLF *by Arnold Haultain*
 The 15th At Oakmont *by Donald Moss*

ANTIQUITIES
A Girl With A Golf Club *Artist Unknown*

76 THE GOLFER'S GARLAND *Anonymous*
 River Scene In Winter *by Aert Vander Neer*
 The Two MacDonalds *Artist Unknown*

78 THE ORIGIN OF GOLF *by Sir W.G. Simpson*

79 BALLADE OF THE ROYAL GAME OF GOLF
 by Andrew Lang
 The Royal Game Of Golf *by F.T. Richards*

80 GOLF PRINTS: A Visual Link to the
 Traditions of the Royal and
 Ancient Game *by John M. Olman*
 Horace Hutchinson *by Sir Leslie Ward*
 The Drive *by Charles Edmond Brock*

85 GOLF *The Oxford Dictionary, 1814*
 St. Andrews 1800 *by Lawrence Josset*

87 THE OBJECT OF THE GAME *Anonymous*
 The Nineteenth Hole *by Linda Jane Smith*

88 A GOLFING SONG
 by James Ballantine
 Ted *by Maud Humphrey*

90 A COURSE TO TRY MEN'S SOULS
 by Joseph C. Dey
 The Home of Golf *by Mick Bensley*
 Old Course St. Andrews
 by Graeme W. Baxter

94 AN ODE TO ST. ANDREW
 by W.A. Campbell

95 ADDRESS TO ST. ANDREWS
 Anonymous
 Open Championship St. Andrews
 by Michael Brown

96 HIAWATHA ON THE LINKS
 Anonymous
 Turtle Point #14 *by Jim Moriarty*

COMMENTARIES
Ginger Beer *by William Blake Lamond*

100 ON DUFFERDOM *by Royal Cortissoz*
 Duffer's Yet *Artist Unknown*
 Mac Foozle, Chief Of The Clan
 Artist Unknown

103 THE REAL GOLFER *by Joshua Taylor*
 Bobby Jones *by Bob Crofut*

106 WORDSWORTH RE-WORDED
 by Robert Browning
 The Old Apple Tree Gang, 1888
 by Leland Gustavson

109 THE PLAYER AND THE GIANT *by Steve Heller*
 Untitled *by Michael Vaughan*
 Golf *by Lepas*

113 THE HAPPY HACKER *by Jim Bishop*
 Hooked *by A.B. Frost*

116 LOST BALL *Anonymous*

117 OUT OF THE DEPTHS *by Tom Morrisey*
 Obstacle Course *by Gary Patterson*
 Pebble Beach #7 *by Jim Moriarty*

123 A DUDE GAME? *Philadelphia Times*
 A Difficult Bunker *by Douglas Adams*

125 IN SEARCH OF THE PERFECT PRO-AM
 by Ben Wright
 The 87th U.S. Open *by Jim Moriarty*
 The Flower Hole #16
 by Margaret Tvedten

129 THE CONQUERING HERO
 by Gerald Batchelor
 Awarding the First USGA Trophy
 by Leland Gustavson

130 A CURE *Anonymous*
 The Sabbath Breakers *by J.C. Dollman*

133 THE THREESOME *by Robert Browning*
 Invitational *by Bob Dacey*

134 A WOMAN'S WAY *by A.W. Tillinghast*
 Golf *by Chuck Wilkinson*

GRANDEUR

Augusta National #12 *by Gordon Wheeler*

141 MAKING THE SHOT, TAKING THE SHOT
 by Jim Moriarty
 Pine Valley #2 *by Jim Moriarty*
 16th At Cypress *by Jim Moriarty*
 Boulder's 'Saguaro' #9
 by Jim Moriarty

144 THE GREATER JOYS
 by Audrey Diebel Collins
 Cannes Travel Poster
 Artist Unknown

146 CRYSTAL AMONG THE GEMS
 by Tom Stewart
 Crystal Downs #13 *by Tom Doak*
 Crystal Downs #8 *by Tom Doak*

149 THE SPIRIT OF HOPE *by Henry Leach*

150 WALKING AND GOLF *by Tony Morse*
 Carmel Valley Ranch From The 13th
 by James Peter Cost
 'Young Tom' Morris *by Arthur Weaver*
 The Gleneagles Hotel Kings Course, Scotland
 by Graeme W. Baxter

154 ON CREATING GOLF HOLES
 by Desmond Muirhead
 The Wave Hole #16 *by Paul Barton*
 The Dragon Hole *by Paul Barton*
 The Mermaid Hole #11 *by Paul Barton*

158 THE CALL OF THE MASTERS
 by Herbert Warren Wind

160 GOLF IN THE KINGDOM *by Michael Murphy*
 The "Postage Stamp" *by Mil Radler*

SECRETS OF THE GAME

Mr. William Innes *by L.F. Abbott*

164 THE SECRET OF GOLF *by Carlyle Smith*
 Hoylake *by Sir Leslie Ward*

166 WHERE'S THIS (YOUR) GAME GOING?
 by Chuck Hogan
 Curtis Strange, Open '88
 by Lawrence N. Levy
 Sun Valley #7 *by Jim Moriarty*

171 ON MAKING A HOLE IN ONE
 by Royal Cortissoz
 Untitled *by Michael Vaughan*
 Royal Lytham & St. Annes
 by Bill Waugh

173 THE GOLFING GHOST *by R. Barclay*
 Augusta #11 *by Mark King*

177 A VINDICATION OF THE THEORIST
 by Leslie Schon
 A Cabinet Minister's Holiday *Artist Unknown*

179 THE MENTAL HAZARDS OF GOLF
 by Charles W. Moore

182 ON THE DEVIL IN GOLF *by Royal Cortissoz*
 Fair Play *by Karin Boinet*

184 SILENCE AT THE TEE *by Frank J. Bonnelle*
 Robert Tyre Jones Jr., 1930
 by Leland Gustavson

185 WHY DOES THE GOLFER "LOOK UP"?
 by Charles W. Moore
 Legends Remembered *by Kenneth Reed FRSA*

Lyrics of the Links

Tournament *by Bob Dacey*

191 A Golfer's Wish *by Edgar A. Guest*
Good Form *by A.B. Frost*

193 A Brighter World *by Jesse G. Clare*
The First Clubhouse In America 1892
by Leland Gustavson

194 Jinx's Office *by A.W. Tillinghast*

195 Theories *from Locker Room Ballads*
Untitled *by Michael Brown*

197 The Golf Girl *by Minna Irving*
One Putt *by Maud Humphrey*

199 The Village Golfer *by Frank J. Bonnelle*
Saturday Afternoon *by A.B. Frost*

200 Perfection *by John Thomson*
The Drive *by Douglas Adams*

202 Reflections *Anonymous*
Iona Golf & Grazing Grounds
by Jan Vandenbrink

205 Golden Rules of Golf
Anonymous
Golf Boy *by C. Spiegle*

207 The Golfer's Prayer
by Ring W. Lardner
Francis D. Ouimet Wins United States
Open Title, 1913 *by Leland Gustavson*

209 Golfer's Ballade for Autumn
by Clinton Scollard
Sugarloaf #11 *by Chip Carey*

210 The Sages on the Links
by Rudyard Kipling
Golf Player *by Frank Gude*

Counsel

Willie Park Sr., *by Arthur Weaver*

214 Golf as Therapy *by Dr. Richard H. Coop*

216 Advice to Beginners
by Horace G. Hutchinson

217 The Pro *Anonymous*
The Ballesteros Hole *by W.K. Waugh*

218 Keep the Rules and They Keep You
by Colman McCarthy

221 The Pro *by John Updike*
Willie Park, Jr. *by Arthur Weaver*
Hole #13, Ocean Golf Course,
Sea Pines Plantation
by Paul Kuchno

225 Dr. Golf *by Judd Arnett*
Seve *by Lawrence N. Levy*

Whimsical

Mt. Rushmore National Public Links *by Loyal H. Chapman*

228 Golf-Mania! *by A.S. Gardiner*
15th And 16th At Cypress *by James Peter Cost*

230 Concerning Curses *by Lord Balfour*
Boyne Highlands #18 *by Brian Morgan*

231 The Guest *Anonymous*
The Golfers *by Charles Lees*

234 Golf *by David R. Forgan*

Bibliography 235

Index 237

FOREWARD

As we celebrate a new millennium — the 21st century — the game of golf is exploding in popularity across the globe. Millions are coming to the sport each year, especially in Europe and Asia and among the young in the United States. Courses are even being built in the Soviet Union and China. Golf seems to have a universal appeal. It is played by hundreds of millions in over 125 countries. In the United States alone there are expected to be 40 million players by the year 2000.

Balls have been struck and lost from Fiji to Alaska and from Katmandu to Patogonia. Golf has even been "played" on the moon. From polar ice to tropic jungle, golfers go forth to conquer par, the course, the weather, opponents and themselves. What is it that attracts us and draws us, as fanatics to our playful addiction? The answers are as unique as we are to each other.

This *Tribute to Golf* is a celebration in art, literature and photography of the 200-year love affair with golf. We visit many countries and previous centuries. We hear the clear voices of literary geniuses from yesterday and today. We gaze through a colorful gallery of art and photography inspired and created by masters of present and past.

Within this anthology we find glimpses of golf's great attractions and the lure of the links. Golf is one of the most unique and diverse games that we play. It is both an athletic and an aesthetic sport. It is arboreal and ethereal. For some it serves as a prism. For others it is prison. Some golfers describe their exceptional and sublime days on the links as the equivalent of a religious peak experience — an intimate fusion of transcendance and immanence.

Golf is a chance to discover ourselves or the chance to escape ourselves. It is a private struggle played in an open field. It is a view of ourselves in a public mirror. It reminds us of our imperfections and inconsistencies. It cultivates a sense of mystery within.

Golf is an arena for realizing human potential. It is a marvelous blend and confluence of body, mind, psyche and spirit. It calls for the integrative process of becoming a whole person. During the play of a long par-five one will need to play a brutish drive, a courageous and long second, and be left with a delicate pitch and a sensitive putt. Nowhere in sport do the masculine and feminine roles merge so closely. In this regard it is a healing phenomena.

Golf allows us to build and transform personal character. Out of the surge of competitive spirit rise the gamut of our highest and lowest instincts. It is such a naked occupation. We are exposed far beyond the limits we normally allow. The lighter and darker sides of our persona or being may be exhibited within a single hole. Meeting and transcending these nuances of latent personality is, in itself, a form of self-actualization or fulfillment.

Golf builds patience amid cultures which crave instant gratification. Success comes slowly. We improve our skills through long hours of physical practice and through many years of creative, visual and cerebral exercises.

In today's frantic pace, golf gives its advocates space, breathing room, stress relief and a positive peek at the natural world. In golf we transmute landscape into personal experience and reconnect with our natural origins.

The sport of golf can lead us to our higher selves. We find our best shots come from a subconscious source. Very few can think of trees, water or hazards and execute their play to a safe landing. When we get out of our own way we find a subtle knowing of what to do to bring hands and club to ball and ball to target. Great players can tell us about their technique, but their craft is ineffable and indivisible from their deeper lives.

Golf is the rare sport that offers beginners and others a chance to measure their games against the champions of the day. In most sports we are resigned to watch our heroes or heroines. We cannot bat against, run against, or go one-on-one with Hall-of-Famers. In golf, however, we can relate our best shots to the great masters of the game. To all of us, novice and professional alike, perfection is within reach, even if only for one, or a few, shots per round.

Conveniently, the game is so designed that the worse a player is, the more shots he or she has to redeem him or herself. In a single round emotions may change from joy to horror in a matter of minutes. Contrasts abound. On a day when we putt horribly, we are liable to sink a 40-footer on the 18th green. The terrible round is remembered by its good shots.

Golf's influence permeates our culture. Try getting a doctor's appointment on Wednesday afternoon or breakfast with your wife on Tuesday morning. The game is a great social equalizer and a grand facilitator of companionship. Corporate president and school janitor are thrown together in the finals of the city championship. Social and economic backgrounds count for little advantage in this duel of self-mastery. Handicapping allows all levels of competence to enter into matches against one another.

From first tee to 19th hole, golf is a great study of the human condition. The first tee is that pagan starting point from which I have observed judges, lawyers and jurors, fresh from the task of determining truth, agree to hold it in abeyance, until all bets are made. The 19th hole is that mediating respite and electrolyte replacement center where all scores revert back to par and the truth is once again placed in limbo.

In the game our critics call "pasture pool," we join the stream of two centuries of a rich tradition, which embodies the best of individual dignity and collective good sportsmanship.

With the spirit of our worthy forbearers let us celebrate in the following pages the great game of Golf — our universal challenge whose mystery binds us all to a mystical club of shared understanding.

Tom Stewart
Harbor Springs, Michigan, 1990

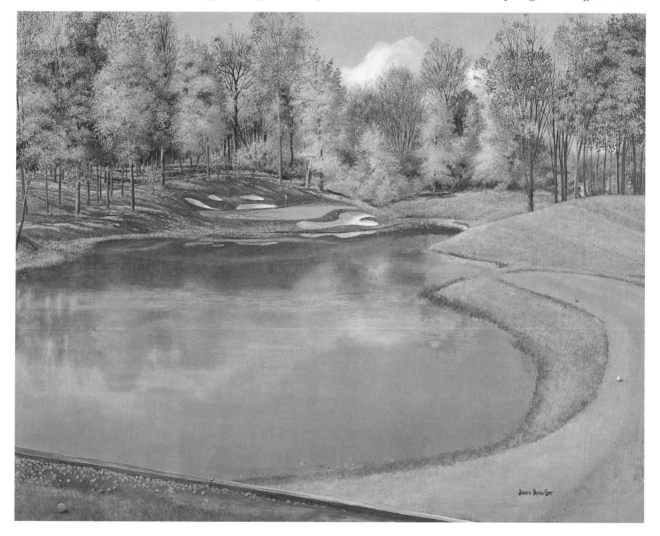

AUTUMN AT MUIRFIELD
by James Peter Cost, 1977

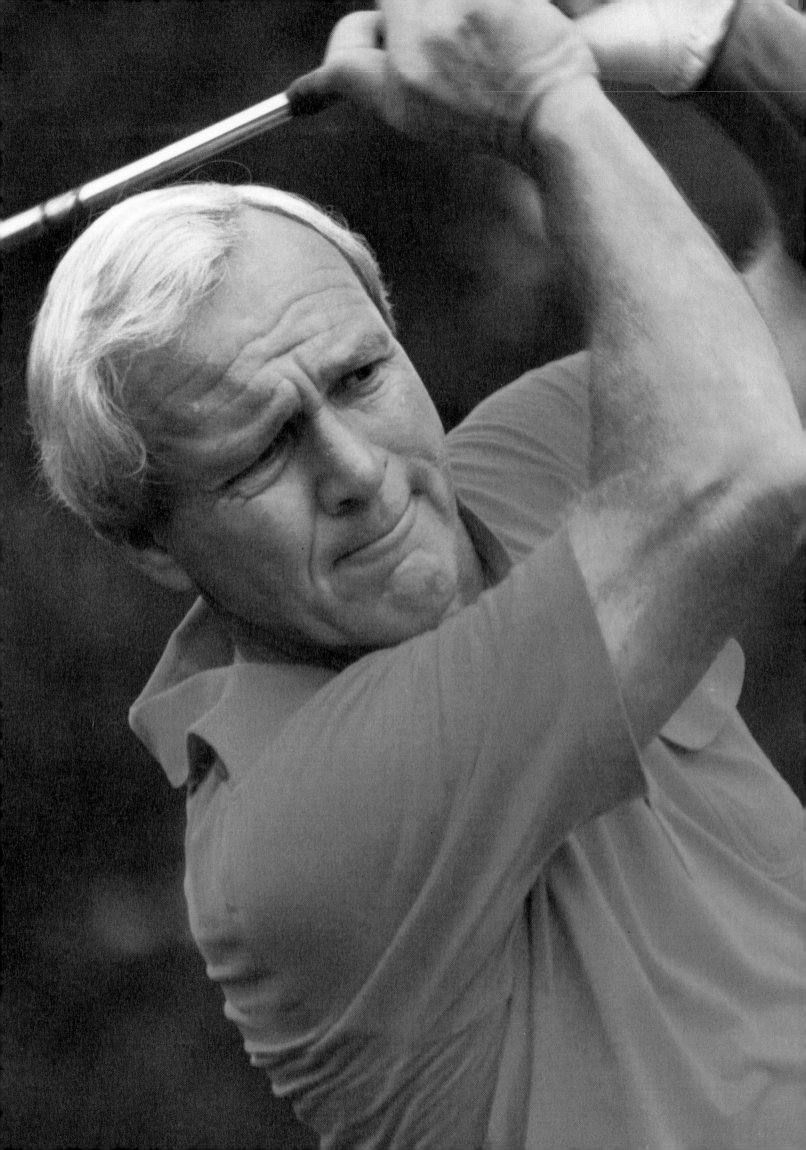

INTRODUCTION

by Arnold Palmer

Every once in a while, I have to stop and remind myself that not everyone grew up on a golf course.

I did and, now and again, I think to pause and thank Whomever it was that arranged for things to work out that way. Early morning, to me, has always been a time punctuated by the distant chatter of water sprinklers. As far back as I can remember, there is the scent of fresh-cut grass, the beauty of a well-hit drive, and the warmth of people who've known one another for years and who share with one another a deep and unbreachable love for The Game.

You cannot be around golf without absorbing a sense of its history, its richness. Golf is legends and lore, great images and greater vision. It's the sense of awe you get when someone so much as mentions Bobby Jones. It's the overwhelming feeling of wonder and tradition that is there, walking alongside you, when you step to the first tee at St. Andrews, or Augusta, or Pebble Beach.

One of the principal joys of the game is that this sense of tradition is so appreciable, and so very contagious. It doesn't matter whether your name is written in the records of the Tour or next to the big numbers on the handicap board. The pro trying for the Grand Slam and the weekend golfer hoping to break 100 have that single thing in common — an unabashed respect for the game and what it stands for, a regard that verges on reverence for the great names and great feats that came before.

Tom Stewart's *A Tribute to Golf* is about all of this and more. It is a wonderful and whimsical recollection of mentors and moments, hushed at one turn and hilarious at the next. It is a multi-faceted book about a many-faceted game. It is, above all, blatantly and honestly, a labor of love.

I trust you'll find it a pleasant fireside companion. And I'm sure it will earn a place of honor on your shelf — whether you're a newcomer to the game, or someone who was virtually born on a golf course, many long and happy years ago.

Golf Links

by W.C. Bitting

What are the links of golf we prize?
The ground o'er which the fine drive flies?
 The dirt of acres finely kept?
 The putting greens so smoothly swept?
The fair green 'twixt the magic holes?
The guiding flags on teasing poles?
 The long grass out of which we pitch?
 The bunker, hazard, pond and ditch?

Not these true golfers love the most,
Though over them we like to boast.
 These earthly links are paths serene
 To things of nobler worth unseen.
Golf clubs are rivets that secure;
Strong links of chains that long endure.
 We name a few. Each golfer knows
 How link to link his own chain grows.

NATURE

Golf links to Nature — dear old dame —
Her skies, her sward, her trees. The game
 On breast of Mother Earth we play,
 And learn to love her more each day.

HEALTH

Golf links to Health. Hygeia's grace
Doth weary muscle, brain, replace
 Through stride and swing, and open pores,
 In sunny air, God's out-of-doors.

PEACE

Golf links to Peace. Far from the mind
It drives the cobwebs, soothes the grind
 Of business, trouble, care and fret.
 In golf, life's bunkers we forget.

HONOR

Golf links to Honor, for we dare
A count and contest strictly fair.
 We play the lie, confess the stroke,
 Nor let our shame untruth provoke.

MEN

Golf links to Men. No lonesome thrives.
We putt into each other's lives.
 Our sticks are hooks both keen and strong
 That grip our friendship tight and long.

SELF

Golf links to Self. The noblest soul,
Not Colonel Bogey, wins the hole.
 The gentleman, self-mastered, high,
 Plays par with self to victory.

GOD

Golf links to God. For, in His sight,
Both work and play, when done aright,
 Help men to grow. And manhood true
 Best shows the world what God can do.

PRIZES

Golf wins these prizes of our game —
Above all titles, cups and fame;
 Within the reach of all they lie.
 Why love we golf? You now know why.

THE TRIUMVIRATE
by Clement Fowler, 1913

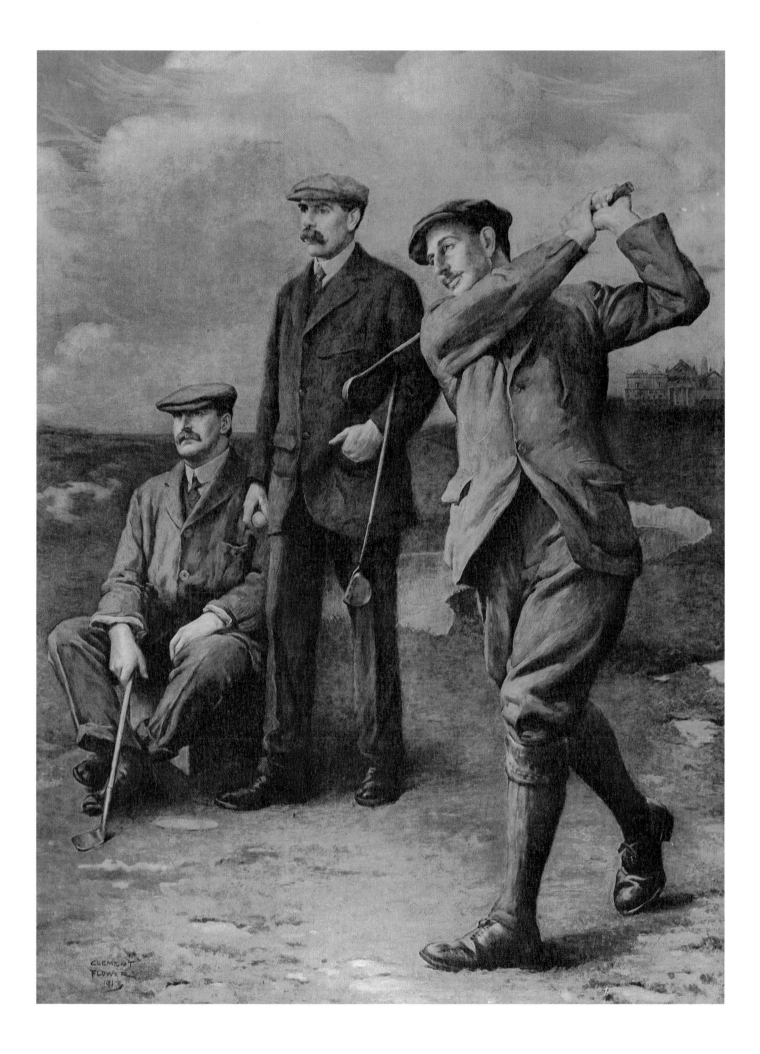

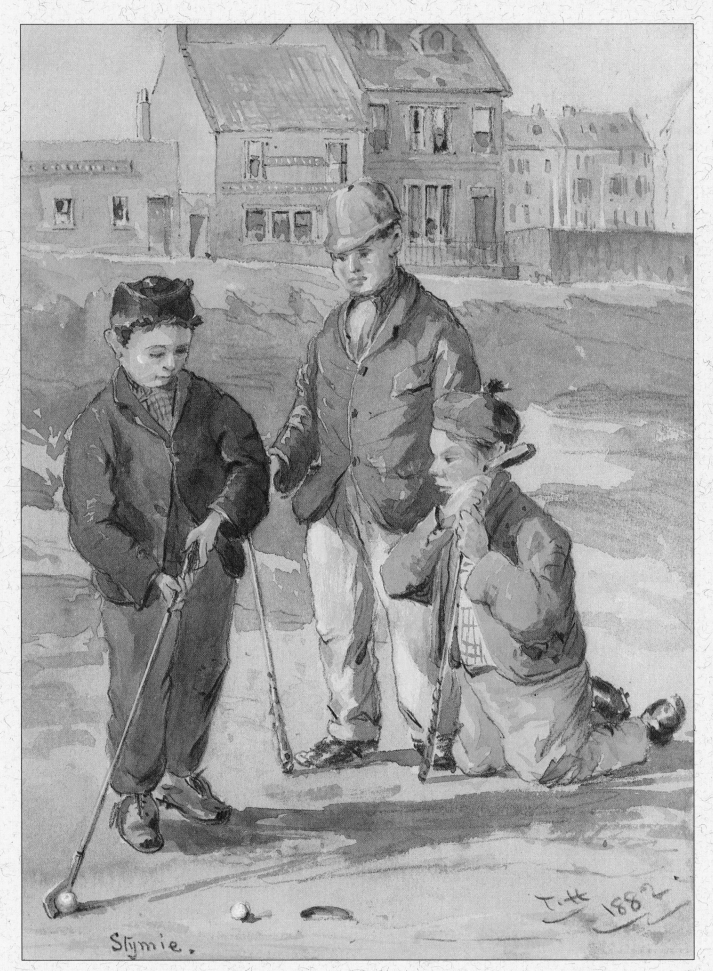

Stymie.

STYMIE – ST. ANDREWS
by Thomas Hodge, 1882

JOYS OF GOLF

THE JOY OF GOLF

The Times of London,
October 5, 1874

We own that at first sight it is difficult for the uninitiated looker-on to sympathise with the evident enthusiasm of the players. There does not seem to be anything very stimulating in grinding round a barren stretch of ground, impelling a gutta-percha ball before you, striving to land it in a succession of small holes in fewer strokes than your companion and opponent. But as to the reality of the excitement, you are soon compelled to take that for granted. You see gentlemen of all ages, often of the most self-indulgent or sedentary habits, turning out in every kind of weather, persevering to the dusk of a winter day, in spite of bitter wind and driving showers; or dragging about their cumbrous weight of flesh in hot defiance of the most sultry summer temperature. The truth is that, appearances notwithstanding, experience proves it to be one of the most fascinating of pursuits; nor can there be any question that it is among the most invigorating. You play it on some stretch of ground by the sea, generally sheltered more or less by rows of hummocky sandhills which break the force of the breeze without intercepting its freshness. You keep moving for the most part, although there is no need for moving faster than is necessary to set the blood in healthy circulation. In a tournament like that which ended on Wednesday at St. Andrews, you select your own partner. The deep-chested, strapping young fellows in their prime, with the reach of arm and strength of shoulder that make their swing so tremendous in driving the ball, pair off together. The obese and elderly gentlemen, touched in the wind by time, and doubtful subjects for insurance offices, may jog along placidly at their own pace...

There is exhilaration in the brisk walk round the links in the fresh sea air, but it is the culminating excitement of the critical moments on the putting greens which gives the national game its universal zest. *Once a golfer you are always a golfer.*

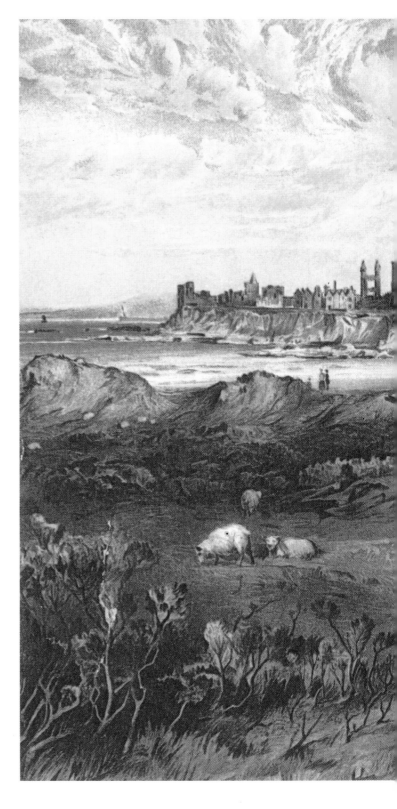

ST. ANDREWS, 1891
by John Blair

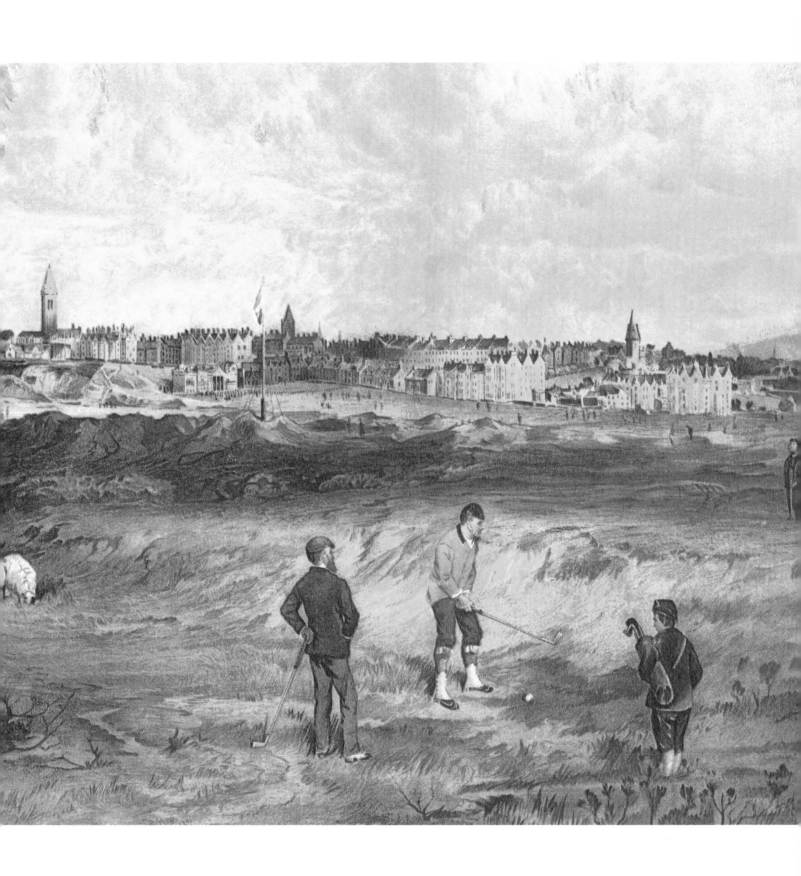

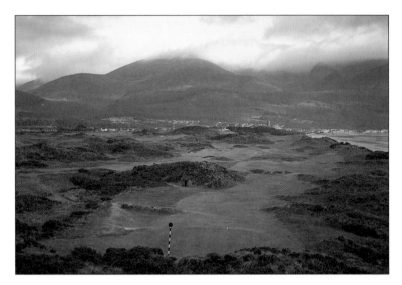

Golf, in short, is a sort of Gargantuan jugglery, a prodigious prestidigitation, a Titanic thimble-rigging, a mighty legerdemain.

ROYAL COUNTY DOWNS
by Lawrence N. Levy

The duffer is puzzled at the extraordinary fascination which his new-found pass-time exercises over him. He came to scoff; he remains to play...

SENTRY WORLD #6

Golf is like faith: it is the substance of things hoped for, the evidence of things not seen...

TEETH OF THE DOG #16
by Brian Morgan

And we look to Pan — in the shape of bunkers and hazards — to Defend the Right; — and Pan is as inexorable as the plough-shares.

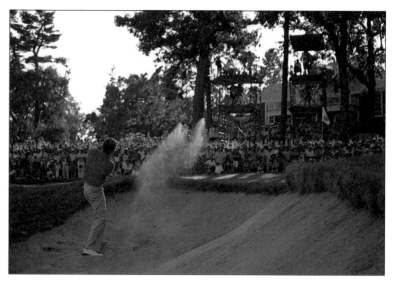

STRANGE, U.S. OPEN 1988
by Jim Moriarty

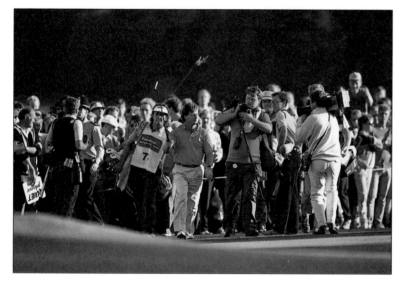

...but I challenge anyone to dispute the fact that every really good golfer will be at heart a good man. Golf, in short, is not so much a game as it is a creed and a religion.

IAN WOOSNAM
by Lawrence N. Levy

Golf is like writing with a crowbar.

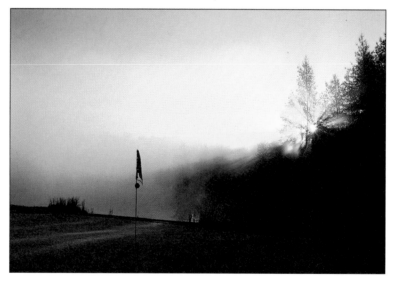

UNTITLED
by Jim Moriarty

PHOTO ESSAY
Text by Arnold Haultain

THE PRAISE OF GOLF

by Sir W.G. Simpson, 1887

There are so many good points about the royal and ancient game of golf that its comparative obscurity, rather than its increasing popularity, are matter for wonder. It is apparently yet unknown to the Medical Faculty. The golfer does not find it in the list of exercises recommended by doctors to persons engaged in warfare with the results of sedentary habits. He is moved to pity British subjects compelled to stir their lives by walking, horse-riding, or cycling. He knows how monotonous it is following one's nose, or flogging a horse and following it, compared with flogging and following a ball. For the wearied and bent cyclist, who prides himself on making his journey in as short a time as possible, he has a pitying word. Men who assume that the sooner the journey is over the greater the pleasure, evidently do not love their pursuit for its own sake.

With any other sport or pastime golf compares favourably.

With cricket? The golfer has nothing to say against that game, if you are a good player. But it is a pastime for the few. The rest have to hang about the pavilion, and see the runs made. With the golfer it is different. He does not require to be even a second-class player, in order to get into matches. Again, the skilful cricketer has to retire when he gets up in years. He might exclaim with Wolsey: 'Had I served my golf as I have served my cricket, she would not thus have deserted me in my old age.' How different it is with golf! It is a game for the many. It suits all sorts and conditions of men. The strong and the weak, the halt and the maimed, the octogenarian and the boy, the rich and the poor, the clergyman

ELK RIVER #8
by Brian Morgan

and the infidel, may play every day, except Sunday. The late riser can play comfortably, and be back for his rubber in the afternoon; the sanguine man can measure himself against those who will beat him; the half-crown seeker can find victims, the gambler can bet, the man of high principle, by playing for nothing, may enjoy himself, and yet feel good. You can brag, and lose matches; depreciate yourself, and win them. Unlike the other Scotch game of whisky-drinking, excess in it is not injurious to the health.

Better than fishing, shooting, and hunting? Certainly. These can only be indulged in at certain seasons. They let you die of dyspepsia during the rest of the year. Besides, hunting, you are dependent on horses and foxes for sport; shooting, on birds; fishing, on the hunger of a scaly but fastidious animal. The pleasures of sport are extracted from the sufferings of dumb animals. If horses, grouse, or fish could squeal, sports would be distressful rather than amusing.

Golf has some drawbacks. It is possible, by too much of it, to destroy the mind; a man with a Roman nose and a high forehead may play away his profile. That peculiar mental condition called 'Fifish' probably had its origin in the east of the Kingdom. For the golfer, Nature loses her significance. Larks, the casts of worms, the buzzing of bees, and even children are hateful to him. I have seen a golfer very angry at getting into a bunker by killing a bird, and rewards of as much as ten shillings have been offered for boys maimed on the links. Rain comes to be regarded solely in its relation to the putting greens; the daisy is detested, botanical specimens are but 'hazards,' twigs 'break clubs.' Winds cease to be east, south, west, or north. They are ahead, behind, or sideways, and the sky is bright or dark, according to the state of the game.

A cause of the comparative obscurity of golf is that the subject cannot easily be treated by the novelist. Golf has no Hawley Smart. Its Whyte Melville did not write, but played. You can ride at a stone wall for love and the lady, but what part can she take in driving at a bunker? It is natural that Lady Diana should fall in love with Nimrod when she finds him in the plough, stunned, broken-legged, the brush, which he had wrested from the fox as he fell,

firm in his lifeless grasp. But if beauty found us prone on the putting green, a 27 1/2 embedded in our gory locks, she might send us home to be trepanned; but nothing could come of it, a red coat notwithstanding. No! at golf ladies are simply in the road. Riding to hounds and opening five-barred gates, soft nothings may be whispered, but it is impossible at the same moment to putt and to cast languishing glances. If the dear one be near you at the tee, she may get her teeth knocked out, and even between the *shots* arms dare not steal round waists, lest the party behind should call out 'fore!' I have seen a golfing novel indeed; but it was in manuscript, the publishers having rejected it. The scene was St. Andrews. He was a soldier, a statesman, an orator, but only a seventh-class golfer. She, being St. Andrews born, naturally preferred a rising player. Whichever of the two made the best medal score was to have her hand. The soldier employed a lad to kick his adversary's ball into bunkers, to tramp it into mud, to lose it, and he won; but the lady would not give her hand to a score of 130. Six months passed, during which the soldier studied the game morning, noon, and night, but to little purpose. Next medal day arrived, and he was face to face with the fact that his golf, unbacked by his statesmanship, would avail him nothing. He hired and disguised a professional in his own clothes. The ruse was successful; but, alas! the professional broke down. The soldier, disguised as a marker, however, cheated, and brought him in with 83. A three for the long hole roused suspicion, and led to inquiry. He was found out, dismissed from the club, rejected by the lady (who afterwards made an unhappy marriage with a left-handed player), and sent back in disgrace to his statesmanship and oratory. It was as good a romance as could be made on the subject, but very improbable.

Although unsuited to the novelist, golf lends itself readily to the dreaming of scenes, of which the dreamer is the hero. Unless he is an exceptionally good rider, or can afford 300 guinea mounts, a man cannot expect to be the hero of the hunting-field. The sportsman knows what sort of shot he is, and the fisher has no illusions; but every moderately good golfer, on the morning of the medal day, may lie abed

and count up a perfect score for himself. He easily recalls how at different times and often he has done each hole in par figures. Why not this day, and all the holes consecutively? It seems so easy. The more he thinks of it the easier it seems, even allowing for a few mistakes. Every competitor who is awake soon enough sees the necessity for preparing a speech against the contingency of the medal being presented to him in the evening. Nor is any one much crushed when all is over, and he has not won. If he does well, it was but that putt, that bad lie, that bunker. If his score is bad, what of it? Even the best are off their game occasionally. Next time it will be different. Meanwhile his score will be taken as a criterion of his game, and he is sure to win many half-crowns from unwary adversaries who underrate him.

The game of golf is full of consolation. The long driver who is beaten feels that he has a soul above putting. All those who cannot drive thirty yards suppose themselves to be good putters. Your hashy player piques himself on his power of recovery. The duffer is a duffer merely because every second shot is missed. Time or care will eliminate the misses, and then! Or perhaps there is something persistently wrong in driving, putting, or approaching. He will discover the fault, and then! Golf is not one of those occupations in which you soon learn your level. There is no shape nor size of body, no awkwardness nor ungainliness, which puts good golf beyond one's reach. There are good golfers with spectacles, with one eye, with one leg, even with one arm. None but the absolutely blind need despair. It is not the youthful tyro alone who has cause to hope. Beginners in middle age have become great, and, more wonderful still, after years of patient duffering, there may be a rift in the clouds. Some pet vice which has been clung to as a virtue may be abandoned, and the fifth-class player burst upon the world as a medal winner. In golf, whilst there is life there is hope.

It is generally agreed that the keenest pleasure of the game is derived from long driving. When the golfer is preparing to hit a far clean straight shot, he feels the joy of the strong man that rejoiceth to run a race; that is to say, the joy we have authority for

believing that the Jewish runner felt. The modern sprinter experiences none. On the contrary, there is the anticipation, through fatigue of as much pain as if he were ringing the dentist's door bell. For the golfer in the exercise of his strength there is neither pain nor fatigue. He has the combined pleasures of an onlooker and a performer. The blow once delivered, he can stand at ease and be admired whilst the ball makes the running.

There is no such being as a golfer uninterested in his driving. The really strong player seems to value his least; but this is merely because so many of his shots are good that they do not surprise him. Let it, however, be suggested that some other is a longer driver than he, and the mask of apathy will at once fall from his face, his tongue will be loosened, and he will proceed to boast. Even when a man cannot feel that he drives quite as far as the best, his pride in his own frame is not necessarily destroyed as by most other sports. The runner, the jumper, the lifter of weights, even the oarsman, is crushed down into his true place by the brutal rudeness of competitive facts. Not so the golfer. A. says, 'I drive with a very light club, therefore admire my strength.' B. smiles complacently, whilst you marvel at the heaviness of his — a brawny muscular smile. Little C.'s club is nearly as long as himself. The inference is that little C.'s garments cover the limbs of a pocket Hercules. D. can drive as far with a cleek as common men with a club. D. is evidently a Goliath. The inferences may be all wrong. A. may be a scrag, C. a weed, D. merely beefy. On the other hand, each may be what he supposes himself. This is one of the glorious uncertainties of the game.

To some minds the great field which golf opens up for exaggeration is its chief attraction. Lying about the length of one's drives has this advantage over most forms of falsehood, that it can scarcely be detected. Your audience may doubt your veracity, but they cannot prove your falsity. Even when some rude person proves your shot to be impossibly long, you are not cornered. You admit to an exceptional loft, to a skid off a paling, or, as a last appeal to the father of lies, you may rather think that a dog lifted your ball. 'Anyhow,' you add conclusively, 'that is where we found it when we came up to it.'

GOLF

Anonymous

They do not know what golf may be
　　Who call it childish play
To drive a globule from a tee
　　And follow it away.
They do not understand who scoff
　　And all its virtues miss;
Who think that this is all of golf —
　　For golf is more than this.

For golf is earth's ambassador
　　That comes to haunts of men,
To lure them from the banking floor,
　　The counter and the pen.
To lead them gently by the hand,
　　From toil and stress and strife,
And guide them through the summer land,
　　Along the path of life.

The pastime of philosophers;
　　For such a man must be
When far away the golf ball whirrs
　　And hides behind a tree.
A man may see his business fall
　　And never turn a hair;
But men are strong who lose the ball
　　And still refuse to swear.

It is a game of honor, too,
　　That tries the souls of men;
It's easy in the public view
　　To be all honest men.
But he deserves an angel's wings
　　Who paths of truth has trod,
When left alone with just two things —
　　His score card and his God.

If golf shall teach you patiently
　　Adversity to meet;
If it shall teach philosophy
　　To keep your temper sweet;
If it shall teach you still to grin
　　With mirth, no matter what —
You are a victor if you win
　　A loving cup or not.

8TH HOLE PEBBLE BEACH
by James Peter Cost

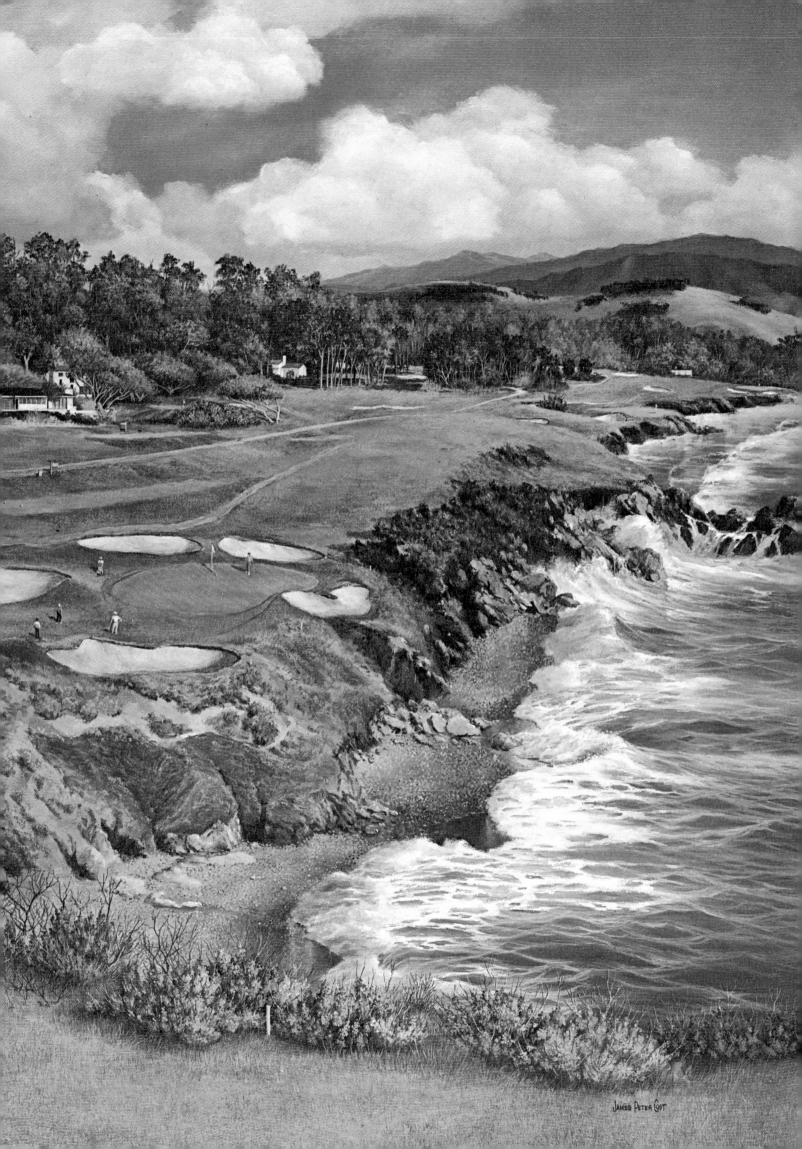

James Peter Cost

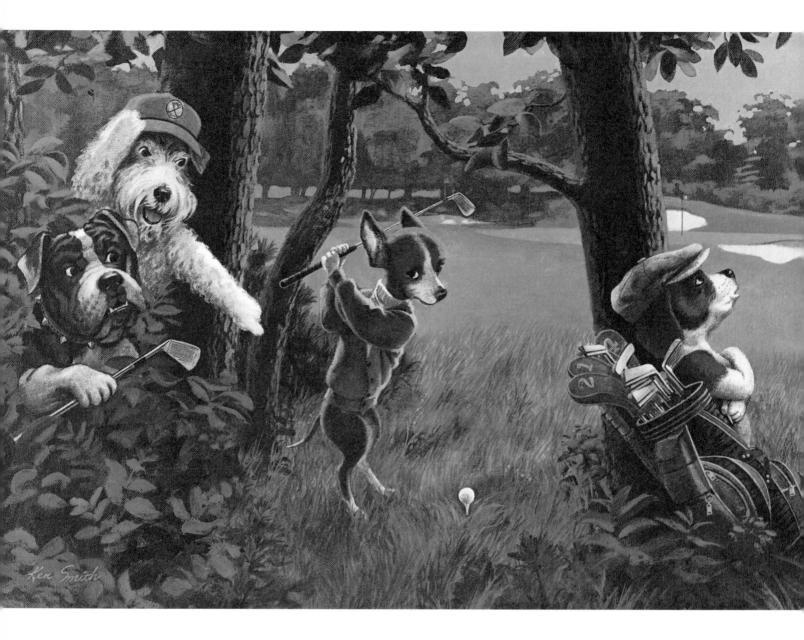

IF THE BEASTS PLAYED GOLF

by Gerald Batchelor, 1914

Man is a selfish brute. He wants to keep all the good things to himself.

For many years Scotsmen guarded the secret of the pleasures of golf, and when this secret at last leaked out to England and quickly ran over the whole world, man still tried to monopolise the links.

Once having tasted the blood of a foozled drive, however, his womenfolk and children insisted on sharing his new-found troubles and triumphs. Man has now recognised their right to golf. Should he not extend this concession to the other animals?

Perhaps he would be more inclined to do so if it could be proved that this course would be directly to his advantage.

We have been told that other beasts besides man need recreation of mind as well as body if they are to be brought to their proper state of physical perfection. It is found that sheep which are kept fully occupied and amused show their gratitude by providing a superior quality of mutton. That is why sheep are so often turned loose upon the golf links.

Chickens, also, may be induced to offer a more tender tribute to the taste of man if they are given some real interest in life — such as playing "last across" on some popular motoring high road.

What need of further instances? Go to the Zoo, and you will find all the inmates either fast asleep or playing games. Special appliances are provided for their diversion, but the management have so far shown a lamentable lack of local knowledge in failing to offer adequate opportunities for the playing of golf.

Perhaps it may be doubted that the animals *could* play golf. Let us see. You give your dog a stick or a ball to play with, but you never give him *both*.

Many of the poor brutes are evidently designed by nature for the enjoyment of golf. One or two examples should suffice to prove the point.

The horse often goes out for a long drive. Sometimes, however, he is inclined to pull a bit, and consequently receives a good many strokes.

The donkey also takes a lot of beating in a team match. One of his favourite courses is "Ye Banks and Brays."

The pig is a very porky player, and none knows better how to negotiate a sty-mie.

The bat has the good fortune to enjoy a good lie all through the winter.

The tortoise is a slow player, yet we cannot hope to teach him as much as he has taught us.

The cat can quickly come down to scratch. She can knock spots out of the leopard, anyway.

Most of the fishes get along swimmingly. The lobster, for instance, is quite good at a pinch, though it must be confessed that he is a confirmed pot-hunter.

The salmon begins life as a "par" player and can always be relied on to keep his plaice. Everyone must have noticed that the sardine has a happy knack of finding the tin.

Some of the animals would, unfortunately, be rather unpopular in the Club house, for who would care to pal up with the long-tailed tit, the lyre bird, the badger, the boar, the grouse, the puff-adder, the cheetah, the carp, or the bear (with a sore head)?

On the ladies' course we should find the spoon-bill, and possibly the shrew. The wry-neck would be noticed on the green, and all the game birds would certainly be bittern with the sport.

The secretary bird would be there, closely associated with the dormy mouse and the casual water-rat.

Not to try the reader's indulgence too severely, we may conclude by reminding him that the albatross keeps going all the time, that the rabbit can run down the hole from any distance, that the sand-hopper and the mud-skipper skillfully avoid the bunkers, that the gnu could play quite well if he only newt, that sea-urchins make good caddies, and that the butterfly is frequently found to be dead on the pin.

CAUGHT IN THE ROUGH
by Ken Smith

GOLF: THE ESPERANTO OF SPORT

by Lorne Rubenstein

International golf is a feast for the senses. You will never feel the game so deeply as when you golf in foreign lands. There's the different language, the exotic food, courses far different than we might encounter at home, and people who know you have made a special effort to visit their land and who will reward you with kindness and openness.

Golf, after all, is probably *the* universal sport. British golf writer Henry Longhurst called it the "esperanto," or universal language of sport. Indeed, golf crosses cultural barriers and fits into various societies because it meets the needs of the people. There's something in golf for everybody.

Consider this: When I travelled to Japan, I met Tak Kaneda, a middle-aged, nattily dressed businessman who at the time wrote a weekly column on golf, zen and business, called "Green Salon," for a Tokyo newspaper. He had written more than 20 golf books — an indication of just how golf-mad the Japanese are. I was given to understand that Red Flag, the Japanese Communist Party's daily paper, also included a regular golf column. Golf is in some ways beyond political ideologies. Or put another way, an argument can be made that golf serves any and all political needs.

Another story will further make the point. Some years ago American businessman-diplomat Armand Hammer used his extensive contacts in the Soviet Union to argue that a course near Moscow would serve the international community well, and that the Soviets might also find pleasure in the game. But the Soviets faced a problem: Wasn't golf a rich man's game? Wasn't it the ultimate expression of capitalist decadence?

The Soviets learned differently. Arguments were put forth that golf suited the common man as much as it did the wealthy man. After all, the game as we know it began in Scotland, and even today there is hardly a golf course in the entire U.K. that is not available to the man on the street.

The argument caught. The Soviet government paper Pravda apparently printed a lengthy article on the benefits of golf to all citizens. Golf became a sport uniquely suited to communist ideology, a simple game played with a club and a ball.

Today there are several courses on the drawing board within the USSR.

But back to Japan. One evening Kaneda took me to Shiba golf, a triple-tiered driving range that is packed night after night. What a vision it was in the evening: hundreds of golf balls criss-crossing one another before falling into an almost concave grass bowl. Was this a high-tech, super-magnified reflection of the Scottish pot bunker, also known as a "gathering bunker," a tiny hollowed out area into which golf balls bounced and fell? I felt again that Longhurst was correct. I didn't know a word of Japanese, but here we were, speaking golf, a universal language.

Another afternoon I drove balls from a rooftop range high above the Maruzen department store in the heart of Japan. Later I found another range in the sky, this one equipped with a putting green. As I travelled further into the heart of Japanese golf I met Keiichi Harada, a professor of American literature at Chiba University, an hour out of Tokyo. He too was wild about golf.

Harada himself was a victim of one of golf's universal urges, one that nearly every Japanese paper and golf magazine exploits: the desire to improve. He said ruefully that he wasted two years while trying to incorporate the square-to-square method, once advocated the U.S., into his 17-handicap game. Frustrated, he relieved his disappointment by translating and having published nine golf stories written by that master of prose and understatement, British writer P.G. Wodehouse.

"I found his collection called The Golf Omnibus," Harada said, "and thought it was wonderful. I felt that golfers would need this form of humour. I hope the publishers will soon put out the back nine."

Iwao Iwamoto joined us one day for a round at the Anegasaki Golf Club near Tokyo. He was teaching American literature at the University of Tsukuba,

and often turned therein to console himself over a golf game gone sour. Iwamoto had translated some of John Updike's writing. After our round, and following the ritual bath, a meal of tempura in a local house, and some warming sake, we found ourselves in a bar in the middle of Tokyo, finishing up with a round of whisky.

"Have you noticed," Iwamoto asked, "that Updike often uses golf metaphors to make a point?" We raised our whisky glasses in a toast to fine golf writing.

Late another evening I viewed the Tokyo skyline from the 50th floor of a sleek new downtown hotel. Here I pondered the question of why the game is so popular in Japan. Why, as Iwamoto had said, is it such a fiesta?

Then it hit me. Suddenly I understood, or thought I understood, the Japanese passion for golf. Here, high above the city, there was room. And on a golf course there was room. The cities, meanwhile, where choked with traffic and people. It was difficult to circulate, to move freely, even to see the sky and the sun. But more than anything, *a golf course offered space.*

I remembered a story Kaneda told me while we whacked balls into the night at Shiba golf.

"It's the story of the armour bug," Kaneda said. "The children in Japan play with this bug, but when it dies, they say, 'Daddy, the bug has run out of batteries.' "

Kaneda couldn't have made his point more effectively. The Japanese have little contact with the natural environment. Even children feel the separation. Already they cannot distinguish a life form from a technological creation. No wonder the Japanese golfer feels so much for the game. It's a return to something essential that he lacks in daily life: contact with the earth.

"When the Japanese person plays golf," Kaneda elaborated, "his space is increased. We live in such confinement in Tokyo or Osaka. So when we play on the golf course we have a good feeling. We see the beautiful sky. On a golf course the Japanese feel for the first time that they are living."

Another time, another place, another language. This time I was at the Olgiata Golf Club in Rome to report on the World Cup. Walking along, I chatted with Joseph Messana, then 19, then a one-handicap

FRENCH OPEN, 1983
by Lawrence N. Levy

golfer from the Tuscany area. His father was born near Times Square in Manhattan and worked for NATO (North Atlantic Treaty Organization) for 22 years. I wondered why Silvano Locatelli and Delio Lovato, the two golfers representing Italy in this international competition, gave up playing for a living for the relative ease of club jobs, though they were still in their thirties.

"Italians don't like to sacrifice the life of the teaching pro at the clubs," Messana explained. "Somebody like Lovato, he likes to go to the bar, to play cards and to watch soccer."

Yet golf is a reasonably popular sport in Italy. There are some 65 courses, and the government sports agency supports the game financially. Messana himself mentioned that many golfers hope to see a successful professional emerge one day, perhaps an Italian Seve Ballesteros. West Germany has Bernhard Langer, Spain Ballesteros. So why not Italy?

Messana continued. The Italians, he feared, like la dolce vita too much. He spoke of Ugo Grapas-

sonni, Olgiata's professional and a man who, in his mid-sixties, had taught many Italians. Messana himself had learned from the gentleman.

"He helps the young people with the swing," Messana acknowledged, "but, like all people from Rome, he is a little bit lazy. They like to eat the spaghetti and drink the wine." He feared, then, that we're not likely to see a world-class golfer emerge soon from Italy.

But don't Spaniards enjoy their paealla and their wine? Don't they thrive on café life? Where there's golf — and there is golf in Italy, and plenty of it — there's a possibility that a brilliant player might emerge. This is part of what makes golf the international sport it is. Ballesteros, Langer, Australian Greg Norman, Englishman Nick Faldo and Scotsman Sandy Lyle prove that even pro golf is international. One of the game's great charms is the chance to see these players compete against one another. Europe won back-to-back Ryder Cups, at home and in the U.S., and tied the latest. Golf continues to put a girdle around the globe, to paraphrase Robert Browning from his erudite 1955 study, A History of Golf.

What a wide band it spreads, this royal and ancient game of golf. One early winter I found myself in Indonesia, home to more than 60 courses. There I heard another reason that golf inspires such interest in its participants. This was at Senayan, a government athletic complex near Jakarta that included a golf school and driving range.

John Lantang presided over the school. In his mid-sixties, Lantang instructed from six a.m. until seven p.m. The school was filled all along its 200-yard width the night I visited, and as we spoke, Lantang looked into the darkening Indonesian sky, surveying his khusus sekolan golf, or driving range.

Golf, Lantang remarked, is "a good sport for Indonesians, because we like philosophy, and golf is a game where you must think. I tell the students what they will find in golf. I tell them that golf is like their lifeline. It will point out their mistakes."

It can do this all right, and in no small part because of the courses we can play around the world. We choose where we play and by doing so we set up a confrontation with the architect; he can tease us or scare us, but the emotions we feel are all our own. In this way we learn about ourselves.

We do not, for example, visit Ballybunion in southwest Ireland for the weather, though there are sweet days when the wind is calm and the sun

SWISS OPEN, 1983
by Lawrence N. Levy

high and warm over the Atlantic. These days are gifts, but so are the rough days. The golfer who speaks the true language of the sport accepts this. He even welcomes it. He's golfing, not sunbathing.

Tom Watson, for one, licks his lips anytime he tees it up on a wild day. Many times he has visited Ballybunion, there to find a way to guide his ball through massive sand dunes, along, over and across knobs, hollows and nearly subterranean lairs formed by the wind. A few years ago as Watson played in a lashing wind and rain he turned to his companion, rubbed his cold hands and said, red-faced and loving it, "Now this is fun, isn't it? I don't think I've ever enjoyed golf as much."

In this adventurous spirit we also accept unusual — to us — golf course architecture, especially blind holes: the Himalayas and the Alps; two examples at Prestwick, Scotland; the par-three hole known as the Dell at Lahinch in Ireland. Such holes offer a timeless pleasure lost in modern North American golf. Their appeal has never been captured better than in an article Horace Hutchinson wrote in 1890 about Prestwick.

"The holes lay in deep dells among sandhills, and you lofted over the intervening mountain of sand and there was all the fascinating excitement, as you climbed to the top of it, of seeing how near to the hole your ball might have happened to roll."

There are many other delights of world golf: a par-five at the Jagorawi Club near Jakarta that wraps round and above rice paddies where children work and play; the three-foot high stone wall in front of a green at North Berwick outside Edinburgh; the tiny, often malevolent bunker in front of the 17th green at the Old Course in St. Andrews, and the road and wall behind, on this, the famous Road Hole; the starter at Leven Links near St. Andrews using a whistle from his hut behind the first tee to get play moving.

But I must return to Ireland. Here I met brothers George and Kevin Christie, then 11 and 15 years old and not much taller than my golf bag. The boys have caddied for me the couple of times I have played Portmarnock, near Dublin, surely one of the finest courses in the world. It is absolutely uncontrived, 18 marvelous holes beside the Irish Sea. As if the golf weren't enough, George and Kevin made my time at Portmarnock memorable.

I remember how they used the language. On one hole I debated between an eight and a nine-iron for my approach shot to the green. George, who has

since gone on to become a jockey, sensed my indecision when I picked the eight from the bag. "And you needn't force it either," he advised.

This unexpected comment was but one of many that made listening to the boys a pleasure. Their chitchat varied from Harold Pinter minimalism to Runyonesque colour. I knew the Irish had a flair for language, but I hadn't expected it in lads so young.

"Home sweet home," Kevin said as we approached the 18th green at Portmarnock one late afternoon. "Will ye come back again? I hope ye will."

I assured him I would, as I will to other special places in the world of golf. There is, for example, the Bali Handara Country Club on the magical island of Bali in Indonesia, 4,000 feet up in a tropical rain forest. As I played there one afternoon I could hear Hindus chanting from the neighbouring village of Pencasari, while here and there the sounds of a flute wafted across the course. I can still call up the sense of tranquility I felt at Bali Handara.

But that's another story in the esperanto of sport.

SPANISH OPEN, 1987
by Lawrence N. Levy

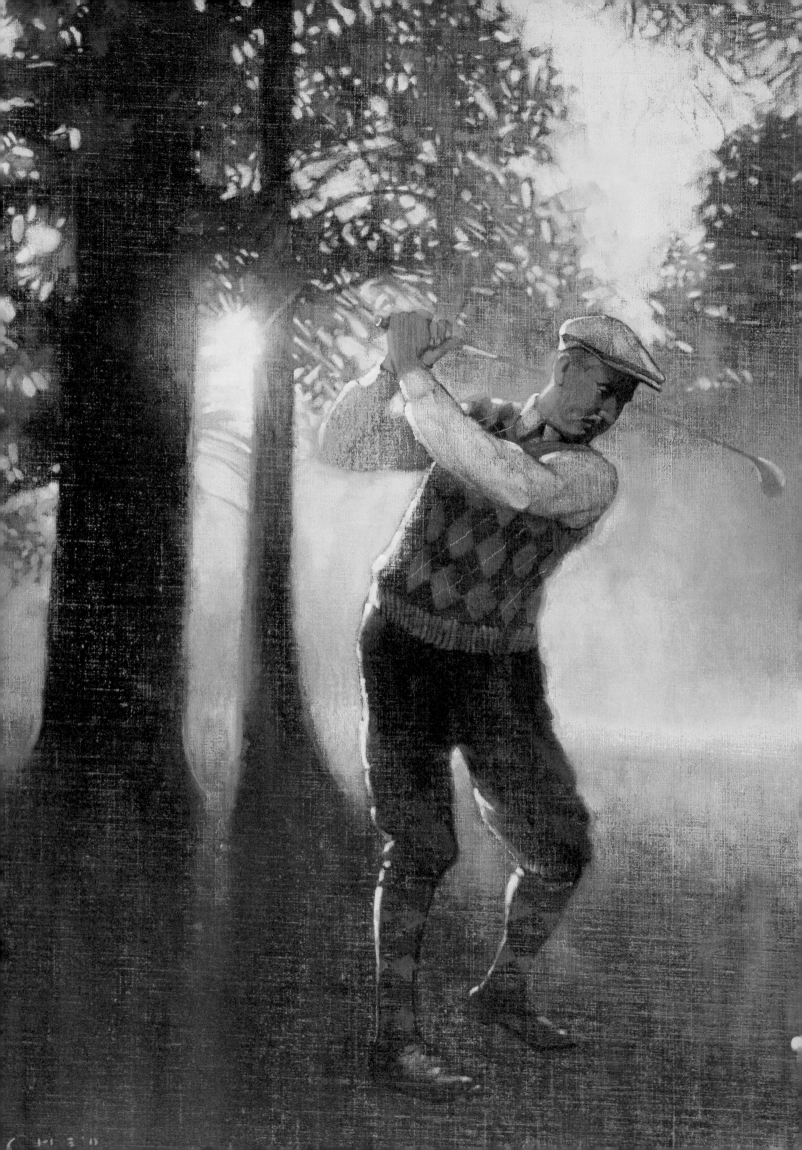

A GOLF SONG

by Rose Champion de Crespigny

When the world in Spring is smiling,
 And the heart of man is young,
Is there aught that's more beguiling,
 All terrestrial joys among,
Than to roam o'er grass and heather,
 Or along a sandy shore,
Be it fair or frowning weather,
 With a golf ball on before.
Then hey! for the drive from the tee;
 For the links by the sounding sea;
And the wide sand dune,
 It is never too soon,
And golf is the game for me!

Summer claims our glad ovation,
 And the heart of man is strong;
What is better in creation
 Than the golf links all day long?
Throw aside your cares and worries
 At the radiant sun's behest;
Every wise man surely hurries
 To the green he loves the best.
Then hey! for the drive from the tee;
 For the links by the sounding sea;
It is never too hot,
 Be it June or not,
And golf is the game for me!

Though the Autumn days are shorter
 And our strength is on the wane,
By the briny salt sea-water
 Let us all play golf again.
Though cold fogs and winds assail us,
 We shall never feel the chill;
Though the summer sunshine fail us,
 We will seek the green links still.
Then hey! for the drive from the tee;
 For the links by the sounding sea;
For it's never so gray
 As to spoil your play,
And golf is the game for me!

When the year is nearly ended,
 In the Winter of our days,
Let our strength be still expended
 On the game beyond all praise.
Though the sun in glory waneth,
 And the leaves are sere and dun,
Make the most of what remaineth,
 Play until the round is won.
Then hey! for the drive from the tee;
 For the links by the sounding sea;
For it's never too cold,
 And we're never too old,
And golf is the game for me!

SUNRISE GOLFER
by Shed

The Best Game

by Frank Poxon, 1922

Which sport or recreation gives the best return to its devotees? Those who are choosing a game which is to last for many years would do well to compare all the advantages which different pastimes have to offer.

There are many factors to consider — health, actual enjoyment, and by no means negligible social possibilities. A man who sets out to use his proficiency in sport as a lever for social advancement is often a bounder, but the advantage cannot be avoided. Take the case of two young subalterns in a crack cavalry regiment. They are equally placed in everything with the exception that one of them is a brilliant polo player. It does not require much imagination to see that the polo-playing subaltern will have a much pleasanter time — and greater chances of promotion — than the other, who can just sit a horse well enough to pass muster on parade.

A real enthusiasm for sport opens many social doors nowadays. Lawn tennis and golf are two games which constitute a kind of world-wide brotherhood, and there are many exiles from England who find a ready welcome in their new homes overseas because they can wield a tennis racket or golf club to good purpose. For it is still very largely true that sport is a great leveller, with merit the one thing that matters. One would like to be able to add that snobbery in sport is dead, but it would be more accurate to say that it is dying.

Everything depends upon the frame of mind in which a game is taken up. Some people, for instance, regard sport as a cheap alternative to the doctor. It is a case of Walton Heath or Harley Street, and they elect for golf. Those folk who defy gout with a brassie and, niblick in hand, dare a peevish liver to do its worst, do not really get the most out of the game of their adoption, but they get what they are looking for, an insurance against ill health.

The finest spirit in which to play a game is one of sheer unquestioning enjoyment; health and fitness will follow as a matter of course, and as a natural sequel to the care-free enjoyment which is the first desideratum. If you make of sport a drudgery, all you will achieve is a waste of time.

Recently I asked a doctor of my acquaintance who also happens to be a keen sportsman which game he would put first in the list of all-round desirability. He replied: "Golf, I think. It is stimulating but not violent; scientific but always a game. For the young, fit man of thirty I would perhaps recommend lawn tennis; but he would have to give up the game far sooner than he would have to give up golf, which can be a real companion for life."

GOLFER'S HYMN

by E.W. Stansbury

A bag of clubs, a dimpled ball,
Fair verdant greens, that rise and fall,
An azure sky, a glorious sun,
And a day of golf is well begun.

A score that does not bring disgrace,
Good will for all the human race,
Enjoyment of a setting sun,
And a splendid day of golf is done.

IN CLOVER
Artist Unknown

GRANT OF GLENMORRISON
by R.R. McIan, 1847

THE SOUL
OF GOLF

◆

FAVETE LINGUIS

by Arnold Haultain, 1910

There are some woods fringing portions of the course most tempting to explore, woods in which I get glimpses of lovable things, and a wealth of colour which for its very loveliness I forgive for hiding my sliced ball. There are deep ravines -- alack! I know them well — where, between lush grass edges trickles a tiny rill, by the quiet banks of which, but for the time-limit, I should loiter long. There is a great breezy hill, bespattered with humble plants, to traverse the board back of which almost tempts to slice and to pull. A thick boscage, too, whereon the four seasons play a quartet on the theme of green, and every sun-lit day composes a symphony beautiful to behold. And there are nooks, and corners, and knolls, and sloping lawns on which the elfish shadows dance. Smells too, curious smells, from noon-day pines, and evening mists, from turf, and fallen leaves ... What is it these things *say*? Whither do they beckon? What do they reveal? I seem to be listening to some cosmic obligato the while I play; a great and unheard melody swelling from the great heart of Nature. -- Every golfer knows something of this. But, as Herodotus says, these be holy things whereof I speak not. *Favete linguis.*

PAR SHOOTER
by Ralph Furmanski

THE GAME'S HIDDEN BUT ACCESSIBLE MEANING

by Michael Murphy

Certain events may reflect the significant dimensions of all your life, mirroring your entire history in a passing moment. Have you ever had an experience like that? Have you been caught by an event that suddenly pulled the curtains back? Shivas Irons maintained that a round of golf sometimes took on that special power.

The archetypes of golf are amazingly varied, he said, that is the reason so many people gravitate to the game.

GOLF AS A JOURNEY

"A round of golf," he said in his Journal notes, "partakes of the journey, and the journey is one of the central myths and signs of Western Man. It is built into his thoughts and dreams, into his genetic code. The Exodus, the Ascension, the Odyssey, the Crusades, the pilgrimages of Europe and the Voyage of Columbus, Magellan's Circumnavigation of the Globe, the Discovery of Evolution and the March of Time, getting ahead and the ladder of perfection, the exploration of space and the Inner Trip: from the beginning our Western World has been on the move. We tend to see everything as part of the journey. But other men have not been so concerned to get somewhere else — take the Hindus with their endless cycles of time or the Chinese Tao. Getting somewhere else is not necessarily central to the human condition."

Perhaps we are so restless because like Moses we can never make it to the promised land. We tell ourselves that It is just over the next hill: just a little more time or a little more money or a little more struggle will get us there; "...even our theology depends upon that Final Day, the Eschaton when the journey will finally arrive, to compel our belief in God."

The symbol of the journey reflects our state, for man is surely on the move toward something. Many of us sense that our human race is on a tightrope, that we must keep moving or fall into the abyss.

"This world is for dyin'," he said that night. We must die to the old or pay more and more for remaining where we are.

Yes, there is no escaping the long march of our lives: that is part of the reason people re-enact it again and again on the golf course, my golfing teacher said. They are working out something built into their genes.

But there are other myths to govern our lives, other impulses lurking in our soul, "myths of arrival with our myths of the journey, something to tell us we are the target as well as the arrow."

So Shivas Irons would have us learn to enjoy what *is* while seeking our treasure of tomorrow. And — you might have guessed it — a round of golf is good for that, "...because if it is a journey, it is also a *round*: it always leads back to the place you started from...golf is always a trip back to the first tee, the more you play the more you realize you are staying where you are." By playing golf, he said, "you re-enact that secret of the journey. You may even get to enjoy it."

THE WHITENESS OF THE BALL

What the golf ball was to Shivas has been hinted; what it has come to mean for me remains unsaid. And for a reason. Its power as a symbol is so complex and labyrinthine, so capable of lending itself to the psyche of each and every player, that once an attempt like this has begun to comprehend its "inner meaning," all bearings may be lost. For the golf ball is "an icon of Man the Multiple Amphibian, a smaller waffled version of the crystal ball, a mirror for the inner body; it is a lodestone, an old stone to polarize your psyche with." The more I ponder its ramifications the more I see that each and every bit of this world reflects the whole.

A friend of mine sees it as a satellite revolving around our higher self, thus forming a tiny universe for us to govern — a marvelous image really when you think about it, one I am sure Shivas Irons and

Seamus MacDuff would have approved of. Our relation to the ball is like the Highest Self's relation to all its instruments and powers; the paths of its orbits reflect those of the planets and suns. The ball is then a symbol of all our revolving parts, be they mental or physical; for a while we re-enact the primal act of all creation: the One casting worlds in all directions for its extension and delight. Shivas anticipated the image in his notes: "For a while on the links we can lord it over our tiny solar system and pretend we are God: no wonder then that we suffer so deeply when our planet goes astray."

The ball is also a reflection, as Adam Greene said, of projectiles past and future, a reminder of our hunting history and our future powers of astral flight. We can then ponder the relation between projectile and planet, our being as hunter and our being as God; the hunter, the golfer, the astronaut, the yogi, and God all lined up in the symbol of the ball.

"The ball is ubiquitous," say the notes. "It is in flight at this very moment above every continent. Moreover, it is in flight every moment of the day and night. It may take flight one day on the moon, especially when you consider the potential prodigies of mile-long drives and the wonder they would bring to millions. Consider the symbolism inherent in that indubitable fact: a golf ball suspended in air at every moment!" There are so many golfers around the globe.

At rest, it is "like an egg, laid by man," for who can tell what prodigies the next shot will bring? In flight it brings that peculiar suspended pleasure which lies at the heart of the game; it is "a signal that we can fly — and the farther the better!" — it is a symbol of our spirit's flight to the goal. It is perfectly round, for centuries of human ingenuity and labor have made it so, and "the meanings of roundness are easy to see." (Parmenides and other Greek philosophers said that Being itself was a globe, that we must therefore "circulate" our words in order to tell a "round truth.")

So the symbols and meanings are endless. But when all these are said and done, there is a fact about the ball that overpowers all the rest. It is the whiteness of the ball that disturbs me more than anything else. "Though in many natural objects whiteness enhances beauty, as if imparting some special virtue of its own," said Herman Melville in a well-known passage, "and though certain nations have in some way recognized a certain pre-eminence to it, there yet lurks an elusive something in the color which strikes panic to the soul."

Only black so reminds us of the great unknown. Black and white, we throw them together in the old cliché, but somewhere deep in both there lies a hint of powers unforeseen. Do they remind us of the void, since they represent the absence of all ordinary hue? Is it annihilation we fear when we encounter them? "All colors taken together congeal to whiteness, the greatest part of space is black," say the journal notes. "What would happen if someone introduced a golf ball painted black?"

THE MYSTERY OF THE HOLE

In no other game is the ratio of playing field to goal so large. (Think of soccer, American football, lacrosse, basketball, billiards, bowling.) We are spread wide as we play, then brought to a tiny place.

The target then leads into the ground, leads underground. I realized this once reaching into one of the exceptionally deep holes our Salinas greenkeeper was cutting in 1949 (he had procured a new hole-cutter). What a strange sensation reaching so far into the ground. What was down there, underneath the ball?

There was a section in his notes entitled "The Psychology of Passageways," which has a bearing on the hole's mystery. In it there was a list of "holes and doorways in our ordinary life," which included a long paragraph about the significance of looking through windows (something to the effect that windows have a function other than letting us look outside, that we build them to simulate our essentially imprisoned state), another on the subject of toilets and the draining away of our refuse (including some sentences about the need to examine our stool whenever we feel disjointed), an essay on picture frames and other boundaries on art objects, and a list of all the "significant openings" in his own apartment (apparently, he had taken a careful inventory of these). There was also a list of "Extraordinary Openings." This included a constellation in the new zodiac he had made, various kinds of mystical experience — an entire catalogue in fact of transports and ecstasies; a list of historic figures (including Joan of Arc, Pythagoras, Sri Ramakrishna, Seamus MacDuff, the Egyptian Pharaoh Ikhnaton, and a Dundee cobbler named Typhus Magee); a list of historic events (including the outbreak of philosophy all over the world during the sixth century B.C., the first flights at Kitty Hawk, and a drive he had hit sometime during the summer of 1948); certain places in Burningbush and its environs (I think he compared these to the points on the body which are probed during treatments with acupuncture); a golf

course in Peru (perhaps the Tuctu golf course, which he had mentioned during our conversation at the McNaughtons); certain phrases, philosophical terms, and lines of poetry (including the word *Atman*, the *Isha Upanishad*, and a limerick by one of his pupils); a list of coincidences in his life; and the unpublished manuscript of his teacher.

Our first passageways, he said, are the avenues of sense — our eyes, ears, nostrils, and mouth. We build our houses and churches to simulate these, we relate to the earth itself as if it were our body, for "we start as someone looking out, and as soon as we look we think of escape."

"Life is a long obsession with passageways," the notes go on, "we are ever breaking through to the other side — of ignorance, isolation, imprisonment. Memory, catharsis, travel, discovery, ecstasy are all ways of getting outside our original skin."

He thought it significant that an entire fairway, with its green, rough, hazards, and traps was called a "hole," that the tiny target was used to characterize all the rest of the playing field. " 'How many holes have you played?' is the way the question is asked, not 'how many fairways?' or 'how many tees?' " He thought it had something to do with the fact that after all our adventures, all our trials and triumphs on the journey-round we are left with that final passage through; that the hole and what it leads to is really what the game is all about.

As it turns out some of the most original thinking on the subject has been done by Jean-Paul Sartre, who ends Part Four of *Being and Nothingness* with a short essay on the hole and its implications. I don't recall Shivas quoting Sartre but their thinking on the subject has some extraordinary similarities. The French philosopher, admittedly, is not an accomplished golfer, but his apparent grasp of the hole's mystery suggests that he has had his problems and triumphs on the links. "Thus to plug up a hole," he says, "means originally to make a sacrifice of my body in order that the plenitude of being may exist." (How we golfers can sympathize with that.) "Here at its origin we grasp one of the most fundamental tendencies of human reality — the tendency to fill...A good part of our life is passed in plugging up holes, in filling empty places, in realizing and symbolically establishing a plenitude." In establishing a plenitude! Perhaps this is the most fundamental clue. And the comprehension of the essential act of sacrifice involved in every disappearance of the ball into the hole (sacrifice and inevitable rebirth)! For the journal notes say, "In golf we throw ourselves away and find ourselves again and again...A ball is in flight somewhere at every moment..." What

are all these but glimpses of plenitude! To fill the hole with our ball is to reaffirm that fullness.

REPLACING THE DIVOT

Our green-loving philosopher claimed there was no better way to deal with our existential guilt than replacing a divot or repairing a friendship. "We act on friendship every moment: with our fellows, our land, our tools, with the unseen spirits and the Lord whose world we are tending."

"Golf is a game of blows and weapons. In order that the game continue we must make amends for every single act of destruction. In a golf club everyone knows the player who does not replace his divot. One can guess how he leads the rest of his life."

Replacing the divot is "an exercise for the public good." It is also a reminder that "we are all one golfer." There would simply be no game if every golfer turned his back on the damage he did.

A GAME FOR
THE MULTIPLE AMPHIBIAN

Bobby Jones and other lovers of the game have attributed its widespread appeal to the fact that it reflects so much of the human situation: comedy, tragedy, hard work, and miracle; the agony and the ecstasy. There is something in it for almost everyone. Shivas liked to quote the *Religio Medici,* especially the passage that described man as "...that great and true Amphibian whose nature is disposed to live, not only like other creatures in divers elements, but in divided and distinguished worlds." He believed that golf was uniquely suited to our multiple amphibious nature. It gives us a chance to exercise so many physical skills and so many aspects of our mind and character.

I need not catalogue the game's complexity to make my point: you know about all the long and the short shots; all the nuance of weather, air, and grass; all the emotion and vast resolution; all the schemes for success and delusions of grandeur, and the tall tales unnumbered; the trials of patience and fiendish frustrations; all the suicidal thoughts and glimpses of the Millennium. We all have a golfing friend we have had to nurse past a possible breakdown or listen to patiently while he expounded his latest theory of the game. How often have we seen a round go from an episode out of the Three Stooges to the agonies of King Lear — perhaps in the space of one hole! I will never forget a friend who declared after his tee shot that he wanted to kill himself but when the hole was finished said with total sincerity that he had never been so happy in his entire life. No other game is more capable of evoking

a person's total commitment.

This immense complexity delighted Shivas. In fact, he would add more complexity to the game, perhaps to satisfy his endlessly adventurous spirit. Running, for example, has been left out, as well as jumping and shouting; so he advocated your exercising these basic functions sometime during the golfing day if you wanted to balance your mind and nerves. We must give these large needs adequate expression, he said, otherwise golf would "imprint too much of its necessarily limited nature on us." For "...every game must have its limits, simply to exist, just as every form and every culture does, but our bodies and our spirits suffer." So somewhere and somehow we should run and jump and sing and shout. (I don't want to give you any advice about this, especially when I think about some of the trouble I have had on golf courses when I have tried to follow his advice. Perhaps you should confine these more strenuous activities to your local schoolyard or gym. But you might find it interesting to see how your game fares when you exercise those muscles and functions that golf neglects.)

This is true for much more than running, jumping, and shouting though. For our golfing teacher maintained in his inexorable way that our "emotional and mental body" needed as much exercise as our physical body did. So "poetry, music, drama, prayer, and love" were essential to the game too. "There is no end to it," he said, "once you begin to take golf seriously."

OF A GOLF SHOT ON THE MOON

It can now be argued that golf was the first human game played on another planetary body. Those two shots Alan Shepard hit with a six iron at the "Fra Mauro Country Club" have brought a certain stature and gleam of the eye to golfers the world over. Coming as they did while I was writing this book, they appeared to me as synchronicity: the game has a mighty destiny, the event said; Shivas Irons was right. In the shock I felt when the news appeared (I had not seen the television show) I thought that in some inexplicable way those shots had been engineered by Shivas (from his worldly hiding place) or by Seamus MacDuff (from his hiding place on the other side). But the subsequent news that Shepard and his golf pro, Jack Harden, had planned the thing ruled out Shivas and restored some perspective to my hopeful speculations. Still, the meaning of it continued to loom before me. Golf on the moon! And the command module named Kitty Hawk! (Shivas had called Kitty Hawk an "extraordinary opening" in this unfolding world and

had worked with Seamus all those years on the possibilities of flight with "the luminous body.") The event was a tangle of synchronicities.

I wonder how many other golfers have felt the same way. So many of us are alive to the other edge of possibility (perhaps because the game has tried us so sorely) and ever alert for the cosmic meaning. This event confirms our sense of mighty things ahead.

There are other implications, however, some less promising. A trusted friend of mine, someone with a quick keen eye for injustice and intrigue, saw an ugly side to the whole affair. It was, he said, an imperial Wasp statement, however unconscious, that this here moon is our little old country club for whites, thank you, and here goes a golf shot to prove it. I hated to hear that, for I wanted to dwell on the hopeful meanings. And I hated to think what Seamus would do, being half-black, if he were fiddling around with it all from his powerful vantage point. The Kitty Hawk might not make it back to earth! But the heroes are back and so far so good. Still, I am left wondering what latent imperialism lay behind that six-iron shot.

And I am left with other thoughts about the character of Alan Shepard. What could have led the man to design that faulty club, smuggle it on board with those "heat-resistant" balls and risk some billion-dollar disaster from flying divots or tears in his space suit? What could have led him to such monumental triviality amid the terrors and marvels of the Moon? The madness of the game had surfaced again, I thought, as I pondered his motives.

Had NASA put him up to it for public relations reasons? Maybe they wanted some humor in the enterprise or the backing of certain rich and powerful golfing senators. Perhaps he would collect on some stupendous bet (after all, he was interested in money and had made a pile in his astronaut years). Or could it simply be that all his golfer's passion to hit the ball a mile now had a chance to express itself, indeed the chance of a lifetime, the chance of history! Perhaps the collective unconscious of all the golfing world was delivering itself at last, seizing him as instrument for the release of a million foiled hopes for the shot that would never come down. And indeed the cry came down from space, "...it's sailing for miles and miles and miles," Alan Shepard was giving the mad cry of golfers the world over who want to put a ball in orbit and reassume their godlike power.

Yes, indeed, indeed, Shivas was right; the game keeps giving us glimpses.

THE STORY OF A TEE-CLUB

by Thomas March, Poet-Laureate of the Blackheath Club

From a gay wood cut, cruelly rent, and torn
From the parent tree; tremendously shorn
Of all my beauty; my young life cut short,
And broken down to furnish others' sport;
Thus from my gnarly trunk untimely ript,
And all my gay green leaves so early stript;
Bound on a raft with many a *billet* more,
I bade good-bye my *billet* on the shore.
Stowed in a vessel's hold, oh darksome sight!
I faintly sighed, "My native land, good night!"
Tossed on the billows, borne with fav'ring wind
Toward England, to which land I was consigned —
Arrived, I lay in durance vile ('twas hard,
'Most past endurance) in a timber-yard.
One day there came a man of aspect wild,
A northern accent had this *canny* child,
Can he have come to set me free? kind fate;
He bargains for me, and with face elate
He buys me, then me he falls to fingering,
While with *lingo* strange he still keeps *lingering*.
At last we reached his home, a place so quaint,
Smelling of varnish, leather, glue and paint.
Are these folks mad? What jargon's this they
 utter
About tee-clubs, spoons, heavy irons, and putter,
Cleeks, niblicks, stymies, putting on the green,
Foursomes, furze-holes; they're *all* gone mad,
 I ween!
Bunkers, quarries lying a wee bit bafty;
O yes, I thought, they're all a wee bit dafty.
My master, like the rest, was quite insane;
To give me beauty, why, he used a plane.
One day he seized me, and most *happily*
A head of *apple* did to me *apply*.
What's that queer tool that in his hand I see?
I fear it *augurs* very ill for me.
I'm right; without so much as "What's your wull?"
He drills three holes nigh half-way through my
 skull,
Then seizes a *pannikin* of molten lead,
And pours it into my devoted head.
Hot was the *pan*, I *ken*: my face was tanned,

As with a lump of lead I was *trepanned*;
And lest my face should jagged get or torn,
He *faced* it with a toughish bit o'horn;
Then with an iron, sharp-pointed as a dirk,
He printed on my face this sign, "R. KIRK."
The work being done, emerged I from the grub,
Thus from the timber came a perfect club.
Exposed for sale, awaiting offers, I
Longed that some golfer keen my face would spy.
Many try me — "short," "too long," "handle
 don't please":
Few handle me with elegance or ease.
I recollect one grasp upon my leather
As if two icebergs vast had crashed together,
While a gruff voice, in tones soon recognised,
My graceful shape and form thus criticised:
"Pshaw! this won't do; pray, let me have a bigger:
This fine club would never make *me* a digger."
One morn — methinks 'twas in the summer
 time —
Came a true golfer; he was in his prime.
He saw and bought me: language is all too tame
To tell his triumphs, blazon forth his fame,
Or chronicle his deeds. He was the admired
Of all admirers. Men seemed never tired
Of praising him. Kind fates, that thus 'twas fated
To this great golfer that I should be mated!
And thus together in sweet companionship
We went on many a pleasant golfing trip,
Winning no end of prizes, medals, crosses;
In singles or foursomes we knew no losses.
Sometimes to sunny Devonshire we'd go,
Enjoying much our stay at Westward Ho.
There, towards evening, we have often strayed
To where the fairest of fair golfers played.
As each fair maiden play'd, no doubt that she
Thought of the medal of great J.L.B.
How can I paint in words my vast delight
When first the ancient city burst in sight!
Spell-bound I stood upon its rocky shore,
Gazed on the old cathedral, grand in lore;
Still gazing to where the land so gently sinks,

Mapped out below me lay the glorious links,
Scene of a thousand fierce-contested fights,
The golfer's home, and Eden of delights.
Ever to thee my soul its homage yields,
Rememb'ring always thine Elysian Fields,
And those joyous days when, free from grief and
 care,
We in thy glorious pastime had our share.
Changed is the scene: the joyful days are past;
Age with his stealing steps comes on at last;
Death claims my master, and with feeble gasp
He sighs farewell, and drops me from his grasp.
My toil is over — yes, my work is done:
Neglected, lost, I'm in the world alone;
I'm badly sprung, I'm shaky in the head,
Cracked is my horn, and all loose is my head;

My shaft to crookedness does somewhat tend,
And being greasy, I have the *greasyun* bend.
Ah! I am only fit for childhood's tricks:
Use me for tipcats, hoop or popgun sticks.
Now could I quote from Master Shakespeare's
 tome:
"To what base uses do we sometimes come!"
How sad a ratio do we often bear,
In what we are, to what we used to were!
Stuck in the cold ground am I to prop a rose,
To shield and succour it when the wild wind
 blows.
I'm tightly hammered in for full a foot —
Who knows, perhaps I may again take root,
And springing upward to the fair blue sky,
Become once more a *tree tre*mendous high!

UNTITLED
by Bart Forbes

THE SONG OF THE IRON

by Joshua Taylor, 1920

Yes, I am a battered, worn-out looking apology of a golf-club, am I not? And you would scarcely believe that once I was as bright as the smile of the man who has just returned a "four-up" on the "Colonel," and the particular pet, for a time, of a scratch player.

Where I first saw the light of day I don't remember, but where I first felt it was in the dirty, dusty, dingy — I almost feel inclined to finish the Ds — forge of a golf iron maker. From the first I was unlucky. Once during the ordeal of being heated and hammered and hammered and heated I struck. My dignity was offended at the repeated efforts of an alleged workman to hammer my socket right. From the very commencement I liked to be handled with delicacy and I resented this heavy-handed, grimy, son of toil, who was making an awful hash of my delightfully curved heel. All white with righteous indignation and the heat of the fire I spun round, wiggled out of the grasp of the pincers and bit him on the wrist. His language was awful, at least I thought so at the time. I have since learnt that what he said was honey to what some players have since called me when I have playfully hit a ball into the open jaws of a hungry bunker. The workman spitefully flung me into the far corner of the grimy shop, picked me up again, and before I had time to even squeal, dropped me in a trough of dirty water. I hissed and literally bubbled with rage, so much so that the fellow picked me out again quickly muttering "you'll do, confound you."

With a batch of others I made the acquaintance of the emery wheel. I liked that. I felt as bright and clean as a London tripper after his annual bathe and did not resent at all being punched violently in the back which left an impression that is only now beginning to wear off. I was packed off, with a dozen others, to a man who my packer called a pro. Who this pro was I could not find out, but he must have been a disagreeable man for my packer remarked as he tied the last knot — I could hear him quite plainly through the paper — "There, I wonder what complaints you will have to make about this lot."

I arrived at my destination. My clothes were a bit torn and damp but I was alright. I was thrown on to a bench. There was a snick, the point of a sharp instrument just missed my nose and once again I saw the light of day. A grubby-face urchin with hands that smelt of pitch and varnish picked me up, gave me a glance and flung me down again with the remark that he hoped this lot would be easier to fit than the last. I made a mental reservation to myself that if I could help it, my fit would be the hardest job that young man ever attempted. It was. For an hour he tried to force a piece of wood down my neck, but by dint of side-stepping and slipping I prevented that piece of wood going straight home. He hammered the wood in, knocked it out again, or rather knocked me off, filed a piece out of the wood on one side and stuck a piece of paper on the other. Tried wrapping it with string, but still I would not give in. Finally he gave it up and I heard him say "You'd better have a go at this one, I can't get it on straight." I felt another hand grasp my neck. No pitch-covered hand this, but one with fingers, although they held tight, yet had that indescribable feeling which betrays the master mind. I went on as tamely as a player lays a stymie, and had my revenge when I heard the pro advise the urchin to "practise on the gas pipe" and not to defile a beautifully-shaped head with his filthy hands. I was finished, placed into another room, and after a deal of handling and banging on the floor and bargaining, was sold to a player. My troubles commenced. I was swished through the air, and made to take mouthfuls of earth. I was used as an instrument to recover a dirty ball from a stinking pond and to hit that ball, after I had rescued it from the branches of a tree. I was flung into a hedge after I had hit a ball into the back garden of a house and was retrieved by a grinning caddie. Every indignity that could be showered on me I suffered and I was not sorry when I became the property, in exchange for what was called "half-crown," of another player. Through a dozen hands I went. I was knocked this way and that. One said I carried my nose too high.

In ten minutes my nose was like the tail of a half-drowned dog. Another said I had too much weight in my heel. This was a libel, as my heel was as perfect as that of Pavlova, but I lost a bit nevertheless. I got tired of it all. I, who was once so bright and clean. Had been fondled with gentle care by the caressing fingers of the pro was now a dirty, misshapen lump of red iron. The punches on my back were nearly obliterated but a close study would reveal enough to identify me as once being the work of a famous maker. I decided that enough was as good as a feast, so one day when my latest owner was using me to coax a ball from a forest of thick grass, I bit through the wood at my neck and flew away into space. I heard a cry that sounded like "Where the 'll did that go," but I smiled as I bored a hole into a soft mud bank. I was free. For days I hid in that bank and should have been there now but for my present owner. He was diligently looking for a lost ball when he caught sight of my neck. With a yell he yanked me out. I was cleaned of mud, and the remaining piece of wood was patiently bored out of my neck. A new stick from the hedge was cut and with difficulty fitted in. I bore it all for I felt I was at last in the hands of one who appreciated me. My trappings were not so fine. There was no grip on the stick, while the ends of the rivets that held it and me together, stuck out like the eyes of a Scotsman at the sight of a sovereign. I did all things. I knocked balls about the cast-iron roads and knocked nails into my owner's boots. I won pennies at putting in the caddie-yard, and have been the means of dislodging a cat from the top of a wall. My life is a hard one, but I am content. I am the most-valued treasure of my owner — I sleep with him — and I would not change places with one of a dozen that adorn the bag of one of my earlier masters. I may be nothing to look at, but I am appreciated and that's what makes life worth living. Don't you think so?

THE BAG
by Karin Boinet, 1987

Fun, Friends and Play

by Tom Stewart, 1985

Everyone needs a buddy and we all need to laugh and play. In today's fast-paced, stressful world, we all need friends with whom we can let down our artificial barriers. We need a pard with whom we can be ourself — pals who will lighten us up.

Psychologists' studies are showing how healthy and beneficial play, humor and affection can be in our lives. Norman Cousins, in his book *Anatomy of an Illness*, documents his healing from a serious disease by surrounding himself with close friends, peaceful music and funny movies. A positive, light environment can help us all take ourselves a little less seriously.

Buddies usually come together out of common interests and a strain of shared trust. Our closest comrades place few expectations, demands or preconditions on our relationships. When together, absolute acceptance allows for ease and relaxation. Many of us have friends who we see only once a year, or less, and yet we feel as though they are always a part of our lives. Real true friends allow us to share our deepest aspirations or our silliest fantasies.

Golf is a special facilitator of this unique bond of friendship, which the poet, Robert Bly, calls "the mystical club of shared knowing." Golf is a common denominator that draws people together from across the gamut of socio-economic backgrounds. During a match golfers are often exposed beyond the veneer of their persona. Subconscious nuances of character come to the surface during the heat of competition. Egos are unmasked as we react to our successes and failures. Our partners or competitors generally can see us as we are "on the inside."

Golf, though serious to some, is a form of play for most of its followers. As play, it can assume a big role in reducing the stress in our lives. Golf can bring back the childlike qualities of lightness and fun that many of us lose when we get older.

When we are in touch with the playful part of ourselves, there is a quality of fulfillment, peacefulness and centeredness that emerges. Play provides us with a more expansive perspective. Fun transcends the mundane. It offers moments in our lives that help us recognize our connectedness to something bigger and more powerful than our immediate surroundings or the job at hand.

Golf, or any form of play, can add balance to our existence. It encourages us to take our work seriously and ourselves lightly. Fun is the fulcrum that helps us walk that fine line. Playfulness helps develop health, hope, optimism, love, joy, laughter and a will to live. Our internal organs are massaged when we laugh and play, and it seems respiration and circulation are enhanced as well. Medical studies show laughter as activating the endorphin system in our brain — the endorphins being the body's natural pain killer.

Play is an important form of stress management — an antidote to burnout. Recreation keeps us fresh, young at heart, young in spirit, young in mind and even young in body, when it is part of physical activity, like golf. In a machine, "play" refers to some kind of looseness in the structure. So it is in our lives as well, when we loosen up our mental structures. We accept more and judge less. In so doing, we open ourselves to all kinds of newness and whole-person learning. Play keeps us from hardening of the arteries and hardening of the attitudes.

Games and fun are great ways to build bonds and to strengthen and improve relationships. Golf teaches us to be open and accepting of others and ourselves.

Looking back over lives filled with fun and challenge, many of us may view our close friendships as our biggest blessings.

The Fishing Hole
by R.A. Finlayson, 1988

THE SOUL OF GOLF

by P.A. Vaile

There is in England a curious idea that directly one acquires a scientific knowledge of a game one must cease to have an interest in it so full as he who merely plays it by guesswork. There can be no greater mistake than this. If a game is worth playing well, it is worth knowing well, and knowing it well cannot mean loving it less. It is the peculiar idea which has put England so much in the background of the world's athletic field of late years. We have here much of the best brawn and bone in the world, but we must give the brain its place. Then will England come to her own again...

The fact is that we are losing because our players do not, in many sports, know the soul of the game. The idea is lost in the prosaic grappling for cups or medals, in the merely vulgar idea of success. Thus it comes to pass that many will not be content to get to the soul of a game in the natural way, by long and loving familiarity with it.

Hordes of people are joining the ranks of the golfers, and their constant cry is, "Teach me the swing," and after a lesson or two at the wrong end of golf, for a beginner, they go forth and cut the country into strips and think they are playing golf. Is it any wonder, when our links are cumbered with such as these, that those who have the soul of golf are in imminent daily peril of losing their own?

One who would know the soul of golf must begin even as would one who will know the soul of music. There is no more chance for one to gather up the soul of golf in a hurry than there is for that same one to understand Wagner in a week...

Much has been made of the assumption that golf is the greatest possible test of a man's temperament. This has to a great extent, I am afraid, been exaggerated. It is one of those things in connection with the game that has been handed down to us, and which we have been afraid to interfere with. I cannot see why this claim should be quietly granted. In golf a man is treated with tragic solemnity while he is making his stroke. A caddie may not sigh, and if a cricket chirped he would be considered a bounder. How would our golfer feel if he had to play his drive with another fellow waving his club at him twenty or thirty feet away, and standing ready to spoil his shot? — yet that is what the lawn-tennis player has to put up with. There is a good deal of exaggeration about this aspect of golf, even as there is a good deal of nonsense about the interference of onlookers. What can be done when one is accustomed to a crowd may be seen when one of the great golfers is playing out of a great V formed by the gallery, and, needless to say, playing from the narrow end of it. Golf is a good test of a man's disposition without doubt, but as a game it lacks one important feature which is characteristic of every other field sport, I think, except golf. In these the medium of conflict is the same ball, and the skill of the opposing side has much to do with the chances of the other player or players. In golf each man plays his own game with his own ball, and the only effect of his opponent's play on his is moral, or the luck of a stymie. Many people consider this a defect; but golf is a game unto itself, and we must take it as it is. Certainly it is hard enough to achieve distinction in it to satisfy the most exacting. He who knows the game most thoroughly will have an undoubted advantage...

Therefore it behoves every golfer to strive for the soul of golf.

GOLF
by Frank Gude, 1988

Zen Golf

by Gordon Weaver

Zen: a Chinese and Japanese school of Mayhayana Buddhism that asserts that enlightenment can be attained through meditation, self-contemplation, and intuition.

◆ ◆ ◆

Golf: a game played on a large outdoor obstacle course having a series of nine or eighteen holes spaced far apart, the object being to propel a small ball with the use of a club into each hole with as few strokes as possible.

◆ ◆ ◆

And the wind shall say: "Here were decent godless people: Their only monument the asphalt road
And a thousand lost golf balls." *—T.S. Elliot*

◆ ◆ ◆

The Zen golfer is he who comes to the game in search of a clarity of vision and an exactitude of execution denied him in the mundane world.

Clancy, a middle-management executive with Unitron, Inc., felt himself on the brink of collapse; his family, his job, and whatever space in his life not filled by either seemed doomed — when he wasn't botching his domestic life, he was screwing up on the job, and when he was engaged in neither, all he could think about was how utterly hopeless both were.

To his wife, Clancy said, "I'm forty-three years old. We've been married nineteen years, and the only time you talk to me is when you complain I'm not making enough money or I don't pick up after myself around the house."

She said, "That's silly," and, "By the way, are you hearing any rumors about your promotion to bonus row at Unitron?" and, "How many times do I have to ask you to please throw your towel in the hamper when you finish in the bathroom?"

Clancy said, "I have two children. I joined the country club just so my daughter could have her

debut dance there, and she hasn't even said thanks. My son wants to cut his hair in a Mohawk and dye it orange and wear a safety pin in his ear; I don't think he's spoken to me for a year except to say I'm hassling him when I ask him to please turn down his hi-fi when I go to bed."

His wife said, "You know how kids are, Clancy," and, "Is that or is that not your yesterday's shirt lying on the bedroom floor?" and, "I asked you a question: are there any rumors down at Unitron about your making it up to bonus row this year, or are we still scrimping in limbo for another year?" and, "When you take off your socks at night, Clancy, I'd appreciate it if you'd turn them inside out for washing, okay?" and "Why don't you take up a hobby, get

Heather Hole
Bay Valley, Michigan

At Unitron, Inc., the rumor was that Clancy would not be promoted to bonus row. Clancy discussed it with Southard, his middle-management peer, who was rumored to be a cinch for promotion to bonus row this year.

"I don't understand it," Clancy said. "I'm diligent, I'm loyal, I'm dependable, I give as much of my time as anyone, even you."

Southard said, "True, true enough, Clancy. But you're not keen, you're not sharp. You seem distracted, detached."

"Be specific," Clancy said.

"Your necktie knot's off-center," Southard said. "Even now your shoes could stand buffing, you get your haircuts a week too late all the time — you bite your fingernails, you smoke unfiltered cigarettes, and once I saw you picking your nose at a staff conference. Don't deny it, Clancy, you turned your head away to hide it, but everyone saw!"

"I have a lot on my mind, my wife and kids— " Clancy began to explain.

"No excuse!" Southard said. "We all have problems, Clancy. Everyone has a wife who nags or spends money like water or drinks too much and flirts at parties, right? Who doesn't have kids failing in school or into dope or going off in cars to attend rock concerts or getting married too young under the gun? No excuse, Clancy!" Southard said.

"You too?" Clancy said.

"Me in spades!" Southard said. "My wife's gone wacko active in women's rights organizations, my son's one step away from ward-of-the-court status for vandalism and truancy, and the twins, I won't even tell you the mess the two of them together got into with some guy about thirty who rides a motorcycle."

"How do you do it? How do you manage to cope?" Clancy asked.

"Do what?"

"Stay keen. Sharp. On the ball. You're going up to bonus row this year, everyone says so," Clancy said.

"You're damn tooting!" Southard said. "My secret is I have an escape. I get away from it all when it feels like it's crushing me. Two afternoons a week and twice on weekends. I golf," he said.

"Golf?"

"Golf. You should try it, Clancy," he said. "Golf. Handball. Racquetball. Anything. You belong to the

interested in something to take your mind off yourself, Clancy?"

"Like what for example?" Clancy asked.

"Stamp collecting," his wife said. "Bird watching. Woodworking. Lapidary. Current events," she said. "You could read a good book once in a while."

"I watch television," Clancy said.

"You do," she said, "and leave dirty ashtrays and half-full cups and glasses and dishes from your snacks. I have to clean up after you every time."

The Zen golfer is he who seeks the fulfillment of satisfaction in the realm of sport when all other paths to inner peace present only the prospect of failure.

country club now, don't you?"

"We joined so my daughter could have her debut dance there," Clancy said. "My wife insisted."

"I figured," Southard said. "So golf. Members get a reduced greens fee."

"I don't know the first thing about the game," he said.

"So get yourself a book on it and read up. What's the use of education and affluence if you can't learn something, Clancy?" Southard said.

The Zen golfer prepares himself before commencing his game; by diligent study, he progresses from a condition of the innocence of skills to one of sophistication, and by this knowledge attains to the innocence of vision requisite to satisfaction.

Clancy, no ready cash to spare, bought books with his Visa card. First he read Mike Wilson's classic *Historical Origins of Golf;* after skimming Bobby Jones' anecdotal *Grand Slam: How I Did It* and *Our Legendary Matches*, co-authored by Walter Hagen and Gene Sarazen, he completed his background studies by reading Hogan's *Adversity Made My Game Stronger.*

"Clancy," his wife said, "Clancy, I'm talking to you!"

"What?" he said. "Sorry, I was reading."

"Your nose is always in a book," she said, "but at least it's better than you doddering around the house leaving messes for me to clean," she said. "What do you hear about your odds for promotion to bonus row lately? Clancy!" she shrieked when, his nose in a book, he failed to answer.

"What? Oh, sorry!" he said. "No, nothing tangible, dear."

He then read a series of modern and contemporary tomes written by acknowledged masters, a sampling of manuals devoted to the game's techniques. In order, Clancy read: Arnold Palmer's *How to Sustain the Charge on the Back-Nine*, Nicklaus' *Baby Beef Speaks: Tips From the All-Time Money Winner,* Gary Player's *Golf Methods Know No Race, Creed, or Ethnic Origin,* and the indispensable anthology, *Birdies and Bogeys: An Alphabetical Compendium on Techniques Secured in Personal Interviews with PGA Tourney Champs.*

"Clancy," Southard said to him one afternoon in Unitron's executive cafeteria, "what is it with you lately?"

"Do I seem different?" he said.

"Sort of," Southard said, "I'm not sure. Yeah! Maybe. Yeah, you seem more composed sort of. You still act like you don't know which way's up half the time, but it's like you're more relaxed about it."

"I've been reading a lot," Clancy said.

"Do tell," said Southard. "The pro at the country club said you were out there yesterday afternoon when you were supposed to be at the production control meeting. But you didn't play. He said you just asked if you could walk the course. Is that true, Clancy?"

"I feel the need," Clancy said, "to get the lay of the land."

"Come out this weekend with my foursome, shoot a round with us," Southard said.

"I'm not ready for that yet," Clancy said.

"Suit yourself," Southard said. "Oh hey, Clancy, did I tell you the personnel board's meeting next month to finalize this year's promotions to bonus row?"

"Do tell," said Clancy. "I guess I should be sweating it out like you, but somehow I don't seem to take it as seriously as I know I should."

The Zen golfer utilizes only the finest equipment, full knowing the game cannot be well played, the visionary goal realized, no worthy end attained, if the tools employed are not suitable.

Having reached his Visa card's credit limit, Clancy purchased his clubs and accessories with his Master Card. He bought custom-length-shaft top-of-the-line irons (two through nine with sand and pitching wedges), a precision machine-balanced Klump putter, and space-age metal alloy woods (one through five) endorsed by the legendary Geoff Walker. To carry them, he bought a buffed cowhide Rorgelberger bag with tube-slots, imported knitted wood covers, Naugahyde face-savers for his irons, a striped umbrella with a fixture that attached to the handle of his portable pull-cart. He stored his gear in a rented locker at the country club, along with a gross of best-quality maxi-distance Lucke balls, his new pair of Italian-made Sciori mini-spike shoes, and three complete outfits — caps, pullover jerseys, knickers, and long argyle-pattern socks.

"I got a phone call from the credit bureau today, Clancy," his wife said, "asking if we needed our credit limit expanded, and also a notice from American Express approving our application. Clancy, are you listening to me?"

"Sorry," he said, "I was thinking."

"That's an improvement," she said. "Do you know anything about this?"

"Must be a computer glitch of some kind. Don't hold supper for me, I'll be back as soon as I can," he said.

"Where are you going, Clancy?" she said. "Do you know your daughter's debut is in three short weeks and all the invitations still need to be mailed and your son swears he won't even come to the dance unless we hire a punk-rock band and let him wear one of his crazy get-ups instead of a tuxedo?"

"Right," Clancy said as he went out the door of their split-level. "That's where I'm headed, to the country club to check on things. Don't expect me back soon."

"Why?" she said. "What's going to take so long?"

"I need to use all the light that's left until sundown," Clancy said, and was gone before she could speak again.

The Zen golfer understands, beforehand, that the path to ultimate satisfaction will be strewn with frustrations, yet he persists in the face of all obstacles, confident that his triumph is ordained if he but endures in the proper state of spiritual and emotional equilibrium.

Playing late in the afternoon and at dawn's first light, Clancy managed to avoid being joined by the tee starters with long-established foursomes and fivesomes. His game was wretched.

Off the tee, he whiffed often, resorting to Mulligans that he more often than not squibbed left and right, seldom carrying further than the ladies' tee box marked with red blocks. When he did make contact, he sliced deeply into the rough, even into the parallel fairway, or hooked left, or skyed, high as a mortar shell or a softball pop-up. But he felt a rush of joy when he drew his driver from the bag, marveled at the highgloss enamel of the club's head that caught highlights from the sun; when he managed to loft the ball, his heart rose with it, and his eyes flashed as he tracked its brief flight through the crisp air.

"You're never home, Clancy," his wife said. "If I didn't know you better, I'd think you were carrying on with someone."

He lost balls by the score to the roughs and water hazards, but felt an unexpected ease as he tramped in search of them, eyes fixed on the ground, slashing casually at the long grasses with an iron; once he discovered a nest of baby field mice, once an unbroken robin's egg, once thrilled at the sudden chill that swept his bones as a harmless snake slithered across his shoes. On the fairways, his long irons were a disaster. He skulled the ball, skewed it off the shaft and toe of the club face, dug deep divots without even making contact. But the morning sun warmed him, painted a brilliant wash of colors on cloudbanks when it set, and breezes splashed his cheeks like the soft caresses of a mistress's hand on the open fairways.

"I saw your name on the sign-in sheet at the clubhouse, Clancy," Southard said. "You must be becoming some kind of a fanatic. You sure you wouldn't like to join my foursome this weekend? Clancy?"

"I'm sorry," Clancy said. "I guess I was miles away."

"So I noticed," Southard said.

Around the greens Clancy was pathetic. He dubbed his attempts to pitch and run, or else swung too hard and shot over the green; he rarely avoided bunkers, had to swing again and again to get up and out, churning up sand like fountain water. He could not read the breaks on the greens, and his putting stroke was as graceless as a hesitant slap at the ball. But he loved the barbered grass that was a shade lighter than its surroundings, and the sandtraps reminded him of ocean beaches he knew as a boy, and when he hunched over the ball to putt, there was a sudden still in the air, a total quiet impervious even to the shrill twanging of bluejays.

"Mom," his daughter said, "I asked Daddy three times if he called the country club about the catering, and he just kept looking at me like I wasn't there!"

"Where's Dad?" his son asked his mother. "I want to tell him I'm getting my hair cut the way I want and that's final, but I can't find him. You think he'll really hassle me about it?"

"Your father," Clancy's wife said, "rarely talks to me these days, so don't expect any answers from me!"

The Zen golfer confronts obstacles, but sees only opportunities; the Zen golfer wastes no anguish on what is past, no anxiety on what is to come; the Zen golfer, ever-conscious of the oneness of all things, exists with tranquility in a never-ending present.

Clancy's play never improved, but his delight in the game increased. When his lie was impossible, the ball against a tree trunk, mired in ooze at the edge of the creek, wedged in a crack in hard-pan dirt, he felt blessed by the cool shade, the slow trickle of water, the packed solidity of the earth beneath his feet. His approach shot to a green blocked by a clump of graceful willows, their leaves trembling in the breeze, he saw only the narrow window of space between them he tried for, and the hard thunk his ball made when it rebounded back toward him sounded like the snap of a lock opening. When his drives were held up in the winds he failed to compensate for, he experienced a sense of magic, as if he had a momentary power to suspend gravity. When he hit into water, the loss of his ball and the penalty stroke were as nothing against the liquid sound it made as it broke the surface, nothing against the concentric circles that radiated like a natural geometry.

He found a wholeness emerging in the small acts of replacing divots, repairing ball marks on the greens, raking sandtraps smooth, the tiny bubbles of detergent that clung to his cleaned ball when he took it from the ball washer. Slaking his thirst at the fountains situated at every other tee box was like drinking chilled wine, and cleaning his spikes on the metal bristles set in the sidewalk outside the pro shop felt like sloughing off the woes of the world. He breathed deep sighs of pleasant exhaustion when he shouldered his bag at the end of the eighteen holes, the sun-warmed odor of fine leather like dusky incense.

From the seventh tee, the highest elevation on the course, he paused before setting his stance to swing, looked out at the emerald symmetry of the course, fairways lined with trees and rough, dotted with ponds and sandtraps, crossed and re-crossed by the casually meandering creek. Lifting his eyes, he could see the pro shop and clubhouse, the country club's pool and tennis courts and parking lot, the bar and restaurant where his daughter's debut would be celebrated, only a week away now. Squinting to pierce the distances, he saw the whole of the great city stretching away to infinity, the towers of Unitron, Inc., on the horizon.

"Well!" said Clancy. "Oh my!" And he experienced a tiny epiphany of knowing that the sum of things was greater than its parts, and that he, Clancy, might claim to be the center of it all.

"Are you losing weight, Clancy?" Southard asked him.

"Not that I'm aware," he said.

"Maybe it's just your tan," Southard said. "You look like you just came off a Florida vacation."

"I quit smoking," Clancy said. "I didn't do anything special, I just found I wasn't even thinking about it after a while."

"Lucky you," Southard said. "I also notice you broke yourself of biting your nails to the quick. What are you, Clancy, on some self-improvement kick?"

"Did I?" Clancy said. "I guess I did at that. So how's it going with you, Southard?" he asked.

"Murder," he said. "The wife, kids. I did hear the personnel board won't announce this year's promotions for a few days. I can't sleep nights worrying, and my golf's gone into the dumper."

"You're a cinch," Clancy said. "I'm almost just as glad knowing I don't stand a chance."

"Nothing's certain," Southard said. "Hey, got your invite! I'm looking forward to your daughter's bash at the club. By the way, what's your handicap these days if you don't mind my asking?"

"I never keep score," Clancy told him.

For the Zen golfer, there is no failure, no success; for the Zen golfer, there is only Being, the changeless law of change, the union of cycles and seasons that form the constant inconstancy of existence; for the Zen golfer, the ultimate vision is the marriage of means and ends.

Clancy was startled to realize that, despite the boundless ineptitude of his game, he executed every possible shot to perfection at least once in every eighteen-hole round.

At least once, his swing on the tee was fluid, effortless, and he struck the ball with the club head's sweet spot, drove long and straight and high, rolling to a stop in the exact center of the fairway. At least once in each eighteen holes he played he picked the ball up cleanly off the fairway with his number three wood, or lifted it out of long grass with an iron, watched it streak toward the green as if fired from a gun. At least once he pitched and ran to the lip of the cup, avoiding water and sand like anathema; at least once he one-putted from 30 or 40 feet across swales on the green downhill, as if he had calculated distance and break with a minicomputer. Twice he shot pars on the back nine, once a birdie on a tricky par three, and holed out with his wedge from the deep bunker that half-circled the fourteenth green.

He found his wife huddled at her vanity table,

crying. "What's wrong, what is it?" Clancy asked.

"Everything's terrible!" she said through her tears. She hiccuped, sniffed, dried her eyes. "The debut's going to be a nightmare. Our friends from Unitron won't know what to make of that crazy band your son made me hire, and I'm going to have to hide him somewhere if we don't want him disgracing us with that haircut and what he swears he's going to wear, and our daughter's going to hate the memory of this for the rest of her life, and we'll embarrass ourselves in front of all the bonus row people from Unitron I've invited, and lord knows you're no help always out golfing, and I've plucked so many white hairs out of my head my scalp burns!" she said, and began to cry again.

"It will be okay," Clancy said as he patted her on the back, "I know it will."

"What do you know!" she said. "What have you got to smile about, Clancy?" and, "Are you dieting or is it just that tan from golfing?" and, "Have you seen how I look in my dress I'm going to wear to this humiliation?"

The Zen golfer is all things unto himself, yet is as nothing. Certain of his uncertainty, the Zen golfer weighs all things in the balance, yet neither accepts nor rejects. The Zen golfer knows, and knows he knows, and knows the sufficiency that lies therein.

Clancy's daughter's debut was a debacle. The sneering caterer blamed the country club's surly waiters for the cold, bland dinner served. The bar was popular, but the drinks tasted watered and were inhospitably poured. The orchestra's lifeless dance music could not compete with the electronic frenzy of the amateur punk-rock band. Clancy's wife looked over-dressed in her new gown, and the color rinse in her hair looked garish against her complexion. Their son, clad in a sequined caftan, his hair a harlequin of orange, grape, and sea-blue stripes, his earlobes crusted with pins and studs, his face painted grotesquely, caused guests to point, whisper, giggle, and shake their heads sadly. When Clancy danced the first dance with his daughter, she muttered in his ear, "Stop stepping on my instep," and, "This is the worst moment in my entire life," and, "I hate myself, and I hate you, and I hate everything forever!" The ritual applause of the bored guests was scattered and faint.

Southard, flushed and grinning, said to him, "When you get a minute, Clancy, I've got something to tell you. Don't forget to talk to me before I leave, okay?"

When it approached midnight, and the musicians began to yawn as they played, and only confirmed alcoholics still patronized the free bar, and Clancy's wife had taken their daughter to the ladies' lounge to calm her, and his son had disappeared, Clancy went to the clubhouse locker room, took off his tuxedo jacket, untied his bow tie, and changed his patent leather pumps for his spiked Scioris, hoisted his bag, and walked into the night, stumbling in the dark to the first tee.

The end of Zen golf is not playing the game, but The Game itself; the vision of the Zen golfer is not a means by which to see Life, but the identification of seeing with seen, seen with he who sees — the Zen golfer's vision is of himself as Vision.

"Clancy?" his wife called as she searched for him. "Clancy, I need you! Your daughter's incoherent and your son's gone and gotten himself caught smoking those funny cigarettes in the men's! Clancy, if you don't answer me I'll never talk to you again, I'm warning!"

"Clancy?" he heard the voice of Southard in the darkness near the pro shop. "I saw you come out here, Clancy, where are you? I've got great news, man! I made it, Clancy! I talked with a person in the know, I made it! Old Southard's wife may be wacko and his kids are a mess, but he's on bonus row, Clancy!"

In the total dark at the number-one tee box, Clancy teed up his ball, groping in the blackness. Placing the club head behind the ball, feeling his way like a blind man, he stepped back, set his stance, and found his grip on the shaft. He breathed deeply, once, twice, three times to relax.

Then, the voices of Southard and his wife still calling his name out to the empty night, the warring music of the orchestra and the punk-rock band playing their final sets, wafting up to the star-studded vault of the universe, Clancy drew his club back slowly, then swept it forward.

Clancy swung, oblivious to voices and music, to industry and civilization, to night and nature, yet in and of them. In the heart of his vision, himself the vision, he swung, anticipating the crack he was sure he would hear when the sweet spot made contact with the dim white orb that seemed almost to pulse and glow in the black night.

My Better Self

by Robert Browning, 1910

I had not observed the Stranger's approach, and even when he had in the most courteous way suggested a round together, I had accepted his offer with no more than a casual glance at him.

But his first drive gave me pause. It was so exactly the drive that I always hoped for and so rarely got — a trifle further perhaps than I had ever managed even at my best. I looked at him more closely.

I noticed that he had slightly the advantage of me in height, and I daresay most people would have considered him better looking. All the same, he was much of my own build. His play was superb.

I was even more off my game than usual, but nothing was able to upset the Stranger. His one or two mistakes scarcely seemed to detract from the excellence of his play, and the only holes I managed to halve with him were the eighth and ninth. I joked with him then about having found my true form, and he gave me a queer look — but my game soon fell off again.

He was out in 37. I remembered one occasion when I might have done it in that had I not finished with a 6 and a 5 instead of two fours. At the ninth he played a chip-shot from the edge of the green, and I noticed that he played it with his forefinger down the shaft — a trick I had always deemed peculiar to myself.

I began to watch him more carefully, and was staggered to find how exactly similar his style was to my own. But it seemed somehow to have a finish that mine lacked. It reminded me of my practice shots without a ball, in its ease and confidence.

I was thirteen down on the round, having won a single hole — through putting down my pitch. As we were leaving the last green the Stranger looked at me with that same queer smile.

"You do not know me?" he asked.

I assured him that I had never seen him before.

"No!" he said. "You have never seen me in your life, and never will again. I am he of whom you speak so often to your club-mates when things go wrong. *I am your True Form.*"

My opponent was gone.

Untitled
by A.B. Frost

THE GREAT MYSTERY

by Henry Leach

No other game or sport exercises anything like such power of fascination upon its people as this. A tennis-player may leave tennis if he must; the cricketer often voluntarily gives up cricket for no compelling reason; a man of the hills and moors may cease to care for shooting; and one who has made an automobile speed like the wind along the roads may sell his car and be motorist nevermore. But the golfer will and must always golf, and never less but more while strength permits. Men who go down to the sea in ships take golf clubs with them; I have known golfers carry their materials into deserts, and one of the greatest and noblest explorers the world has known took them with him to one far end of earth. Surely this is a very remarkable thing, a feature of life that is strange as it is strong, and it is

BOYNE HIGHLANDS HEATHER #5
by Brian Morgan

not nonsense to suggest that this is no ordinary game and cannot be considered as a game like others. Somewhere in a mysterious way it touches the springs of life, makes emotions shake. It grips; it twitches at the senses... It has become the Great Mystery. Wonder and awe are thick about it. Men who were innocent and have turned to golf do not give a reason why; they are silent to the questioner. They say that he too will see in time, and then they golf exceedingly...

In the strong action upon the emotions which takes place during the practice of the game there are effects which are purely physical and others which are largely mental and spiritual. The physical thrills of golf are above the comprehension of any man or woman who has not played the game. We are certain that in the whole range of sport or human exercise there is nothing that is quite so good as the sublime sensation, the exquisite feeling of physical delight, that is gained in the driving of a golf-ball with a wooden club in the manner that it ought to be driven. This last provision is emphasised, for this is a matter of style and action, and the sensuous thrill is gained from the exertion of physical strength in such a mechanically, scientifically, and physically perfect manner as to produce an absolute harmony of graceful movement. It is as the satisfaction and thanks of Nature. Sometimes we hear sportsmen speak of certain sensations derived from particular strokes at cricket, others of an occasional sudden ecstasy in angling, and one may well believe that life runs strong in the blood when a man shoots his first tiger or his first wild elephant. But the feelings of golf are subtler, sweeter, and that we are not stupidly prejudiced or exclusive for the game may be granted if it is suggested that we reach some way to the golf sensations in two other human exercises, the one being in the dancing of the waltz when done thoroughly well and with a fine rhythmical swing, and the other when skating on the ice with full and complete abandon. In each case it is a matter of perfect poise, of the absolute perfection of coordination of human movement, of the thousands of little muscular items of the system working as one, and of the truest rhythm and harmony being thus attained. We come near to it also in some forms of athletics; we have it suggested in the figures of the Greek throwing the discus. In golf there is an enormous concentration of this effect in the space of a couple of

seconds, not too long to permit of becoming accustomed to it, not too short for proper appreciation. In this brief time, if the driving is properly done as Nature would have it, the emotional sensation is tremendous...

Some of these emotions are experienced in a minor key when playing the short game, as we call it, particularly in finely-made pitching strokes with iron clubs. Here there are restraint and sweetness; it is as if we listen to the delicacy of Mendelssohn after the strength and stateliness of Beethoven. Undoubtedly there are keen physical sensations enjoyed in this part of the play. When it comes to the last and shortest strokes, to the putting, only a faint trace of action upon the physical emotions remains, and the pleasure and satisfaction, if any, that are gained are purely mental. So in the short space of five minutes, in playing one hole of fair length, we may run along a full gamut of emotions, and herein is a great part of the joy of golf.

DISGUSTED CADDIE
by Norman Orr

Par Four, Dogleg Left

by William A. Nowak, 1988

At each tee I can begin my life again
 even if contrived the past dragged along
As only the strokes so far

Satisfying thwack off the tee
 confidence of youth years ago toward the unseen flag
Too much club today past the bunkers right rough
 but lucky clear there to the pin

That my life's progress off the course
 could have been this simple ritual seasons
Courtesy nature's beauty challenges from without within
 far more moments of self control than not
The Scots so Oriental in this invention

Everyone away has hit on with sixes
 my seven should be enough feeling so good
I lay up short twenty yards too much too little
 in fifteen minutes and fifteen years fifteen deals
Fifteen times fifteen crises with those long close
 now I'm really away escaping with a shaky chip
Two-putt one over your honors friend nice golf shot

This incomparable game endures to give
 eighteen holes
 to play over our lives as many times
 to slowly grow beyond mere scores
 to honors in the few things that matter

Never again away

The Bogey Man
by L. Earle

FASCINATION

by Frank J. Bonnelle

O Golf, thou siren of the lea,
To whom both sexes bend the knee,
 What is the subtle, magic power
That makes the world all else forsake,
And follow in thy grassy wake
 From early morn to twilight hour?
Each other sport has had its day,
But none has carried us away
 Completely — body, brain and soul —
Like golf; in fact, I'd yield them all,
To hit just once that little ball
 And drive it onward to a hole.
Yet deeper still there's something more —
A hope to make a better score
 Than one has ever yet achieved;
And in that hope, that ever leads
Up on to do more worthy deeds,
 May you and I be not deceived!

CYPRESS PT. #16
by Jim Moriarty

Hey, Flytrap

by Al Barkow

Over at the K&L the other night we was having some cheesecake which by the by has gotten so heavy that one slice and you can't get the club back for three days instead of the usual one and Three From the Edge — remember him the artistic guy, a sign painter except he can't chip or putt — he starts into one of his deep thought gizmos about why we are addicted to golf.

Edge says he has this theory that we are spell-blinded by having to deal with so much space out there on the course. Now Augie the Snipe, Hacker, Chili Dip and me we all look at each other with our eyes going up into our forehead and then the Snipe asks Edge if he's been reading that English guy who invented the evolution of the speeches and also wrote some golf on his side and Edge says no hes thought this one up all by his own self.

So we ask him what he means and he goes on about how on the course we are just like thin weeds without much substance and hardly any significance at all compared to the size of the earth and the sky and that this is scary because we have to hit a tiny little ball into all that space using just a rod which is skinnier than even we are.

I pipe up saying yeah but when your playing your only looking at the fairway and the green which narrows the world down. Like when you look at France through a camera lens. Or the ponies on the backstretch. But Edge says your still seeing all the rest of it out of the sides of your eyes which is what is called perforal vision. And he says even if you forced yourself to tunnel your vision like Watson does — or did — and see just the fairways and greens — and the bunkers in your case — your still conscientious of how big and wide the world is because your subconscience is working on it. Edge says this is the reason why golfers take the game like it was a religion. He says golf is like being in a huge cathedral which makes you feel real small.

Thats philosophy aint it. Or poetry — and you know no poet or philosopher has ever won the U.S. Open or even the County Amateur. And which is to be sure why Three From the Edge is always taking three from the edge if you ask me.

Still and all I had to admit that Ive had that feeling of being small out there — especially when I was a punk kid just starting out. Even at Billy Caldwell which as you remember is just a rinkydink 9 holer as flat as your feet but was like being on the north pole when I was a squirt. I mean like Edge says, in baseball you got the foul lines. Football you got that rectangle marked out. So now you get that cozy feeling and you don't feel so lonely. Maybe thats why I always play better on courses with a lot of trees.

The way I worked it out to handle Edges space deal is to think that every hole is like a funnel. Or a kitchen sink in which everything ends up swirling around and going down the drain. Anyway if the game makes us feel so puny like Edge is saying the next question is why do we do it. Edge says its because we all think we can be God once in awhile. That's when I started thinking that maybe Three From the Edge has taken three from the edge one time too many and that he has gone off it.

Do you wanna be God everytime you tee it up. I dont. I just wanna be able to hit a 2 iron again.

Hey, seeya round,

Jocko.

Playing Through
by Karin Boinet, 1986

THE DRAMA OF GOLF

by Arnold Haultain

The outsider does not know that at every hole is enacted every time a small but intensely interesting three-act drama. There is Act I, the Drive, with its appropriate mise-en-scéne: the gallery, the attendant caddies, the toss for the honour. At long holes it is a long act if we include the brassey shots. There is Act II, the Approach. This is what the French call the *noeud* of the plot: much depends on the Approach. And the mise-en-scéne is correspondingly enhanced in interest: the lie, the hazard, the wind, the character of the ground — all become of increasing importance. There is Act III, the Put. It also has its back-ground, its "business," and its "properties": the caddie at the flag, the irregularities of the green, the peculiarities of the turf, the possibilities of a stymie. — Eighteen dramas, some tragical, some farcical, in every round; and in every round protagonist and deuteragonist constantly interchanging parts. No wonder the ardent golfer does not tire of his links, any more than the ardent musician tires of his notes. What theatre-goer enjoys such plays? And what staged plays have such a human interest in them? And, best of all, they are acted in the open air, amid delightful scenery, with the assurance of healthy exercise and pleasant companionship. What theatre-goer enjoys such plays? — And when the curtain is rung down and the eighteenth flag replaced, instead of a cigar in a hansom, or a whisky-and-soda at a crowded bar, or a snack at a noisy grill-room, there is the amicable persiflage in the dressing-room or the long quiet talk on the veranda.

THE 15th AT OAKMONT
by Donald Moss

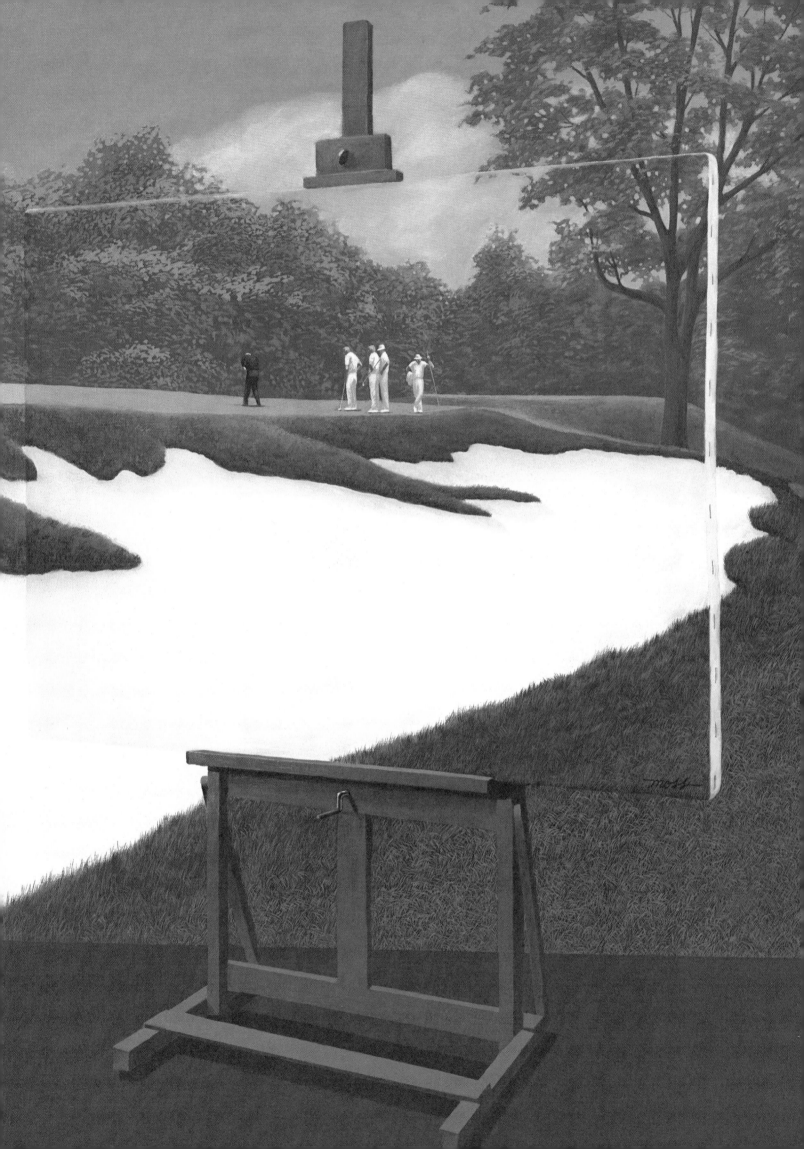

A GIRL WITH A GOLF CLUB
Artist Unknown, 1595

ANTIQUITIES

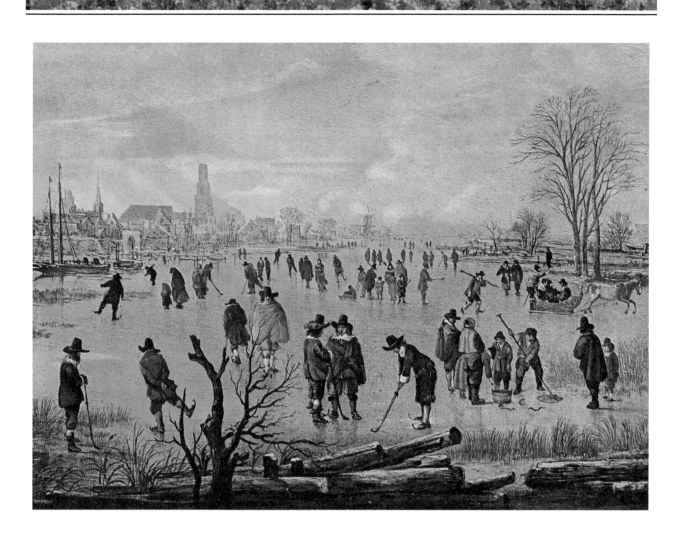

THE GOLFER'S GARLAND

Anonymous, 1780

Of rural diversions too long has the Chace
All the honours usurp'd, and assum'd the chief place;
But truth bids the Muse from henceforward proclaim,
That Goff, first of sports, shall stand foremost in fame.

O'er the Heath, see our heroes in uniform clad,
In parties well match'd, how they gracefully spread;
While with long strokes and short strokes they tend
 to the goal,
And with putt well directed plump into the hole.

At Goff we contend without rancour or spleen,
And bloodless the laurels we reap on the green;
From vig'rous exertions our raptures arise,
And to crown our delights no poor fugitive dies.

RIVER SCENE IN WINTER
by Aert Vander Neer

From exercise keen, from strength active and bold,
We'll traverse the green, and forget we grow old;
Blue Devils, diseases, dull sorrow and care,
Knock'd down by our Balls as they whizz thro' the air.

Health, happiness, harmony, friendship, and fame,
Are the fruits and rewards of our favourite game.
A sport so distinguish'd the Fair must approve:
Then to Goff give the day, and the ev'ning to love.

Our first standing toast we'll to Goffing assign,
No other amusement's so truly divine;
It has charms for the aged, as well as the young,
Then as first of field sports let its praises be sung.

The next we shall drink to our friends far and near,
And the mem'ry of those who no longer appear;
Who have play'd their last round, and pass'd over that
 bourne
From which the best Goffer can never return.

THE TWO MACDONALDS
Artist Unknown

The Origin of Golf

by Sir W.G. Simpson, 1887

Golf, besides being a royal game, is also a very ancient one. Although it cannot be determined when it was first played, there seems little doubt that it had its origin in the present geological period, golf links being, we are informed, of Pleistocene formation.

Confining ourselves to Scotland, no golfer can fail to be struck with the resemblance to a niblick of the so-called spectacle ornament of our sculptured stones.

Many antiquarians are of opinion that the game did not become popular till about the middle of the 15th century. This seems extremely probable, as in earlier and more lawless times a journey so far from home as the far-hole at St. Andrews would have been exceedingly dangerous for an unarmed man.

It is not likely that future research will unearth the discoverer of golf. Most probably a game so simple and natural in its essentials suggested itself gradually and spontaneously to the bucolic mind. A shepherd tending his sheep would often chance upon a round pebble, and, having his crook in his hand, he would strike it away; for it is as inevitable that a man with a stick in his hand should aim a blow at any loose object lying in his path as that he should breathe.

On pastures green this led to nothing: but once on a time (probably) a shepherd, feeding his sheep on a links — perhaps those of St. Andrews — rolled one of these stones into a rabbit scrape. 'Marry,' he quoth, 'I could not do that if I tried' — a thought (so instinctive is ambition) which nerved him to the attempt. But man cannot long persevere alone in any arduous undertaking, so our shepherd hailed another, who was hard by, to witness his endeavour. 'Forsooth, that is easy,' said the friend, and trying failed. They now searched in the gorse for as round stones as possible, and, to their surprise, each found an old golf ball, which, as the reader knows, are to be found there in considerable quantity even to this day. Having deepened the rabbit scrape so that the balls might not jump out of it, they set themselves to practising putting. The stronger but less skilful shepherd, finding himself worsted at this amusement, protested that it was a fairer test of skill to play for the hole from a considerable distance. This being

arranged, the game was found to be much more varied and interesting. They had at first called it 'putty,' because the immediate object was to putt or put the ball into the hole or scrape, but at the longer distance what we call driving was the chief interest, so the name was changed to 'go off,' or 'golf.' The sheep having meantime strayed, our shepherds had to go after them. This proving an exceedingly irksome interruption, they hit upon the ingenious device of making a circular course of holes, which enabled them to play and herd at the same time. The holes being now many and far apart, it became necessary to mark their whereabouts, which was easily done by means of a tag of wool from a sheep, attached to a stick, a primitive kind of flag still used on many greens almost in its original form.

Since these early days the essentials of the game have altered but little. Even the styme must have been of early invention. It would naturally occur as a quibble to a golfer who was having the worst of the match, and the adversary, in the confidence of three or four up, would not strenuously oppose it.

That golf was taken up with keen interest by the Scottish people from an early day is evidenced by laws directed against those who preferred it to archery and church-going. This state of feeling has changed but little. Some historians are, however, of opinion that during the 17th century golf lost some of its popularity. We know that the great Montrose was at one time devoted to it, and that he gave it up for what would now be considered the inferior sport of Covenanter-hunting. It is also an historical fact that Charles I. actually stopped in the middle of a game on Leith Links, because, forsooth, he learned that a rebellion had broken out in Ireland. Some, however, are of opinion that he acted on this occasion with his usual cunning — that at the time the news arrived he was being beaten, and that he hurried away to save his half-crown rather than his crown. Whatever the truth may be, it is certain that any one who in the present day abandoned a game because the stakes were not sufficiently high would be considered unworthy of the name of a golfer.

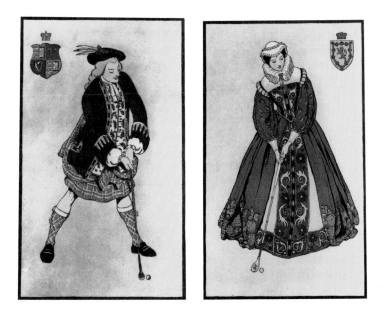

Ballade of the Royal Game of Golf

by Andrew Lang

There are laddies will drive ye a ba'
 To the burn frae the farthermost tee,
But ye mauna think driving is a',
 Ye may heel her, and send her ajee,
Ye may land in the sand or the sea;
 And ye're dune, sir, ye're no worth a preen,
Tak' the word that an auld man 'll gie,
 Tak' aye tent to be up on the green!

The auld folk are crouse, and they craw
 That their putting is pawky and slee;
In a bunker they're nae guid ava',
 But to girn, and to gar the sand flee.
And a lassie can putt — ony she —
 Be she Maggy, or Bessie, or Jean,
But a cleek-shot's the billy for me,
 Tak' aye tent to be up on the green!

I hae play'd in the frost and the thaw,
 I hae play'd since the year thirty-three,
I hae play'd in the rain and the snaw,
 And I trust I may play till I dee;
And I tell ye the truth and nae lee,
 For I speak o' the thing I hae seen —
Tam Morris, I ken, will agree —
 Tak' aye tent to be up on the green!

ENVOY.

Prince, faith you're improving a wee,
 And, Lord, man, they tell me you're keen;
Tak' the best o' advice that can be —
 Tak' aye tent to be up on the green!

THE ROYAL GAME OF GOLF
by F.T. Richards, 1901

GOLF PRINTS:

A *Visual Link to the Traditions of*
the Royal and Ancient Game

by John M. Olman

Golf can be a beautiful game — as evidenced by the abundance of attractive artwork created over the past two centuries. The personalities, the golf courses, and the traditions have all been inspirational subjects to hundreds of accomplished artists.

Beginning in the late 18th century, the first golf paintings to be offered in print form were portraits of prominent golfers. These men earned their prominence not for their golfing ability, but rather for their roles as leaders of the organized groups of golfers which were called "golfing societies."

Several earlier paintings (that have been reproduced) are considered by some to show golf, but they actually depict golf-like games such as the Dutch game of kolven. Several of the Dutch artists of the 17th century, including Rembrandt, created scenes of "club and ball" games which were played primarily on ice or in streets and courtyards.

Of even greater significance than the fact that noted artists were commissioned to paint portraits of golfers was that there was a need for the paintings to be reproduced in a limited number of prints.

It was no easy task to make a print in those days. We are now accustomed to the speed and quality offered by modern offset lithography but this and other photomechanical methods for reproducing the image of a painting onto paper were only developed within the last century. Therefore, an engraver — an artist in his own right — had to be hired to duplicate the image of the painting onto a metal printing plate.

The printmaking techniques employed were generally mezzotint, aquatint, etching, or line engraving. Since most of the portraits were full-length, life-size oil paintings, the engraver had to reduce the image to a reasonable size for ease of printing. As further testament to the skill of the engraver, he also had to expertly convert the original, which was painted in color, to shades of grey, since his final work would be printed with only black ink. Many of the original monotone prints were later tinted with watercolors, so it is not unusual to find varying color schemes in the original prints (or later reproductions).

THE FIRST FOUR GOLF PRINTS

The first known golf print was published in 1790. Taken from a painting by Lemuel Francis Abbott, it shows William Innes, captain of the Blackheath Golf Club near London, posing with his caddie. Commonly referred to as "The Blackheath Golfer," this print has been reproduced many times and is by far the most reproduced of any golf art.

The next two golf prints, published in 1796 and 1806, respectively, were of paintings done by Sir Henry Raeburn. Raeburn was most qualified to paint the likenesses of James Balfour and John Gray, two office-holders of the Honourable Company of Edinburgh Golfers. Not only was Raeburn a fellow member of what is recognized as the first established golf club — it was founded in 1744 — but he was also one of Scotland's top portrait painters.

These two prints of Raeburn's works primarily appeal to golf historians and diehard collectors because, unfortunately, nothing in the pieces connotes golf; both gentlemen are shown seated in chairs. However, the captions on each of the prints do indicate the subject's involvement in the game.

Furthermore, the official "Bet Book" and "Record of Gentlemen Golfers" can be seen resting on a table beside Balfour.

The fourth of what have become known as the "First Four" of early golf art was also painted by Abbot and again featured a captain of the Blackheath Golf Club, resplendent in red coat and white britches: Henry Callender. This full-length portrait, which was done in a studio setting, shows two golf clubs and has been reproduced numerous times over the last century.

It is believed that less than 50 copies of each of the aforementioned prints were run in mezzotint, thus making each worth thousands of dollars and highly sought after by collectors. Since both of the works by Abbott were engraved and printed again in the early 20th century, a collector should consult with an expert and also become familiar with the various engravers, sizes of prints, and printing methods prior to investing a sizable amount of money in these or any other golf prints.

1890s A POPULAR TIME FOR GOLF ART

After the publishing of the "First Four" prints, numerous oil and watercolor paintings showing golf were done, but only a few additional works were offered as prints until the golf boom of the 1890s. This decade brought the mechanization of golf club and ball manufacturing, a rash of books on golf, and the publication of the first golf periodicals. With the rapidly growing number of golfers, it was not surprising that a substantial market for golf art developed.

In 1890, *Vanity Fair Magazine* began to publish stone lithographs of noteworthy golfers as part of its "Men of the Day" feature. Two outstanding amateur golfers, Horace Hutchinson and John Ball, were the first to be so honored by the British weekly. The last of the eight *Vanity Fair* golfers was published in 1910.

Prints of British golf courses by Douglas Adams and Charles Edmund Brock were the first golf scenes published in the 1890s. Both artists depicted a set of three views, each showing a drive, a putting green, and a bunker. The Adams' prints are especially handsome and have been reproduced several times in color. Owners of Brock's works will be pleased to know that their prints recently became even more desirable when the three original paintings sold at auction for more than $90,000.

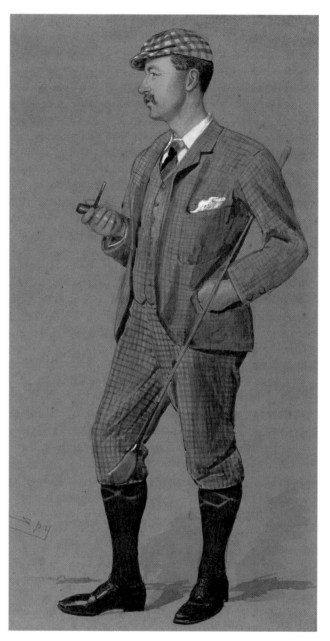

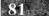

HORACE HUTCHINSON
by Sir Leslie Ward

Other notable golf artists of the 1890s include: H.J. Brooks, the first artist to publish a print of the venerable Old Tom Morris; Michael Brown, known for his illustrations of golfers for Life Association of Scotland calendars; J.C. Dollman, whose print called "The Sabbath Breakers" is very popular; and John Hassall, who provided numerous golf illustrations for advertisements, postcards, and pottery in addition to producing a portfolio of seven prints.

FAMOUS ILLUSTRATORS TAKE UP GOLF

As golf periodicals and highly illustrated books came into being in the 1890s, a number of men with an artistic flair for golf emerged. Among those were: Charles Crombie, noted for his humorous "Rules of Golf;" Thomas Hodge and Harry Furniss, who both contributed classic illustrations to *The Badminton Library of Golf*; and William Nicholson, illustrator of Rudyard Kipling's *Almanac of Twelve Sports.*

When golf finally became popular in America just before the turn of the century, none other than A.B. Frost — the extremely popular and prolific illustrator — produced the majority of American golf art. Prints and reproductions of his oftentimes humorous watercolors are readily attainable and accurately reflect the golfing styles of his time.

With the coming of the 20th century came even more golf prints. Illustrators abounded and with improved printing techniques, their works could be published at relatively low costs. On the American side of the Atlantic, names like Howard Chandler Christy, Harrison Fisher, James Montgomery Flagg, Norman Rockwell, and Charles Dana Gibson began to appear on golf works. And yes, the famous "Gibson Girl" was even portrayed on the links.

Cecil Aldin, Henry Mayo Bateman, Tom Browne, Lionel Edwards, William Heath Robinson, W. Dendy Sadler, and Victor Venner are just some of the outstanding British artists of the early 20th century who made substantial contributions to the vast realm of golf prints.

The publishing of golf art worldwide was very sporadic after the Great Depression and the dealing was limited primarily to the older prints. Finally, in the 1970s, there was a dramatic increase in the interest in the collecting of golf memorabilia, thereby causing a resurgence of print publishing, which continues today. Artists began to paint both traditional and contemporary golf subjects from which lithographs were run. Oldtime favorites were repro-duced as well, so golf fans can now purchase new prints of famous players ranging from James Braid to Bobby Jones to Lee Trevino.

Two of the most successful of the modern-day artists are Leroy Nieman and Arthur Weaver. Not only do they live continents apart — Nieman in the United States and Weaver in Great Britain — their styles are also miles apart.

Nieman is noted for his bold, colorful works of sports action, while Weaver is best known for his portrayal of peaceful, subtle views of the great golf courses of the world. Recently, Weaver has exposed another of his artistic skills to the golfing world by painting portraits of three of the game's most historic figures: Old Tom Morris, Young Tom Morris, and Willie Park, Sr.

PRINTS IN ALL PRICE RANGES

Fortunately, for those golfers not seeking museum-grade original prints valued in the thousands, many of the classic works of golf art have been reprinted in recent years by offset lithography and are very affordable. But don't assume that an old print is necessarily an expensive one, as some of them were produced in large enough quantities that the prices are quite reasonable.

To add further confusion to the value of golf prints, a potential purchaser should not be surprised to find some brand new lithographs with a price tag of $200 to $300. The artist's reputation, the type of paper, the printing quality, and whether the piece is signed and numbered by the artist are all factors that affect both the initial price of a print and the likelihood of it appreciating in value.

Due to the diverse beauty of golf, we are fortunate that so many talented artists have created attractive images of the game in the form of paintings that were then made into prints. Undeniably, golf is one of the few sports that can provide a substantial quantity of classic, quality artwork suitable for decorating any room in a home, office, or clubhouse.

THE DRIVE
by Charles Edmond Brock

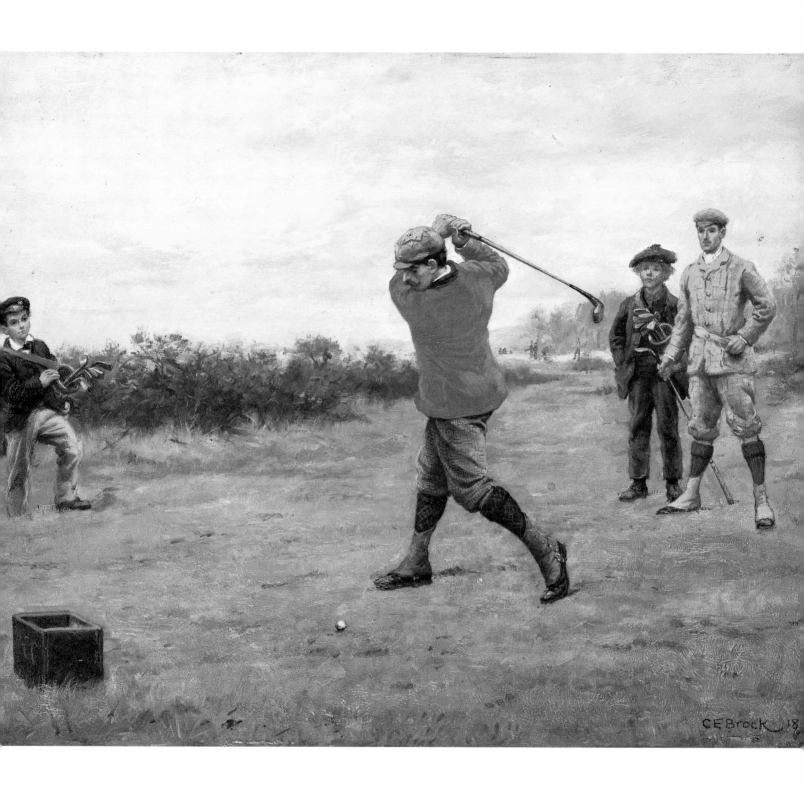

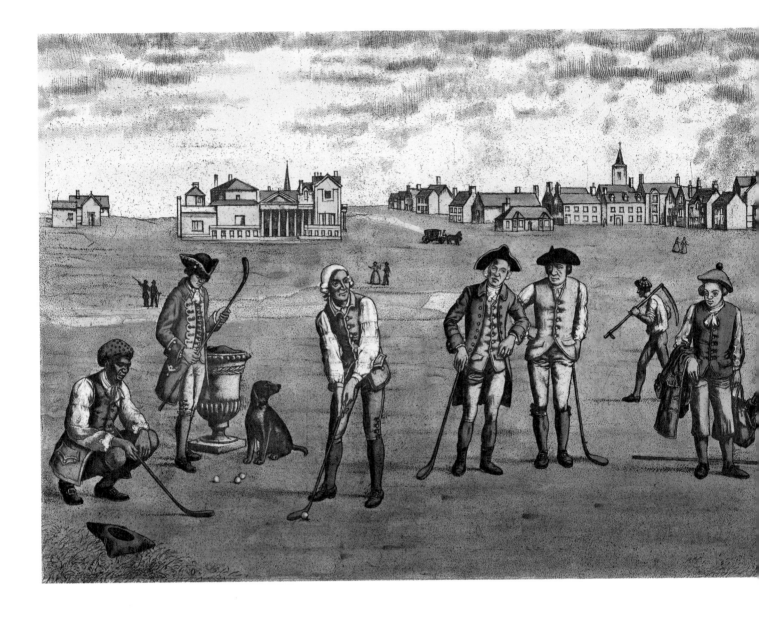

GOLF

The Oxford Dictionary, 1814

Golf, *sb.* Forms: gouff, goif (f, (golfe), goff, gowff (golff, golph), golf. Of obscure origin.

Commonly supposed to be an adoption of Dutch *kolf,* kolv-, "club," the name of the stick, club, or bat used in several games of the nature of tennis, croquet, hockey, etc. But none of the Dutch games have been convincingly identified with golf, nor is it certain that *kolf* was ever used to denote the game as well as the implement, though the game was and is called *kolven* (the infinitive of the derived verb). Additional difficulty is caused by the absence of any Scottish form with the initial *c* or *k,* and the fact that golf is mentioned much earlier than any of the Dutch sports. Some modern Scotch dialects have *gowf,* "a blow with the open hand," also, verb, to strike. The Scottish pronunciation is "gouf;" the pronunciation "gof," somewhat fashionable in England, is an attempt to imitate this.

A game, of considerable antiquity in Scotland, in which a small hard ball is struck with various clubs into a series of small cylindrical holes made at intervals, usually of a hundred yards or more, on the surface of a moor, field, etc. The aim is to drive the ball into any one hole, or into all the holes successively, with the fewest possible strokes, commonly two persons, or two couples (a foursome), play against each other.

1457 *Sc. Acts Jas. II* (1814) II 48/2 And at pe fut bal ande pe golf be vtterly cryt downe and nocht vsyt. 1491 *Sc. Acts Jas. IV* (1814) II. 226/2 Fut bawis gouff or vthir sic vnproffitable sportis. 1538. *Aberdeen Reg.* V.16 (Jam.) At the goiff. *a* 1575 *Diurn. Occurr.* (Bannatyne Club) 285 Certane horsmen of Edinburgh ... past to the links of Leith, and ... tuck nyne burgessis of Edinburgh playand at the golf. *c* 1615 *SIR* S. D'EWES *Autobiog.* (1845) I.48 Goff, tennis, or other boys' play. 1669 SHADWELL, *R. Shepherdess* III. Wks. 1720 I.260 We merrily play At Trap, and at Reels ... At Goff, and at Stool-ball. 1711 RAMSAY *Elegy M. Johnston* 37 Whan we were weary'd at the gowff, Then Maggy Johnston's was our howff. 1771 SMOLLETT *'Humph. Cl.* 8 Aug., Hard by, in the fields called the Links, the citizens of Edinburch divert themselves at a game called Golf. 1806 MAR. EDGEWORTH *Mor. T., Gardener,* Colin's favourite holiday's diversion was playing at goff. 1815 SCOTT *Antig.*ii, Rather than go to the golf or the change-house. 1867 KINGSLEY *Lett.* (1878) II.251 Golf is the queen of games, if cricket is the king.

As an attributive and in combination:

1545 *Aberdeen Reg.* V.19 (Jam.) Thre dossoun and thre *goif bawis. 1637 in Cramond *Ann. Banff.* (1891) I.78 He sauld twa of the golf ballis to Thomas Urquhart. 1824 SCOTT *Redgauntlet* ch.i, I'll get him off on the instant, like a gowff ba'. 1508 *Reg. Privy Seal Scot.* in Pitcairn *Crim. Trials* I.108* Slaughter committed 'on suddantie,' by the stroke of a '*golf-club.' 1753 *Scots Mag.* Aug. 421/2 The city of Edinburgh's silver goff-club was played for Aug. 4. 1800. A. CARLYLE *Autobiog.* 343 Garrick ... had told us to bring golf clubs and balls. 1890 *Spectator* 4 Oct. 438/1 Long stretches of turf ... are indispensable for the formation of *golf-courses. 1801 STRUTT *Sports & Past.* II. iii. 95 *Goff-lengths, or the spaces between the first and last holes, are sometimes extended to the distance of two or three miles. 1881 *Sportsman's Year-Bk.* 256 Prince Henry, the elder brother of Charles I, was a zealous *golf player. 1839 LANE *Arab. Nts.* I.85 He ... made a *goff-stick with a hollow handle. 1856 KANE *Arct. Expl.* II. xxi. 206 Each of them had a walrus-rib for a golph or shinny-stick.

ST. ANDREWS 1800
by Lawrence Josset

THE OBJECT OF
THE GAME

Anonymous

The object of the game is not
 (As sometimes seems to be)
To long "address the ball" and "press"
 When "driving" from the "tee."

The object of the game is not
 (Though loath I am to coach)
To talk o'er much of "spoons" and such
 When "lofting" an "approach."

The object of the game is not
 (No matter what you've seen)
To miss the hole by half a pole
 When "putting" on the "green."

The object of the game is not
 (Our experts so inform me)
To boast a "set" of clubs and yet
 To call the "cleek" a "dormie!"

The object of the game is not
 (I pray you do not laugh)
To give club-corner lectures for
 The "baff" against the "schlaff."

The object of the game is not
 (The rhyme grows drunk and drunker)
To "slice it" in a "fog" or "whin,"
 Or "foozle" at a "bunker."

Oh, no! the object of the game
 (As I can prove by oaths)
Is just to see which one can be
 Most clamorous in clothes.

THE NINETEENTH HOLE
by Linda Jane Smith

A Golfing Song

by James Ballantine

Come leave your dingy desks and shops,
 Ye sons of ancient Reekie,
And by green fields and sunny slopes,
 For healthy pastimes seek ye.
Don't bounce about your *"dogs of war,"*
 Nor at our *shinties* scoff, boys,
But learn our motto, *"Sure and Far,"*
 Then come and play at golf, boys,

Chorus — Three rounds of Bruntsfield Links
 will chase
 All murky vapours off, boys;
 And nothing can your sinews brace
 Like the glorious game of golf, boys.

Above our head the clear blue sky,
 We bound the gowan'd sward o'er,
And as our balls fly far and high,
 Our bosoms glow with ardour.
While dear Edina, Scotland's Queen,
 Her misty cap lifts off, boys,
And smiles serenely on the green,
 Graced by the game of golf, boys.

Chorus — Three rounds, etc.

We putt, we drive, we laugh, we chat,
 Our strokes and jokes aye clinking,
We banish all extraneous fat,
 And all extraneous thinking.
We'll cure you of a summer cold,
 Or of a winter cough, boys,
We'll make you young, even when you're old,
 So come and play at golf, boys,

Chorus — Three rounds, etc.

When in the dumps with mulligrubs
 Or doyte with barley bree, boys,
Go, get you off the green three rubs,
 'Twill set you on the *"Tee,"* boys.
There's no disease we cannot cure,
 No care we cannot doff, boys;
Our aim is ever *"far and sure"* —
 So come and play at golf, boys.

Chorus — Three rounds, etc.

O, blessings on pure caller air,
 And every healthy sport, boys,
That makes sweet Nature seem more fair
 And makes long life seem short, boys:
That warms your hearts with genial glow,
 And make you halve your loaf, boys,
With every needy child of woe —
 So bless the game of golf, boys,

Chorus — Three rounds, etc.

Then don your brilliant scarlet coats,
 With your bright blue velvet caps, boys,
And some shall play the *"rocket shots,"*
 And some the *"putting paps,"* boys,
No son of Scotland, man or boy,
 Shall e'er become an oaf, boys,
Who gathers friendship, health, and joy,
 In playing at the golf, boys.

Chorus — Three rounds, etc.

TED
by Maud Humphrey, 1897

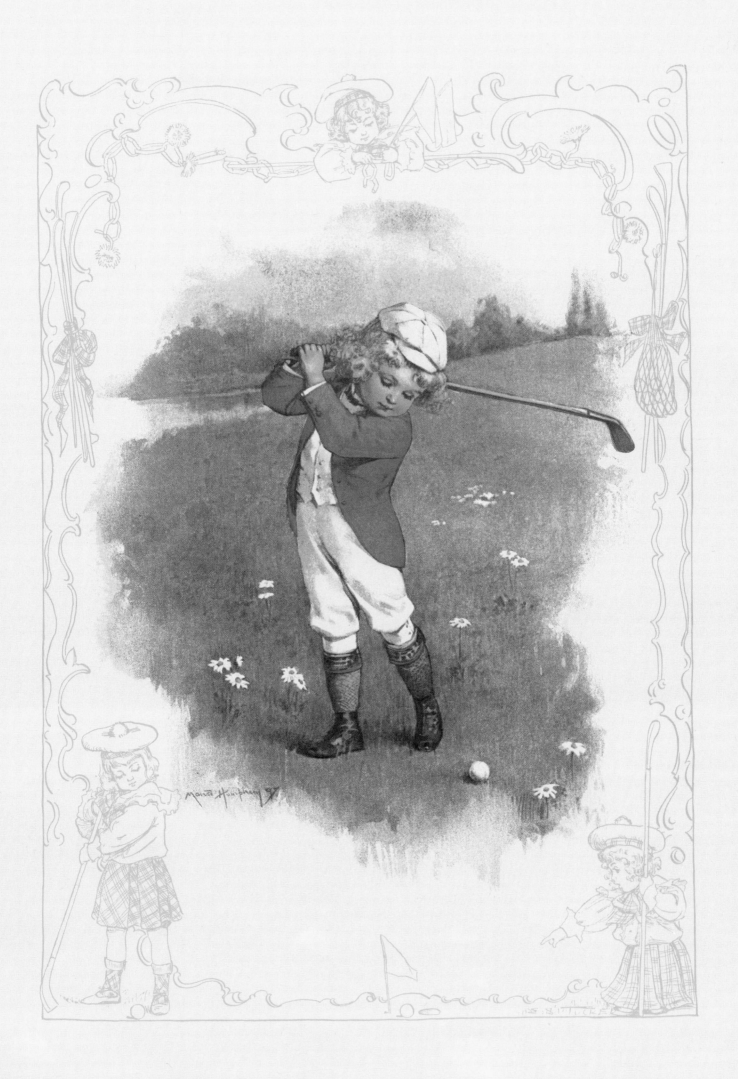

A COURSE TO TRY MEN'S SOULS

by Joseph C. Dey, 1978

In the middle of town, archaeologists patiently dig in Louden's Close, a quiet enclosure. On the edge of town, less patient golfers dig into more pliant soil; once the British Open championship starts there next week, they'll be watched by hordes, kept informed by modern scoreboards.

The players, having driven on the home hole, will cross a small stream, the Swilcan Burn, over a narrow arched bridge of uneven stones. Hundreds of years before golf was played here, pack-laden donkeys crossed the Swilcan on that bridge. Since golf's advent, the feet of all the game's great men have gone over the bridge — some in happy stride, some just plodding to get a sad round done. One lady visitor with twisted ideas of history wondered "why the Romans would build such a bridge on a golf course."

Old and new, side by side.

The contrast is more pointed when you drive toward the town. Tall spires in the distance, surmounting gray stone buildings, beckon you on. Then, of a sudden, there are ultramodern structures on both sides of the road — additions to the university, a hotel looking not unlike a giant's dresser with the drawers open.

On into the city, you choose a route through the West Port. You may have to wait your turn because, while this ancient gateway, built in 1589, was meant for two-way traffic, only one modern vehicle at a time can pass through. Sometimes a lorry decommissions the West Port for two or three weeks. Not far away is a small supermarket.

Past and present. St. Andrews. The Kingdom of Fife, in a nook of the east coast of Scotland, along a broad bay of the North Sea. St. Andrews, the old gray town. The Mecca of golf. The cradle of golf. A city of many facets, of unsuspected charm.

"Cradle of golf" was not coined by Madison Avenue, although Madison Avenue would be proud to have invented such an attraction. St. Andrews was not invented. It evolved; with it, the beguiling game of golf; from it, golf spread to many lands.

The Scots have a splendid way of celebrating events in verse, and when the Royal and Ancient Golf Club of St. Andrews had its bicentennial in 1954, Dr. J.B. Salmond wrote these lines:

> *So this then for a toast, the written*
> *story*
> *Of twice a hundred years of this*
> *fair scene,*

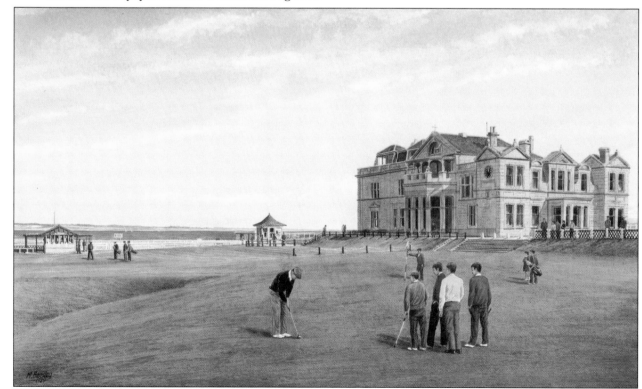

All of Elysium. To them the glory
Who fostered for us fairway, bunker,
green,
Who spread Golf's Empire all
across the world,
And ruled with justice and with
equity.

No one knows precisely when and where golf began. More than 500 years ago in Scotland it distracted men from archery and other military activities. Starting in 1457, the Parliaments of three successive Scottish kings prohibited golf. The bug bit the third king, James IV; he became a golfer.

In the smallish community of St. Andrews, golf had a warm, natural home for its nurture. It was a game of people, lairds, nobility; Mary Queen of Scots played at St. Andrews. In 1754 the first semblance of organization came with the formation of The Society of St. Andrews Golfers, the second golf club in Britain, the first being the Honourable Company of Edinburgh Golfers, founded 10 years earlier. With the approval of William IV, the name was changed in 1834 to The Royal and Ancient Golf Club of St. Andrews. Today the R&A is a worldwide club of 1,800 members of which no more than 1,050 may live in Britain and Ireland; of the rest, 275 may reside in the U.S. Six continents are often represented at the club's Autumn Meeting.

There are anomalies. The R&A, a private club, does not own a golf course. It helps support and has privileges over the four St. Andrews courses, which are open to the public. There are five men's clubs and two for women. The R&A, by common consent, has conducted the British Open and Amateur championships since 1920, although both championships were originated by other clubs — the Open by Prestwick (1860), the Amateur by Hoylake (1885). The R&A, one single club, and the United States Golf Association, comprising nearly 5,000 clubs, jointly make the rules for the world of golf.

From that wide world of golf, devotees pour into St. Andrews every summer. Last year 140,000 rounds were played over the four courses, but the Old Course is the real magnet. The worshiper has not made a proper pilgrimage if he does not play the Old Course, the championship course.

It is a course that tries men's souls. It is peculiar by modern standards: hidden bunkers, unforgiving whins and heather, unexpected bounces, double putting greens for 14 of the 18 holes — that is, two holes are cut in each of seven huge greens, the largest almost an acre. A fascinating course. If you don't come to love it, you probably don't understand it. As exacting as the Old Course is, it was first holed in 79 almost 120 years ago by Allan Robertson, the first great golfer and leading maker of "featherie" balls. Now the record is Neil Coles' 65.

Great players have won the Open on the Old Course. The Americans include Bobby Jones, Sam Snead, Jack Nicklaus. In 1930 Jones began his Grand Slam there, winning the British Amateur, then going on to win the British Open and the American Open and Amateur. Jones is a demigod still worshipped in the old gray town. They named the 10th hole for him. They made him a Freeman of the Burgh 28 years after he retired, the first American so honored since Benjamin Franklin. When Jones died they held a memorial service in the Town Kirk, which now has an organ division given by his family and a plaque hailing him as a citizen of Atlanta and St. Andrews. A memorial scholarship fund named for him finances student exchanges between the University of St. Andrews and Emory University in Atlanta, where Bob earned his law degree.

Sir Guy Campbell once heard the Old Course speak in verse, partly this way:

So it was and has been; so it is
and will be.
I abide unchallenged, and peerless
is my Name.
History behind me, I give all who
find me
Welcome and a Blessing, to the
Glory of the Game.

A less rhapsodic American student, R.F. Murray, thought of it thus:

Would you like to see a city given over
Soul and body to a tyrannising game?

Tyrannizing? Today you see a schoolboy pedaling his bicycle to the links, a little golf bag slung over his shoulder. At 7 p.m. you may see men arrive pulling golfbag carriers attached to their bicycles — it is still light at St. Andrews in the summer at 10 p.m. Leaving the cycles, off they start on a late round.

But St. Andrews is vastly more than the tyrant golf. Golf has been the beneficiary of several converging influences in the old gray town. Climate, education, perhaps religion, have lovingly rocked the cradle.

The climate is superior to that sometimes found on an unlucky quick visit. On the average, there are four-plus hours of sunshine daily throughout the

THE HOME OF GOLF
by Mick Bensley, 1989

year, seven hours in summer. Average annual rainfall of 26 inches compares with 43 inches in Nassau County, Long Island. Summer spawns stretches of balmy bright days and light atmosphere. So St. Andrews has long been a holiday resort. In the summer, its normal population of 13,000, excluding students, swells to about 23,000. When the Lammas Market invades the town early in August, some 15,000 out-of-towners visit the stalls and booths along two main streets, Market and South; it is a hodgepodge carnival of medieval origin.

The rectitude of the code of golf could well have had its beginnings in the religious bent of old St. Andrews. Start with the very name: Andrew, a fisherman in the Sea of Galilee, one of the first Apostles called by Jesus and brother of Simon Peter. How did Andrew go in name and spirit to the remote coast of what is now Scotland?

Andrew is said to have carried the Gospel to Russia, Greece, Asia Minor and Turkey; in Patras, Greece, on refusing the Roman proconsul's order to lead the people in sacrifice to heathen gods, Andrew suffered a martyr's death in 69 A.D., when quite old. His cross was X-shaped, *crux decussata;* it is said that he was fastened to it by cords, not nails, so that his death was lingering, perhaps over two days, and all the while he preached.

Legend holds that his remains were moved to Constantinople and it continues as follows, although historians do not validate it: Andrew's body remained there until 369. Then the Abbot Regulus, or St. Rule, took relics (an arm bone, three fingers, three toes) on a missionary journey. He was shipwrecked off what is now Fife. Regulus and a few monks escaped, buried the bones of St. Andrew, built a chapel in his honor, and converted the Pict king, who erected a costly church on the chapel site. The place was named St. Andrews.

The St. Andrews cross, white against a blue background, is the national symbol of Scotland.

One historian says Andrew's relics were brought to the place about 736, some 150 years after a monastery arose there. Certain it is that a great cathedral, the largest in Scotland, was founded in 1160 and consecrated in 1318. It has long lain in ruins, still fascinating, with a large graveyard adjacent.

Nearby, overlooking the bay, is the castle, built about 1200 as a fortified palace for the Catholic bishops. It has a bloody history—besieged, wrecked, rebuilt, retaken. At the insistence of Cardinal Beaton, who looked on, the reformer George Wishart was burned to death in front of the castle in 1546; less than three months later, Beaton was murdered by reformers who broke into the castle. The great John Knox, priest turned reformer, took refuge in the castle for a while, until troops from a French fleet assaulted it in 1547 and carried him to France. He pulled an oar in French galleys for a time before returning to Scotland to help establish Protestantism in the British Isles. The castle has a grisly Bottle Dungeon, so called because of its configuration.

One of the loveliest edifices in St. Andrews is the Church of the Holy Trinity, the Town Kirk. Founded in 1112, it was restored and reopened late in 1909, a center of Presbyterian faith. Today there are ten churches in the city, representing seven denominations of Christianity.

The question lingers: Could the bloody history of religion have had any effect on the nurture of early golf, aside from so-called rectitude, which sometimes was mere mulishness?

From earliest times education was at the heart of St. Andrews, and so it is today. The University of St. Andrews is the oldest in Scotland, chartered in 1412 and given university status in 1414. A prime function was to educate the clergy. Today the university has 3,600 students, of whom 1,950 are male. The institution is a centerpiece of St. Andrews life.

A colorful centerpiece it is. Many students go about the town in red gowns, long a university hallmark. They may be worn at any time. Female heads sometimes are adorned with mortarboards (trencher caps) but not about town. Tassels of differing colors denote their years.

The main disciplines are science (including pre-medical), arts and divinity, and they attract students from many countries. Tuition and living expenses are very low by American standards; government allowances subsidize some British students. Rudyard Kipling was Rector of the University from 1922 to 1925.

Marvelous style distinguishes many old university buildings. The University Chapel contains the pulpit from which John Knox once fulminated. But women's lib has overtaken the chapel: male and female students no longer sit on separate sides.

So university life is not as encrusted as in the day of a certain aged professor who, after approving a mixture of common table beer and strong ale, deliberated whether the beer should be poured into the ale or the ale into the beer; said he, "If the small beer should be poured into the ale it would make the ale worse, but if the ale should be poured into the beer it would make the beer better."

The visitor to St. Andrews should resist the tendency to become preoccupied with the great edifices, for he will find much else to captivate him — the residences, be they small or large; the golf-club-makers' shops; the parks; the old harbor, no longer a fishing center except for a few lobster pots;

the seals cavorting in the estuary of the River Eden; the broad beaches; the craggy cliffs; the narrow wynds or lanes. St. Andrews is a treasure hunt for the diligent seeker, with things of interest to be found in unlikely places.

St. Andrews has examples of every type of house since the 12th century. Most domestic buildings date from the 16th, 17th and early 18th centuries; Queen Mary's house, 1523. Gray stone predominates. Sometimes it is dull gray, but the smallest garden plot in front has colorful plantings. A large house with a facade squarely on the street has a huge garden in the rear.

Glimpse the charming home of Mrs. Jean Tynte. The street side of the three-storied house was built in 1668, the last additions about 1820. The back opens onto a very large garden, with pear trees older than the house still bearing fruit. Mrs. Tynte says, "Mary of Guise brought pear trees to St. Andrews in 1538, and they were planted by monks as an avenue between St. Mary's and St. Leonard's chapels. There is a stream running underground below the pear trees, which presumably has kept them going all these years, and my great-uncle, Captain W.H. Burn, always told me that the largest was about 400 years old." Captain Burn was chairman of the R&A Rules of Golf Committee.

Ever hear of "marriage lintels"? Some doorways are decorated with the initials of the owner and his wife and the date of building. Homes in old St. Andrews invariably give the impression of solidity and loving care. Many are gems, no matter the size.

For all its fame and history, its architecture, its golf, its things, St. Andrews is lovable primarily for its people. They are, of course, of varying degrees of education and differing tastes. Almost without exception, they are warm, friendly, convivial, not intrusive, courteous in the extreme, not outwardly demonstrative, with fine humor and a sense of the rightness and the fitness of things. They make do with relatively much less of the world's goods than Americans, and they make do wonderfully well, thanks to their sense of values.

Some years ago I had a touching insight into their faith and affection. Wandering through the old cathedral graveyard, I came quite by chance upon an epitaph to a departed spouse. This is what it said:

Then steal away.
Give little warning.
Say not good night,
But in some higher clime
Bid me good morning.

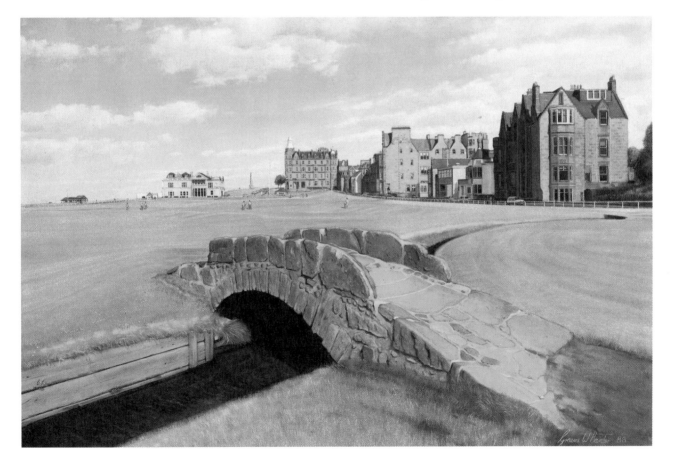

OLD COURSE, ST. ANDREWS
by Graeme W. Baxter, 1988

AN ODE TO ST. ANDREW

by W. A. Campbell

That man upon whose natal hour
 Thy beaming eye has smiled,
Inspiring with a Golfer's power,
 Dear Saint, thy favoured child,

'Tis not for him, a Golfer born,
 The warrior's paean rings;
Nor his the laurel rudely torn
 From the brow of conquered kings.

But the sunlit seas that, laughing, lave
 Bright Eden's sandy shore
Shall whisper his name in each rippling wave
 Till time shall be no more.

And the deep green seas, with their billowy clash
 And their stern triumphant roar,
Shall bellow his name, as they thundering crash
 On old St. Andrews' shore.

In Royal and Ancient records placed
 Amidst the sons of fame,
With never-ending medals graced,
 Great master of the Game.

Sweet Saint! whose spirit haunts the Course,
 And broods o'er every hole,
And gives the Driver vital force,
 And calms the Putter's soul,

Thou giv'st me, to the world's last hour,
 A Golfer's fame divine;
I boast — thy gift — a Driver's power;
 If I can Putt — 'tis thine.

ADDRESS TO ST. ANDREWS

Anonymous

St. Andrews! they say that thy glories are gone,
That thy streets are deserted, thy castles o'erthrown:
If thy glories *be* gone, they are only, methinks,
As it were, by enchantment, transferr'd to thy Links.
Though thy streets be not now, as of yore, full of
 prelates,
Of abbots and monks, and of hot-headed zealots,
Let none judge us rashly, or blame us as scoffers,
When we say that instead there are Links full of Golfers,
With more of good heart and good feeling among them
Than the abbots, the monks, and the zealots who sung
 them:

We have red coats and bonnets, we've putters and
 clubs;
The green has its bunkers, its hazards, and *rubs;*
At the long hole across we have biscuits and beer,
And the men who sell it give zest to the cheer:
If this make not up for the pomp and the splendour
Of mitres, and murders, and mass — we'll surrender;
If Golfers and caddies be not better neighbours
Than abbots and soldiers, with crosses and sabres,
Let such fancies remain with the fool who so thinks,
While we toast old St. Andrews, its Golfers and Links.

OPEN CHAMPIONSHIP, ST. ANDREWS
by Michael Brown, 1895

HIAWATHA ON THE LINKS

Anonymous

Hiawatha went a-golfing,
Went with gentle Minnehaha,
Where the golfers were a-golfing,
Where they swiped the bounding gutty,
Where they sclaffed and where they foozled,
Where the mighty Auchterlonie,
And the Alecs and the Willies —
Willie Smith and Willie Wailer —
And the other famous Willies
And the Turpies and the Campbells
And the Foulises were gathered.
Full of zeal, brave Hiawatha
Bought a brassie and a mashie,
Bought a bulger and a niblick,
Bought a baffy and a driver,
Rolled his sleeves up and his trousers,
Paid a quarter to the caddie,
Winked at smiling Minnehaha,
Winked and murmured: "Minnie, watch me!
Watch me while I wield my brassie,
Or my mashie or my driver!
Watch me hit the ball and knock it
So blamed far they'll never find it —
Watch me closely while I swat it —
Watch me knock out Colonel Bogey,
Watch me beat great Auchterlonie —
Auchterlonie, Auchterlonie!
Oh, I wish that I could stand here
All day saying Auchterlonie —
Not a thing but Auchterlonie;
For it tickles me to say it —
Tickles me down in the thorax,
Down around my Adam's apple —
If you don't believe it, try it —
Just say Auchterlonie, Minnie —
If you do I know you'll like it —

Merely murmur Auchterlonie,
And you'll never want to quit it!
Watch me beat this Auchterlonie
And these various famous Willies!
When I hit the ball I'll bust it!
Knock it into forty fragments!
Knock the pieces through the bunkers!
Stand aside and let me wiggle —
Give me room to swing my driver!
Hurry! Here comes Auchterlonie,
See him coming with his baffy —
Auchterlonie, Auchterlonie!
I can almost seem to sing it!
Watch me now!** — ?!* Say, Minnehaha,
What has happened? Where'd it go to?"
"There it lies," the maiden murmured —
"There it lies, right where you put it —
All you hit was terra firma,
Merely hit the ground and doubled
Up as if you'd eaten something
That had gripped you in the middle.
Auchterlonie's laughing at you —
There he stands convulsed with laughter,
And the Willies, too, are laughing,
All these various famous Willies —
Standing 'round and laughing at you,
O, my noble Hiawatha!"
With a groan the prostrate warrior
Looked and saw; his heart was broken,
And the maiden, kneeling, heard him,
As his spirit left him, murmur:
"Auchterlonie! Auchterlonie!"

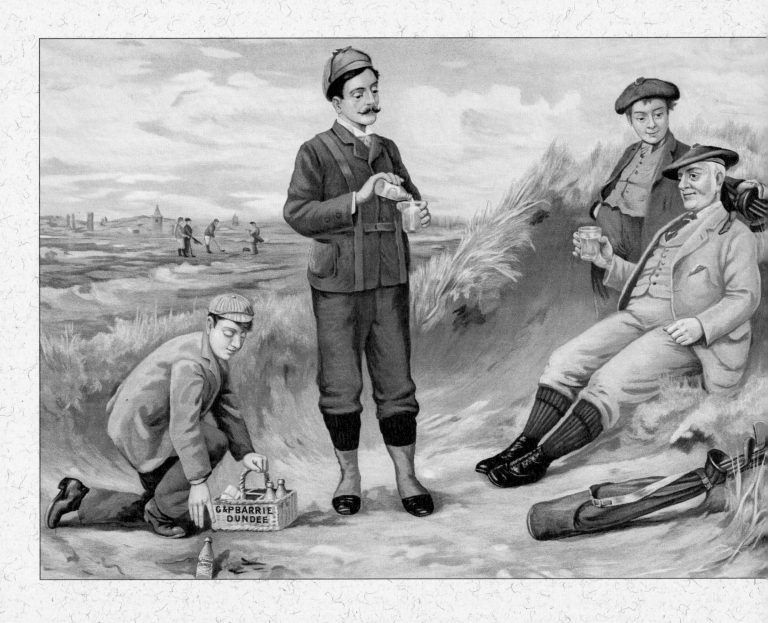

GINGER BEER
by William Blake Lamond, 1894

COMMENTARIES

On Dufferdom

by Royal Cortissoz, 1922

It is a broad and goodly land, this land of dufferdom, its limits marked only by those of the golf-courses of the earth. Does not its representative figure deserve some consideration? Voltaire would appear to have answered that question as far back as the eighteenth century. To the duffer who reminded him that even duffers must exist he sweetly replied: "I don't see the necessity." There are commentators who stand by that assertion to this day. They are a little too austere. After all, the duffer is a friendly human brother. Suppose he does top his ball. Nevertheless, hath not a duffer "hands, organs, dimensions, senses, affections, passions"? He abounds in error, of course. Mayhap he is fairly steeped in it. But —

> "Errors, like straws, upon the surface flow;
> He who would search for pearls must
> dive below."

Let us then dive into dufferdom, an adventure which especially appeals to me at the moment, for as I write the welkin is ringing with the exploits of Mr. Jesse Sweetser, winner of the national amateur championship at Brookline. His scores read like the "Eroica." The talk is all of birdies and eagles. If one listens to it long enough one develops the suspicion that golf has been lifted to a Homeric plane and that only Homeric men are fit to play it. But the duffer remains — immovable, monumental. We may turn to him, if only in the spirit of Calverley and his invocation to that "grinder who serenely grindest":

> " 'Tis not that thy mien is stately,
> 'Tis not that thy tones are soft;
> 'Tis not that I care so greatly
> For the same thing played so oft:
>
> But I've heard mankind abuse thee;
> And perhaps it's rather strange,
> But I thought that I would choose thee
> For encomium, as a change."

DUFFER'S YET
Artist Unknown

I thought sympathetically of the duffer not long since, in the midst of a conversation which seemed to leave him no excuse for being at all. The merits of a certain hole had come up for discussion. It was a hard hole, so hard as to be denounced by some as merely tricky and demoralizing. When I had the chance I submitted the problem to the one august authority in these matters, the wizard and wonder-worker, Mr. Charles MacDonald. He settled it in a saying which I suppose might well be inscribed in letters of gold over the portal of every golf-club. "Well," quoth he, "a golf-course is designed for men who can play golf." How everlastingly true and inspiring that is! It sums up the rigor and the glory of the game. It erects the only authentic standard. To question it would be to speak disrespectfully of the equator. Your golf-course is unquestionably made for the men who can play golf. But, on the other hand, if one may with diffidence hazard a small interrogation: Who on earth keeps it going?

Establish yourself comfortably on the bench at the first tee and watch one foursome after another drive off. Keep careful tally for an hour or so. Then tot up the numbers of those who played golf and the numbers of those who launched themselves blithely into dufferdom. The latter region has, I verily believe, a density of population rivalling that of a Chinese slum. Only, you see, there is nothing in the least slummy about it. On the contrary, its sunny slopes are rich in elbow-room, which is used in ecstasy by happy myriads. Not for them the sublime certainty of a Sweetser. In Grantland Rice's account of that young old master's dazzling triumph I find this tribute to his flawless form: "He reminded you of a well-oiled machine that could continue to send the ball on a straight line for year after year, until the cogs wore out." The duffer's straight line may be, in a sense, an annual affair, but there is otherwise nothing of the inerrant machine about him. He hasn't a cog to his name. But, I ask again, is it the Sweetsers of this world who keep a golf-course going?

What a deadly place a golf-course would be if they did! It might please a Henry Ford to watch the functioning of a long procession of well-oiled machines, and the rest of us would, for a time at least, be so keen about the spectacle that the committee would probably have to cover up the rough with bleachers. But sooner or later the duffer would

rebel. He would be first fascinated, then stupefied, and, finally, bored to death. He would want the feel of a club in his hand. For a little while he would shrink from the ordeal of making a birdie whether he liked it or not. He would end by making that hole in seven and glorying in his shame. Driven to bay by an irate committee, he would ask the members if they would not, for one thing, look at the statistics. What these would reveal in the personnel of almost any club I have already hinted. And there are other items that build up a formidable economic total. Who is it that buys and tries every new club? The duffer. Who is it that buys and tries every new ball? The duffer. Who is it that enters sweepstakes after sweepstakes, counting his defeats as naught? The duffer. And so on. He is the rock-ribbed foundation of golf. If he were to withdraw, the golf-courses of the country would infallibly bust up. But I would not dwell importunately on his status as an economic factor. Indeed, I would far rather emphasize his traits as a sportsman, his significance as an embodiment of the immortal spirit of the game.

The duffer is nothing if not an artist. To quote my friend Rice again: "In golf there is no man who is ever master of his destiny." That is the artist's point of view. The duffer has it, rejoices in it, and is steadily faithful to it. For him the very mutability of the game constitutes one of its strongest lures. He faces each game as an experiment, just as a painter faces a new canvas. The thing may prove a botch. It may prove a jewel. And this artistic conception of the struggle involves a peculiarly exquisite satisfaction in victory, when the victory comes off. Rarity, most of us will admit, is one of the supreme blisses of life. The passion for it is a universal attribute of human nature. There are few men who would not exchange a fixed income for a thumping windfall. It must be, beyond all peradventure, a delectable thing to play six holes in succession in authoritative, automatic par, to play them with the assurance of an acrobat sailing over six elephants at a jump. But, frankly, can this trained, rehearsed achievement equal in high emotion the unexpected prowess of the duffer who makes a two where he never made a two before? The question answers itself. It is like painting a composition that has always got confused and suddenly having it resolve itself into perfect clarity.

Think of the moments in a duffer's progress in

which he perceives that it really is progress that he is making. He studies Sarazen's grip until he feels like Laocoön in the coils of the serpent, but some fine morning he actually gets the hang of it. He wrestles with his brassie in despair, and then, unaccountably, discovers that it is the best club in his bag, the one with which he can do incredible things. He makes a two-shot hole out of an interminable brute that had previously done nothing but deface his score. And, mark you, he does all this by the process which is the very life-blood of the game, by the process of trying. I never could comprehend the complacent scorn of the Pharisee in golf for the duffer at whom he directs his gibes. When the potentate misses a two-foot putt it is, I suppose, because the solar system shifted just then. The duffer in the same case is assumed to have sounded the depths of ineptitude and receives the opprobrium due to personal guilt. I have seen numbers of very good players do fairly terrible things. We read about them even in historic matches. Nobody is blamed for them. Neither should the duffer be blamed. What he needs is not blame but sympathy.

If he deserves it for anything it is for the all-essential virtue of resolution. You couldn't dampen his ardor with a cloudburst. Sweetser, Hagen, Sarazen, Ouimet, and the rest fight on through thick and thin. So does the duffer. That is where he is on all fours with the best of them, though his resources, compared with theirs, are like wind-blown sparks compared with the roaring flame at the heart of a conflagration. He may top his ball, as I have said before, but he will tackle it again, and again, and yet again. His head is bloody but unbowed. Jocund as the morning, after unnumbered rebuffs, he swings his driver from the first tee and with Gilbert sings:

"Roll on, thou ball, roll on!
Through pathless realms of Space
Roll on!
What though I'm in a sorry case?
What though I cannot meet my bills?
What though I suffer toothache's ills?
What though I swallow countless pills?
Never *you* mind!
Roll on!"

MAC FOOZLE, CHIEF OF THE CLAN
Artist Unknown

THE REAL GOLFER

by Joshua Taylor, 1920

Do you know him? Have you seen him? He is only to be met at London Suburban clubs, or clubs that boast clay as the mother of greens, and that only between October and April. The layman usually pictures a golfer as a red-coated figure, with well-cut knickers showing shapely calves, a trim, neat moustache tacked on to a sunburnt face, club curled gracefully round the neck, a la Vardon, the whole occupying the immediate foreground of a picture that also presents a stretch of golden sand, a half-circle of blue sea, of a colour never met with within a thousand miles of England, Dolls-house villas, and oh, you know what I am aiming at, the Railway poster, which by the aid of brilliant colour-schemes, a martial figure, seemingly at first sight to have been stung in the neck by a wasp, but who is really coming to the end of a perfect swing. The luxuriantly-appointed hotel with a cuisine only equalled by the Ritz. Bus meets all the trains, all to boust up a little nine-hole course in County Donegal or some such easily get-at-able spot. There might be golfers who answer to the above description. There might also be sea-side resorts that can show all the colours of that poster, and it is not impossible that the local hotel could give points in culinary art to the Ritz, but — there is a doubt. Golfers on holiday are weird people. A perfectly cut coat that allows as much freedom as a pair of handcuffs, a pair of breeches that resemble nothing on earth so much as corn sacks. Stockings, with a dainty, tasselled end of "tie-up" showing below the over-lapping top, fit into shoes with a network of leather strips which flap around the ankles, but are really supposed to keep the rain out of the lace holes. Crowning all is usually a felt hat of the "Homburg" type, rakishly set at an angle over one ear. This proceeds to play golf. It enjoys the breezy open expanse of usually the good sea-side course. It fights the wild elements that have a birthplace in the east, and returns to the clubhouse boasting of how it drove on to the 7th green (with the wind of course) and was on the 15th in 2 against the gale. It boasts of the stinging sand that, swept up by the wind, bites into his face. It is pleased with the pleasure of a child at hitting a "cocked-up" ball in the fairway with a brassie, while over a low hit cleek shot (a wind cheater it calls it, whereas the ball was half-topped), it cannot find thoughts which express sufficient admiration for itself. It has played golf as golf should be played. As it was intended to be played. In a hurricane of wind, in *August*. Leave it alone. It does someone good, even if it only be a caddie. Real golf is played in the winter on inland courses, and the players thereon are the real golfers. There are some London courses that are dry, but it is the dryness of the man who has finished his two rounds half-an-hour ago, not that of he who is just playing the 32nd hole. After a week in a London office, or an office in any large town. After five and a half days of strenuous toil, commencing at 10 and finishing at 4, with a hour and a half for lunch, the golfer hurries away to the station. He knows that his only chance of getting a round in on a Saturday afternoon is to get there before the thirty or so other players who are even now making their way to the links from various points. Arriving at the club-house he makes haste to change into golfing clothes before proceeding to the 1st tee to put a ball into the starting rack. His golfing clothes are priceless. A once green stockingette coat what has been darned in a dozen places, and with one pocket burned out through forgetting that his pipe was alight. A round protuberance from the middle of the back shows that the loop usually used for hanging the coat on the peg, has drifted away. A pair of grey-flannel trousers, baggy at the knees, and very frayed round the edges, and with ventilated pockets, are kept in place at the top by an elastic cricket belt, and at the bottom by a pair of leather anklets. Boots of the farmer type, thick-soled and crinkled, and very dirty, and topping all, a cap with an abundance of peak that would put to shame the best effort of an Apache. A perfect golfing suit. Plenty of freedom. No irksome tightness round the

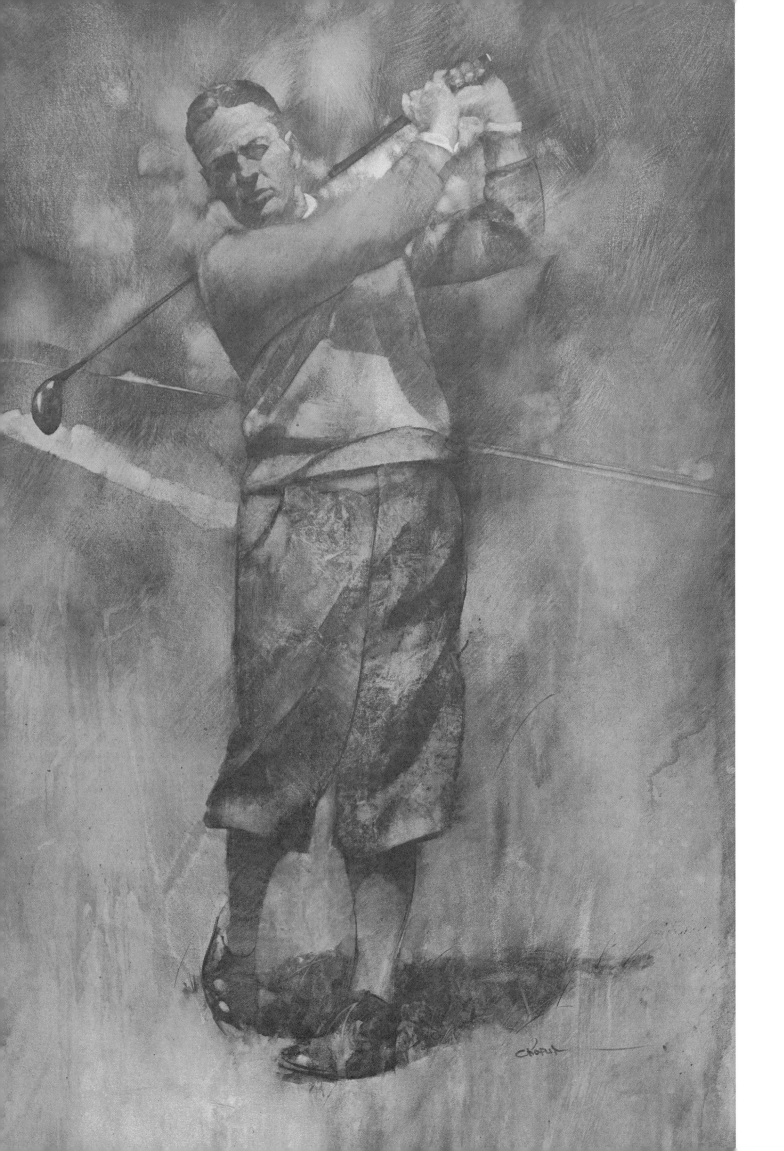

shoulders. Plenty of fresh-air, and boots that are comfortable. He proceeds to the first tee. Passing the caddie-master he asks for a caddie. "Sorry, Sir," replies the caddie-master, "haven't a boy left. Can't understand the rush to-day. There are 'undreds playing. I've been here 17 years an — " but the player passes on. He knows the caddie-master. Ever ready for a yarn. Charles, as he is known, is an asset to the club, and valuable at that. Arrives on the first tee. A group of some twenty players greet him. Players who have not stopped to change before putting down a ball. He puts his in the rack. He is twelfth. A little mental arithmetic: 12 times 3 are 36, over half-an-hour to wait. He curses his lack of forethought first for not 'phoning for a caddie early in the morning, and second for changing before putting down a ball. He passes a few remarks about people who put down balls before both players are ready. He points out that the rule distinctly states that both players have to be present before that rite is performed, but he is laughingly informed that he has been known to depart from the strict letter of the law, and that his golfing virtue has, at times, undergone a fall; while he is told that he must get up earlier if he expects a clear course. His turn comes and off he goes. If he can get through half-a-dozen couples and his opponent does not lose any balls, they might finish the round, but there isn't any time to spare. Soon he is squelching through mud and slush. His boots leak horribly, (he has promised himself a new pair for a couple of years but he always forgets it), and he is sure to get his feet wet. The ball lies where it falls and he is continuously playing "suckers." His clubs are caked, the shafts filthy. His bag a mass of sodden canvas and most unpleasant to touch, and no amount of pitch, begged from the pro. will enable him to get a grip as his hands are blue with cold. The wind whistles round his ears.

He turns up the collar of his coat as it commences to rain and curses himself for being such a fool as to play on a day like this, but he plays on. What with that lost ball at the 4th and the altercation with the couple waiting on the 9th, there is grave doubts whether the whole round can be played. The rain gets worse. Of course, if his opponent would only suggest it, they would go in, but as he (the opponent) is two down, and there is half-a-crown on the game, he will want to see it through. He plays the long 12th. A mist, stealing gently up from the low corner of the course, spreads itself like a curtain over the field of play. He would have won the 14th but for that. He couldn't see well enough to judge his second shot and it got caught in the hedge. They

were all square. The drives from the 14th tee were taken. His opponent, with the honour, could only manage a shot of about forty yards, but he hit one of his best. Straight as a line it flew into space. He could tell by the way it left the club that it was a good drive, and that it should be found in the middle of the course. A protracted search fails to reveal its presence. The whole of the fairway and the bunker was hunted over, but with no result, so he reluctantly comes to the conclusion that he must have hooked it over the fence. He was right. It was over the fence, but it was in the pocket of a wide-awake urchin who, with the malice-aforethought of a Thug, had taken up a position of great strategic value just by the bunker where, hidden by the fog, he reaped a rich harvest of balls. The fog, by this time, was impenetrable so they decided to "chuck it." They take a short cut across the links towards the club-house and are soon floundering amidst a maze of hedges, bunkers and trees, that lead them to the belief that there is more obstacles on their links than any part of the hunting country in Liecestershire. A joyous recognition of the pond at the 18th, which Providence has kept them out of, and they see the diffused lights of the house. They enter. Wet to the skin, covered with mud, boots omitting water at every step. Clubs and bag all over slime. Cold as chilled salmon, but HAPPY. A bath, change of clothes, a drink, and more happiness. He sits before a blazing fire in the lounge and recounts the round. Forgotten is the heart-breaking drizzle that beat like a thousand pin-points on his ears. Forgotten the "suckers" and the flying mud. The ball lost in the fog is a thing of the past as is the journey across the links in the dark. He has had his weekly game of golf and is content. He has played, during his summer holidays, on sea-side links and enjoyed it. He has known the thrills of the well-hit brassie shot through the green and the tingle of the gorse bush from under which he has hacked his ball. He prefers to play on a course where mud is only to be met with on the road to the links, but fortune has decreed that he earn his living in London and play his golf on clay. Sea-side golf pleases him as a beer-drinker is pleased with a glass of "Extra dry," but there is something lacking. The difficulties to be circumvented on a course that is within sound of breaking surf is not to be compared to what confront a golfer who plays on mud in the winter. Winter golf on mud is not a thing of beauty, neither is there much joy about it, but I am convinced that the real golfer is only to be found where the mud is thickest.

BOBBY JONES
by Bob Crofut, 1988

WORDSWORTH RE-WORDED

by Robert Browning, 1910

An agéd man,
Racked by a ceaseless cough,
And shivering in his wretched clothes,
What should he know of golf?

But when he saw me start to play
His sides he well nigh split;
He said, "I'll take you round to-day
For the mere fun of it."

"With strokes and misses, empty head,
How many have I had?" —
"You've taken seven to here," he said.
His answer made me mad.

"And how d'ye think that that can be?" —
He answered, "Take my word;
Two strokes to knock it off the tee,
And bunkered from your third.

"And other two to get it out,
And also — here's the rub —
Two more, because beyond a doubt
I saw you ground your club."

"But this is not a match," said I,
"For cups I do not strive;
And leaving out the penalty,
It seems I've taken five."

"Two on the tee — and one — makes three" —
He checked them on his hand —
"Two to get out, and other two
For grounding in the sand."

"But they don't count; those two don't count;
The slip must be forgiven." —
'Twas throwing words away, for still
That ancient man would have his will:
"I say you've taken seven."

THE OLD APPLE TREE GANG, 1888
by Leland Gustavson

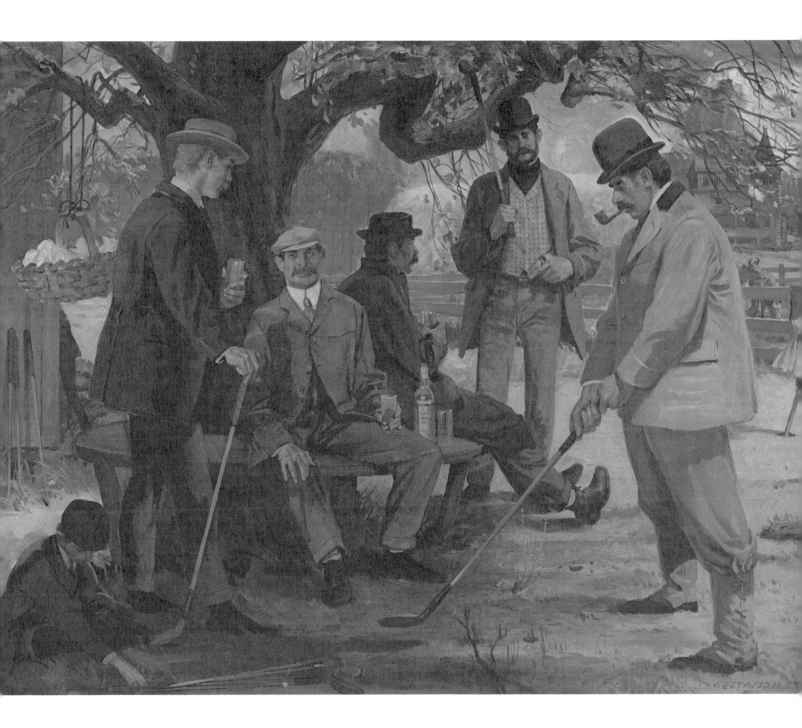

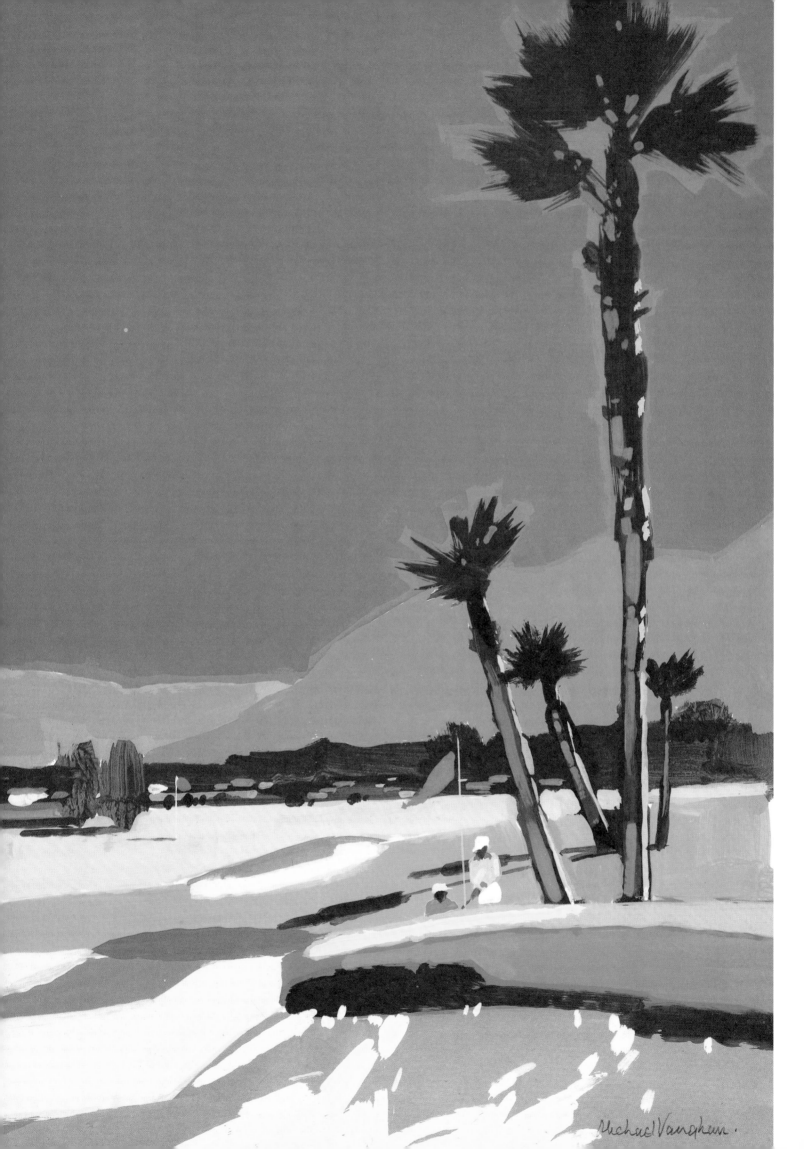

Michael Vaughan.

The Player and the Giant

by Steve Heller

Mitsumo Takara slept soundly the night the ocean vanished. He dreamed of the perfect seven-iron shot he had holed out that morning on number fourteen at the Garden Isle Country Club. It was beautiful, the way the ball soared in a gentle high arc above the trees as it approached the green. It was the arc, the curving form of flight, rather than the ball's fortunate bounce into the hole that intrigued him.

And when he awoke, it was not the excited cries outside that struck him — there were always such sounds along the beach by the Kauai Sands Hotel — it was the silence behind them. He arose and stepped through the sliding glass doors to his second floor balcony, where the leaves of a queen palm brushed softly against the railing in the morning breeze. A crowd had gathered beneath the line of gray-green ironwood trees shading the beach below.

All were looking out where Mitsumo looked, toward an ocean desert surrounding them, a vast empty basin, shimmering red and pink beneath the bright sun, like the color of raw flesh. The solid surface sloped away from the edge of the beach into a sparkling pink plain stretching all the way to the distant horizon.

More and more people were gathering along the beach, and Mitsumo hurried down to join them.

On the beach he could see the sand was still moist below the mark of the last tide. There were no fish lying stiff in the pink mud, but the coral reef around the island remained, blackening in the sun like ridges of unearthed coal. Children, held back by their parents, stared in fascination at the sight.

"It's a miracle!" one man cried. "The work of the devil!" another countered. "*The Menehune*," a third suggested, referring to the legendary little people of Hawaii who secretly built great works at night.

"The color's all wrong," complained a man as he dug his hands into the sticky sand and mud. He wore a green patch that read *Geological Survey*. "It

shouldn't be red like this," he said, flinging sand away in disgust.

"Perhaps it's an illusion — a mirage," a woman suggested.

"No," said an old man with a beard and tattered clothes. "It is a sign that our former way of life has passed, that we must start anew." Several people turned toward the old man and recognized him as one of the wise *kahunas* from the mountains. They nodded and began to crowd around him.

"Tell us what to do!" they shouted.

"We must begin at once!" the *kahuna* pleaded. "The world we knew has crumbled — the truth we believed in has vanished like the sea. We must not look back, but join together to build a new world. One that will endure." Cries of assent rang out.

"There will be sacrifice," the kahuna warned. "Accept the limits of our new existence. We must work unceasingly and learn to live without those foolish pleasures which almost destroyed us." Many applauded, but others began to drift away now, back toward the hotel. At the airport all flights had been canceled, someone complained. There was talk of forming an expedition to reach the island of Oahu, a tiny gray-tipped peak on the pink horizon.

"There is nothing to seek there," the *kahuna* called to the dispersing crowd. "We must all work together if we are to survive." Behind him a clerk was explaining to several tall men that the hotel had run out of liquor. In the breezeway-lobby a fight broke out. Tourists began to demand their money back.

"We will lead by example," the *kahuna* said confidently to those who remained. "The others will join us when they see there is no other way." From his shirt he produced a long sheet of kapa cloth. "I will record your personal skills here," he said, "and together we shall begin our task."

It was all very confusing to Mitsumo as he stood in line with the rest. In Honolulu he sold office furniture. Surely there would be no need for office

UNTITLED

by Michael Vaughan

furniture salesmen in a world born anew.

"I'm a golfer," Mitsumo said when it was finally his turn. The *kahuna* paused and frowned at this, but silently recorded it with a stick dipped in dye made from the leaves of the taro plant.

When a list was made, work began under the *kahuna's* sure and simple direction. There were only a few at first. Strong-bodied men began digging irrigation ditches, while others combed the island for water and gathered children into groups. But as the sun climbed higher and temperatures rose, discomfort and fear drove more and more to join the rebuilders. "We are all one," the *kahuna* said to those who came back. A camaraderie was developing; personal needs were forgotten as everyone shared in the labor.

Everyone but Mitsumo. He stood alone in the shade beneath the graying ironwood trees and watched, until he grew bored with that and wandered next door to the Country Club to practice his putting.

It might work out, he thought as he sank a twelve-footer on the practice green. The greens were all turning brown, baking beneath the hot sun, and huge bare patches were beginning to appear in the parched fairways lined with wilted hibiscus. But Mitsumo felt reassured. All the familiar landmarks remained. The green central mountains of Kauai still rose abruptly from the plain. Only their lush color was fading. Mt. Waialeale, the world's wettest spot, usually obscured by heavy gray clouds, stood out above the rest. Mitsumo could see traces of dry rust forming around the edge of the green peak.

But it was a closer landmark that drew Mitsumo's full attention.

Beyond the practice driving range, the Sleeping Giant lay quietly, stretching in a mile-long profile above the dry sandy bed of the Wailua River. Not everything is changing, thought Mitsumo, though he could see the Giant growing tanner by the minute as he lay. To Mitsumo, the Giant looked even more real, lying there in his new brown skin.

Mitsumo had always dreamed he could wake the Giant from his massive slumber — if only he could drive a ball into the sleeper's eye. Imagining what it would be like to see the Giant's huge craggy muscles ripple awake, shaking the pandanus trees and lifting clouds of swirling red dust above the sugar cane fields, Mitsumo would stand on the

practice tee and hit ball after ball at the small gap between the Giant's coco palm brows and boulder cheekbones. Each ball would fall miles short, but Mitsumo was not discouraged. It would take a perfect shot, he told himself.

Tourists would often remark how life-like the Sleeping Giant looked. Mitsumo always chuckled at that. They didn't share his secret. The truth was that Mitsumo regarded the Giant as an old friend. He trusted the slumbering figure; he knew that no matter what else happened, the Giant would always be there: massive and silent, his eyes forever closed until the perfect shot was struck.

Mitsumo was about to head for the practice tee when the *kahuna* appeared carrying a small calabash.

"I've been looking for you," he said. "You must give up your play and join us — there is much to do!"

Mitsumo said nothing.

"Your occupation is frivolous," the *kahuna* charged. "While you play, we have been hard at work — look!" He held out the calabash, half-filled with water. A trickle had been found near Wailua Falls. Mitsumo stared at the container, then off toward the mountains, as he felt thirst beginning to claw at the back of his throat.

"Don't you understand?" the *kahuna* asked sharply. "The world you knew is gone — there is nothing left us but the bare bones of the earth. The time for play is over." His voice softened. "You will not survive alone."

"I believe you," Mitsumo answered. "But I will not come." And with that, he picked up his bag, slipped the strap over his shoulder, and trudged down toward the beach.

He could see everything was well organized at the hotel. The hotel itself was ransacked and already falling apart, but beside it a new building was taking shape. All around, old things were being torn down and new things built from them. Now there were other leaders besides the *kahuna*. Everyone was busy.

Just beyond the shadows of the wilting ironwood trees, Mitsumo walked out onto the beach. The ocean desert still stretched before him, but it too was changing. Its color was now a dark crusty brown. The bright red and pink hues had faded as the sun's hot rays baked the ocean floor. He remembered his thirst, and his throat made a scratching sound as he

GOLF
by Lepas

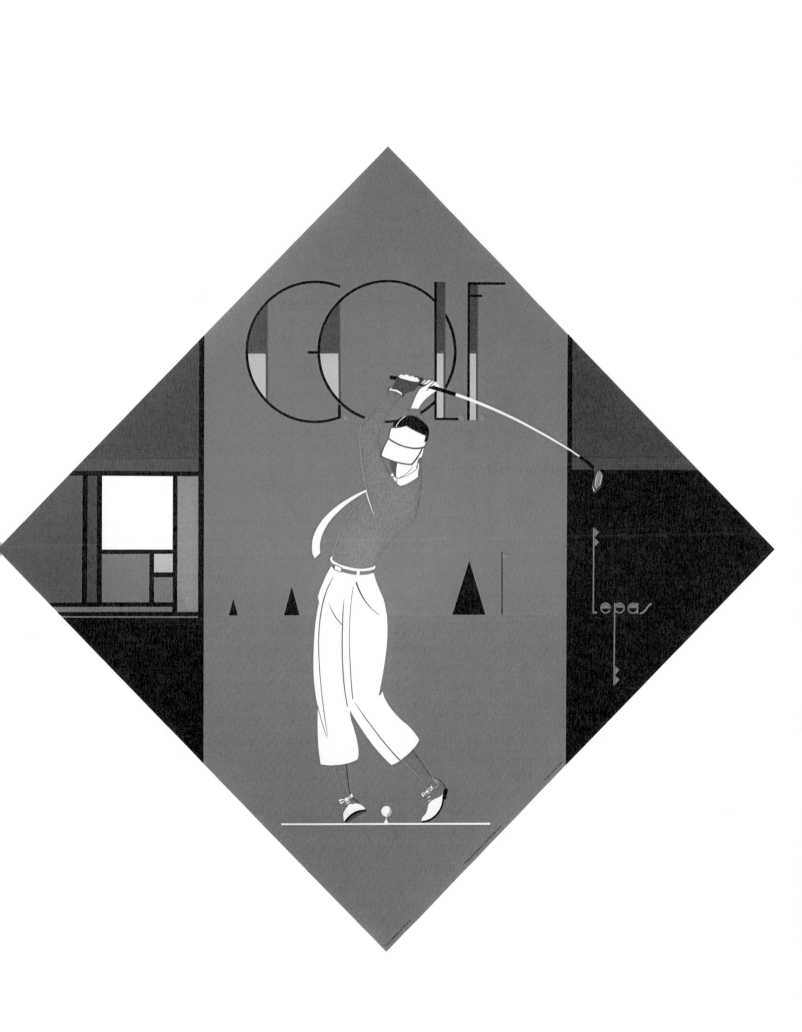

tried to swallow.

He frowned and re-adjusted the strap on his bag, then began to wander along the edge of the beach. There were others along this way, most of them busy digging wells and building shelters. A few sat motionless in the sand, staring silently at the brown plain stretching toward the horizon.

Soon Mitsumo grew tired of walking. He laid his bag in front of a shelter made of driftwood and dead pandanus leaves. In the entrance stood a girl with long raven hair.

"You look weary," she said. "Sit down and rest." When he sat in the shade of the pandanus leaves, she smiled and offered him water in a small hollow gourd. He shook his head. "Please," she said, and pushed the cup into his hands.

He felt his dry thirst disappear as he drank. The water was sweet, and he lay back in the shade of the shelter, feeling a cool release from the heat outside.

"That's better," the girl said, smiling softly. "Is everything all right now?"

The fairways will never survive the sun, he wanted to say, but lying there in the cool shade he felt his body beginning to relax. It was peaceful here in the shelter. "How do you survive here?" he asked.

"Someone always comes along," she said cheerfully, and gave her hair a toss. Mitsumo noticed the soft curve of her shoulder as she moved closer. "Don't worry," she assured him. "It's safe here; relax and feel good." Mitsumo nodded; it was good to forget about the outside for a moment. "Don't worry," she repeated, and for a time he thought of nothing as her hair brushed lightly over his arms and chest. "That's better," he thought he heard her say later, but her voice was growing indistinct. He lay quietly, watching the curving line of her raven hair fade into the darkening shadows of the shelter. After a while he closed his eyes and slept.

He dreamed of a single beautiful shot, the best he had ever struck — arching so high above everything that only the spinning white ball itself was visible.

He awoke feeling thirsty. He could see nothing at first. It was dark and his vision was blurred. Then slowly his eyes focused, and a single bright figure stood before him — the *kahuna*.

"Come out into the light, Mitsumo," he said. Uncertainly, Mitsumo crawled out from the shade of the pandanus leaves onto the beach where the bearded *kahuna* stood, his eyes blazing bright as the sun. "Look!" he commanded, pointing beyond the beach.

Mitsumo squinted into the glare. The scene was the same — a vast ocean desert stretching all the way to the horizon. "You look upon the world as it exists," the *kahuna* said. "No night, no sleep, no dream can replace this fact." Then the fire in his eyes dimmed and his voice was kind. "We must all labor to survive, but there is relief for those who earn it. Join us."

"Or stay here if you wish."

The voice came from the shelter. Mitsumo turned to see the raven-haired girl emerge. She stood in the entrance and smiled invitingly.

"No!" the *kahuna* urged. "There is no time to waste — join us now!"

Mitsumo shook his head. "I should do something," he muttered. But it was all so confusing.

"Do what feels good," the girl urged softly.

"Do your part," the *kahuna* said.

Mitsumo said nothing. He felt thirst scratch at his throat again as he turned away from the girl, past the anxious eyes of the *kahuna*, back toward the hollow expanse of the vanished sea, miles and miles of emptiness fading into a uniform gray in the brilliant heat. A thought startled him: What if *everything* disappeared? He frowned and began to look around for his bag.

He found it lying on the sand a few feet away. He said nothing as he removed his seven-iron and hurried on past the astonished faces of the girl and the *kahuna,* past the fallen line of ironwood trees toward the practice tee. He did not look back.

The fairway grass was dead now and the yard markers had disappeared, but Mitsumo knew the place where he had struck so many shots. In the distance the mountains of Kauai were crumbling into dust. This time Mitsumo had to search for the usual object of his gaze. The bold profile of his old friend had flattened into a tiny wrinkle on the featureless plain. It's going to be difficult, Mitsumo thought, noting that soon there would be nothing left, no criteria to judge against.

He laid a ball on the bare earth. The heat was growing more oppressive by the minute, but Mitsumo paid no attention as he assumed his stance, addressed the ball, and carefully, lovingly, took aim at the Giant's eye.

THE HAPPY HACKER

There is No Triumph in Golf — the
Proper Attitude is to Forestall Disaster

by Jim Bishop

One of the frauds of history occurred when the Scots referred to golf as a sport. These are the dour folk who squeezed a bagpipe and called it music. Golf is no closer to sports than being hanged out-doors is a reliable way of getting a tan. The game, as it shall be called hereafter, consists of a hundred or more neurological spasms — called shots — involving the use of 14 clubs and a dismaying number of white balls over, on and under a landscape of 18 holes.

A true sport involves skill and the avoidance of one major disaster. In football — fumbling; in bowling — the gutter; in boxing — a head hunter; in tennis — the net; in baseball — a called third strike; in hockey — murder; in basketball — a foul. In golf almost everything the player does falls into three categories — slightly wrong, wrong and disastrous. The player who executes good shots is referred to scornfully as a hustler. It is the only game in which a degree of excellence elicites contempt.

The basic truth is golf is the only game in which the player is not permitted to see what he is doing. He must continue to look down after he swings. The rest is up to the ball. It can stop in the fairway (a likely story), rough, woods, trap or lake. With five options, what ball will elect to fly straight?

The hacker dreams of relaxing as though, in golf, lassitude will cut 10 strokes from his game. *Au contraire.* He who relaxes is a ruptured pigeon. Good players find that a mixture of equal parts of tension, hatred, and self-loathing insure a good round. It is not only permissible, but desirable, to despise the course, the ball, wives, children, and weather and the score.

The secret wish of hackers is to walk up and hit the ball like Julius Boros. This, in my set, is called no-think. You grab a club, keep your intellect scrambled and take a whack at the pill. The result of the no-think hit is a no-lie landing.

The woods are full of home-run hitters. Much can be said for the long hitter, but not here. I have been told that there is a psychological relationship between the long ball hitter and his sex life. The better he is at one game, the worse at the other. I have no proof of this canard.

The men I play with are still looking at women. They peer into tennis courts and stare admiringly at young women who can't bounce a ball 30 yards off the tee. Those who miss a putt and stare heavenward murmuring: "Why me, God?" will see a flashing pair of slender legs and mutter: "Why not me, God?"

After 30 years of penance, I am certain that most of us entertain the wrong philosophy. We go out to win. There is no triumph in golf. The proper attitude is to forestall disaster. Fear is an important element. Only the naive play to have fun. Nobody laughs after watching a two-foot putt glide eight feet beyond the cup. Or watching the next one stop three feet short.

When the Danny Thomas Open was played at the Presidential Course of the Diplomat Hotel, at least 4,000 people paid to watch it. Two were on crutches.

The pro-celebrity was a unique affair. The sucker had to donate $2,000 to Danny Thomas' favorite charity in order to play with a celebrity and a professional. An abysmal hacker from Grosse Pointe gave his check to play with me (left-hander, playing in sneakers) and Chuck Courtney, who was 6-feet-3, 120 pounds out of San Diego.

We hit off, Courtney's shot went down the middle 270 yards on a par five. My shot, a tremendous swipe, stopped in the left rough behind the ladies' tee. Grosse Pointe tapped his driver to the right rough. The day was sweaterishly cool, but Grosse Pointe and I perspired. We got out of a bad situation in three apiece. Chuck Courtney was on in two, eight feet from the stick. I was in a bunker to the left in seven; Grosse Pointe was in the one on the right in eight. I began to feel slightly snobbish.

Courtney stood on the green, holding the pin. It was unfortunate that Grosse Pointe and I tried to come out of opposite traps at the same time. It wasn't intentional. He used a seven wood; I hit a putter. Courtney acted as though he had been killed. The balls didn't touch him. They whizzed by his ears on opposite sides of his head. He began to mutter the name of the Lord. Perfection cannot endure the slightest imperfection.

The match was slow and painful. There was a fat lady marshal who charged us a stroke every time a ball slid into a lake. Another for every time we tapped a ball out from under a low branch.

At the 16th, Chuck Courtney smiled sweetly. "Ever play this game before, Mr. Bishop?" he said.

"Oh," I said, "about 25 years." He nodded back toward Grosse Pointe, who was threshing weeds looking for his ball.

"Is it true he's a rich man who paid $2,000 to play with you?" I nodded. "Then tell me," he said, "how come he spends 20 minutes looking for a dollar ball?"

Once Sam Snead was listening to Ted Williams while sipping a drink that was on a stranger's check. "Sam," he said, "you use a club with a flat hitting surface and you belt a stationary object. I stand up there with a round bat and hit a ball that is traveling toward me at 90 miles an hour — and curving."

"Yeah," said Snead, popping his peanuts, "but you don't have to go up in them stands and play your foul balls."

My wife tried golf. I bought the bag, the clubs. She played the ball like a ceiling fan in an old southern hotel. She is also a non-drinker. When we got off the course, she ordered a triple vodka and tried to light a pack of cigarets with a beer can.

A man named Dick Brooks wrote about golf. He claims that a man, standing up to a ball armed only with a club, undergoes shortness of breath, tightness in the chest, curling of the toes, back ache, clenched teeth, locked knees, muscle spasms and paralysis. In sum, he's ready to hit.

A neurologist might understand golf. The game, philosophically, involves a plethora of twanging nerves and a small amount of skill. The good golfer feels miserable all the time. He drives over hill and dale armed with 14 weapons. Each is designed for a specific distance and loft. Does he use 14? Nope. He has convinced himself that he cannot use six; they have betrayed him many times. Does he leave the bad clubs at home? Nope. They *grow* old in the bag.

Players who walk around the locker room with a towel on the shoulder and a grin on the kisser are masking the misery of the putts which died on the lip. Or the wedge shot which almost cleared the trap. Or the bounder which needed but one more hop to get across the lake. Some are not aware that they are grinning. It amounts to an assortment of wrinkles the wretch has pasted on his face. I feel no sympathy for the jerk who says: "It was nice and sunny today." He fools me not. That man probably shanked a putt.

It has been said that insanity helps a player. This is not so, because a psychosis indicates a warped mentality. A golfer can lower his handicap if he has no intelligence. If he thinks like a chimpanzee and hits like one, it is not necessary to look like one. He will be hard to beat because he doesn't understand disappointment.

He will hit a wood out of a sand trap and pick it clean. He will whack a putt too hard and it will hit the back of the cup, bound upward and fall in. This is precisely why no human has ever mastered golf. Nicklaus didn't make the cut in Hawaii. Why? He was caught thinking.

At present there are about 22,000,000 hackers in this nation. There are almost that many wives who think their husbands are out there having fun. Any duffer who comes home claiming that he enjoyed himself has either just played his first round, or his last.

HOOKED
by A.B. Frost

LOST BALL

Anonymous

He sat beside the silv'ry stream
 Beneath a shady tree,
Alone in sweetest solitude
 And reading peacefully.
And while he sat, his wandering glance
 Unwittingly did fall
Upon an unexpected sight,
 A little dotted ball.

He pick'd it up with interest
 And scann'd it o'er and o'er,
"A curious thing," he muttered low,
 "To find out here, I'm sure."
So in his pocket carelessly
 He dropped it out of sight
And turning to his treasured book
 He soon forgot it — quite.

The silence of that soft retreat
 Far from the madd'ning crowd
Was all at once disturbed by
 A voice both stern and loud:
"By gad," it said, in tones of wrath,
 "It came this way all right,
And I will find the blasted thing,
 If I stay here all night."

He hunted round, and as he glared,
 The man beneath the tree
Began to think it was for gems
 Or gold, he searched, maybe —
So nervously he cough'd, ahem!
 To let the other know
That he was there against his will
 And would be glad to go.

The searcher turned with startled air
 Surprised a man to see,
Who rose before him like a ghost
 Saluting nervously.
"Beg pardon," said the timid one,
 "I notice, sir, with pain,
You seem to be in trouble
 And search, alas, in vain!"

"The blankest luck I ever had!"
 The searcher snorted, mad,
"I play'd the first eight perfectly
 And now I'm lost, by gad!
My drive I missed, and then I sliced
 And right round here I fell,
O! blank the blank blank blanket thing
 My good score's gone to H—l!"

The timid gent was quite appall'd
 And rack'd his worried brain
To guess what prize this fearful man
 Expected there to gain,
For, on his knees, he puff'd and cuss'd
 Inspecting angrily,
Every bush and blade of grass
 Around that fatal tree.

At last the timid gent inquired
 In gentle tones withal,
If he, the anxious one, perchance
 Had lost a little ball?
And as he spoke he handed out
 The ball — then sure as fate —
He got a true description of
 A brain-storm — up-to-date!

OUT OF THE DEPTHS

by Tom Morrisey

Uncle Hank was delighted when he got the job as general manager at Coalton Fields. I was only nine at the time, but I remember the day he called to tell my father. It was, he said, his chance to "be his own man."

As it turned out, it was his chance to be the only man; Coalton Fields was a little nine-hole municipal course in downstate Illinois, and the term "general manager" was interpreted there as something including the duties of greenskeeper, starter, Pro Shop operator, short order cook and window washer. But Uncle Hank was working on a golf course and he was

OBSTACLE COURSE
by Gary Patterson

happy. I was happy, too; it only took about three days of pleading to convince my mother to pack me off to Coalton for a summer job as the shop boy.

It never occurred to Uncle Hank to ask what had happened to his predecessor. We should have gotten a hint, though, the day that two regulars came in after play, complaining that "another one of those holes" had opened up on the fourth fairway.

We went out to look and, sure enough, there was a gaping hole in the ground, just short of the 150-yard marker. Uncle Hank got a truckload of fill and dumped it in, but the hole looked as empty as before. We limed some white lines around the mysterious abyss to mark it as ground under repair, and made plans to get more fill the following week.

That night, it rained hard. The next morning, as I was walking the course, searching for fairway pearls, I noticed something awry next to the seventh tee. I looked for a long moment and then saw what it was — the big oak tree next to the tee was missing. It appeared that, in its place, someone had planted some low shrubbery.

I was almost on top of the "shrub" when I realized it was the top of the tree; the entire oak had dropped into the ground.

Even to a nine-year-old, this did not seem right. I went back to tell Uncle Hank what I had discovered, but never got the chance. Long before I'd entered the pro shop door, I'd gleaned six new words from the angry shouting within.

The shout*er* was Andrew McAddamms, mayor of Coalton, a man who considered Coalton Fields his private reserve. The shout*ee* was Uncle Hank, who was backed up against the handicap board, looking pale and bewildered.

After several minutes, we discerned that whatever had upset McAddamms lay out on the first hole, a diabolical 430-yard dogleg which the architect had obviously laid out first thing after a bad night. We unhooked the gang mowers from the old Allis-Chalmers, and set out down the left side, Uncle Hank driving the tractor and McAddamms and I clinging to the fenders. We were at the bend when we understood the mayor's discomfort.

There, in the middle of his fairway, was his brand new E-Z-GO golf car, resting at an angle usually reserved for the final moments of the Titanic. We stopped the tractor a respectable distance away,

and approached with elaborate caution. The back end of the E-Z-GO was poised precariously at the edge of a fresh sink-hole.

"How deep do you think it is?" I asked.

As if in response, the golf car groaned a little and slipped to a steeper angle. In back, one of McAddamms' custom-made Wilson woods slipped from his kangaroo-skin MacGregor golf bag and disappeared into the chasm, to be followed a second later by a resolent persimmon "thunk."

I learned two more new words.

Uncle Hank got a chain out of the tractor's toolbox and pulled the E-Z-GO to safety. Purple with rage, McAddamms got in and drove off, ordering Uncle Hank to fix the sinkhole problem "or else."

There was only one geologist listed in the Coalton Yellow Pages, and he didn't even have to come out to tell Uncle Hank what the problem was.

"Your golf course is built on top of an abandoned coal mine," he told us over the phone. "The shoring timbers have to be 70, maybe 80 years old. They'll collapse a little more every time you get rain. I'm surprised you didn't know — I already told this to the last fella that ran the course."

I was sitting on the pop cooler, the only cool seat in the pro shop, when McAddamms came in the next day.

"Well," he asked my uncle indignantly, "what are you going to do about *your* sinkhole problem?"

"There's only one thing that can be done," my uncle said. "We'd have to fill in the mine shafts. The problem is, I'm not sure how much it will end up costing."

"Why not?" the mayor snarled.

"The adding machine won't carry over that far."

This time, I picked up an entire new sentence, which described something I've long since decided is an anatomical impossibility.

Poor Uncle Hank was stuck between the sinkholes and a hard place. He could never fix the course on Coalton Fields' shoestring budget, and the mayor wanted Pebble Beach at Putt-Putt prices. The only thing to do was something a greenskeeper almost never does — pray for a drought. Uncle Hank did that, and started to carry around a dog-eared copy of *The Farmer's Almanac*, which he consulted hopefully at the slightest hint of a cloud. He arranged to

play a Monday-morning round with McAddamms, in hopes of a reconciliation, a move he soon regretted — it poured non-stop the evening before.

That fateful morning, we took the precaution of leaving the E-Z-GO in the barn. I went along as caddy, double-bagging my uncle's clubs and McAddamms' kangaroo-skin behemoth. I thought of the sink-holes and tried not to put my full weight down as we walked.

McAddamms' money had gone into equipment, not lessons, and the day dragged on into a torturous succession of quadruple bogeys. My uncle, worried as he was, managed to play his usual scratch game, which didn't help the conversation any. But things held up well until the ninth hole, a 100-yard "thank-God" par-three designed to lure duffers into plunking down three bucks for another round.

Even though Uncle Hank had the honor, he asked McAddamms to drive first. Armed with a 6-iron and a bad attitude, the mayor teed up a Top-Flite, waggled his hips for about 45 seconds, and swung.

It was his only decent shot of the entire morning. The ball climbed like it had turbo-props, hung in the air for a long moment, and then dove like a banshee for the green.

We heard something that sounded like King Kong after he lost his grip. All three of us sprinted up the hill. Uncle Hank got there first and came to a sudden stop atop the bunker.

We saw why when we got there.

The entire green was gone. Soaked to the saturation point by the previous night's rains, it had taken only the weight of the ball to get it to collapse into the weakened mine shaft beneath it.

"*Well?*" McAddamms snarled to my uncle. "What do you have to say about *this*?"

Uncle Hank just stood there a long moment, working his lips. Then he reached into his hip pocket, pulled out a little book, leafed through it for a few minutes, and began to speak in his quoting-from-a-textbook voice.

"In the case of casual or unusual hazards which remove the hole from play," he said, "such hazards not being in existence when the player commences the shot, the ball will be deemed to be playable on the nearest available surface, *except in those cases in which the hole is enlarged by the hazard, in which*

case the ball will be deemed to have been played into the hole!

"Andrew!" my uncle gasped. "You've just shot a hole-in-one!"

Any hint of anger evaporated immediately. The mayor began to dance wildly, and we pulled him away just as the bunker joined the green in the Bottomless Abyss. McAddamms and my uncle walked toward the clubhouse, the mayor promising unlimited access to municipal funds. They'd fix up the golf course, add a back nine, air-condition the club house, widen the practice range ...

The two celebrants were soon out of hearing range. I turned to follow them, and my foot hit something. It was Uncle Hank's book, lying on the grass where he'd dropped it in the excitement. Thinking it odd that he would just happen to have a copy of *The Rules of Golf* in his back pocket at a time like that, I reached down and picked up the little paperbound volume.

It wasn't *The Rules* at all.

It was a well-worn copy of *The Farmer's Almanac,* open to the weather predictions for the remainder of the month.

The forecast called for rain.

PEBBLE BEACH #7
by Jim Moriarty
(overleaf)

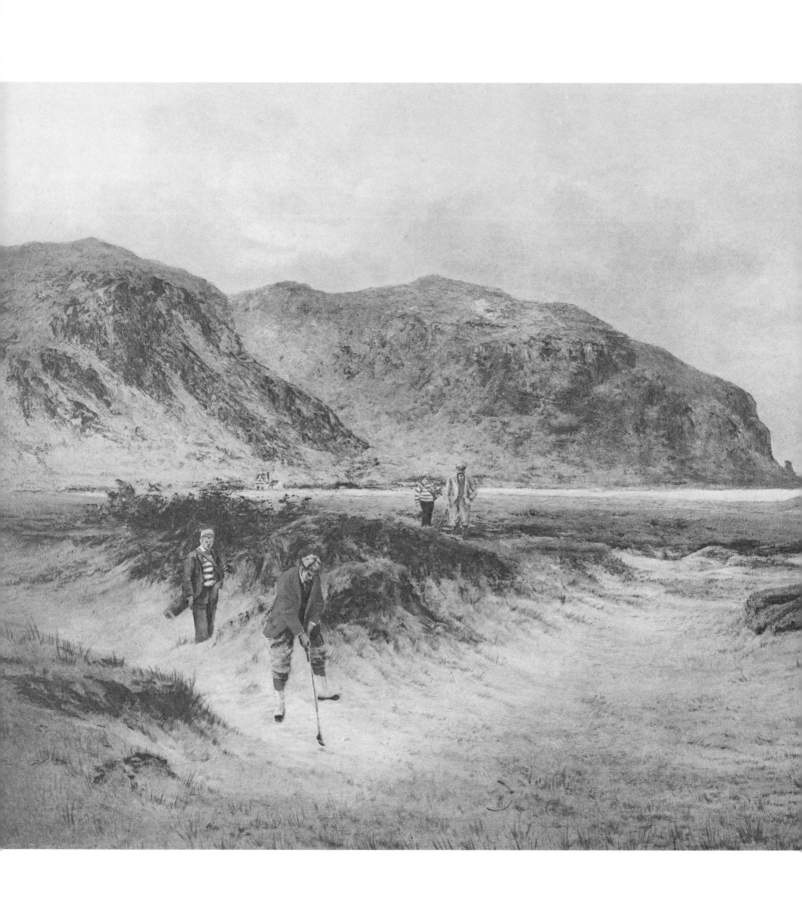

A Dude Game?

Philadelphia Times, Feb. 24, 1889

It is far from being a "dude" game. No man should attempt to play golf who has not good legs to run with and good arms to throw with, as well as a modicum of brain-power to direct his play. It is also, by the nature of the game itself, a most aristocratic exercise, for no man can play at golf who has not a servant at command to assist him. It is probable that no sport exists in the world to-day, or ever did exist, in which the services of a paid assistant are so essential as in this national game of Scotland. The truth is that the servant is as essential to the success of the game as the player himself.

All play must be done with the tools. In this, the caddie really gets about as much exercise out of the sport as his master, and he must be so familiar with the tools of the game that he can hand out the right implement at any moment when it is called for. If a player has succeeded in throwing or pushing his ball into a hole, his opponent must wait until he has succeeded in spooning it out before he begins to play. Obedience to this rule obviates any dispute as to the order in which a man's points are to be made ... If the ball is thrown beyond the hole, it must be returned to it and carefully spooned out again.

Spectators sometimes view games of golf, but as a rule they stand far off, for the nature of the implements employed is such that a ball may be driven in a very contrary direction to that which the player wishes, and therefore may fall among the spectators and cause some temporary discomfort. There may be as many as thirty spectators at one game, but seldom more, and a good game is frequently played without any at all.

The principal qualifications for the game are steady nerve and eye and good judgment of force, with an added ability to avoid knolls and sand-pits, which, in the technical terms of the Scotch game, are called "hazards."

It is not a game which would induce men of elegant leisure to compete in, but those who have strong wind and good muscle may find in it a splendid exercise for their abilities, and plenty of chance to emulate each other in skill and physical endurance.

A DIFFICULT BUNKER
by Douglas Adams

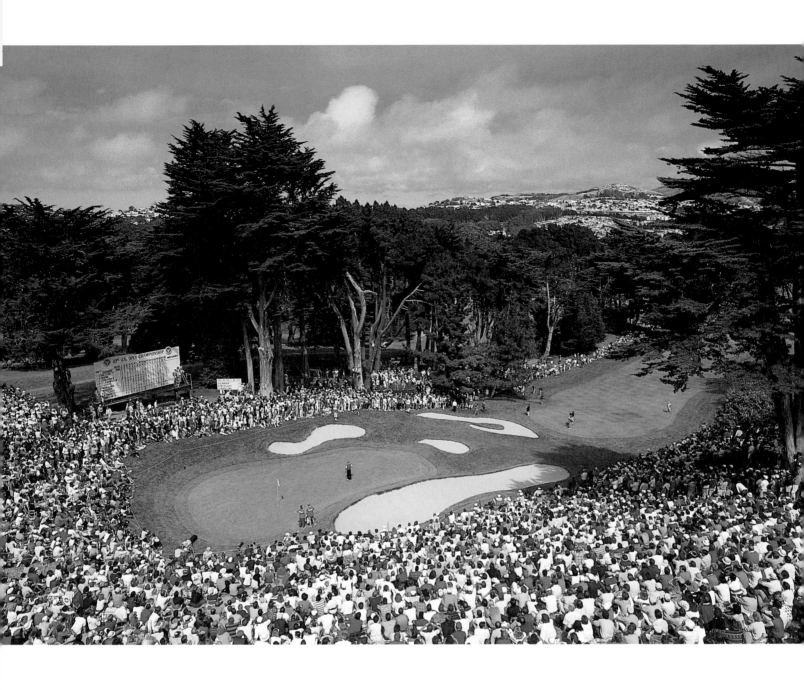

IN SEARCH
OF THE PERFECT PRO-AM

by Ben Wright

The perennial pro-am player is in many ways a strange animal, and definitely not an endangered species.

It has always amazed me, for instance, how many stiff and staid captains of industry are prepared, even eager to make fools of themselves in public on the golf course, a situation they would never allow to occur anywhere else. Men of dignity and business acumen when sailing through the corridors of power with a flock of underlings and yes-men in their wake become semi-paralytic when overcome by first tee nerves. Yet they will fall over each other in a furious dogfight behind the scenes to ensure a featured pairing alongside Jack Nicklaus rather than some unknown rookie, although they are fully aware of the almost certain consequences. Five thousand people will be clustered around the first tee to watch Nicklaus crunch the ball, while the rookie will probably start in total obscurity from the tenth tee in the company of his current girl friend, either toting the bag or pulling the trolley, and a couple of close friends. Of course any chance of our hero hitting even a halfway decent first drive evaporates under Nicklaus' baleful glare, while those 5,000 spectators, many of them incompetent golfers themselves, will chuckle and rub their hands with gleeful sadism as our man dribbles his ball along the ground, just reaching the ladies' tee. Naturally he could have taken the pressure off himself, and played an enjoyable, uncluttered game alongside the rookie in question.

But as a perennially masochistic pro-am player myself these past 30-odd years, I know only too well that, deep down in my heart, for reasons that defy logic, playing in pleasant obscurity is not what I crave. If I am going to suffer a round that will take the best part of six hours to complete, I want to rub shoulders with the best, and later show off the mandatory photograph of our illustrious group, duly mounted, to my children and grandchildren. I'll probably tell them how well I played, for good measure!

There is no guarantee that a pro-am will be a pleasant experience, even if you happen to play the best golf of your life. There is a thankfully small minority of famous professional golfers who have gained well-deserved notoriety for their scornful disdain of their amateur hacker partners, on whom their very living really depends. This short-sighted, brainless bunch is very much outnumbered by those who are only too aware of the value of pro-ams as a powerful public relations exercise.

I have since become a friend, admirer and commentating colleague of Tom Weiskopf. But this most magnificently elegant of world class players did not earn his nickname "Terrible Tom" for nothing. In early 1968 I was the pro-am guest of the long defunct National Airlines at their tournament at the Country Club of Miami to inaugurate their service between that city, their home base, and London. I arrived several days in advance, and worked diligently on my game, then played to a respectable five handicap. Poor Tom came down from the snows of Ohio, having just completed a compulsory period of Army reserve training. His game was very short of its awesome best. And for eight glorious holes I outplayed him into the greens, constantly hitting my second shot or tee shots much closer to the hole. Imagine my chagrin when, on the eighth green, with my ball five feet from the hole and on Tom's line — but his ball was 20 feet farther away — he hissed: "Putt your _ _ _ _ ball, and get out of the _ _ _ _ way." I promptly three-putted, quickly fell apart, and did not speak to Weiskopf for five futile years,

THE 87TH U.S. OPEN
by Jim Moriarty

having written about the incident in the *Financial Times* and *Golf World* magazine (UK). To Tom's eternal credit he apologized by inviting me to his intimate dinner party at the Marine Hotel, Troon, to celebrate his Open Championship victory of 1973 — a memorable evening indeed — and we have laughed about the incident several times since.

There are two more types of perennial pro-am players who continually amaze me. The first jealously guards a low handicap although his first swing tells his professional partner he has no earthly chance of playing to it, or even anywhere near it. As one world class professional golfer told me recently: "Before the end of the round, as his game becomes more and more unglued, this type of player will always look you squarely in the eye and say: 'I can honestly tell you this is the worst round I've played in 10 years,' or something to that effect. Can you imagine how many times he has to tell that story, and how many times I've heard it before?"

The vanity of this type of amateur golfer is obviously monumental. But I infinitely prefer his sadly deluded type to the cheat, or in American parlance "sandbagger," who checks in with a sixteen handicap, and from his very first practice swing shows his professional he is unlikely to drop more than half a dozen strokes to par. He rarely, if ever, does so. Of course there are high handicap golfers who enjoy magical days in the sun, and these are very often professionals at another sport, who are not mortally afraid and totally unhinged by playing in front of sizeable crowds, and who possess obvious ability at all ball games — natural athletes. To me there is nothing more enjoyable than being in the company of an obvious hacker who is playing way over his head, and is basking in the consequent euphoric glow. Goodness knows, such euphoria is destined to be very short-lived.

I well remember being paired with Charles Heidseck in a long gone American Express French Open pro-am. This elegant purveyor of fine champagne took his pro-am debut so seriously he went into a health farm for two weeks, did not touch a drop of his company's product, and took a lesson every other day. Hardly surprisingly Heidseck played well below his handicap in the company of an Irish professional who shall be nameless because he shot 86 in that pro-am, and had the courage to return that score rather than tear up his card. The elegant Frenchman obviously drew inspiration from his partner's travail!

Going from the sublime to the ridiculous, several years later I played in the Heritage Classic pro-am at wonderful Harbour Town Links on Hilton Head Island. When we set out in early afternoon a score of 22-under par (par is 71) had already been posted, and I remarked to my partner that it was hardly worthwhile going out in the face of such insurmountable odds.

To my astonishment one of my amateur partners replied: "Nonsense! We'll beat that score. You'll see." Five and a half hours later we brought in a score of 23-under par 48, and I fully understood why my partner had been so confident. Off an 18 handicap he had scored 75 off his own ball. Our professional, Lou Graham, the 1973 U.S. Open Champion and a true Southern gentleman from Tennessee, was so angry that he gave our sandbagger a stern lecture. And all we amateurs won was a box of a dozen golf balls!

My own pro-am experiences have embraced farce, tragedy, comedy and, on very few occasions the ecstasy of victory.

My first "major" pro-am appearance was in the old, long forgotten Bowmaker tournament at Sunningdale, England, in the company of the late, great Bobby Locke. I arrived hours ahead of my starting time, ever the neurotic, asked the caddie master for assistance, and was told my caddie was known as "One Tooth Jock." A giant, malodorous Scotsman in a too-long military greatcoat, cloth cap and laced up boots emerged from the caddie shed, the solitary fang in his upper jaw hanging over his lower lip. We made for the practice tee, where I flailed away for what seemed like an age with no comment, just an inscrutable stare from my companion. And then I made my fatal mistake.

"Do you need lunch before we go at 12:52?" I asked Jock. "Yessir," he answered with his first display of transparent enthusiasm. I handed him a five pound note, took my putter and four golf balls, and told him to meet me on the first tee at 12:45 by the clubhouse clock.

Needless to say, despite several appeals over the public address system, Jock failed to appear. My confusion was complete. Eventually the legendary Arthur Lees, Sunningdale's professional at the time, sent out a brand new set of clubs and accessories

and, totally embarrassed, we set out. We were walking up the hill from the seventh tee when I first heard the raucous strains of "Glasgow Belongs to Me," a famous Scottish ditty, and Jock heaved over the horizon towards us, stumbling dangerously, my bag of clubs slung across his chest.

"Where the hell have you been?" I asked One Tooth.

"Well sir," he grinned frighteningly through a haze of Scotch whiskey fumes. "I set off with this group, sir. And after we had gone seven holes and nobody had asked me for a club, I realized I was with the wrong foursome, and came looking for you ... "

The best pro-am partner I ever had, bar none, was Gary Player. In the 1974 La Manga Campo de Golf resort's pro-am played over 72 holes, the then-owner of that splendid southern Spanish facility, American entrepreneur Greg Peters, conceived the idea that the professionals should not record their individual score, but rather take forward that of their team's best ball. It was a praiseworthy attempt to foster cameraderie between professionals and amateurs, and with the exuberant South African it worked like a charm. Each team played with a different professional every day, and we drew Player for the vital third round in 1974 or, as Gary calls it, "moving day." So determined was Player to make the three of us play to the summit of our capabilities, he mostly ran from amateur to amateur to coach us on every shot. I don't remember what phenomenally low total we posted as a team that marvelous day — I think it was 19-under-par 53 — but it helped us to spreadeagle the field, and we won the event going away by seven shots with a record aggregate. And Player was the professional winner, hardly surprisingly.

The euphoria I experienced that magical day alongside the great Gary Player is unlikely to be repeated. But I keep on trying, and hoping. And I suppose that is what pro-ams are all about. They bring out the Walter Mitty in all of us hackers.

THE FLOWER HOLE #16
by Margaret Tvedten, 1988

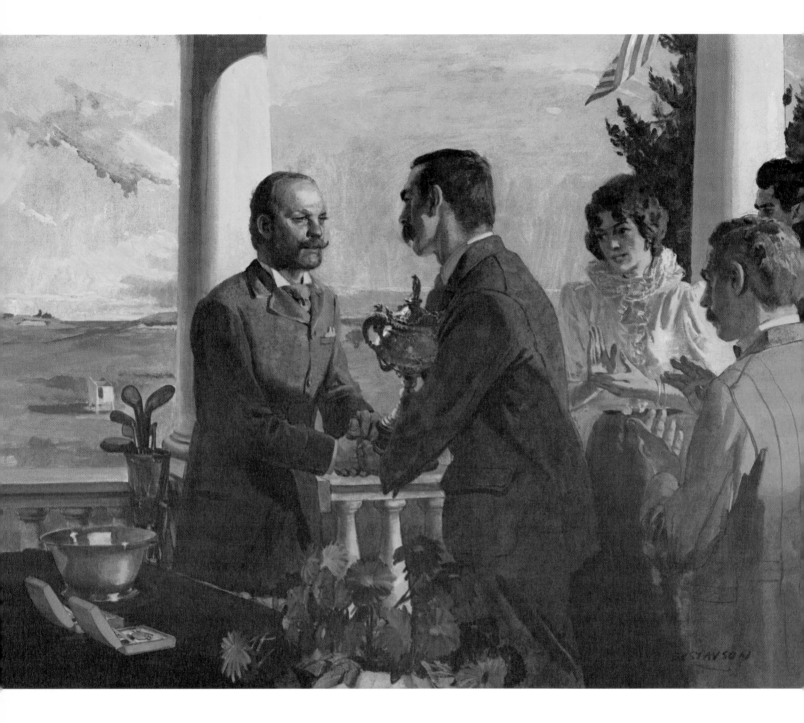

THE CONQUERING HERO

by Gerald Batchelor, 1914

The front door banged importantly, heavy boots came clumping along the hall, the Master staggered into the drawing-room and subsided with an assertive sigh of satisfaction into the softness of the central sofa.

"The day of my life," he beamed; "a red-letter day! Never have I played such sterling golf. ... I was in champion form! ... It was a regular exhibition match!" ...

The Mistress sat very upright, intent on her sewing.

"You didn't — "

"Yes, yes, I did," the Master broke in. "I won the Grand Championship Cup presented by our President, Count Ivan Offelitch, and valued, so I heard him say, at more than two hundred guineas. I keep it for six months only, of course, but just think how fine it will look on your silver table! ... Yes, I know you asked me not to bring home any more prizes because the servants object to cleaning any extra silver, but this trophy is fashioned out of solid gold, and — well, I don't mind giving it a rub over with emery paper myself now and then. As to the responsibility, I met a man to-day who is willing to insure it at reduced rates for golfers, for a sovereign or two a month. ... You really should have seen my play to-day. You would have been proud of me. Poor old Howker never got a sniff in the final. I was dormy four, but I so arranged it that I only won by a long putt on the last green. Doesn't do to break a fellow's heart, you know. Only a game, after all. Everybody was talking about me afterwards. You'd have blushed to hear their flattering remarks. I'd explain all about the match, only I'm afraid you wouldn't appreciate the beauties of it. Pity you don't play golf! The best part of it all is to come, though. As it was a holiday some of the members thought the visitors might like to have a sweepstake in the afternoon. The Secretary made the groundsman cut new holes during lunch, and there was quite a fair number of starters considering that the entrance fee was a quid."

"You didn't — "

"Oh, yes, I really *had* to go in for it. You see, it would have seemed so unsporting of me not to enter, after winning the Cup in the morning. Besides, I was at the top of my form, and I know the course so well that I could play it blindfolded. It would have been foolhardy to chuck away a chance like that. I know you don't like me to play two full rounds a day, but somehow I don't feel a bit tired to-night. I was eighty-three net, and just as I came to the last green I heard that some stranger had put in a scratch score of seventy-nine, but what do you think I did?"

"You didn't — "

"Tear up my card? Not much! I put it in, and the stranger was disqualified for breaking our local rule about dropping instead of placing his ball off a wrong green. Served him right for not knowing the rules, eh? My score was the next best, so here I am a winner of something like thirty pounds! ... Of course I must spend the money on something to do with golf or I should become a mere pro. at once. I stood a bottle of fizz to the other competitors, but I haven't decided what to do with the rest of the money yet. Perhaps I shall buy a piece of plate as a memento, or I may join that expensive new Club at Northsea ... or treat myself to a holiday at Le Touquet ... or Biarritz. ... *What* a pity that you don't play golf!"

The Mistress glanced at the clock, gathered up her work, and walked to the door.

"You didn't wipe your boots when you came in," she said; "go and do so at once."

And the Master went.

AWARDING THE FIRST USGA TROPHY, 1895
by Leland Gustavson

A CURE

Anonymous

A New York pastor received a call in his study one morning from a man with whom he had a pleasant but not intimate acquaintance. And the visitor told him, without much ado, that he had called on a peculiar errand.

"Some time ago," he said, "as you know, I lost my wife. I have no children, I have no near kins-people, and I am very lonely in the world. Last week, by an unlucky speculation, I lost my whole fortune. I am, therefore, without companionship, without an occupation, without money. I am too old to start again, and I have no joy in life as it is. I have deliberately decided, therefore, to commit suicide. And I called on you to ask the favor of you that when my body is found you will make such an explanation as your good judgment and kindly feeling toward me may suggest. I have come simply to ask this favor and not to argue the question, which I have settled for myself. If you do me this last service, I shall be very grateful."

The preacher said little, and was far too wise to undertake to dissuade him; but he permitted the man to say all that he had to say without interruption.

Then, as he was going away, the preacher called to him and said: —

"I have not seen you on the golf links for some time. You used to enjoy the game."

"Yes," said the other.

"Well, go out and play one more game to-day before you carry out your purpose."

The man smiled for the first time, and went to the golf course, and — he is living yet.

THE SABBATH BREAKERS
by J.C. Dollman, 1896

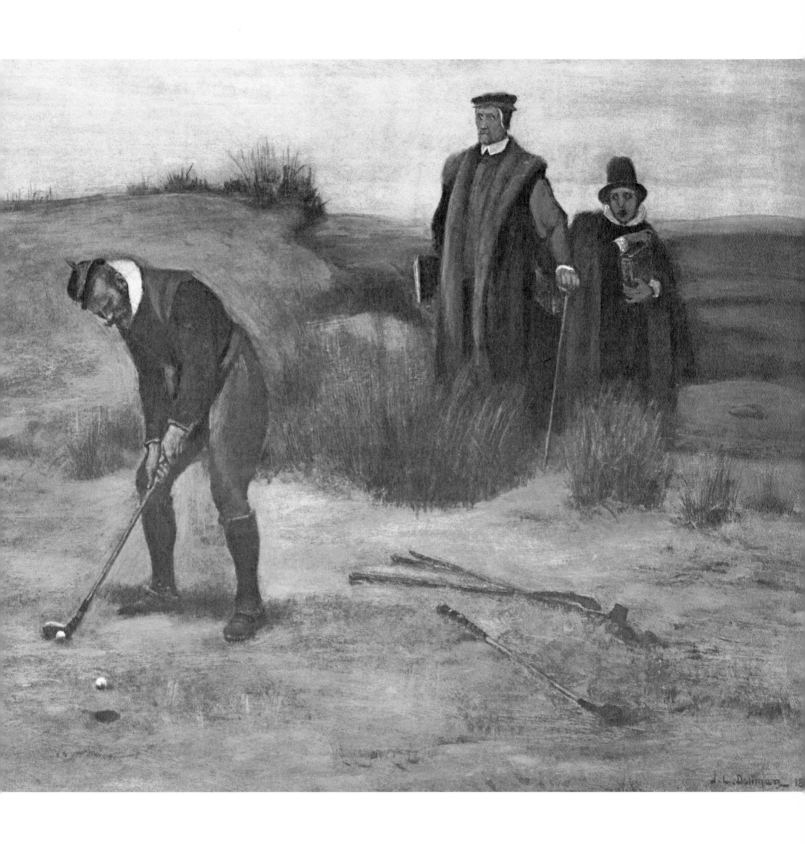

THE THREESOME

How I Disposed of Tommy

by Robert Browning, 1910

According to the definition, when two persons playing one ball between them contend against a third person playing his own ball, the match is called a "threesome." I explained all this to Milly on the way to the first tee. For on the principle that a beginner's enthusiasm is more likely to be encouraged by a real game than by any amount of practice, we had agreed that Milly's first lesson should take the form of a match between us two on the one side and her youngest brother on the other.

Milly was rather huffy at the start because I picked out the oldest and dirtiest ball I had got to tee up for her. But I know what ladies' golf is. You would think that they don't swing the club with any strength at all, and yet I have seen a girl, playing for the first time, cleave a brand-new Haskell to the mid-riff in a manner that Ivanhoe himself might have envied.

However, her first shot — I mean the first one she hit, for, of course, we were not counting misses — was such a rattling good one that it made her quite pleased again. We were on the green in two to Tommy's three. "Do you know," said Milly, as she held out her hand for the putter, "I think women, though, of course, they can't hit as far as men, should be able to do the wee shots on the green better." I admitted that a delicate touch was everything in putting; and pointing to a spot about half way between the ball and the hole, "You try and play it to there," I said.

Milly laughed — she had a particularly nice kind of laugh — and asked me if I thought she knew no more about golf than that. "Well, if you're going to play for the hole," said I, "be sure not to hit too hard. The ball flies off far faster than you are apt to think." "Oh, I know," said Milly, and played the ball straight for the hole. It was a longish putt, but I believe if she had hit the ball with just about one-quarter of the strength it would certainly have gone in. As it was, I was able to play the ball back on to the putting-green again with my next, but Milly's second putt was so timid that we had never any chance.

After that, we wrestled along pretty comfortably until the sixth hole, though Milly never came near repeating the success of her first shot. But at this point I had to help Tommy to hunt for his ball which he had lost in a patch of whin, and when I got back to Milly I found that she had played her ball and had not the slightest notion where it had gone. All that she could say was that she thought it was a pretty far shot, although she had "hit the earth a little too." However, we hunted for it in vain.

At last I suggested that we might have a better chance of guessing whereabouts it had gone if she would take us back to where she had played it from. Ye gods! she certainly had "hit the earth a little too." I would never have dreamed that so much strength lay in these slight wrists. For there lay a fine tough divot of about four inches by six, not taken clean out certainly, but folded over, for all the world like the lid of a milk-can.

"I don't think the ball would go very far, when you took the earth as heavily as that," I said, and stooped to replace the divot. Never was wisdom more quickly justified — for the ball lay underneath. All the same Milly need not have been so angry just because I laughed.

However, by the time we had played two holes more, and Milly was playing with so little heart that Tommy won both with ease, I saw that her enthusiasm for golf had pretty well evaporated. Yet if I suggested stopping I knew what a nuisance Tommy would make himself. It was a time for desperate measures. The way to the tenth hole is bordered by a fence on the right-hand side, with a stretch of heather beyond. I teed a brand new two shillings' worth before Tommy's gleaming eyes, and adopting the stance which Vardon recommends for the player who wishes to slice, I sent the ball curving gracefully well into the heather.

"Ugh!" said I, "there's small use in searching for it there!"

"You don't mean to say you're going to leave it?" — Tommy's youthful thrift was instantly in arms against such heedlessness. I explained that I thought it a bit too tiresome for Milly to wait while he and I hunted for a ball that we might never find. "But if you like to have a search," I added, as indifferently as I knew how, "you can hang on to it if you find it."

"Right-oh!" said he, "I've got my eye on just about the very place." And with that he was over the fence like a shot.

We left him still searching. But as I whispered to Milly on the road home round by the Lochan, "Two is a match, and a threesome is none."

INVITATIONAL

by Bob Dacey, 1987

A WOMAN'S WAY

by A.W. Tillinghast, 1915

"When a man acts like that there's only one thing to it;" and Jim Donaldson, commonly called the "Sage" at Cobble Valley, wagged his head wisely. "And if I could line out a brassey like that I wouldn't be playing alone, either," he muttered. Then he smiled contemptuously and sniffed in disdain as he continued to address himself; "But what are you talking about, you big mutt? Why if you could play at all you wouldn't be sitting here alone, waiting for the others to finish!"

Out on the course there stood a man. At his feet a number of balls proclaimed that he was practicing, while far away the figure of the retrieving caddie was proof that the efforts were not without merit. The golfer would carelessly reach for one of the balls with the head of his club, and tapping it away from its fellows he would allow it to find its own lie. Then quickly taking his stance he would drive it straight and sure almost to the feet of the distant boy. One by one the balls had been driven, but it was not the unusual length of the drives or the beautiful timing and power of the stroke which had caused the solitary figure on the veranda to wonder. He knew, as did everyone else, what Andrew Graves could do with his wood, and iron, too, for that matter. But Donaldson had been attracted by the alternating listlessness and vigor of this man, who on a Saturday afternoon had obstinately declined to join any of the matches; gone out alone for practice, and then after launching forth a series of screaming drives, manifested not the slightest interest in the results. It was while Graves was waiting for the caddie, sitting dejectedly with his elbows on his knees, chin between his hands and staring vacantly out over the course, that he first attracted the attention of the other man.

With the balls once more in his possession he attacked them as viciously as before, then throwing down the club, which had been serving him so well, he turned and walked thoughtfully to the clubhouse.

"Um-m-!" mused the Sage. "If our Mr. Graves hasn't come a twister over a petticoat, he sure shows all the symptoms. I wonder who's responsible? He dances with them all and he seems to be popular enough; about as popular as the scratch man ever can hope to be around his own club" (which observation shows how the Sage came to be called such).

"How is it you're not playing, Andy?" Donaldson inquired as the other mounted the steps and slid into the chair by his side.

"Oh! I don't quite know, Jim," Graves answered, carefully selecting a cigarette from his case and lighting it with the last half-inch of match. "Not feeling very fit today."

"I suppose that's why you had that boy running his legs off trying to catch up to some of those brasseys of yours. Honest, Andy, you ought to be arrested for hitting balls that hard — and in front of me, too. Why, I remember that once, years ago before I gave up the game to become a sort of shepherd to you boys, I hit one ball — just one, remember, — once, almost as far as the only one you sliced out there, and I scarcely spoke to anybody around here for two days.

"The trouble with you champions is that you get so used to championing that you gauge your physical condition by the scores you make — a 74 and you're nearly normal; a 76 and you commence to worry about your appendix; but 80? Horrible! That proves that you're sick enough for bed and a trained nurse. Don't you ever talk to me about being 'fit' and then maltreat golf balls like you've been doing this afternoon!"

Graves laughed good-naturedly, but his eyes wandered over to the drive, where a smart little runabout was gliding through the gateway. It might have been only a shade of annoyance that fleeted across his face, but the Sage saw it. He did not turn immediately, but he made this mental note: "The cause of today's unfitness is at the other end of that flash."

Graves arose immediately as the car stopped and the Sage turned in his chair to see the arrivals — a girl and a young man. She was pretty, bewitchingly pretty, but there was none of the wax-doll about her as she sprang from the car, up the steps,

and stopped before the two men.

"Hello, Andy!" she exclaimed, holding out her hand, then turning she greeted the other, "Good-afternoon, Uncle Jimmy! I hope we haven't broken into one of your profound discussions. Do you know Mr. Hodge?" She indicated her companion, who had shaken hands with Graves. "My uncle, Mr. Donaldson."

As the Sage greeted his new arrival he noted that he was good-looking, and he said to himself, "Here's the fly in the ointment!"

Betty Pringle was not only pretty, but it would take only a moment for one to agree with her uncle that she was "a regular fellow." Not that she breezed around in hoydenish fashion, but she possessed that vigorous something which veils the feminine without cloaking it with the slap-bang of mannishness. She golfed moderately well; played tennis better than most girls; rode a horse irreproachably, and drove a car with supreme confidence; but this same Betty seated at a piano would cause the listeners to sit silently until the last lingering note of Chopin or Mendelssohn had died away, or as her fine contralto gripped and swayed them — hear the echo of the song in themselves.

"Why don't you two boys have a round while I sit here and chat with uncle," exclaimed the girl.

The two glanced at each other keenly, and in the glances the Sage detected challenge. "I'm quite agreeable," assented Graves, and Hodge, starting off for the locker-room, shot back: "I'll be with you in a moment."

After they had gone Donaldson looked at his niece and chuckled. She raised her eyes quizzically, and meeting his, smiled in spite of herself. The Sage had read her like a book.

"Well?" he queried.

"Well, what, Uncle Jimmy," she parried.

"Who is he?"

"Mr. Hodge? Oh! he's a Westerner. I met him in the Spring at the Brice's house-party. He's visiting the Newtons in Homesburg just now. Why? Don't you like him?"

"Sure! He looks all right. Seems to be a fine, manly fellow and I imagine he would improve on acquaintance. Why did you sic him on Graves? Can he play golf?"

"Scratch man in the Western," tersely explained the girl, then in a burst of confidence, "See here, Uncle Jimmy, you've been the best pal I ever had, and I don't intend to beat around the bush. Did you ever know that Andrew Graves asked me to marry him?"

"No, Betty, I never did." The Sage regarded the girl gravely. "I never suspicioned that he cared more for you than any of the other boys. He's a fine fellow, my dear! Do you like him?"

"Yes." Her blue eyes were looking straight into his and she went on determinedly. "Yes, Uncle Jimmy, I like him tremendously, but — "

"But Hodge, eh!" interrupted Donaldson. "Let me finish for you. You met him and you liked him, too. He's here in Homesburg because you're here — probably raked up some old friends like the Newtons as an excuse. Where there's a will there's always a way, you know.

"Now, Betty, here's where your old uncle gets off. He's been a sort of court of appeals for you ever since you were a wee toddler. When you broke your doll you tearfully brought it to Uncle Jimmy, knowing that either he would fix it or produce a new one. Do you remember when you had the mumps, then the measles, and afterwards the fever, how I used to sit for hours and read to you? First from 'Mother Goose' then Grimm's fairy tales and later from the other books that girls love. You could always depend on your Uncle Jim, but now you've got me stumped. This game you've got to play out for yourself. Of course, I wouldn't let you make a mistake if I could help it. Andy Graves is as good as they make them, and Hodge looks right. It's up to you."

Betty's hand had sought her uncle's, and as he finished she patted his arm affectionately. "I know it, dear, but you can help me. I've thought it all out." She looked up suddenly, "They play for Marsh's Cup next week, don't they?"

Donaldson regarded her in surprise. "Certainly," he replied, "but what's that got to do with it?"

"Just this. It looks easy for Andy, doesn't it? Mr. Rattray is away, and he's about the only one at Cobble Valley who could hope to stand a chance with him. That's true, isn't it?"

"Yes, Andy's got it nailed down tight, barring accidents."

"It's an invitation tournament?"

"Yes."

"Include Mr. Hodge, then, won't you please, Uncle Jimmy?"

"But, Betty!" he exclaimed, "you don't mean to say that you would want to have a serious matter like this decided by a round of golf?" He laughed uneasily. "Why, the days of tilts for milady's favor are over, and knights — "

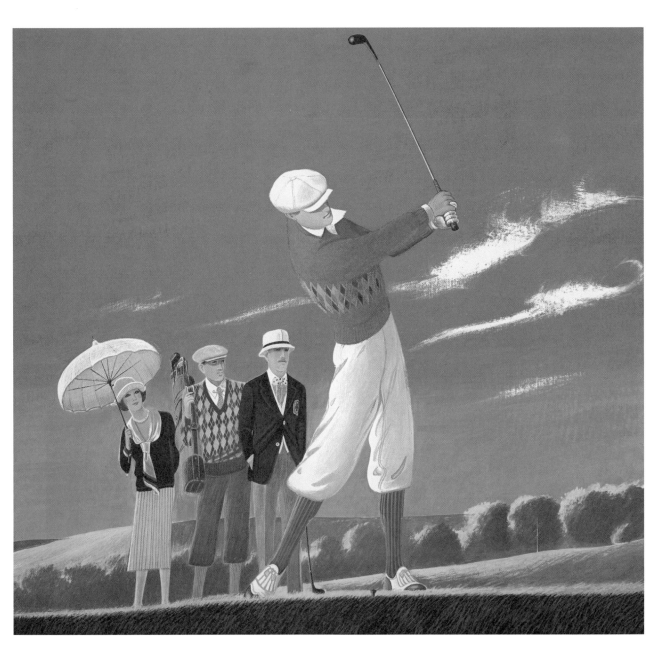

"Don't laugh at me, please," she pleaded. "It's just a little foolish of me, perhaps, but I do want it that way. I want to see them both under fire."

"Well, I'll be — forgive me, Betty. I'm out of it. Certainly I'll get Hodge an invitation. It's your game."

◆ ◆ ◆

What was it that Bobby Burns said about "the best laid schemes o' mice and men?" But the plot of Betty Pringle did not miscarry. Hodge came through one bracket with ridiculous ease and opposed to him in the final was Graves.

His play proved that Hodge was a magnificent golfer, and his every stroke was crisp and vigorous. Clubhouse opinion was equally divided and the betting was at evens. Never had Cobble Valley turned out such a gallery as on that Saturday afternoon. Motorcars were parked everywhere and the clubhouse veranda was alive with the colors of dainty frocks, and buzzing with conversation. Here, there and everywhere darted Betty Pringle, and the Sage, seated in a quiet corner, followed her energy with curious eyes. He had not been able to fathom this queer whim. Could it be possible that this girl, whom he had loved from the time she was able to toddle up to his knee, was about to hazard her very life as would a gambler staking his last dollar on the turn of the wheel. The Sage could not understand.

When the players came out on the veranda and the club-rooms slowly emptied as the crowd prepared to follow, Hodge chatted gaily with Betty for a few moments, and the Sage observed that Grave's

GOLF
by Chuck Wilkinson

jaw was set hard as he saw them together. Then the girl sought him. "Good luck, Andy!"

He looked at her earnestly, almost pleadingly. "Do you want me to win, Betty?"

"I want you to show all you've got in you this afternoon," she answered slowly. "Go to it!"

Two long, raking drives brought murmurs of approval from the crowd. There was little to choose and two equally fine irons found the green — a pair of fours. There was no suggestion of nerves in the strokes of either man, and the gallery, scenting a struggle, prepared for it. The first four holes were halved, and there had not been a single loose stroke displayed. At the fifth Graves laid a long brassey within ten feet of the cup and holed the next one. He kept his lead to the turn, but Hodge squared the match by laying a finely hit chipped approach, stone dead on the tenth. He secured the lead with a remarkable putt on the thirteenth, but Graves came back hard on the very next one. The drive that he hit there is pointed out to incredulous visitors, and he was home with his iron. Hodge couldn't quite get there with two from his wood and the match was squared.

Coming to the seventeenth Graves was one up, and he took his stance in that dead silence which always falls over a gallery when the situation is tense. A man lit a match and it sounded almost like a pistol shot, but Graves gave no heed to it. Looking over the course, he prepared to swing, and with beautiful deliberation the club went back.

"Ker-choo-o!" from the back of the gallery came a sneeze, but all eyes followed the ball. All eyes but two. The Sage knew.

There had been no stopping of that swing, but the flinch was there, and the ball, sliced badly, found the pits and the hole was lost — all square.

"Why?" the Sage asked himself. "Why had she, of all others, been the one to deliver that blow?" He had been watching her throughout, trying to fathom her thoughts, and he had seen her time that sneeze to Graves' back swing. It seemed cruel to him, and the thought of his little girl stooping so low cut him like a whip-lash.

At the home hole some of the gallery scattered along the fairway, but most of them lined up by the teeing ground. Betty Pringle was walking deliberately to the clubhouse, far in advance; but she stopped and stood aside as a "Fore!" came booming over the course.

Hodge drove, and it was a beauty. Then Graves hit out a terrific ball, but it left the fairway and ended in the rough. On came the players; on trooped the gallery. The caddies searched; the players searched; the gallery searched, but without success.

Finally Graves spoke: "See here, Hodge, we can't hunt forever. The rules give me five minutes, and I'm sure we have gone by that limit. It's a lost ball." And walking over he grasped the hands of his opponent, "It's your match, — I congratulate you!"

His voice was even and his action free of any semblance of displeasure. He was taking his medicine without making any faces over it.

As they walked to the clubhouse Betty warmly congratulated Hodge, and then turned aside to greet the loser. "Tough luck, Andy! I'm truly sorry." Her eyes searched his face as he smiled back bravely. "Thanks, Betty. It was a tough match to lose, but it's all in the game!"

◆ ◆ ◆

That evening a little runabout slowly found its way through the Cobble Valley gate and disappeared in the shadows.

"Andy?"

"Yes, Betty."

"Do you remember asking me something two weeks ago?"

"Yes; yes, of course. Why, Betty, I'll never forget that," and his voice was eager.

"Oh! Andy dear, do you still want me?" was the plaintively eager question.

His arms were about her and his voice choked, "God bless you, my darling."

The little car moved along quietly in the shadows.

"Andy!"

"Yes, dear!"

"Do you know I'm an awful sinner? Listen, dear! Do you remember somebody that let out an awful sneeze this afternoon? That was I! And, Andy, if you'll put your hand in my coat pocket you'll find the ball you lost on the home hole — I was standing on it all the time!"

His arm tightened around her. "But why, dear?"

"Well, you see, Andy, you always have been a winner — and it's so easy to act the winner's part. A man doesn't have to try very hard to smile when they hand him prizes — it just comes natural.

"But he does have to have the right sort of stuff in him to take his beating without crying about it. I hoped you had, I thought you had — and now I know it, dear."

And the little car went chugging on through the shadows.

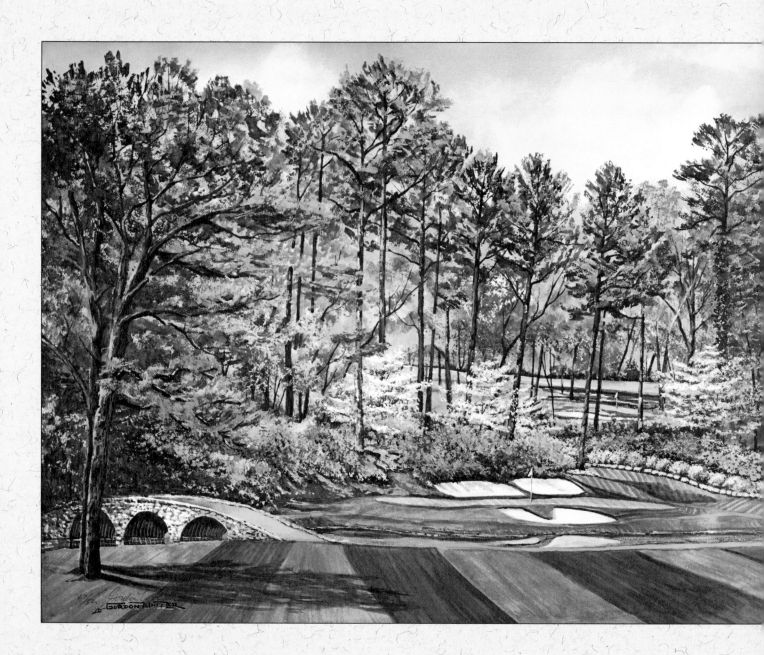

AUGUSTA NATIONAL #12
by Gordon Wheeler, 1989

GRANDEUR

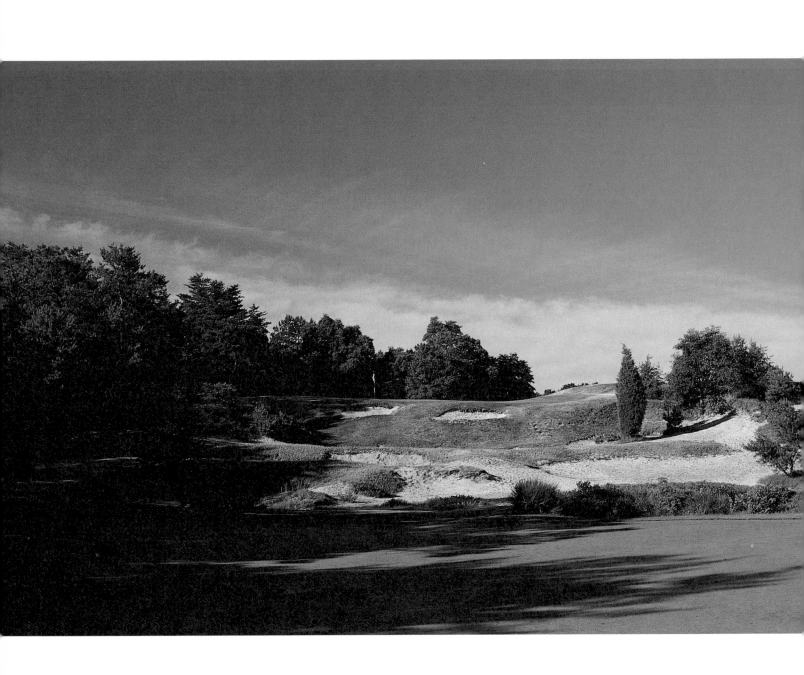

MAKING THE SHOT, TAKING THE SHOT

by Jim Moriarty

Photography and golf are strikingly similar art forms. Both are precise and mechanical. F-stops and shutter speeds. Chemical equations and reactions. In golf the left hand goes here, the right hand there. We're parallel at the top and biomechanically engineered throughout. Yet neither golf nor photography achieves anything until it surpasses its craft and becomes its own creation.

What was it Mark Calcavecchia said about the 4-iron shot he played to the 18th green at Royal Troon to win The Open? "I could have watched that shot forever." That's as much art appreciation as a sophomore standing in front of Van Gogh's 'Starry Night.' Did it have anything at all to do with weight transfer or footwork or grooves? Only in the same way that marble has something to do with the Pietà.

PINE VALLEY #2
by Jim Moriarty
(opposite)

16th AT CYPRESS
by Jim Moriarty
(above)

Photography is much the same. It is Everyman's artform. Who among us hasn't had the chance, at least once, to stand and watch our own 4-irons boring through the air curving inexorably toward the flag? And who doesn't have a photograph of their own framed and gathering dust somewhere that they regard (quite correctly) as a work of art?

What makes photography and golf difficult to raise to that higher level consistently is that both are so damn literal. In each, your shots tend to reveal what you've put into them. Sometimes a little less, sometimes a little more.

In photography what separates the happy accident from the consistent achievement is an elegance of light and a confluence of form. When you are fortunate enough to find those two ingredients, you simply push the button.

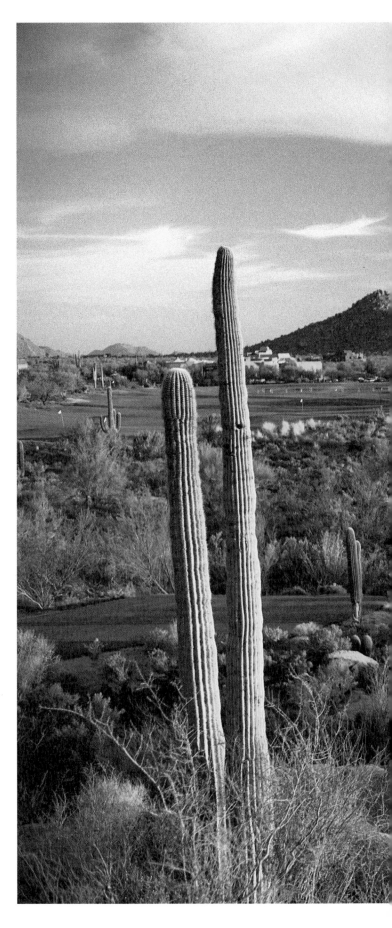

BOULDER'S 'SAGUARO' #9
by Jim Moriarty

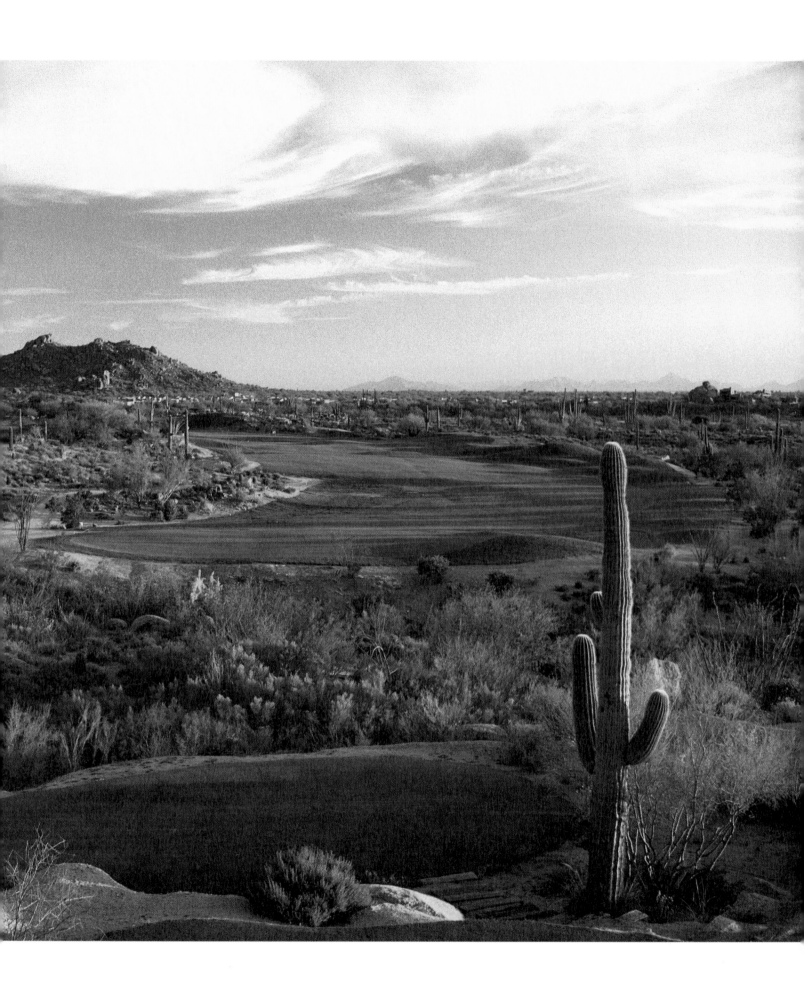

THE GREATER JOYS

by Audrey Diebel Collins

Although most serious golfers work arduously to rid themselves of such flaws, the hook and the slice have been known to introduce astonishingly satisfying new dimensions to the Sport of Presidents.

Chasing the little white ball that moments ago sailed screaming into the woods is a test of character that few willingly seek. Yet those who can choke back the string of four-letter invectives and make the most of their penalty strokes prove they deserve their club memberships.

There is, after all, more to the game than keeping your head down, your elbow locked, and your eye on the pin. Golf is not just a game of concentration, not merely a contest against the omnipotent par.

Think of it. How many times have you defended your sport of choice by extolling the virtues of fresh air and exercise? How many times have you fled the jangling of office telephones and the glare of fluorescent lights in favor of a leisurely eighteen holes?

Alright, so you find yourself knee-deep in the rough, a canopy of green above, a thick carpet of wildflowers below. Instead of telephones, you hear robins warbling. Want to really improve your lie? Wave the next foursome through and take time to smell the roses — or in this case, the newly mown grass.

If you're out early in the day, you may be lucky enough to see something really special. Perhaps you've always thought of it as the fairway. But when the morning sun slants across those dew-laden blades, a mere fairway is transformed into a field of light-struck prisms, each boasting its own minute rainbow. A simple spider web exposed to this magic becomes a glimmering tracery that would pauper the finest gems locked in Elizabeth Taylor's vault.

Ah, whoever said the game is everything? In golf, half the fun is getting there! And only half the challenge lies in the swing. The other half rests in enjoying the sensory treats pridefully built into vest-pocket urban courses as well as monster courses carved from acres of hilly wilderness.

That nasty tree your ball rests under may be birch, cedar, or oak. Could you tell which by running your hands over the bark? Most of us probably haven't given much thought to trees since our third grade teachers sent us out collecting leaves. Now, on an incomparable Indian Summer day, after the leaves have been sent into their autumnal oblivion and the winey smell of Fall wafts about your nostrils, think about trees again. Could you distinguish a beech from a cottonwood just by looking at the way the limbs spread out against a turquoise sky? And in springtime, have you ever noticed the riot of color brought on by the new green of the poplars set against the bright red budding of the maples?

Ever notice, after a rain, how the fragrance of balsam and fir saturates the air? No aerosol freshener spritzed around the board room can match bragging rights with the grove of evergreens out there on the back nine. No photo mural really does justice to an endless expanse of cloud-filled sky.

And what is that you don't hear? Right! Muzak! Top Forty! Heavy Metal Head Banging Rock and Roll. Instead, savor the sounds of chirping sparrows and sassy blue jays. Listen to the breezes and the silences that are crowded out of most of our days.

Why, with the right attitude, a golfer could even find something beautiful in the way spreading rings ruffle the surface of the pond when the ball takes a dunking in the water hazard.

Now that, you may say, is taking a good thing a bit far. Just to avoid argument, we'll agree in this last instance. We'll even say it isn't necessary to have blown your lead before you resort to fully enjoying the ambience that golf course architects spend millions of dollars creating.

Only golfers, after all, have the dual pleasures of a lifelong competitive sport and a playing field that is no less than an oasis in a dusty world.

So go ahead, work on whittling those strokes off your score. Just remember, you're a winner every time around when you latch hold of the greater joys of playing the game.

CANNES TRAVEL POSTER
Artist Unknown

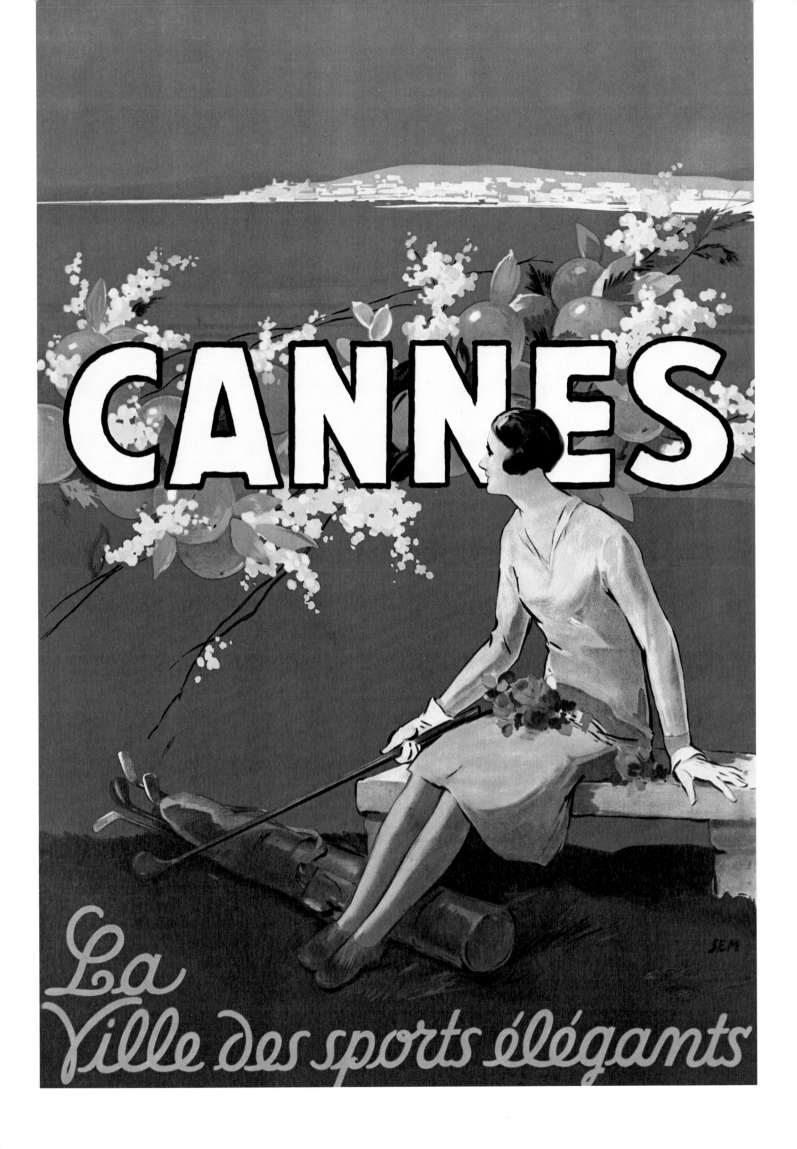

CRYSTAL AMONG THE GEMS

by Tom Stewart

By the year 2000, Northern Michigan will have solidified its claim as one of the Summer Golf Capitals of the world. With dozens of courses by architects Jones, Nicklaus, Palmer, Fazio, Doak, Newcombe, Diddle, Deskin and Matthews, the "Golf Coast" of Lake Michigan is visited by hundreds of thousands of visitors from around the world. Courses like The Bear, Treetops, Legend, Boyne (Alpine and Heather), Donald Ross Memorial, Monument, Wequetonsing, Hidden Valley, Belvedere, Schuss Mountain, Michaywé, Highpoint, Wilderness, Little Traverse Bay Club and Birchwood Farm draw players back each year to savor the blending of lake, land, mountain and forest.

But no tee time is more coveted than a round at Crystal Downs. Set outside the sleepy resort and fishing village of Frankfort, Michigan, Crystal Downs is nestled between Crystal Lake on the east and Lake Michigan on the west.

Founded in 1927 by Walkley Ewing of Grand Rapids and designed a year later by renowned architect Dr. Allister MacKenzie and his associate Perry Maxwell, the "Downs" easily fits among the elite courses of the world. For many years it has been Michigan's best-kept golf secret. Today, however, its reputation is widely known as golfers seek out its charm and challenge. In 1980 it was ranked in the top 25 courses of the world. As MacKenzie's genius has been honored and copied in recent years, his limited works of art have become a "must" in the portfolios of many serious golfers and designers.

The appeal of Crystal Downs is apparent at first blush. The winding drive up to the clubhouse gives magnificent views of Crystal Lake to the east and Lake Michigan to the west, as the course unfolds below.

Reminiscent of the Scottish region of its designer, MacKenzie, this course is an amazing amalgam of heather, gorse, mounds, bunkers and the traditional windy air from a nearby sea. The front nine is a "downs course" while the back nine follows the "North American Inland" style.

The property for the course was discovered by Walkley Ewing on a backpacking trip he had taken from Grand Haven to Mackinac in the early 1920s. He related that his first view of Sleeping Bear Dunes, the Manitou Islands, and Crystal Lake was "love at first sight." As he toured the Big Lake bluff above the present 18th green, Mr. Ewing admitted he "had never been so overwhelmed with the blend of land-and-seascape." Upon subsequent visits as a realtor, Mr. Ewing dedicated his efforts to preserving the integrity of the property, and the idea for a course was born.

Surrounding himself with four partners — Messrs. Merrick, Wallace, Van Raalte and Landwehr, Ewing set about to find an architect who would fashion a course commensurate with its surroundings. His search ended with the selection of Dr. MacKenzie, the Scot who was just finishing his work on the California Monterey Peninsula with Cypress Point. Though skeptical at first of finding suitable grounds for a course in Michigan, MacKenzie was persuaded to visit the property with his American associate, Maxwell, in the fall of 1928. As Ewing drove them along the coastal dunes approaching Point Betsie, MacKenzie, according to Ewing, "could hardly remain in the car as he began to image an outstanding golf course every few miles."

Ewing relates, "Crystal Downs created in Dr. MacKenzie an instant impression of near-perfection, and he delayed his sail back to London to design a course out of a spirit of obligation to the land." For their design services, MacKenzie and Maxwell were paid $5,000, and Crystal Downs was born. In addition to the Downs and Cypress Point, MacKenzie built many of the stellar courses of the world, including Augusta National and Pasatiempo in the U.S.; Royal Melbourne and Kingston Heath in Australia; Titirangi and Paraparam in New Zealand; the Jockey Club in Argentina and the Alwoody Links in England. The only other MacKenzie-designed course in Michigan is the superb University of Michigan layout.

One can easily run out of adjectives in describ-

ing the Downs, but perhaps longtime professional Fred Muller sums it up best when he says, "The course is a rare coming together of a magnificent piece of property and a genius architect at his best. It is diverse, natural and peerless."

MacKenzie's experience and service as a camouflage artist, which saved thousands during the war, was to instill in him the importance and integrity of natural undulation and roll. He did not like fairways or green complexes to look like croquet lawns. To create slope and grade, which he felt marked the character of his courses, MacKenzie studied the manner and process of how nearby dunes were formed.

The topography at Crystal Downs is a continuous roll from the highly elevated first tee to the pinnacled 18th green.

The Downs easily sports 14 "ideal holes," a rank which MacKenzie insisted must offer pleasure, beauty, test and continual variety. Crystal is not a "card and pencil" course where competitors can count on continual 3's or 4's, but rather is a true "sportsman's course" with a spirit of adventure in each hole. It is not an overstatement to say that

Crystal Downs is a thrill to play. Adrenalin shoots through the competitor's veins as one seeks to navigate the nuances of its character.

The layout of the course seems indistinguishable from nature itself. It appears that flags were simply stuck in the terrain at various intervals. Its magic comes from an ideal blending of balance, harmony and fine proportion.

A walk in print around a few holes of our subject course may give an added notion of its challenge and beauty.

Standing high on the first tee, one must drive long into a stiff, prevailing south wind to reach the green in regulation two shots. A second shot with a fairway wood or long iron must come to rest below the hole on this reverse-contoured green. Missed shots here will draw bogeys or higher to start the round.

The fourth hole demands another drive into the prevailing wind around a corner dogleg right, landing between tall rough left and horseshoe bunkers right. A long second shot must land softly into a diagonally running green that slopes from right to left. Hole five, at 353 yards, is a magnificent ridge

CRYSTAL DOWNS #13
by Tom Doak

hole with a divided fairway. After driving around the 3 Sisters bunker, one must loft a high iron shot to a green that slopes away and to the right.

The eighth is a magnificent par-5 at 550 yards. One must drive to a level portion of the fairway or be prepared to try and hit a 3-wood from a ball position above your waist. The hole climbs dramatically at the green and approach shots must be kept below the hole.

Making the turn toward the back nine, we climb to the tee of the eleventh hole. Driving through a frame of yawning oak trees, a player must hit a fairway wood or long iron to an elevated green 202 yards away. The green complex is surrounded by out-of-bounds to the right and steep slopes both in front of and behind the hole. Wildflowers are in abundance throughout the woods leading to the next tee.

The thirteenth hole is a test of skill and concentration ... and perhaps the best par-4 in Michigan. Measuring 451 yards, the hole is guarded by a dense woods to the right and a bunker and steep hillside left. A long iron must be played from a sloping lie to a green that is humped in the middle and rolls

drastically to the back. A missed shot left leaves the ball on a hard pan or in a bunker toward a green that slopes away.

The seventeenth is a true "sportsman's hole." On the card it measures a measly 330 yards, but those who have played its narrows in competition know of its treachery. As difficult to describe as it is to play, this hole begins from an elevated tee, and drives must carry to a landing area the size of a barroom pool table. If the drive is off mark, one may have to hit from an 80° uphill slope to a green elevated 100 feet above. Indicative of the blend of beauty and beast that is Crystal Downs, the seventeenth hole remains etched in players' memories.

At the back of the seventeenth green or from the eighteenth tee, one becomes awed by the magnificent blend of land and seascape spread in panoramic view.

Standing on the clubhouse lawn one might easily reflect upon Dr. MacKenzie's original philosophy of design: "While always keeping uppermost the provision of a splendid test of golf, I have striven to achieve beauty." At Crystal Downs, on the bluffs overlooking Lake Michigan, his case is rested.

CRYSTAL DOWNS #8
by Tom Doak

THE SPIRIT OF HOPE

by Henry Leach

Golf is not like other games which stir up great enthusiasms in their players. Long spells of failure or of ambition thwarted often kill the passion that has fed the energy of the players of these games; but that is not the case with golf, and golf almost alone. Nor does a surfeit of play lessen the desire for it as it does in the case of other field sports, which need close seasons for their healthiness. When one day's golf is over, the thought is of the next that will succeed it, and the hope already goes forward to anticipation of the superior delights that may be in store. And it makes the same appeal to all persons of all classes who once attach themselves to it, and it has been found that the golf impulses are as strong in the men of other races and of other colours as they are in the British who have cultivated the game. This universality, the constant enthusiasm, the unweariedness of the golfer, and the intense ardour that distinguishes him from the players of other games, suggest to us that some strong emotion of the human mind is touched by golf in some peculiar way, that its principles and the conditions of its play make a special appeal to some elementary feature of simple human nature; for it is the appeal to these primitive instincts that is always the strongest, the most overpowering. Upon this line of investigation we come upon a clue that leads us to a more satisfactory idea as to the secret than any other which has been suggested. The strongly humanising tendencies of the game are evident to all, and admitted. No cloak of convention can be worn over the manners and thoughts of the player; he is the simple man. And what are the subtle features of the primitive instincts that are awakened in him so constantly, at almost every stroke, in every round, and on every day? It is sometimes difficult to seize upon them, floating in a vagueness as they do, but it does seem that all the strong emotions of the golfer combining to make up his grand devotion to the game are clustered round the simple human instinct, most human and most potent of all, the instinct of Hope ...

So it is hope and hope all the way through the golfer's life, and it is the most joyous, the most uplifting of all the instincts, and the most intensely human, and that which is given to man alone. It is because golf strikes always this chord in his nature that it makes the strong appeal to him. There is no other game or sport that permits him to hope through failure in the same way, that leads him on, coaxes him, cajoles him, even fools him. And this drama of the emotions of the individual is played always in the most perfect setting for such a simple human play — the sea and green fields and plain earth, and the simplest tools to move a little white ball, not along marked lines or within narrow limits or in protected arenas, but anywhere along that green grass, over the hills and through the valleys and across the streams and rushing rivers, while the wind blows now this way and then that, and the rain pours. All the time the golfer pursues the little ball, alone with nature and his human adversary. Here he is released from all the conventionalities of mind that hold him in his other doings in this complicated civilisation. The primitive instincts are in command; they have the fields and the sea for harmony in the scene, and the golfer is away from all the intricacies of the twentieth century, and is the simple man and the hopeful man.

Walking and Golf

by Tony Morse

Walking is a complimentary activity to many sports. It serves as an exercise leading up to the sport. It serves as a relaxation winding down from the sport. Walking can also be the threading action from beginning to end providing the above services and more. Golf comes to mind as the sport that most perfectly embodies this energetic activity of walking.

Traditionally the walking involved in playing golf was a good part of the joy produced by the game. My own impressions and those of friends when talking of golf is how a certain golf course remains in the memory — its length, layout, condition of terrain, size of hills, density of trees, amount of water, etc. — the combination of which would be discussed in glowing terms impressing upon one's mind a picture of grand and stately beauty. And for most, these impressions were gained and remain more through walking that course than on a particular occasion in which an unusually low score or a most difficult putt was achieved.

If walking while playing golf, a natural setting is generally agreed upon to be one of the great attractions of the game. There is another level in which walking particularly adds to the quality of the game of golf itself. A person walking onto and through a golf course becomes externally and internally (consciously and unconsciously) a unique instrument (with feeling) of measurement.

Externally, one sizes up (measures) the day — temperature, wind, humidity, light. A golfer, because he is on foot and out in the open, continuously absorbs the elements and makes mental calculations even as they imperceptably change throughout the game. In applying these measurements hole by hole the golfer is not unlike the most exacting scientist.

The golfer also has gained two great advantages given to walkers: an accurate lay of the land and a discerning judgement of distance. By walking,

CARMEL VALLEY RANCH FROM THE 13TH
by James Peter Cost, 1984

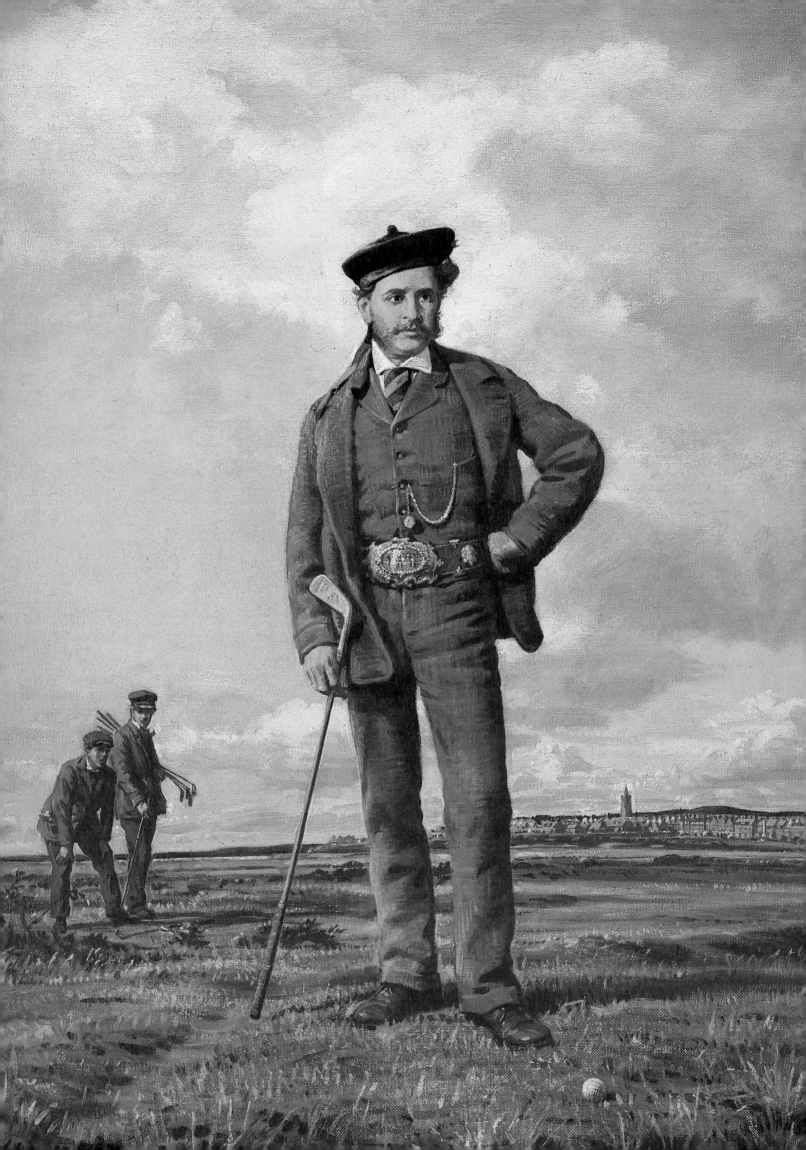

one most naturally extends oneself into the surrounding environment, partaking of its influences, recording onto oneself the shape and measure of this world. By repetition this process comes to be known as experience. And this experience becomes part of one's self knowledge, intuitions that strike deep roots allowing the golfer to perfect his game because he knows. It becomes a physical and mental accomplishment as fulfilling as the executions of a good drive or perfect putt.

Internally, the walking golfer takes careful measurement of himself — works up then works down, reflects then relaxes interchangeably throughout the game. First, mind and body, already conditioned, approaches and works through a challenging problem (ball, shot, play). Then there is a relaxing and reflecting as one walks to the next problem, again to be worked through. Optimum attention has been worked up and now the attending stress is worked (walked) down. With the interaction of reflection and relaxation, this mental and physical process is allowed to revitalize and ready itself as one walks to the next problem. The activity of golf is supported and thus enhanced by the activity of walking.

This most natural ability to take and give measurement in one's walk through a golf course is really more miraculous than all the technologies that have come to surround the game. Miraculous and yet most understandable since the human being is allowed to naturally interact with his or her surroundings. This is as it should be. And the game of golf, itself, becomes one way in which we receive a glimpse of this living process.

The golfer through walking has become one with the earthly elements, thus creating a source always available — of power and perfection, of health and excellence, of confidence and joy.

'YOUNG TOM' MORRIS
by Arthur Weaver, 1987
(opposite)

THE GLENEAGLES HOTEL
by Graeme W. Baxter, 1988
(above)

ON CREATING GOLF HOLES

by Desmond Muirhead

After designing Muirhead Village with Jack Nicklaus in the early 1970s I took a long absence from the hurly-burly, ego ridden world of golf course building. While working with Nicklaus I was strongly confined by the commercial dictates of professional golf and felt I was limited.

I had long been convinced that golf courses should be works of art and when I returned to design in 1982, I was determined to expand the frontiers of golf course architecture.

To me the word "classic" means having an unquestioned high quality with straightforward, traditional rules of design. The course at Muirfield aptly fit that description, but as a creative artist, I wanted most desperately to escape the inhibiting nets of pattern precedents and classical traditions; to break out, however, without roving too far from the communal language of the game. I was looking for a golf course which was easily distinguishable as such, yet which was like no other golf course in existence. I could not avoid the memory of either Muirfield or Desert Island, as they were my last two golf courses in America. Inevitably they became jumping-off points for anything new.

Desert Island was the first *residential island surrounded by a golf course* in history. So it was clearly structurally creative as a total design. I had first drawn the idea as a diagram on a table napkin, while having a drink at the 'Top of the Mark' in San Francisco. I was in a hurry in those days, so as the design developed the holes tended more toward the classic. I drew it all out on paper, working drawings were completed in my office, and the island (minus the buildings), the lake and the golf course were completed in three months. In consequence, there had been little time for the process invention which I practice on all new courses today.

In 1986 I was offered an opportunity to create a course for the developers of Aberdeen in Boynton Beach, Florida. When I first saw the site at Aberdeen with its sandy soil, lakes, sabal palms and slash pines, I could smell the opportunity for something different. When I sat down to draw, the original layout for course and community came quickly. This time there was not just one residential island surrounded by golf; there were three such islands. And two holes, the 11th and 18th, were surrounded by water on both sides; so that now I had *one residential island surrounded by a lake, a golf hole and then another lake.* This was a definite structural innovation from the development point of view, which also gave me an opportunity for two totally original golf holes.

Yet still, somehow, the course remained in the classical mold. Habits are hard to change. I had to break out, but which way should I go and how far? Obviously not too far. Did I know 'how far not to go too far?' Golf is a very conservative game. One ignores the traditions of golf at one's peril, but what artist wants to be safe?

Aberdeen was my only job after a ten-year hiatus, so I had plenty of time to think. I was able to go through a series of design processes, each of which developed with the articulation of the site. Only a little change occurred daily, so I could see the golf holes as they were slowly being roughed out on the ground, and I was able to help them grow organically out of the site. In this way I could tread the razor's edge of structured creativity. I spent more and more time in the field learning and improving until one day the contractor's superintendent had a heart attack. So for the next two months I was almost running the job, which as Doctor Johnson might have said, "concentrated the mind considerably."

This sudden close relationship with the site told me that a golf course should be fun, a brisk walk in fresh air, an enjoyable day in the sunshine. I found that a golf course is a living, breathing thing with its own range of sadness and happiness, humor and tragedy. Golf was like life and a round of golf was a lifetime contained in a day, like James Joyce's Ulysses. In fact, I was convinced the best courses of the future should be designed with intellectual rigor and psychological substance. For if golf were really like life, meaning was necessary in every hole and every

detail. Images would be needed to create this meaning both for the mind and for the senses. I wanted to create images which had a myriad associations; images that had never before seen the light of day.

And then one sunny morning when the brilliant Florida light was shaking down the lines of sawgrass, I hit upon the idea of a narrative or a theme which would accompany the golf course and give it meaning hole by hole. Why should a golf course not have a story to tell? That's how Aberdeen became part of the creation of the earth. I delved into cosmic history from John Milton to Mount Meru, so that each hole had an extra significance and an extra dimension.

I soon realized that these images would also make the course memorable, so that you would be able to remember every hole just by walking it. This was acutely important to me as I could not myself remember a great many of the numerous holes I had designed on other courses. I found this was also true of some great courses such as Pine Valley and Augusta. But because of this imagery at Aberdeen all the holes came to me instantly whenever I needed to bring them to mind. I believed these holes must also be inspiring as should the stories attached to them. This made the golf course design process altogether a much more enjoyable proposition.

Cognition, a familiar word from one of my other disciplines, urban design, should be another important concern of golf course architecture. This meant you should never be lost in either community or course and I must provide orientation points to ensure that this did not happen.

Musing by the long lake on number 11, on another day while the bulldozers were merrily shaking the earth, I had a further brainwave. I started to think again about the Old Course at St. Andrews, Scotland. I recalled its many symbols. Bunkers named Hell, Lion's Mouth, and Principal's Nose. The landing areas named for the Elysian Fields on number 14 and that dangerous depression in front of the 18th hole with the well-justified name, the 'Valley of Sin'!

I had used some new and perhaps more literal symbols in a widely published plan for a golf course in Hokkaido, Japan in the spring of 1984 and no one had complained. Anyway, the tradition was clear, so why not expand it to embrace entire holes with symbols? And who would ever forget them?

I was totally firm in believing that these sym-

bols must be well-rooted in the emotional world from which true art originates. I realized that in insensitive hands they could become trivial.

As time progressed I found myself on the project all day long and coming home tired. The sun sets early in Florida and I spent the evenings reading. Gradually I started to expand into those realms which were part of life but not yet part of golf, and began to introduce ideas from philosophy, psychology, as well as symbols into the course; I found that I could synthesize these ideas and compress them as energy into tees, greens, mounds and lakes so that these objects had their own vitality, and in some cases, an almost spiritual life of their own. Philosophical ideas, such as existentialism, favored choice and self-actualization on the part of the player. Gestalt psychology led to continuity, closure and isomorphism, which refers to shape-inducing emotions, such as a rattlesnake form inducing fear.

There were ideas from art and artists in a continuous flow. Number 16, the Great Wave, was influenced by the Japanese painter Hokusai; num-

THE GREAT WAVE
by Paul Barton

ber 12 by the Rumanian sculptor Brancusi. Analogy, metaphor and expressionism, and many other methods of affecting art were used, even pictorial effects such as making the view backward from the tee just as interesting as the view forward. All these ideas, once absorbed, became a new vocabulary for intuitive design. I tried to use my imagination to its maximum capacity. I wanted Aberdeen to be a turning point in the history of golf course architecture.

Immersed in many disciplines from art to urban design, it was a stimulating time on the golf course. One day in the late fall of 1985 I had been listening to Wagner's Rheingold on a tape in the car. I looked again at the water-bound 11th hole and began to think about it. This was already a decent golf hole requiring two well-placed shots to reach a wide landing area and a rather small green. I sensed that all golfers could enjoy it as it is always easier for players to control distance rather than direction, and the fairway narrowed to challenge the longer hitter. I observed the tapering peninsula containing the tee and sketched in an arrow-like, triangular shape across the formerly straight tee.

I had a rapid apocalyptic vision.

Quite suddenly this hole transformed itself in front of me into a mermaid.

Hardly thinking, I started to fill in the details: the scales, a large rising mound with a belly button, two smaller more concentrated mounds for breasts, two bunkers shaped like fish which were placed to prevent errant shots from less-skilled golfers from going into the water.

The green became Botticellian with an envelope of white hair encircling the oval face. I never did a formal drawing of the hole, just a small sketch on a piece of paper, and a detailed study of the green with contours. And the mermaid's scales were about two-thirds marked in, as an indication that they should cover the entire area between belly and tail. But the bulldozer operator only shaped those which had been in the plan and we were pressed for time. So there is this strange gap. Nevertheless, the image became a sort of cosmic breakthrough and many of the ideas from the back nine were triggered from it.

In this mood of continuing creativity on the project every day, I found myself adopting an attitude which Jackson Pollock and the abstract expressionists would have called "process invention." New shapes, new forms and new ways of playing the hole kept continually emerging. Reality is a powerful stimulant. At dawn and dusk the long shadows sculptured out simple shapes into forms of mystery and magic. The rising sun illuminated the hollowed-out traps. "Here's an opportunity for large-scale sculptured relationships that Moore or Brancusi never dreamed of," I thought.

I covered the tee, the mermaid's tail, with dense swarming masses of love grass whose rich texture contrasted luxuriously with the low curved planes in front of it. Standing on the raised tee the sight seemed dazzling to me and I flushed — a solitary moment of immodest creativity.

In the hole by hole description of the course I wrote the following about number 11:

THE DRAGON
by Paul Barton

Hole #11 The Mermaid —
405 yards, par 4

In contrast to #10, water is very much in evidence on this hole. In fact, it is surrounded by water on both sides from tee to green and all kinds of symbols of the sea have found their way into the design. To avoid cuteness or affectation, I have tried to keep the symbolic forms as intelligent, plausible and subtle as possible, so that the golfer absorbs them gradually, attaining a mounting sense of empathy as each shot is played. An architect's job has to be to make the golfer feel at home so that he feels part of the hole. Without him the picture is incomplete.

The mermaid may be boldly perceived from an airplane, and good luck to all airborne golfers. Yet that is hardly how it is meant to be seen or sensed. From the ground the mermaid is only hinted at. True, there is the water and a series of sinuous curves, starting with the tail, which is the tee, followed by fairway scales, a large convex mound with a navel, two breast-like mounds further up the fairway and two traps with shapes like fish nearer the green. These are all faintly symbolic from the ground, however obvious from the air.

The green is more hyperbolic with a large Botticellian head and wild white hair. It represents the beginning of the love affair between traps and greens which is another of the metaphors I have emphasized on this course and which reaches its climax in the following hole.

The fairway curves which are picked up by similar curves and spaces formed by the building masses, which I have laid out on the nearby island's perimeter, will all emphasize the inherent beauty of the water; here shining, shimmering, glimmering and there with calm mirror-like reflections. At the same time there is a hint of the sadness, gloom and nostalgic melancholy engendered by the sea, the idea of the mermaid as siren, and the future dark row of Norfolk Pines on the island. The small mounds at the edge of the fairways are protective devices guarding us from the darkness and death, which deep water symbolizes in so many ancient cultures. They also stop the ball from dribbling off into the water.

These are some of the constant cues which proclaim the innocence of the architect from the vile slanders cast his way by humiliated golfers. Too many of them are ready to blame him for their looping swings, and accuse him of having buried elephants around the course both in green and fairway. On the contrary, this virtuous man is more often looking for ways to reduce the natural sense of despair, which seems to cloak all golfers. He is trying to provide them with encouragement to ward off some of the deep-seated grief so inherent in golf and life. Perhaps to catch the strange, sad melancholy of Scotland, and some of its wildness and joy, which I never fail to feel whenever I hear the wailing of the bagpipes, or see a mermaid! There is an ancient Celtic burial mound around the green which will hold the errant shot from a watery grave. May there be a rest from water on the next two holes. Actually there is!

You are likely to remember this hole, whatever score you post. But if you hit it in the water you will remember it in a very special way.

As Milton said, first there was chaos, the rest immeasurable abyss ... outrageous as a sea, dark, wasteful, wild, which is the unfathomable depth ...

Hitting it in the water may even be more creative than the design of the hole.

THE MERMAID #11
by Paul Barton

THE CALL OF THE MASTERS

by Herbert Warren Wind, 1962

During his long and remarkable career, Bernard Darwin, the English golf writer, often had occasion to ruminate on the magic that certain railway junctions had for him — those at Leuchars, Ashford, Minster, Preston, and Birkenhead Park, for example. "Their names," he once wrote, "sound in my ears as chimes, ringing me home to my own country." Leuchars summoned up for Darwin the sound of the porter calling out, "Change for St. Andrews!," and Ashford "Change for Rye!" Minster meant Sandwich; Preston, St. Annes; Birkenhead Park, Hoylake. In this country, travelling to the golf courses where the major championships are held has seldom, even in the days when one bore down on them gently by rail, had anything like the cozy quality that warmed Darwin. The relative size of the two countries has something to do with this, naturally. So has the fact that the top British tournaments are almost always played over the same dozen or so courses, which have long made up what is called the championship "rota," while here it has long been the practice of the United States Golf Association, which conducts the National Open and the National Amateur Championships, and of the Professional Golfers' Association, which handles the P.G.A. Championship, to move these annual events around the country, so that golf fans residing in the various sections have a chance to take them in. Periodically, the National Open returns to a "traditional Open course," such as Oakmont, outside Pittsburgh, where it will be played this June and was last played in 1953. Ordinarily, though, the interval between National Opens at any one course is nearer twenty years than nine, and to hear the chimes ringing you home after an absence of this length requires the historically oriented eardrums of an Arthur Schlesinger, Jr., or a Casey Stengel.

All this comes to mind because another Masters tournament — the twenty-sixth, brilliantly won by Arnold Palmer — has just come to a close at the Augusta National Golf Club, in Augusta, Georgia. It is clearer today than it ever was that this comparatively young event not only is a full-fledged classic but already may have surpassed the United States Open in the hold it has on the imagination of the sports public. Attendance figures are never the whole story, or anything close to it, but this year, for the third time, a total of well over a hundred thousand people watched the four days of play of the tournament proper — more than twice the record turnout for the three days of the U.S. Open. (In addition, twenty million people are estimated to have tuned in to each of the telecasts from Augusta.) The Masters has a great many things going for it, some planned and some fortuitous. It is played on a superb and scenic course that inspires the fine field of players to spectacular feats and offers singularly good vantage points for spectators. It is held at a wonderful time of year, when practically every golfer, after a long hibernation, finds his fancy turning to thoughts of supinating the left forearm or some other such crucial action that will make the season at hand the big one he has been waiting for. It has flavor and innate prestige, since it is permeated with the personality of the founder and president of the Augusta National, Robert T. Jones, Jr., who is that rare sort of hero — in sports or any other field — a man whose actual stature exceeds that of the mythological figure he has been made into. In the judgment of quite a few old golf hands, however, the element that has made the Masters the Masters is that it is played on the same course year after year. For players and galleries alike, the tournament has a familiar, homecoming atmosphere, which none of the peripatetic championships can hope to match. Fewer than a hundred golf enthusiasts, I would guess, regularly follow the National Open from venue to venue, but there must be several thousand persons who, in the manner of Chaucer's pilgrims posting to Canterbury, head for Augusta early each April.

Most of those who come to the Masters from any appreciable distance make the journey by plane. Few flights are scheduled directly from faraway cities to Augusta, for although the sleepy old town has recently been aroused by the establishment of several new industrial plants, there are fifty-one weeks of the year in which travellers can hardly be said to descend on it in substantial numbers. Atlanta, accordingly, serves as a junction. It is not, of course, the sort of junction Darwin had in mind; no porter shouts "Atlanta! Change for Augusta!," and a large air terminal, with its long, hollow corridors and its semi-lost transients, hardly conjures up the

feeling that the promised land is at hand. Still, Augusta is only fifty minutes by air from Atlanta, and when you land at Augusta's pleasant little airfield, everything is just as you have remembered. The air is sweet and soft; you never fail to see a few familiar golf faces around the terminal; and the man at the car-rental desk once again can't seem to find a record of your reservation and can't quite fathom how anyone could have written you a confirmation.

The main entranceway to the Augusta National Golf Club is a narrow drive, some three hundred yards long and lined with unbroken rows of magnolia trees, which interlace overhead. A slow progress down this lane to the sunlit white clubhouse is the first of three moves that a very high percentage of the Augusta regulars apparently must make each year before they feel really at home again. The second is a walk around the clubhouse to the terrace at the rear, from which one can gaze down at the eighteen holes, which Jones and Alister MacKenzie, his co-designer, laid out over the slope of a natural amphitheatre. It is the prettiest vista in golf, and the returning regular wants to make certain it's still there. Indeed it is. Rye grass sown with the Bermuda grass is still imbuing the fairways with a distinctive lustre. As befits a property that was once one of the South's leading nurseries, some of the flowering shrubs along the fairways are in full bloom. The pines towering behind the tenth green are just as tall as memory had them. "Yes, it's all intact," the regular says to himself. He is then ready to make the third, and last, move in his annual process of reacclimatization. He watches a twosome of golfers he particularly likes drive off the first tee and follows them out onto the course. After observing the approach shots on the opening hole, a moderate-length par 4, he doesn't bother to find a position near the green but walks directly to a spot at the edge of the rough along the right side of the second hole (555 yards, par 5), about 275 yards out, at just about the point where the fairway begins to tumble downhill to the green. He takes in the two drives. He takes in the two second shots. Somehow this seems to do it — watching one pair of golfers play their tee shots and their long approaches to the second hole. From that moment on, the itinerary of one Augusta regular may have nothing at all in common with that of another. Each man (or small group) plays it by ear. Some go on to the second green, watch their twosome putt out, and perhaps stay with them all the way, if either player happens to be working on a hot round; others wait on the hillside to watch a few more pairs come by, getting their eyes limbered up meanwhile by switching their attention from the putting on the distant green to the second shots played directly in front of them and then back to a new pair driving from the tee; still others head at a brisk trot for the scoreboard near the third green and tune up their arithmetic by studying the scores between quick looks at the action on the third, a short par 4, and side glances at the tee shots on the fourth, a dramatic par 3, 220 yards long, where the pin is usually placed behind a deep key bunker that noses into the heart of the slanting green. Most regulars stay out on the course until late in the afternoon, resting and roving by instinct, and sustaining themselves with pimento-spread sandwiches and the golf itself. The only time they tend to reconvene at a single spot comes when one of the leaders nears the riskiest bend on the course, down by Rae's Creek, for then nearly everyone — as many as fifteen thousand people on some days — perches on a slope that serves as a grandstand for the two make-or-break holes, the twelfth and thirteenth.

This feeling of extraordinary kinship with the Masters is not restricted to those who go to Augusta. In general, golf fans cerebrate and talk about their preoccupation as no other sports group does, and the talk of the returning pilgrims about the Masters — abetted to a considerable degree by the telecasts and by the year-round rhapsodies of the golf-writing press — has created such an inordinate wave of interest in the event that many men who have never set foot on the course have acquired a knowledge of it that really is amazing. You would expect golf fans everywhere in the country to be fairly well acquainted with the last four holes, for these are covered by the television cameras, but somehow they know the terrain and the strategic demands of all eighteen, and can rattle on about "the new green on the eighth," and "that long arm of the creek on the thirteenth that caught Patton's second in '54," and "those gusts of wind that puff up on the short twelfth and give Palmer so much trouble every year," and "the low branches of the pines that kill you on the seventh if you drive it down the right side of the fairway." Only one other course in the long history of golf has ever been comparably familiar to the golfing public at large — the Old Course at St. Andrews. No self-respecting golf club in Britain would think its bar complete unless a print of the famous MacKenzie map of the Old Course hung on the wall, and when you add this handy reference to the decades of chatter about what old So-and-So did on the Road Hole and the trouble young What's-His-Name met up with on the eleventh, it becomes almost understandable — almost, but not quite — that so many Britons know each bunker at St. Andrews by its designated name and could probably walk out blindfolded from the first tee to any one you mentioned.

Golf in the Kingdom

by Michael Murphy

I felt the land as we climbed the hill, the sea breeze, the grass beneath my feet. A film had dropped from my eyes, from my hearing, from all my senses. The smell of the sea and the grass, of leather and perspiration filled the air. I could hear a cry of delight in the distance, then tiny cheers. Something had broken loose inside me, something large and free.

I looked out from our vantage point; we could see for miles now. The sun was dipping behind the western hills, while purple shadows spread across the water and arabesques of grass below. The curving fairways and tiny sounds arising from them, the fields of heather, the distant seacaps were all inside my skin. A presence was brooding through it all, one presence interfusing the ball, the green, MacIver, Shivas, everything.

I played the remaining holes in this state of grace. Specters of former attitudes passed through me, familiar curses and excuses, memories of old shots, all the flotsam and jetsam of my golfing unconscious — but a quiet field of energy held me and washed them away. I can think of no better way to say it — those final holes played me.

The "Postage Stamp"
by Mil Radler

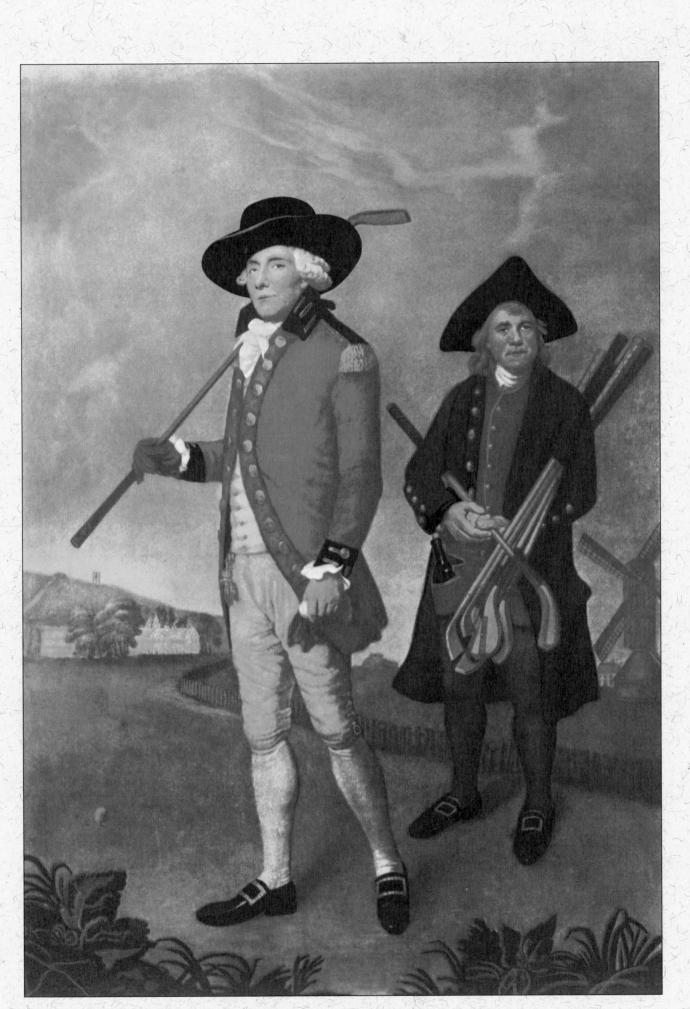

MR. WILLIAM INNES
by L.F. Abbott, 1790

SECRETS
OF THE GAME

---◆---

THE SECRET OF GOLF

by Carlyle Smith, in Harper's Monthly

He could loft a ball from the top of his watch
 straight into his beaver hat.
He could tee a ball on the window-sill and
 pink the vagrom cat.
He could putt from the top of the oaken stair
 to a hole on the floor below,
And niblick the sphere from a baby's ear
 and the baby would n't know.

He could brassie some fifteen hundred feet
 and clip off a daisy's top.
He could jigger the ball o'er a steeple tall
 as most men would jigger a cop.
He could stand on his head to his caddie's dread,
 and dismay of all hard by,
And then with the ease with which I would
 sneeze lift the ball from a cuppy lie.

He could drive a ball for two hundred yards
 to the blade of a carver keen,
And cut it in two as easy as you could
 slice up sod from the green.
The bird that flies high up in the skies,
 he'd wing with his driving cleek,
And I've seen him graze as soft as haze
 the down on a damsel's cheek.

But he never could win in the tournament,
 no matter how well he played.
He'd never a cup on his mantel-piece;
 in medals was never arrayed.
For though his game was the finest golf
 that ever was witnessed yet,
He never could seem to comprehend
 a bit of golf etiquette.

He'd cross the putt of the other man;
 he'd play when nearer the hole.
He could n't grasp the simplest rules
 to save his golfing soul.
And that is why this golfer keen is never up,
 but down;
And that is why this king of the green
 does n't wear the golfer's crown.

The moral is clear, oh golfer bold,
 oh golfer strong and true:
You may be able to whack the ball,
 and make your opponent blue:
You may be able to do freak things,
 and play past all compare;
But unless you learn the etiquette,
 you'd better play solitaire.

HOYLAKE
by Sir Leslie Ward

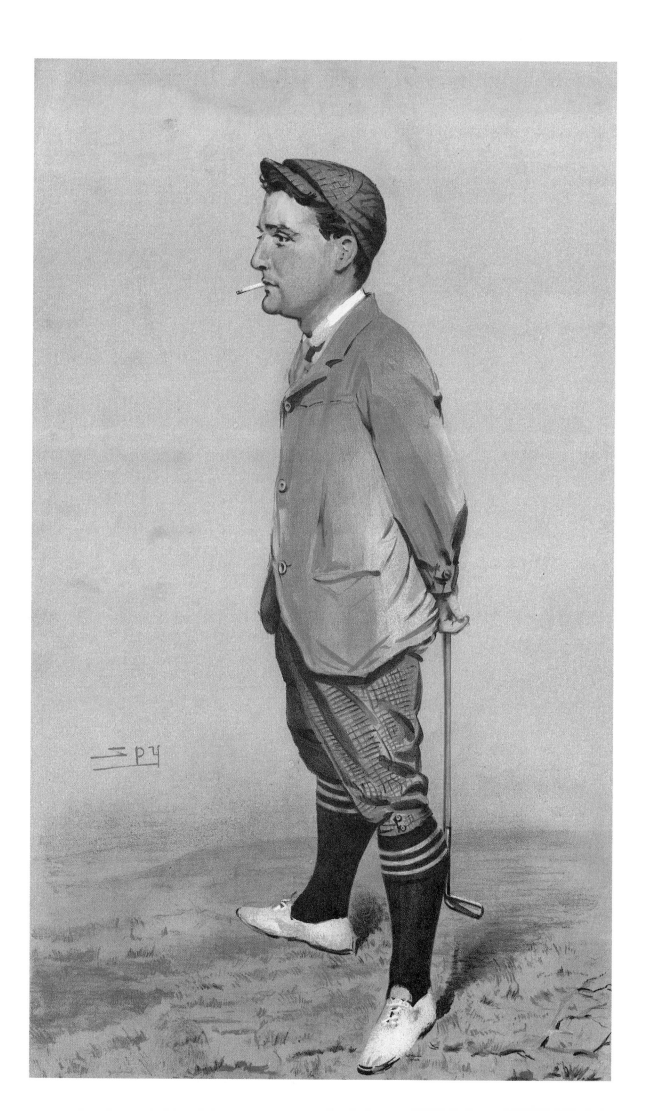

WHERE'S THIS (YOUR) GAME GOING?

by Chuck Hogan, 1987

Golf started as the most humanistic game, challenging the player at every level. For centuries, the quest and exploration for better scores and the reduction of one more stroke, was largely an inner search. The last twenty years have spawned an increasing bias to the technical and technique dimensions of the game. The American golfing institution is pushing the importance of form far beyond that of function. Golf swing has become more important than golf. External processes of golf swings have become the model for so many instructors and students that the internal mechanisms for scoring are largely disregarded. The American golfer and American golf is at a crossroad. We may become hopelessly lost in the minute details of golf swings and golf technology. It is more likely that we will recognize that golf is more than just a golf swing. Hopefully, we will recognize the technical side of the game for its short-term value. Then we can add mental and strategic management back to our game to produce the lowest possible scores and the highest possible satisfaction. This process of self-knowledge and self-management has begun, and you can be a pioneer.

Probably the single biggest reason for the incredibly in-depth search into swing techniques is the lack of clear-cut avenues to stroke reduction on the "mental" side of the game. There has not been a "step 1, step 2, step 3" process for reducing strokes with the brain. Until recently, the mind hasn't even been considered as an avenue for improvement or even a subject for discussion. Virtually every high school graduate learns more about George Washington than about how their brain works. Most golfers know more about the first foot of the backswing than how the mind operates those motor functions. Without an avenue for improvement

outside of the physical realm, there is the likelihood that simple physical mechanisms will be bisected and dissected until they become hopelessly complex and complicated.

And they have. Relatively simple, short-term pre-swing and swing fundamentals have been distorted into elaborate and never-ending things "to do." The golfer is faced with a new technique for every errant shot and unfortunately, there is a "technical" answer for every shot. Frequently, the result is that the golfer's mind is never left free just to "play" golf. And, the worse it gets, the worse it gets!

When a player's game ceases to improve, the search for an answer in technique becomes more urgent and invasive. Most golfers will improve quite rapidly in the formative period of the game. With or without lessons, scores will go down rapidly in the first few months of frequent play or practice. Sooner or later, there will be a point where improvement slows or reverses. The golfer looks for answers available only from the "physical" realm. Through professional lessons, reading or videos, there is considerable energy invested to squeeze out stroke reduction. Eventually, there is more and more time and energy invested to get less and less out. Finally, there is: 1) not enough time and energy left to improve from the physical model, or 2) there is so much search into "how" (swing) that "what" (scoring) is lost altogether. The clichés are "paralysis by analysis," "brainlock," "swing number 602," etc., etc...

In the last few years, however, there has been the recognition that certain "Mental Strategies" can reduce scores and add to the fun of the game. Slowly, there is increasing understanding that mental and physical are just labels to two functions of a

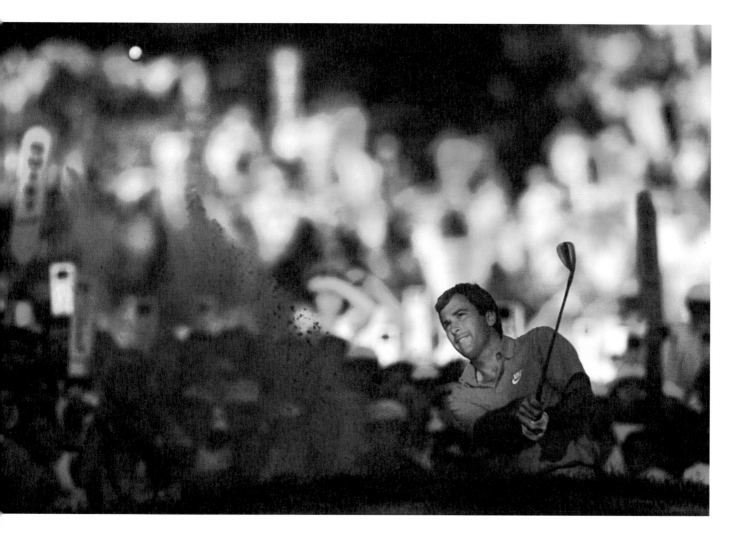

whole human process. It is impossible to have one without the other: Physical is observable mental, while mental is the unobservable portion of physical. So, to improve the mental skills of golf is to simultaneously improve the physical skills of golf, and realize a reduction in scores for beginning golfers as well as professional golfers.

When the mastery of mental and physical skills are combined there is a huge potential for virtually unlimited improvement. The application of mental strategies applied to golf pre-swing and swing fundamentals will:

1. Accelerate the learning process.
2. Make learning personal rather than generic, for each individual.

3. Keep mechanics short-term in the learning sequence.
4. Assure the conceptual imprint of "why" to the "hows" of learning.
5. Assure rapid habituation of fundamentals.
6. Permit the graduation from intellectualizing of golf swing to the creativity of playing golf and becoming "target integrated."
7. Allow the golfer to enjoy the game.

Combining the best of "mental" and "physical" makes you a whole golfer again and scores go down.

It should be pointed out, however, that the "mental" side of the equation can be the same trap as the "technique" side. Going out to the course to execute mental mechanics is no better an avenue

CURTIS STRANGE, OPEN '88
by Lawrence N. Levy

than the physical mechanics. In both cases, it is contrived and mechanical; focusing awareness of self rather than integrating awareness to self *and* target.

Answering the question: "Where is the (your) game going?" requires that you consider a third dimension. Why are you playing? Is it for score? For fun? Or for personal satisfaction? What is your *intent?* A seemingly silly and unnecessary question, but when answered in the minds of professionals, amateurs and recreationalists, it gives direction and purpose to effort.

Many years ago there was a favored axiom: "It isn't whether you win or lose, it's how you play the game." Today, you may hear "Winning is everything, losing is nothing." Whatever your perspective, achievement of intent is unlikely unless the intent is clearly defined. Mastery of technique, mental and physical, is not the end; it's the means. It is your behavior — your action — on the golf course that determines your success or failure.

Many of us lose our perspective or intent by getting too wrapped up in the "hows" of striking the ball instead of focusing on the "why" of our playing. By keeping our focus on the "why" of the game, we will use our energy most efficiently. Good scores and satisfaction will follow as a by-product of the focus.

Keeping your game in perspective will provide the balance necessary for efficient allocation of your practice energy, mental and physical. By knowing your intent, you know when and how much time to put into mechanics, relaxation, imagery, preparation, rehearsal, exercise and diet, attitude and affirmation and other performance components. By taking a piece at a time, as called for by your priorities, and mastering each piece, you reduce your score in a consistent and systematic manner. More importantly, you manage all of your skills and energies as a whole golfer. Increasing self-knowledge as a golfer puts real meaning into "the complete golfer." You become the player of the game — the whole game.

SUN VALLEY #7
by Jim Moriarty

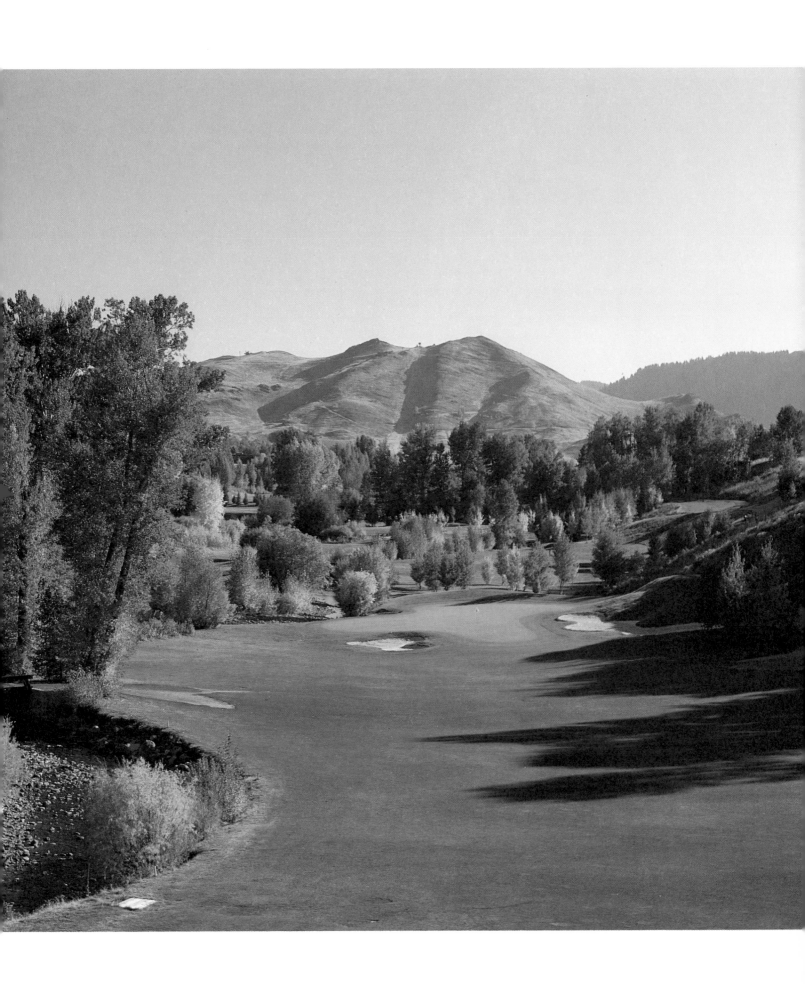

On Making a Hole in One

by Royal Cortissoz, 1922

The distinctive thing about it is that it has, in a sense, nothing to do with golf. That is to say, it is not a planned achievement, like driving a green, or getting successfully out of a bunker, or making a hole in three, or even in two. Making a hole in one is not an achievement at all, but an experience, such as falling in love. He would be a very stalwart fabulist who, having pitched his ball into the cup on a short hole, stood up and, without batting an eye, maintained that that was what he had aimed to do. There is the classical story of the duffer who holed out on a long drive and said "I was afraid it wasn't going in." But that proves nothing save the ingenuity which goes to the making of golf-lore.

Making a hole in one, which, as I have said, has nothing to do with golf, is nevertheless one of the most sustaining stimuli known to golfers. It belongs to the metaphysical side of the game, among what George Meredith somewhere calls "the fine shades." It is the equivalent in golf to that axiom in life at large: "Man never is, but always to be, blest." Who that has gripped a mashie in his hand before a hole anywhere from one hundred and twenty-five to one hundred and seventy-five yards can maintain that he has never hoped in the bottom of his soul to reach the bottom of the cup? I dare swear that there isn't a short hole in the country which is not infested with the ghosts of these unspoken aspirations. I won't say that the wish is always there. But no golfer can truthfully assert that it has always been a stranger to him.

It is done on some courses every season, yet it is never commonplace, and for some occult reason one rarely meets the man who did it; one gets the legend, almost invariably, at second or third hand. The connoisseur in these matters remembers, too, that there are distinctions hedging the thing about in such wise that a man may make a hole in one and yet lay no flattering unction to his soul. For example, though the essence of triumph here is luck, accident, there is a kind of accident which practically cancels the lucky shot. I have known a ball to be driven beyond the green against a tree, rebounding and then trickling into the cup. That was not the canonical mode of making a hole in one; it was crude, grossly fortuitous, helpful to the player's score, but in the nature of things depriving him of any lasting gusto.

I once made an approach shot which was a full five yards to the left of the green. A robin rose up just then, caught the ball on the small of his back, and with an indignant ruffle of his wings caused the ball to ricochet to within a yard or two of the pin. I call that an ornithological fluke, not a shot. Similarly a player who whangs his ball against a tree or a rock and bounces it into the cup is automatically barred from claiming anything. What was he doing assailing the landscape?

The perfect shot that makes a hole in one is naturally not one that is all wrong to begin with; it is the shot that implies skill in that it reaches the green somewhere near the pin, demonstrating reasonable control over distance and direction. That is a good shot, anyway. The player may plume himself. But the life of our ideal shot is a dual life; luck revives it where skill leaves off. The moment of transition is the one in which your heart is literally in your mouth. To make a flawless pitch, to see your ball descending in the neighborhood of the pin, to watch it hit the green, say, six inches away! Has it dropped dead or is there a little roll left in it, and will luck follow through? There is nothing on earth quite like that moment of breathless suspense. I have known it and I wouldn't trade it for anything in this world save a

Untitled
by Michael Vaughan

working bunker exit.

I once saw Jim Whigham make a hole in one, on the short seventeenth, at Piping Rock, and I shall never forget it. We were in a foursome, completely happy and quite unconscious of the fact that in the phrase of Mr. H.G. Wells "there are other dreams." Suddenly the world was transformed. Jim pitched a consummate ball, clean as an orchid. It landed perhaps six feet from the pin, and then, like a startled mouse, ran into the cup. There was silence for a moment, followed by outcries. Yes, outcries. We must have fluttered the gulls at Montauk Point. I was interested in our hero's demeanor. It did not obviously alter. He is too good a sportsman to brag. But there stole over his Roman phiz an indescribable glow. So might a man look who has just been told that they have reserved a tomb for him in Westminster Abbey. With a touch, just a touch, of the look that a conjurer wears when he takes a rabbit out of

a hat. Jim has gone about ever since with his wonted calm. But, privately, I think he is a changed man.

And think, gentle reader, it might happen to anybody! To you. To me. For the prodigious appeal of this sublime *coup* is that it is not, I repeat, dependent upon proficiency in the game. It is as likely to happen to the duffer as to the star. A golfer may find it as impossible to get on a five-hundred-yard hole in two as it is for him to go back and fire the Ephesian dome, where a player like Barnes could make it with ease; but the same golfer may tackle one hundred and thirty-five yards with a mashie and see his ball hole out like a gentleman. On that emprise he and the pro are on equal terms, though on every other count they are as far apart as the poles. Is there any other game which holds out anything like the same possibility?

I have not, that I remember, ever made a hole in one.

ROYAL LYTHAM & ST. ANNES
by Bill Waugh, 1988

THE GOLFING GHOST

by R. Barclay

His name had not been mentioned
 Among the list of blest,
Who from things mathematical
 Had found eternal rest:
His second time attempted,
 But ploughed — I think they say —
Yes! ploughed by cruel Examiners,
 Close to St. Andrews Bay.

Oh how the perspiration
 Of grief began to pour,
As taking up his driver
 He turned towards the shore.
One look around the College —
 He could not go astray —
For he saw the white foam dashing
 In wild St. Andrews Bay.

Down to the Links he hurried,
 His brow was sad and low:
Already — it was pale moonlight —
 He heard the tempest blow:
His gown was on his shoulders —
 A scarlet gown, they say —
As he faced the raging waters
 Of old St. Andrews Bay.

He drove from off the teeing-ground
 A never-falling ball:
Then rushed among the surges,
 They were a fitting pall!
A corpse was found next morning
 Floating far, far away,
Far from the stormy billows
 Of wild St. Andrews Bay.

There are who tell the story,
 Some Caddies by the shore,
How on some wintry evenings,
 When ocean tempests roar,
A figure white's seen golfing
 Golfing, not far away,
White as the foaming billows
 Of old St. Andrews Bay.

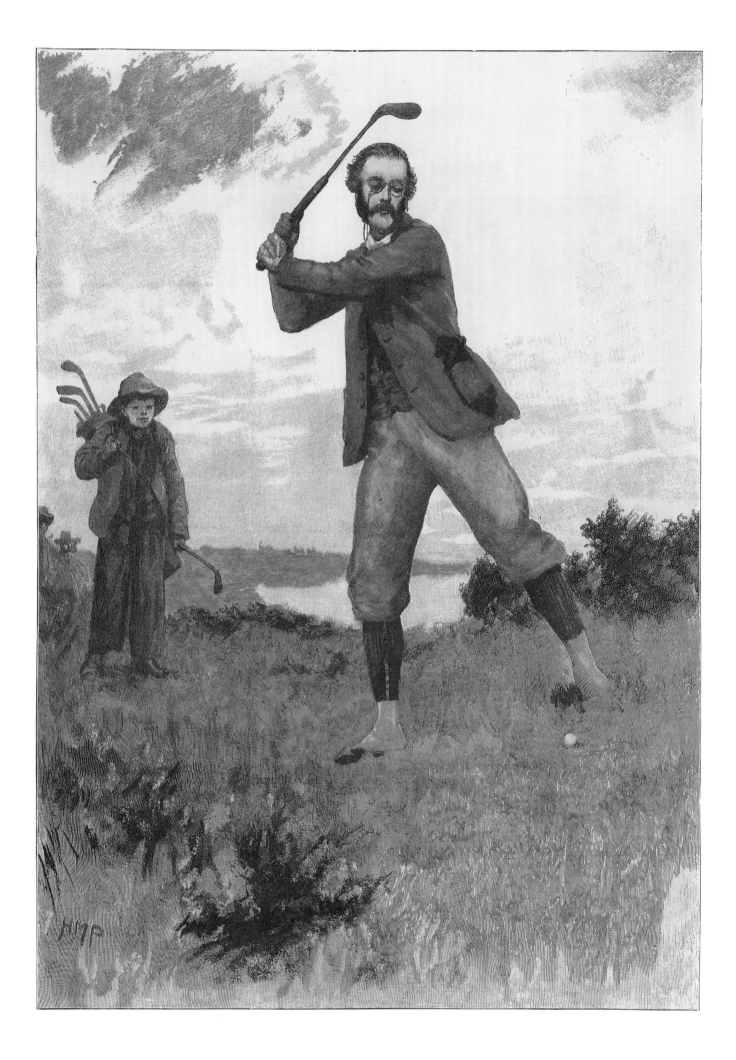

A Vindication of the Theorist

by Leslie Schon, 1923

Very few people, whether they are golfers or not, realize that the mind cannot stand still. Even the most phlegmatic, unobservant man, is continually receiving new impressions. In the course of a single round all manner of new ideas enter the mind of every golfer, possibly leading him on to trying experiments, an alteration either of grip or stance, or, it may be, a deliberate attempt to slice or hook an iron-shot.

Every golfer is at heart a theorist. This, I am aware, is a dangerous statement, a statement that will be controverted by some of the able correspondents to the London Press, who make our breakfast a more enjoyable meal than it might otherwise be, and who doubtless cause many dignified business men to run to the station to catch their train. It is a dangerous statement, because one can have too much of a good thing, and because, so far as golf is concerned, it is terribly easy to theorize too much. To advocate, or rather to glorify, the theorist, is possibly as dangerous as preaching Bolshevism outside Scotland Yard. It would be as perilous to give a small, enterprising schoolboy a stick of dynamite.

But I am convinced that the golfing theorist has the best of it; he derives a keener enjoyment from the game when his risky experimental shots come off than does the phlegmatic golfer whose motto is safety first. And more than this: since the human mind cannot stand still, it is natural to theorize, and consequently, unnatural not to.

For too long the theorist has been under a cloud; he has been the butt of his fellow-golfers, and he has been held up to ridicule by writers whose mission in life, or so one must suppose from their written word, is to make us into a country of world beaters. ...

"Nothing is constant but change!" so wrote Haeckel. "All existence is a perpetual flux of 'being and becoming'!" That is very true of golf.

And not only cannot the golfer's mind stand still, but neither can his play. So many rounds a year may about leave a man playing just the same at the end of the year as he was at the beginning. An increase in the number of rounds, and more time devoted to pondering over the weak points in his game, and a golfer's standard becomes higher; the reverse is also the case; little play, little practice, and no thought, and down the standard slides, and up goes the handicap.

When a golfer's handicap becomes low there is a mysterious process involved termed "steadying down." Strictly speaking, it is hardly correct to say involved, because sometimes the process is not involved, and the player's golf never does "steady down." Nearly every one who starts the game as a boy becomes a low handicap player; possibly not a scratch golfer, but a two or three handicap player. But why some get down to scratch or even plus, and why the remainder stick at two or three, is to my mind one of the most debatable and interesting points in the game. In many cases these players have plenty of leisure, and perhaps they play too much; to some money is no object, they can buy all the clubs that they require or desire, they can practice with the leading professionals over a great variety of courses. Yet they never make their mark in the world of golf. Perhaps the single word "temperament" will account for the golf of many, and yet it seems inconceivable that a man can play golf for a number of years and not find out whether his temperament requires modification. And once that is realized, there is no reason why the modification should not be accomplished.

Really there is nothing so irritating and so thoroughly bad for one's golf as to fail at a particular time when one wants to play well. This is true of the plus player and the twenty-four handicap golfer alike. If there was a golfer who could always play well, one could understand him (or her) sneering at the theorist, but the dissatisfaction engendered by bad play must lead any normal golfer — by which I mean one of sound mental balance — into the realms of speculation. Why did I foozle my drive at the eighteenth hole when I was dormy one? Why do I so

A Cabinet Minister's Holiday
Artist Unknown

often fail at the critical phase in my matches? Why? Why? Why? There must be some answer to the question; some reason, obvious or obscure; but it is an answer that the golfer must find for himself — neither friend nor textbook can help him.

As an instance, the average player will be certain to find out sooner or later that he is incapable of playing short mashie shots, with back spin sufficient to stop the ball quickly. This is an exceedingly useful stroke that may have to be made several times in a single round, and it is a stroke that few golfers, with double-figure handicaps, can play with any degree of accuracy whatsoever. I have one particular friend in mind who has always scoffed at the theorist, and who has eschewed theory as he would the plague. He has accepted as an unalterable fact that it is impossible for him to stop a ball with a mashie, and hence there is a terribly weak spot in his game. Instead of pitching boldly up to the hole, he lofts his ball on to the near edge of the green, in the hope that it may stop running when it reaches the pin. The mental agony that he passes through in playing such a stroke is terrible to behold. Countless friends have told him of this joint in his armour, but their theories have fallen on deaf ears; he will have none of them. And as he scorns theories, so he scorns practice.

Returning to the average golfer and his incapacity for making this stop shot, I am certain that it is of infinitely more value to him to learn by theory and practice how the stroke is made than to have lessons from a professional. This must not be taken to mean that I am in any way opposed to professional instruction, quite the reverse; indeed, as I have already said, the beginner who tries to teach himself the game, instead of having a course of lessons, is making a very serious mistake. He is laying up a great deal of trouble for himself in the future. But I do think that there are some things that a player had much best learn for himself, when it is an act of wisdom to select a quiet corner of the links, and experiment in, for instance, these stop shots with a mashie or mashie niblick.

Really the golfing theorist should be beloved by the golfing correspondent, because not only does he read every word of every article that the latter writes, but he believes every word — for as long as a week at a time! Of course, it is simply a trick of the imagination. "B.D.," or "A.C.M.C.," or "C.B.M.," or "G.W.G." tells us that our salvation in playing a half-iron shot is to "hit the ball with the back of our left hand." We read, and we believe. And when we come to make a half-iron shot, we know that we are going to be successful; we imagine the ball sailing towards the hole, rising gracefully into the air and dropping by the pin. Down comes our mid-iron with a thud on to the ball, and the stroke is successful, for no other reason than that we have imagined it successful, because we are incapable of doubting the success of the stroke. Possibly for five or six strokes in succession we play a perfect iron shot, we are filled with joy; never again are we going to play anything else than a perfect iron shot. We think we have discovered the secret of iron play; but alas! sooner or later our imagination fails us. We foozle once, and then twice, and the secret has gone.

But if we have to puzzle out for ourselves the principles of iron play, if we discover what we have been doing wrong, the knowledge stays with us, although in many cases we may have a relapse and have to rediscover our fault. This is where the Confession Book is exceedingly useful. Each golfer can record the cures for his individual ills, and whenever he is off his game he can refer to the book.

A round of golf is really a struggle against a terrifying horde of weaknesses. The golfer has to keep in his mind, perhaps I should say, uppermost in his mind, his numberless faults. He may have a tendency with his wooden clubs to allow his right hand to slip under the shaft, producing a paralysing hook; he may forget to hit through the ball; with his iron clubs he may have a number of faults that must be remembered and fought against if they are to be held in check. So far as my own experience goes, it is seldom that I play a good round without great mental strain; unless I remember my weaknesses and visualize myself overcoming them, my golf is wretched. But whether this is so with other golfers I am unable to say.

It is hopeless to strive for perfection at golf. There never was, and there never will be, a round played without containing a single mistake. Certain weaknesses may pass; the golfer will superinduce habits that will eradicate them. But others, possibly lesser weaknesses, will take their place. So the struggle will continue.

I fear that my defence of the theorist is but a weak one; that my critics will tear it into rags. But the fact remains, unaltered and unalterable, that the human mind cannot stand still, that nothing is constant but change.

The Mental Hazards of Golf

by Charles W. Moore, 1929

THE CHALLENGE OF GOLF

The hazards of the course throw a friendly challenge to the golfer to lure him from a knitted-browed existence of serious struggle, to quite another world, ... a world out there, away from the human urge, where the fight and rivalry still go on, but now only for the fun of it. Out on those green stretches where the trial of impulses, and the contest of nerves, and the skill of muscle are taken seriously only for the keener pleasure and finer sport. Out there, where the charm of the out-of-doors calls to an answering something within you; where springtime, now smiling, now frowning, now open of countenance, now veiled and hooded, beckons you, lures you, calls you from your winter retreat; and flings you a challenge.

So, assembling your equipment of mind and muscle, out to the club you hasten at the first greening sign of nature, to take up that challenge. Your expectancy grows as you near the old oak, where the road turns invitingly into the club grounds. The stage seems all set for your home-coming, after a long winter.

Reaching the club house, you step nimbly out on to the ground. "Home again!" you cry. "How splendid!" As you scan the fields of your former combats, you find a welcome everywhere you look. Each familiar thing hails you. Sand traps penitently salaam to you. Bunkers grin mischievously behind their green sleeves and sandy cuffs. Elms that have exacted many a toll from you, wave their respects. Bushes whose skirts have smothered many a hapless ball, nod breezily to you. Putting greens drop you a curtsy. Distant flags salute. Even the rough, with an apologetic reservation, pays its regards. While the tee prostrates itself, and the fairway stretches invitingly before you, smiling its challenge back to you.

GOLF IS RIVALRY;
AND RIVALRY HAS ITS HAZARD

Around the first tee old comrades are assembling. Jaunty youth mingles with seasoned manhood. Jocund natures measure drivers with sedate temperaments. Exultant enthusiasts cross mid-irons with dismal pessimists. Talkative spirits grapple with noncommittal, silence-loving souls. A mirthful ego challenges a moody egoist. Light-hearted zest competes with plodding inertness. So gathers the clan at the reveille of springtime, trailing in and out of locker-house, swarming in groups like so many bees, only to fly apart before fully settling. Greetings are bowed, and smiled, and waved, and gripped. Faces you have not seen all winter pop up again. Embers of carried-over friendships are fanned into flames of renewed encounters. Memories, like a scarlet thread running through the frosted winter months, bind old rivalries to new challenges. Cares are tossed to the wind. Tense nerves are relaxed. Crow's-feet are ironed out, cheeks glow, and eyes brim with anticipation. Your hibernated blood awakens as your hand grips the club, and once more you are alive and in love with life in the open. All about, the fighting spirit is as keen for prey as the huntress, Diana of the mountains, speeding to her quarry. So ... the game is on. The hour for struggle has struck!

No sooner have you changed to golf togs and gripped your clubs, than fierce rivalry turns you and your friends into red-hot antagonists, flying at each other like gamecocks! Without rivalry, golf would lose the most of its charm. And one of the reasons is that in rivalry is found one of the most interesting and subtle hazards of golf! The constant threat which you find in your opponent, tests your impulses, your staying qualities, your control, as truly as any physical hazard on the course.

HAZARDS, MENTAL AND PHYSICAL

Hazards form an integral part of golf the same as the tee, the fairway, and the green. And hazards exist not only in traps, bunkers, ponds, streams, trees, shrubs, bad lies, rub of the green, the rough, the out-of-bounds margins, but in such personal traits as haste, inattention, carelessness, indecision, fright, overwrought temper, and the like. Golf architects have placed hazards in strategic localities along the fairway and about the green; and it is only now and

then that a player comes upon a trap or bunker or stream. But the golfer carries mental hazards about with him all through the game; and these mental hazards seem to have a "working agreement" with the physical hazards to play into their hands.

If the golfer could overcome his mental hazards, he would have an easier game than if all the ponds and streams were dry, and all the traps filled, and all the bunkers cut down!

The very existence of the physical hazard is a standing challenge to your mental and physical equipment, whether you actually fall a prey or not. The risk and peril which these jeopardies suggest often go much further than merely warning you to "keep out!" They may so insinuate themselves into your consciousness as to utterly blind you in what you are trying to accomplish. The Hazard of Worry is one of the most destructive enemies of golf. For worry can put a heavier handicap on the player than ten traps along the course. The golfer is in danger of bringing to the golf course something out of his complicated life that interferes sadly with his game. Even if he is not easily upset, but takes his ups and downs more calmly, still, the very nature of the care may so occupy the center of his thought, it will make a strong bid for his attention while he is trying to fix his mind on his game.

One of the things that makes worry the menace to the golfer that it is, is that it seems to be harder to get rid of than many other kinds of hazards. Some are passed by quickly, others fade from the mind as the player grows in the interest of the game; and there are times when worries may be banished, in the stress of the game, no matter how real a foundation these worries may have. However, it very frequently happens that a certain worry brought up out of business or personal life is able so to intrench itself in the golfer's consciousness that it seems to stand by his side when he is on the tee, to dim the fairway itself. It will tug at his arms as he makes his swing. It will fatigue the finer parts of his shot-making mental mechanism. It will take the bloom off his game. In his chip-shots to the green, which call for such an extreme degree of nicety, worry grips at his nerves and muscles. When he tries to make his putt, he seems to be looking at the ball through a haze and film of this ever-present and annoying worry.

The sensitive temperament is more susceptible to worries than the phlegmatic. And generous natures sometimes take on worries added to their own. And some worries are far more important than others. However, generally speaking, there is one method of overcoming the influence of worry, and that is the friendly method of substituting some thought in the place of the worry! A substitute thought will help keep worry from distracting you. Otherwise it can so fill your mind and nerves as to blur or even divert your attention from what you are trying to do.

The Hazard of Haste in your mental golf course drives you into pressing in your swing. It whips you into an eagerness to see what has become of the ball, ... before you have hit it! It spurs you to shoot before attention has had time to focus fairly; and before observation has had opportunity to bring you facts which reason and judgment and association and imagination must have, to help you to choose the most useful club to use, or the most intelligent shot to make.

The Hazard of Inattention lures you to put your mind on something not present, at that critical moment in the shot when the club is coming on the ball, to decide its fate. It clouds your eyes in looking down the fairway, with thoughts miles away. It blinds you to all important undulations on the putting green. It asks you to "hit the ball from memory"! It afterwards apologizes to you for the trouble it has drawn you into.

The Hazard of Distraction has a bag full of stimulations to entice you away from the business of sinking your putt; or of timing your drive. Its playground by preference is the putting green, but it is not above following the willing subject to a sand trap, or even along the easy fairway.

The Hazard of Fear leads you to doubt whether, after all, you have chosen the driver that "just fits you." It crouches in the ball, not only when it lies sullenly in some heel-track or pit, but when teed up nicely on its throne on the tee. It tries to persuade you that your opponent will win in spite of all that you can do. It is often successful in making you believe that your game has advanced as far as is in the reach of your ability. On the other hand, this hazard is not all against you. For the warning which it gives you makes you more careful in avoiding trouble; besides, your anxiety lest you lose the hole or game kindles your emotions just enough to "warm up" your "fighting fire" and, so, to put on more steam.

The Hazard of Discouragement convinces you that when the enemy has you two down and five to go, you might as well concede him the game. It shows you the worst side of a bad lie; and when you are trying to heave the ball out, it gives you a picture of failure. It tells you that your opponent does not have half the bad rub of the green that you do. That this is not your day, anyway.

The Hazard of Indecision has an awkward way of sidetracking your singleness of purpose. It starts you out on one idea, then checks you while you are in the act of carrying it through. On the tee, and while the driver is coming on the ball, it makes you feel that you are going to slice your shot, and foozle; so, it pulls your club across the ball and thus forces you to do just what you were trying to avoid. It has a habit of making your arms fall between two purposes, even when you seem to be struggling desperately to carry out only one. It convinces you that your sense-perceptions have misinformed you as to distance to the green; so, you check the force of your club in the dangerous "hitting arc," and end by falling far short!

The Hazard of Temper leads you into fixing the blame for a poor shot, on your caddy, or your club, or an earthquake in Siam! ... when the real cause of the mischief is all above your neck. It is so full of self-assertion that Reason and Attention and Poise are driven out before its storm, so that the club is in the hands of a mutiny force, and is guided more by avenging anger than by the calm, controlled temperament needed to produce results. But, this hazard of temper, like that of fear, is often the golfer's ally. For when purpose is hindered, and plans balked, either by physical conditions or by the opponent, the kindling of the right degree of temper thrice arms the player. When his good shot is set at naught by a better one from his opponent; when the attitude of triumph settles on the countenance of the enemy; when a won game seems to be slipping; all this often has the effect of so augmenting the player's determination, perseverance, and will-to-win that his temper helps sweep him to victory!

The Hazard of Fatigue strikes at the mental golfer as well as the physical. Tenseness as to the outcome of the game can tire the brain to such an extent that attention is handicapped, judgment is made unsafe, and will power weakened. Mental fatigue is also due to over-strenuous concentration, which may burn up the finer skill in play.

THE FINE ART OF RECOVERY

To possess the ability to overmaster the "hazard idea" in the mental golfer; and to stay out of hazards, or to get out of them when a victim, is a valuable asset just as real as the putting touch, or the timing of a shot. The golfer of "recovering ability" is marked by his cool courage, his mettlesome will, his calm staying qualities, his control of temperament, his utter refusal to allow a bad shot or the rub of the green to fuss him. See how hard it is to get him to haul down his flag! He will never strike colors till his opponent's winning putt is sunk, and there is no more ground on which to stand and give fight! His unafraid resources of mind and muscle seem to come to his aid most confidently and readily when he is in a tight place.

Femininity, also, is easily able to demonstrate its share in this courage and skill, in organizing nerve and muscle for the fiercest of hazardous ordeals. Behind the bachelor girl's niblick is a grim singleness of purpose which has fought its way through many a trying battle to victory. The tender caress of mademoiselle's chip out of a trap, has had in it the kick of a donkey engine, when felt by an opponent, on seeing a title slipping away with it. Walter Hagen represents those masters of recovery, who make shots from difficult places seem easy. In a conversation with Gene Sarazen, Gene said, "I'll now tell you of one of the most daring shots I ever saw made, — and Walter Hagen made it!" He then related to me how Walter, in the 1924 Championship at Croilake, needed two fours on the seventeenth and eighteenth holes to win. On the seventeenth, it happened that Walter got in the rough. Now, the question was whether to play safe and take a five and tie the match, or to go in for a risky four and a win. To try for a four was fraught with danger, for a slight error would put the ball out of bounds, and would put Walter out of the running as well.

This great fighter, indeed one of the greatest fighters of all time, concluded to make the shot. Out of his bag he whipped his mashie. Without hesitation, or doubt, he hacked the ball to within four feet of the pin! He made his precious four. The next hole was easy. So, the championship was his, ... for the price of control, and for his daring, which refused to allow fear of hazard to cheat him.

On the Devil in Golf

by Royal Cortissoz, 1922

If the devil is perfectly at home on a golf-course it is doubtless because that place is so thoroughly well paved with good intentions. There can be no question as to his presence there. How, otherwise, are you to account for certain things that happen to golfers? Surely it is not "the spirits of the wise" that do "sit in the clouds and mock us." It is a dark and sinister force, and, so far from being content to perch upon a cloud, it comes right down to earth, infests every turn of the course, and even lurks in the locker-room. If you do not believe this, accept an invitation to play in a foursome at a club you have never visited before. Let it be on a Saturday, when the crowd is thickest and the time-card is as adamant. Linger a little longer over luncheon than you should and then hurry to dress. Look out of the window and observe the throng at the first tee. Look at your watch and bend to tie your shoe with the realization that you have just two minutes in which to take your place in the game. And then have your shoe-lace snap, close to the eyelet. I will not repeat your gloss upon this pretty situation.

>" 'Tis not mine to record
>What Angels shrink from: even the very Devil
>On this occasion his own work abhorred."

And no wonder. I would not make a mountain out of a mole-hill, a life-line out of a shoe-lace. Goodness knows that though men have died and the worms have eaten them it has not been because they were late at the first tee. But it is the kind of mischance that makes you "dancing mad" and it is unthinkable without diabolical intervention.

There is a whole catalogue of these little pin-pricks which are to be credited to his majesty. Take your short-sighted man, who can't play without his golf glasses. Let him discover, on some such visit as I have indicated, that he has remembered to bring everything else but has left the one indispensable aid at home. Reader, did you ever try playing golf with a pair of bifocals on your nose? If not, try it, and then say whether your predicament is devilish or not. I know of only one other posture of affairs to beat it. That is to reach, say, the tenth hole, well out on the course, remote from the club-house, a good "twelve miles from a lemon," and to take out on that sequestered spot the cigar you have been saving up for about the middle of the game. Everybody in the foursome is in the same blissful case. Pipes come out, and cigarettes. Everybody is ready to light up. And there isn't a match in the house! Not one of the players has a match. Not one of the caddies has a match. There isn't a man with a match anywhere in sight, for miles around. For once Lucifer belies his name. You call upon it in vain. He has gone up a tree to mock at you. Positively, at a moment like that, I have heard his derisive chuckle.

It is when the game moves on that he comes down and moves with it. You can almost see him. His gloomy features,

>"Like a midnight dial,
>Scowl the dark index of a fearful hour."

It is the hour, known to every golfer, in which you try to repeat. Then ensues diabolism of an uncannily high order. You made the hole, a day earlier in the week, in par. You know just how you did it. So much distance is to be assigned to your drive. The second shot will leave you, inevitably, with an easy approach. You have hopes of a four. You are certain of a five. The devil is most like himself at such a juncture. He lets you have your drive, thereby increasing your certitude. He is good to your second shot. But although you know all about the approach, just why you should "go easy" with it, just why you should avoid running over, he comes nimbly to the front and takes you into the pit beyond. O pit, pit, how aptly art thou named! Art thou not his designated dwelling-place? It is there, above all other hazards, that you are "as helpless as the Devil can wish."

You land there never so decisively, never so snugly ensconced in an unplayable lie, as when, having won the hole once, you try to repeat. I can't believe that it is pure error that accounts for this special brand of humiliation. Some analysts lay it to self-consciousness. It is just because you are thinking of repeating, they say, that you lose your grip on concentration and fetch up on toast. It is the demon, rather, who works the evil. One of my fellow golfers

is a particularly good driver, straight and far. In a recent game I saw him slice his ball out of bounds from nearly every tee, sometimes two balls from the same tee. He knew better and there were several players present quite willing to tell him the reason for it if he needed light. But he couldn't help going on slicing. He kept at it with the devotion of a train-despatcher. He knew nothing about my theory of demoniacal possession, yet I was not in the least surprised when he laid it all on the devil.

Some students of the game, strangers to the delights of mystical speculation, are prone to explain away the more fantastic of golfing collapses by what they call, with scientific simplicity and aplomb, physical condition. It is all a matter of nerves, they tell you, a matter of co-ordination. As a friend of mine remarked the other day, "the character of the drive is determined by the synchronization of the pathway of the hands and the pathway of the club-head at the moment of impact," and this in turn depends upon your bodily state. Can't you hear that chuckle coming up from the pit? As a matter of fact

there is nothing like the complete disequilibration of all your corporeal faculties to assure you one of the best of your games. It is when you are outrageously fit that you fall by the wayside. Get up in the morning feeling like a king, all set for a game that you have long been anticipating. Go to the course in the most luxurious of cars. Drive off in cloudless weather, with a cherished friend, having a clear field ahead and no one to press you. It is a million dollars to a tin doughnut that you will flub your drive. It is when all these conditions are reversed and you are made aware, with the upward swing of your club, that you've got a nail in your shoe, that you really hit the ball. Look at the champions, with their not infrequent "slumps." Is it physical condition that betrays them? Why, they haven't any nerves. It is a subtler enemy that lays them low. The devil, after all, is more respectable to cite than an alibi, the most hateful pest in golf. When a great golfer misses a fifteen-inch putt let him repeat for his consolation the words of Cassio: "Every inordinate cup is unbless'd, and the ingredient is a devil."

FAIR PLAY
by Karin Boinet

SILENCE AT THE TEE

by Frank J. Bonnelle

No player, caddie or onlooker should move or talk during a stroke. —
Etiquette of Golf.

This the fateful moment,
　　Let all things quiet be;
For now the golfer's ready,
　　The ball is on the tee.

Don't move while he's addressing;
　　To whisper do not dare;
And when his club he's wagging
　　No sound must stir the air.

Should aught distract attention,
　　It might disturb his poise
And cause the man to foozle,
　　So do not make a noise.

Let not a sigh escape you,
　　Don't speak or laugh or sneeze;
Let all the birds cease singing,
　　And hush thou murmuring breeze!

The crickets must stop chirping,
　　And insects buzz no more;
The broad and restless ocean
　　Must quell its mighty roar.

The deep voice of the thunder
　　Shall not be heard aloud;
There must not be a shadow
　　From fleeting summer cloud.

In fact, I think there's danger
　　Within a simple wink —
And in so great a crisis
　　Perhaps one should not think!

O'er earth and all creation
　　Hang silence like a pall!
And let it not be lifted
　　Till the golfer hits the ball.

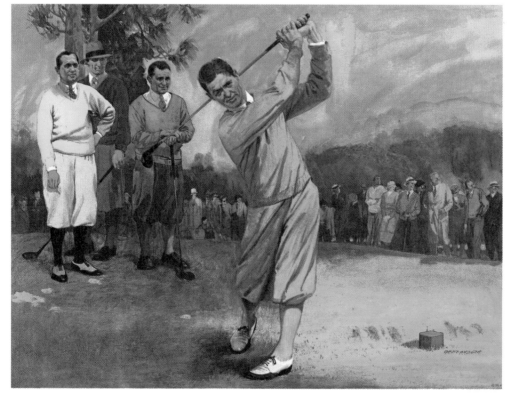

ROBERT TYRE JONES JR., 1930
by Leland Gustavson

WHY DOES THE GOLFER "LOOK UP"?

by Charles W. Moore, 1929

You do not have to learn to attend. The most natural thing you do is to observe. Then, why do we have it dinned in our ears so constantly, "Keep your eye on the ball!"? Because it is the nature of attention to explore. The eyes and ears thirst for new and stronger sensations. Besides, it is fatiguing to hold the attention on one object for a length of time. To fix your attention on an object which is less attractive than another, you must force yourself to do what the eyes or ears rebel against doing. If you go into a semilit room, the eyes naturally wander to the flicker of the candleflame to satisfy the pleasurable sensation of drinking in a stronger sensation. For the same reason you can sit for hours watching a campfire at night in the heart of the woods. But try taking your eyes off the bright light and holding them on some obscure object. They will constantly struggle to turn back to the flame again. And if you succeed in holding your gaze on an obscure or uninteresting object, it will be because you have forced your eyes to stop their exploring, by sheer will power. Now, since the ball on the tee is so much less interesting than almost anything else on the course, being nothing but a simple round white sphere that is soon explored, it does take a lot of discipline to coerce the sensation-loving eyes to "bow down" to that uninteresting orb. Especially is this true, since the eyes are so fond of following moving objects, and crave new sensations. It is clearly the business of the golfer, then, to bring his nomadic eyes under his control. For he will have more need of his eyes than to keep them on the ball. Through them he will gather material to turn over to reason, and imagination, and association, and memory; they will give him information which he will use in shaping the response found in his shot; they will put him in touch with the whole course.

LEGENDS REMEMBERED
by Kenneth Reed FRSA
(overleaf)

TOURNAMENT
by Bob Dacey

LYRICS
OF THE LINKS

A GOLFER'S WISH

by Edgar A. Guest

I have no wish to dress in silk,
 I do not care to wear a crown,
I do not yearn to bathe in milk,
 Or champagne wash my dinner down.

I have no great desire to be
 A man of much importance here,
And have the public welcome me
 With bands of brass when I appear.

And should a fairy, kind and good,
 Grant me one favor, without price,
I'd make this golfer's prayer, I would:
 "Oh, kindly rid me of my slice!"

I am not one intent on fame;
 I do not care to lead the throng;
Though strangers never hear my name,
 Contentedly I'll plod along.

Enough to eat, enough to wear,
 And strength to do my daily task,

With now and then a chance to fare
 On pleasure's ways, is all I ask.

But should a fairy come to me
 And say: "What joy will you suffice?
I'll grant one wish. What shall it be?"
 I'd answer: "Rid me of my slice!"

You that have never swung a club
 And drawn its face across the ball,
And muttered to yourself, "You dub!"
 As in a curve you watched it fall,

May never guess the rage that lies
 Within that shortened arc of flight,
Nor how men curse the fall that flies
 With loss of distance, to the right.

But every golfing fiend will know
 Why gold and fame I'd sacrifice,
If but some fairy, good, would show
 Me how to drive without a slice.

GOOD FORM
by A. B. Frost

A BRIGHTER WORLD

by Jesse G. Clare

Looks as if the world is better
 Than it used to be,
Even if the rain seems wetter
 And the lightning free;
Even if there seems more thunder
 Than we used to hear —
I've a forearm putt — a wonder
 That I've learned this year.

Looks as if the world is brighter
 Than in former days,
Even if the banks are tighter
 And the lank wolf stays.
Troubles, all imaginary,
 Gather day by day;
Playing eighty, regularly,
 Wipes them all away.

Looks as if the world is cleaner
 Than it used to be;
Life itself, friends, is serener;
 Leastwise, so to me.
For my worry is behind me,
 Running all the while;
Wrinkles nevermore can find me —
 I have found my style.

THE FIRST CLUBHOUSE
IN AMERICA, 1892
by Leland Gustavson

JINX'S OFFICE

by A. W. Tillinghast

The 'phone bells are a-ringing; everybody's on the
 jump,
As the clacking of the ticker tells the story of the
 slump;
The clerks are dazed and frightened as the market
 lower sinks,
For they don't know where the boss is — they have lost
 all trace of Jinx.
The manager's exhausted and the office boy's all in,
The stenographer has fainted in the turmoil and the din;
For the market keeps on sagging, as poor lambs are
 shorn of wool,
And though at golf Jinx is a bear, on 'Change he is a bull.
At last they have him spotted and he's dragged in
 from the links,
And then his frantic manager unfolds the news to Jinx
Over the 'phone as best he can, in choking voice and sad;
And Jinx replies: "Why, goodness me, now isn't that
 too bad!"
The boss continues speaking: "Say, just have Miss
 Blossom call
Up Lombard Eight-O-Seven-Two and ask for Jimmie
 Ball,
And tell him that the brassey which he made me doesn't suit,
But the driver is a corker and the putter is a beaut."

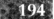

THEORIES

from Locker Room Ballads

He studied all the winter, he practiced all the
 spring,
And struggled through the summer to get the
 proper swing.
He stuffed his head with Vardon, with Hagen,
 Barnes and Ray,
And made a mental note of all these masters had
 to say,
But somehow all this learning and store of golfic
 lore
Seemed useless in his effort to reduce his lofty
 score.
He couldn't win his matches, he never won a prize
And still remained a duffer tho' really golfing
 wise.

The reason is, he's burdened with theories galore,
And exclusive information he's added to his store,
His brain just reeks with systems, and pointers by
 the mile,
On every kind of playing, on every kind of style.
His mind is all bewildered with knowledge infinite
Absorbed from all the experts who dearly love to
 write
And yet with all this knowledge, it's surprising,
 after all,
The poor old dub's a failure, 'cos he cannot hit
 the ball.

UNTITLED
by Michael Brown

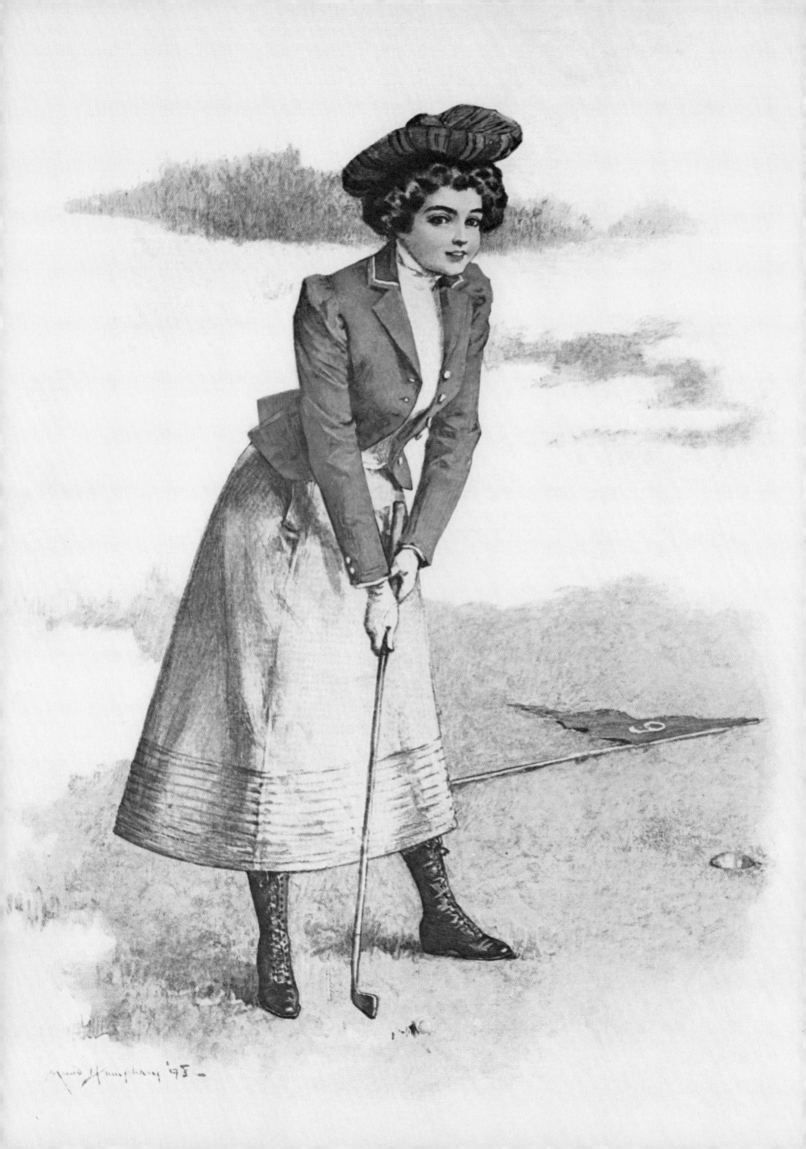

THE GOLF GIRL

by Minna Irving

In a jaunty scarlet jacket,
　　And a mannish little shoe,
A hat with a quill and tartan,
　　And a skirt to clear the dew;
On the grassy links I see her,
　　Every glorious summer day,
And forget to mind my putting
　　While I watch her graceful play.

We have met in dreamy waltzes,
　　When a rose was on her breast,
But her partner at the bunkers
　　Is the one who knows her best.
Though the ball is lost forever
　　And her hair is out of curl,
Nothing spoils the sunny temper
　　Of the pretty golfing girl.

If all women once were flowers,
　　As an ancient legend tells,
She has bloomed a sprig of heather
　　On the breezy Scottish fells;
For the wind that roams the bracken,
　　And the blue of morning skies,
Still is rippling in her laughter,
　　Still is beaming from her eyes.

But in gray or golden weather,
　　Stepping lightly to the tees,
Making drives with daring swiftness,
　　"Holing out" with merry ease,
To the painted balls not only
　　Does she bring the golfer's arts,
For with Cupid as her caddie,
　　She is playing with our hearts.

ONE PUTT
by Maud Humphrey

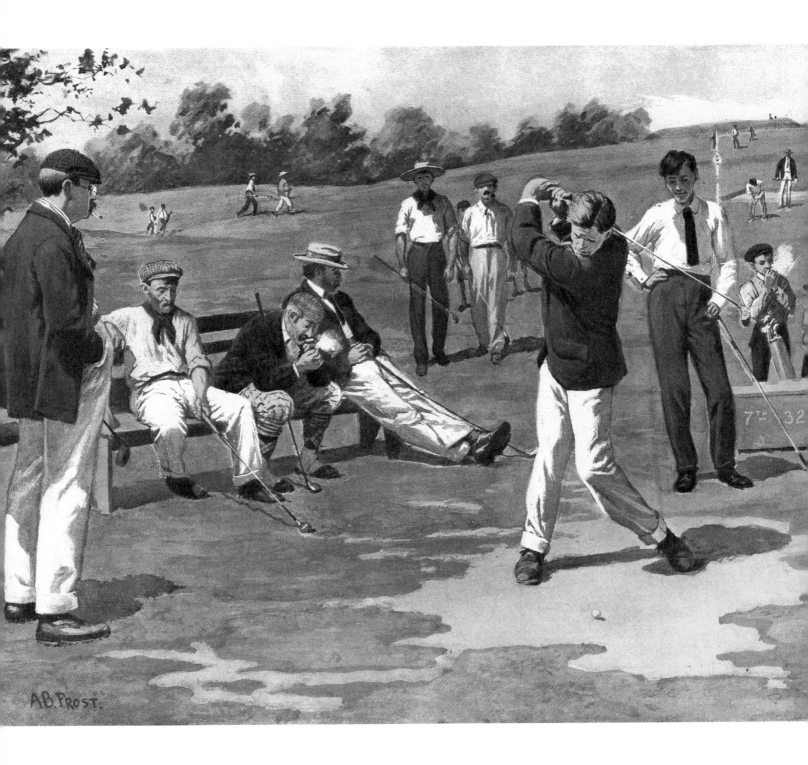

THE VILLAGE GOLFER

by Frank J. Bonnelle

With club and ball upon the tee,
 The eager golfer stands;
In truth, a healthy man is he,
 With strong and sinewy hands,
And the muscles of his sun-browned arms
 Are firm as hempen strands.

His hat is off, his hair blows free,
 His face is like the tan;
His thoughts dwell on the Colonel's score,
 He'll beat it if he can;
He keeps his eye upon the ball
 And fears no bogey man.

Week in, week out, from morn to night,
 You can hear him bellow "fore!"
You can see him swing his various clubs,
 And tramp the meadows o'er,
Like a reaper with a sickle sharp
 Cutting grain for threshing floor.

And children coming home from school,
 Gaze o'er the grassy green;
They love to see the ancient game
 Played with an ardor keen,
And watch the little balls that fly
 As from a gun-machine.

He goes on Sunday to no church —
 Not if he has his choice;
He hears no parson pray or preach,
 But lists to Nature's voice
Resounding o'er the verdant links,
 And body and soul rejoice.

Succeeding, failing, trying again,
 Around the course he plays;
Each morn he seeks to lower the mark
 He's made on other days;
A match attempted — bravely fought —
 He earns the victor's bays.

A word with thee, my worthy friend,
 In golf three things are taught:
To persevere, yourself control,
 For others have a thought;
And if you wish for health and strength,
 You'll find them cheaply bought.

SATURDAY AFTERNOON
by A.B. Frost

PERFECTION

by John Thomson

I

Oh! I played at golf once on a beautiful day,
O'er a green round the marge of a wide sweeping bay,
Where the sea lay in calm, like a babe when at rest,
In a sweet dreamless sleep on a fond mother's breast.

II

The course it was perfect, for both Nature and Art
Had vied with each other which would best do her part,
And the game that I played, well, the like was
 ne'er seen
By the eye of a mortal before on the green.

III

Holes in one were quite common, the longest in two;
Aye, all this, in plain truth, I could easily do;
Yet a pro, at his best, with a card at his back,
Would find it hard work a poor eighty to crack.

IV

Then the caddies were civil, and sober, and clean,
Were all sturdy, well clad, not one ragged or lean;
If you offered them money, they looked in despair,
And would carry your clubs for the sake of the air.

V

The green-keepers wrought hard when no one
 was nigh,
And never sat down for some hours on the sly,
Or went dodging or cringing, with bow and with beck,
While just leaving the course to sheer ruin and wreck.

VI

Many far-away friends did I meet on that green,
Whose kind faces for years I had never once seen;
E'en dead golfers were there, all quite pleasant
 and gay,
And appeared to be living, so keen did they play.

VII

Quick as lightning's bright flash on the bosom of night,
All, all in a moment was lost to my sight,
For a voice yelled, "Get up!" It was cruel, I deem,
To be rudely awakened from such a fine dream.

THE DRIVE
by Douglas Adams, 1893

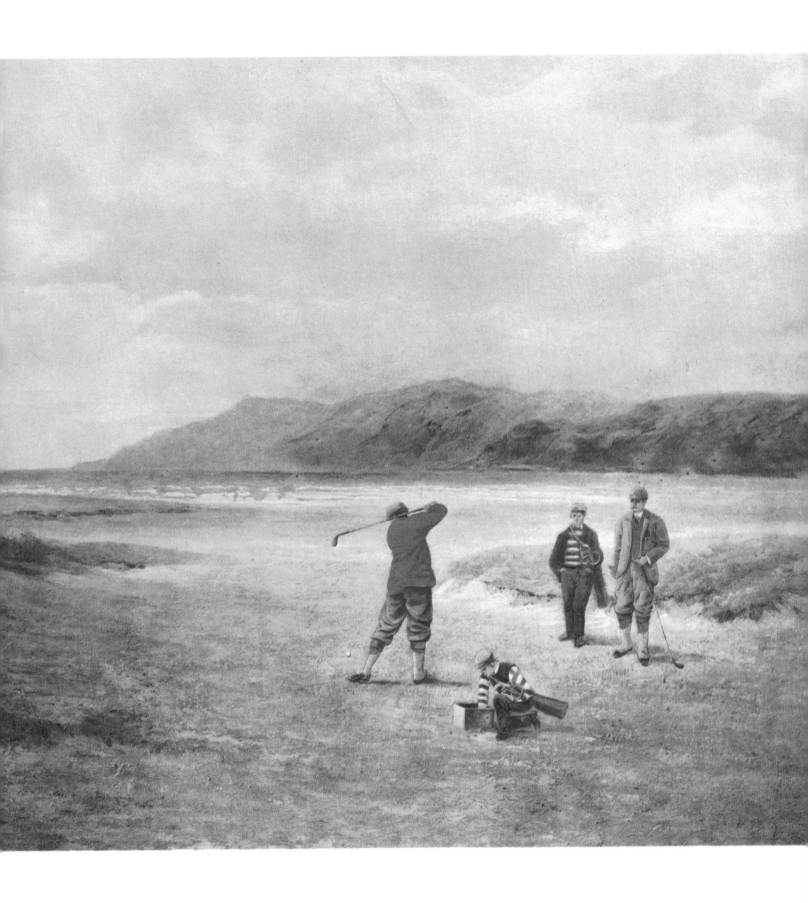

REFLECTIONS

Anonymous

I've always thought a golf ball at heart a
 Bolshevik,
And certain acts confirmed this fact to me
 this present week,
I watched an ordinary ball addressed Vice-
 Regally
And hang me! but it utterly refused to leave
 the tee.

Then sometimes on the fairway I viewed with
 deep alarm
That awful ball in Bunker crawl despite His
 Lordship's charm,
I pondered o'er the punishment that meted
 out should be
For such an act expressive of such *Lèse
Majesté.*

But I've come to this conclusion that golf's a
 game for all;
That there's something democratic about its
 ancient thrall.
It's played by Prince and Prentices and Peers
 of high degree —
That's why the golf ball acts to all with such
 contumacy.

IONA GOLF & GRAZING GROUNDS
by Jan Vandenbrink

"GOLF BOY"

GOLDEN RULES OF GOLF

Anonymous

The rules of golf and etiquette,
Go far to make the game,
And he who wants to make his mark,
Should study it the same,
As he would study any task,
That's worthy of the name.

Replace the divots is a rule,
That all who play should know,
By this one helps to keep in shape
The course, which suffers so
From those who lack a sporting sense
Of decency, you know.

Now, when behind a faster team
Is playing close to you,
And straight ahead the course is clear,
Best bid them play on thro'
Not only will it help their game,
But also help yours, too.

Remember this, don't talk or fuss
When waiting round a tee,
For doing so may oft distract,
A player's mind you see;
And cause his usual careful drive
To end disastrously.

Or if perchance you lose a ball,
Don't seek for it too long,
Nor hesitate, bid those behind,
All courteously play thro',
Then, after this, don't play until
They're out of reach by you.

Thus by a close observance of
The rules of golf you'll find,
A splendid sport and pleasure too,
In this great game, designed,
To make the joys of playing it,
Beyond all joys combined.

GOLF BOY
by C. Spiegle, 1900

THE GOLFER'S PRAYER

by Ring W. Lardner

I do not ask for strength to drive
 Three hundred yards and straight;
I do not ask to make in five
 A hole that's bogey eight.

I do not want a skill in play
 Which others can't attain;
I plead but for one Saturday
 On which it doesn't rain.

FRANCIS D. OUIMET WINS
UNITED STATES OPEN TITLE, 1913
by Leland Gustavson

Golfers' Ballade
for Autumn

by Clinton Scollard

See how the pennoned maples burn,
　　The lindens flaunt their flames of gold!
Each sumac is a crimson urn,
　　Each elm a palmer, russet-stoled;
　　The wind breathes warnings down the wold;
The wild-geese wing their southward way.
　　Too soon will close the cruel cold;
So go ye golfing while ye may!

To silvery notes the rills return —
　　To vernal lyrics, blithely trolled;
The last late-lingering warblers yearn
　　For Spring in songs of yellow mold;
　　Now earlier unto the fold
The wandering flocks, unsummoned, stray;
　　Too soon will close the cruel cold;
So go ye golfing while ye may!

Anon will dawn a morning stern,
　　With brooding cloud-banks ridged and rolled;
Anon a ruthless hand will spurn
　　The woodland arras, brightly scrolled;
　　Anon the year, grown bent and old,
Will shamble by in garments gray;
　　Too soon will close the cruel cold;
So go ye golfing while ye may!

Good golfers, as a tale that's told
　　This life will be, ere many a day;
Too soon will close the cruel cold;
　　So go ye golfing while ye may!

THE SAGES ON THE LINKS

by Rudyard Kipling, 1910

*O! East is East, and West is West, but sundered
 many a mile;*
*And the East-Coast swing is a different thing from
 the common-place half-baked style.*
*On an inland course we learn perforce a style that
 is far from free,*
*But we've more than our score to answer for,
 when we play by the German Sea.*

Oroya Brown, of Camden Town, being weary of
 Bears and Bulls,
Went north one night by the Golfers' Line, to the
 City of St. Rules.
Its classical links inspired such golf as he never
 had known before;
And never a day throughout his stay but he played
 three rounds or more.

His style of dress did not impress the genuine
 native play'r,
Its design was based on ideas of taste which the
 Fife folk hardly share.
But his scores were such as promised much for
 the future of Camden Town,
Though the strokes he made are condemned by
 Braid, and by all but Oroya Brown.

But one forenoon in the end of June ('twas his last
 forenoon in Fife),
He set out for a round with a Prestwick man, and
 he played the game of his life.
His second carried the Swilcan Burn, and he
 captured the first in four,
And when he had won to the Hole of Cross, he had
 taken but nineteen more.

You may make no loss at the Hole of Cross, and
 take ten to the Hole of Shell,
You may carry the Beardies from the tee, and
 foozle your third in Hell.
You may easily do the eighth in two, and yet have
 a lot to learn,
— And Oroya Brown was one hole down, when he
 got to the Hole of Return.

But Oroya then bucked up again, and taking a
 higher tee,
He did the tenth in a perfect four and the next in a
 perfect three;
Being hardly pressed, he played his best, and his
 best was uncommonly strong;
He seemed to have struck a streak of luck, where
 nothing he did went wrong.

His partner's tee-shots left the club as a cross-bow
 bolt is spun,
But Oroya's "Kite" had the even flight of a shot
 from a six-inch gun;
His partner played like a second Braid, and stuck
 to him all the way,
But Oroya's game was much the same as the devil
 himself might play;

He holed his pitch at the Heathery Hole; he
 captured the next in four;
At the Gingerbeer his drive lay clear — three
 hundred yards or more;
His putts rolled in as though the tin were the size
 of a soup-tureen.
And Oroya Brown was dormy two when they
 holed at the sixteenth green.

You may often stand two holes in hand and still
* have a lot to do;*
For a game may be won by two and one, but never
* by dormy two.*
A half indeed is all you need; yet your toil may be
* all undone;*
For none win through by dormy two, though many
* by two and one.*

But Oroya Brown with his clumsy swing again got
 a clinking drive;
He did not make the least mistake, and halved in
 an easy five.
He won the bye with a lucky three, which com-
 pleted his great success —
The record score is a seventy-four; Oroya was one
 stroke less.

Oroya Brown in Camden Town still boasts of the
 game of his life,
But it's not his score that they know him for, in
 the old grey town in Fife,
Where the caddies still have nought but ill to say
 of Oroya Brown,
— A man who teed with a pound of sand, and
 drove with his left hand down.

O! East is East, and West is West, but sundered
* many a mile;*
The West thinks more of the golfer's score, the
* East of the golfer's style.*
On an inland course we learn perforce a style that
* is far from free,*
But an East Coast swing is the only thing when we
* play by the German Sea.*

GOLF PLAYER
by Frank Gude, 1989

WILLIE PARK SR.
by Arthur Weaver

COUNSEL

GOLF AS THERAPY

by Dr. Richard H. Coop, 1989

Although it's doubtful that the IRS would allow it as a tax deduction, I believe a round of golf played in pleasant surroundings with convivial friends can often be as therapeutic to your mental health as a session with a psychiatrist. A round of golf allows us to gain perspective on our problems and frequently leaves us mentally refreshed, enabling us to attack our worries with renewed vigor.

Golf's predictable structure is both comforting and relaxing. We can almost predict the exact words our playing partners will use to set up the game on the first tee. This predictability provides a safe harbor for a few hours to avoid some of the storms of the everyday world. Golf absorbs our minds, and the mental tribulations of our lives are put on hold as we wrestle with errant drives, pulled approach shots and missed putts. We often can displace the anger we may be feeling toward others by placing it on unknown persons who cut the hole in an unplayable spot, or on a faceless architect who designs holes that we simply can't master.

Because we increasingly are a nation of urban dwellers who live amid concrete walls, a golf course's physical beauty also helps our well-being. Even poorly-financed municipal courses have trees, creeks and open space which can refresh the minds of those who spend most of their lives in the rush and hurry of the city. The game's leisurely pace even can provide serenity if we allow it to happen. Leisurely, however, does not mean slow play — it's just a different rhythm from our off-course lives.

In addition to these general therapeutic benefits, I feel at least seven specific mental health skills or strategies can be learned directly from the game and applied to our daily lives.

1. Live in the present tense.

All golfers have to learn the inherent danger to their scores in spending too much time and energy worrying over a missed putt that they foul up the drive on the next hole. Or, if they start fretting about how hard the 14th hole is going to play while they're still on the 11th, which causes them to mess up Nos. 11, 12 and 13 as well as the 14th.

Present-tense focus doesn't mean we should ignore our past mistakes or fail to prepare for the future, but it does say that, as in life, the only shot we can play is the one we are about to hit.

2. Develop a realistic locus of control.

Locus of control is a psychological concept that, in its simplest terms, relates to whether people perceive that they control their environment and the people and events in their lives (internal control) or are controlled by aspects of their environment (external control).

In golf, and in life, there are some things we can control but many others we realistically cannot — the key is figuring out the difference. For instance, there is research to indicate that even on good greens, once a putt is more than 12 feet, whether it goes in is as much up to chance as to the golfer's skill. But we still must take our time and read the green to the best of our ability, concentrate on the line and put our best possible stroke on the ball. It's the same thing in life; we must learn to control those things we can control, acknowledge those we cannot, and have the wisdom to know the difference.

3. Adapt your behavior to fit the situation you're in.

We frequently are subjected to slow play in golf, and there are a number of psychologically healthy ways we can adapt our behaviors to fit the pace of play without ruining our score or our enjoyment. Learning to adapt ourselves to the idiosyncratic ways of different playing partners also is crucial to having a good time.

Again, off the course, we need to be flexible and adaptable in our behaviors. This is particularly important as we grow older and need to adjust to the younger generation, which might not be doing things the way we did. However, adaptability and flexibility can be achieved without having to sacrifice principle.

4. Develop the skill of self-analysis and self-understanding.

The dictume "Know Thyself" is a crucial variable in golf. From tour players to hackers, each person learns to improve his game after first learning to understand himself. To improve, we need to analyze our behavior patterns in areas like decision making (Am I impulsive, or am I more analytic and reflective?); control of emotions (Does my temper interfere with my decision making, and how can I prevent this?); hole strategy (Do I plan ahead as I play each hole, or do I frequently make strategic errors?); and concentration and attention span (Do I frequently allow extraneous thoughts to interfere with my club selection or shotmaking?).

Successful businessmen, professors or athletes prosper largely because they learn to analyze their strengths and weaknesses, emphasizing the former and minimizing the latter. Many times, we procrastinate in developing these traits off the course. Golf, however, is relentless in demanding the development of these skills if you want your game to improve.

5. Develop the skill of cognitive restructuring.

We frequently face trouble shots — over water or to tightly-tucked pins, tee shots with water left and out-of-bounds right. We can choose to magnify these hazards, or we can restructure the shot cognitively and "see" only the safe landing area. How we choose to restructure or interpret what we "see" has a great deal to do with the outcome of the shot.

Say a tour player misses the cut for two straight tournaments: Does he structure, or interpret, this as a sign that he is going into a prolonged slump, or does he restructure the situation and see it as temporary: that the weekends off will do him good because he's been tired? In other words, he can see the glass as half-empty or half-full, and you can imagine with which view he'll be better off.

We can transfer this positive self-talk to our everyday lives, allowing us to coach ourselves positively through business decisions, group presentations and family or peer relationships.

6. Learn to accept yourself.

Many golfers never learn to forgive themselves for a mishit shot. The mistake haunts them for the rest of the round and causes other mistakes. But we need to learn to accept our imperfections, learn from our errors and move on, focusing on the next shot or life task without expending valuable psychic energy punishing ourselves. Some psychological research indicates that people who cannot accept themselves have a very hard time accepting other people. Learning to become more self-accepting and self-forgiving not only will help your game, but also will improve your relations with others.

7. Develop the wisdom to value the basics.

Over time, we learn that to be successful in golf we must value and pay attention to the fundamentals — posture, grip, stance and alignment. The basics might be boring things to practice, but are crucial to a sound game, more so than glitzy swing theories that come and go like the wind.

You can transfer this to life: The fundamental things like family, friends and relationships built on integrity are what really matter.

ADVICE TO BEGINNERS

by Horace G. Hutchinson

Do not, as is most often done, begin your first two or three attempts at striking the ball with a cleek. Begin with a short stiff wooden club — for two reasons: the mode of striking the ball is not quite the same with an iron club as with a wooden one, and with an iron club an unskilful player is more likely to cut fids of turf — *golficè*, "divots" — out of the green. This will by no means conduce to your popularity with the other players on that green. If, even with your wooden club, you should cut up turf, be careful to replace it. Golf is not agriculture.

In the swing of a first-rate slashing driver there are but two portions of his body which are comparatively steady — his head, and the toes and balls of his feet. Every other ounce of him is thrown into the stroke; and the moment the club touches the ball, the head is thrown in too.

Now, as a learner you must not expect to be able to combine such freedom as this with accuracy. You must first laboriously build up your style. The head must necessarily be steady, for it is most important that you should keep your eye fixedly on the ball from the moment that the club-head is lifted from the ground until the ball is actually struck. "Keep your eye on the ball," should be your companion text to "Slow back." A golfing poet writes of

"The apple-faced sage with
His nostrum for all,
'Dinna hurry the swing, keep
Your e'e on the ball.' "

Remember that as a beginner, even under the best of auspices, you will probably be more or less in the way of the other players on the course, and that your safety, if not your very existence as a golfer, depends very much on their forbearance. Do not therefore presume too far. The friend who introduced you to the Royal and Ancient Game may indeed evince some interest in your progress, as is but proper in your father in golf, but you really must not expect every golfer of your acquaintance to listen very attentively to your detailed account of all the incidents of your first round. If you are too prolix, you must not be surprised if some of your friends are almost tempted to hope that your first round may also be your last.

THE PRO

Anonymous

The friendly Pro so tanned and tall
 I love with all my heart:
He shows me how to hit the ball,
 And shares with me his art.

He wanders here, he wanders there,
 Instructing dubs like me,
And charges for his counsel rare
 A very modest fee.

He drops a ball upon the tee
 And knocks it half a mile:
"There, hit it that way, man," says he,
 And never cracks a smile.

THE BALLESTEROS HOLE
by W.K. Waugh, 1987

KEEP THE RULES AND THEY KEEP YOU

by Colman McCarthy

Forty-one rules aren't so many — St. Benedict had 73 to keep the brethren on the straight and narrow. Yet, many golfers who have mastered the runics of the swing have not bothered much to master the simplicities of the rules, kept current by the vigilant fathers of the United States Golf Association and the Royal and Ancient Golf Club of St. Andrews, Scotland.

Most golfers are quite content with a mere acquaintance of the few basics that keep the game civilized — no kicking your opponent's ball into the rough when he's not looking, no stealing the honor on the tee — but after that, it often seems that anything goes. This attitude of abandon is more fitting for sports in which blood lust is an asset — like sparring with broken pool cues. Golf courses are havens for the non-hostile, where umpires and referees are not needed because the players themselves know the rules and obey them.

Is there a finer joy, short of clearing a pond by inches, than assessing an opponent two strokes who (as though playing croquet) strikes your ball on the putting green (breaching rule 35), cleans a muddy ball on the fairway (violating rule 23) or marks a line of flight on a blind shot over a hill (breaking rule 9)?

When calling attention to these rules and their unpleasant penalties, be prepared for pouting or fuming. You will be accused of unmentionable practices. But think of yourself, at such times, as Abraham Lincoln walking back those 10 miles (a distance somewhat exceeding 27 holes of golf) to return the penny. Your mission is honesty.

When someone tells you that you lead a dull life, deep in the sopor of rules and laws, tell them Arnold Palmer probably won the 1958 Masters because he knew the rules. On the par three 12th hole of the final round, on a soggy day in Augusta, Palmer flew the green and the ball imbedded in the back apron. A dispute arose when Palmer claimed he was entitled to a free drop; the official in the green jacket said no. Each was satisfied when Palmer played both a provisional ball, on which he scored three, and his first ball, on which he took a five. The tournament rules men then huddled and determined that Palmer was entitled to a free drop and the three stood.

If the alertness of a Palmer is not sufficiently instructive, consider the wisdom of P.G. Wodehouse, who seldom broke 110. In one of his golf fables, Joseph Poskitt was playing Wadsworth Hemmingway for the President's Cup. On the ninth hole, over water, Poskitt hit one of his "colossal drives." He started to leave the tee but Hemmingway said, "One moment," and asked, "Are you not going to drive?"

" 'Don't you call that a drive?' Poskitt replied.

" 'I do not. A nice practice shot, but not a drive. You took the honor when it was not yours. I, if you recollect, won the last hole. I am afraid I must ask you to play again.'

" 'What?'

" 'The rules are quite definite on this point,' said Hemmingway, producing a well-thumbed volume ...

"Poskitt returned to the tee and put down another ball. There was a splash. 'Playing three,' said Hemmingway. Poskitt drove again. 'Playing five,' said Hemmingway.

" 'Must you recite?' said Poskitt.

" 'There is no rule against calling the score.'

" 'I concede the hole,' said Poskitt."

I had a similar experience once, playing with Bobby Riggs, who knew the rules were there as much for his advantage as for orderly play. We were playing a course on Long Island, when on the first hole I happened to tee my ball ahead of the markers — by a matter of inches. The moment before my backswing, Riggs called out, "wait!" Startled, I paused mid-swing. He sprung to the left marker, pulled it from the ground and moved it ahead by about a foot. "There," he said. "Swing away. You're behind the markers now." It was a subtle move and totally unnerving. My feelings were so vacillating between wonder at his nerve and rage that I sent my drive out of bounds. Riggs won the hole.

The St. Andrew's Scots who wrote the early rules were Calvinists who believed that although a golf course may look like paradise its users are potential wrong doers. Shadows of sneakiness loom in us all, however sunny an aspect we present on the first tee. What is to prevent, say, a threesome of professionals from rigging their scores by signing cards two or three strokes lower than their actual tallies? Strikingly, it

has always been one of the game's distinctions that the golf tour has never had a major cheating scandal. In 1972 Jane Blalock was accused of moving her ball in the rough by some other women on the tour, but the charges were never proven. In fact, she sued, in turn, the Ladies Professional Golfers Association and won a judgment that the LPGA was in violation of the Sherman Antitrust Act for not allowing her to compete in tournaments while her case was pending. In amateur golf, only the Deepdale scandal of the mid-1950s (in which phony handicaps were used by some of the contestants) is a splotch on the sport's purity. I have played with board members of corporations who lied, stole and cheated their way to the top, but who on the fairways were watchful of golf's rules and its etiquette.

Watchfulness goes to the heart of the matter, or at least to the aorta. It is not a great strain, for example, to avoid walking in the line of another's putt. Small effort is needed to keep from moving behind a player as he addresses the ball. And only moderate self-control is required to refrain from hitting into the foursome ahead. All that these standards of basic etiquette ask is that we simply be watchful of the other player, so that what we do on the golf course doesn't make it harder for our partners.

As a boy, I made a point of learning the rules. I would study them in the caddy yard while waiting to be assigned a loop. And, indeed, how often I came to use them. During the course of a round, I would watch closely whoever had matches against those I was caddying for. When I saw a violation, I would call aside my employer and tell him what his opponent had just done. Usually, my man would be glad to get the facts and take action. Occasionally, though, my information was rejected. It would be too embarrassing, some thought. Others feared a stink. Some doubted that the rules made sense. But these were the exceptions. In time, I came to be sought out as a caddy, because my services went beyond merely carrying the clubs and attending the pin. They went directly to the heart of the game — the rules.

It is not by accident that the rules discuss "courtesy on the course" at the top of Section One. When golfers join private country clubs, and fork over high sums for initiation fees and monthly dues, invariably they talk with relief about no longer having to endure public course etiquette. They have something there: behavior on the nation's municipal and public fairways often makes a Route 66 truck stop seem like a well-mannered salon. In the past two decades, many of those taking up the game have been ruffians and rowdies. My suspicions are that golf began attracting the ruck when Arnold Palmer came along. Sitting on the barstools and looking blearily at the corner TV, the unrefined saw Palmer as their model. His thick neck, slashing swing and bullish play became the lightning rod down which the electrified masses slid on their way to the clubhouse. Many brought their rowdiness with them. If they take it any place else, it is when they walk behind the ropes at a tournament in Arnie's Army. There, among shouting and shoving, crudeness and incivility rank high, as General Arnie is cheered on. Pros find it difficult to be paired with Palmer, for he attracts the rabble for whom etiquette, if they know the term at all, connotes questionable chromosomes. Palmer himself is often victimized by his own enthusiasts. I have seen him playing wretched golf only to walk the fairways thick with fans calling out, "Go get'em, Arnie," when all he is capable of getting at that point is another struggle for par.

The point at which many golfers walk away from the rules is when they opt for preferred lies. The advantages of winter rules were intended to apply only when the earth is craggy, pocked by the harshness of the cold and other rudenesses of the winter weather. Such conditions rarely prevail mid-summer. Yet, the winter rules player counters that golf is hard enough without enduring the torment of uncivil real estate; if your Titleist lands in a vulgar piece of turf, move it to a more chaste spot. But rule 16 applies in all seasons: "The ball shall be played as it lies and shall not be purposely touched except that the player may, without penalty, touch his ball with his club in the act of addressing it and except as otherwise provided in the rules of local rules."

The challenge of accepting whatever lie we get is fundamental to the pleasures of golf. To accept the rub of the green, even when we must cross it against the grain, is to bring an objectivity to our play that refreshes the spirit. Once when I had the miffy luck of landing a tee shot in a divot hole, my companion called out, "Move the ball, it's OK. When I land in a divot I'll move mine." How tempting it was — to nudge the ball an inch or two to a tuft of grass waiting since the fourth day of creation for a golf ball to land. But who needs to go easy on themselves while at play? By accepting the conditions of turf on the fairways, you gather respect for yourself. When someone tells you, "Move the ball, it's only a game," answer, "No thanks." It's because golf *is* a game that we can accept its full reality.

In the end, some will always take the preferred lie, as others will ignore the sanctions of other rules. Fidelity to the rules is an acquired skill, and only the few who work at it experience its pleasures. For those who wish to bend the rules, there are always those putt-putt courses next to the truck stops. There, they can shout and stomp until their larynxes loosen when they miss that 10-footer off the sideboard. Amid the traffic and fumes, what could be more appropriate.

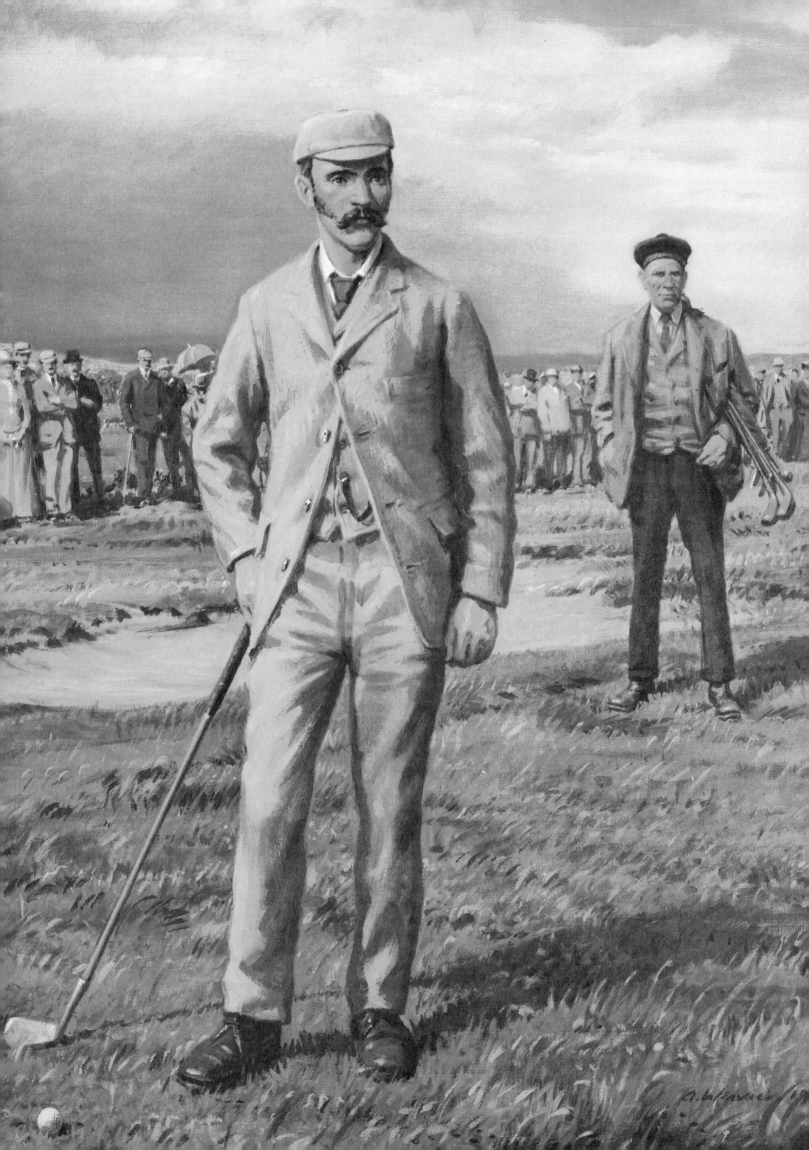

THE PRO

by John Updike

I am on my four-hundred-and-twelfth golf lesson, and my drives still have that pushed little tail, and my irons still take the divot on the wrong side of the ball. My pro is a big gloomy sun-browned man — age about thirty-eight, weight around 195. When he holds a club in his gloved hand and swishes it nervously (the nervousness comes over him after the first twenty minutes of our lesson), he makes it look light as a feather, a straw, a baton. Once I sneaked his 3-wood from his bag, and the head weighed more than a cannonball. "Easy does it, Mr. Wallace," he says to me. My name is not Wallace, but he smooths his clients toward one generic, acceptable name. I call him Dave.

"Easy does it, Mr. Wallace," he says. "That ball is not going anywhere by itself, so what's your hurry?"

"I want to clobber the bastard," I say. It took me two hundred lessons to attain this pitch of frankness.

"You dipped again," he tells me, without passion. "That right shoulder of yours dipped, and your knees locked, you were so anxious. Ride those knees, Mr. Wallace."

"I can't. I keep thinking about my wrists. I'm afraid I won't pronate them."

This is meant to be a joke, but he doesn't smile. "Ride those knees, Mr. Wallace. Forget your wrists. Look." He takes my 5-iron into his hands, a sight so thrilling it knocks the breath out of me. It is like, in the movies we all saw as children (oh, blessed childhood!), the instant when King Kong, or the gigantic Cyclops, lifts the beautiful blonde, who has blessedly fainted, over his head, and she becomes utterly weightless, a thing of sheer air and vision and pathos. I love it, I feel half sick with pleasure, when he

lifts my club, and want to tell him so, but I can't. After four hundred and eleven lessons, I still repress.

"The hands can't *help* but be right," he says, "if the *knees* are right." He twitches the club, so casually I think he is brushing a bee from the ball's surface. There is an innocent click; the ball whizzes into the air and rises along a line as straight as the edge of a steel ruler, hangs at its remote apogee for a moment of meditation, and settles like a snowflake twenty yards beyond the shagging caddie.

"Gorgeous, Dave," I say, with an affectation of camaraderie, though my stomach is a sour churning of adoration and dread.

He says, "A little fat, but that's the idea. Did you see me grunt and strain?"

"No, Dave." This is our litany.

"Did you see me jerk my head, or freeze at the top of the backswing, or rock forward on my toes?"

"No, Dave, no."

"Well then, what's the problem? Step up and show me how."

I assume my stance, and take back the club, low, slowly; at the top, my eyes fog over, and my joints dip and swirl like barn swallows. I swing. There is a fruitless commotion of dust and rubber at my feet. "Smothered it," I say promptly. After enough lessons, one learns the terminology. The whole process, as I understand it, is essentially one of self-analysis. The pro is merely a catalyst, a random sample, I have read somewhere, from the grab bag of humanity.

He insists on wearing a droll porkpie hat from which his heavy brown figure somehow downflows; his sloping shoulders, his hanging

WILLIE PARK, JR.
by Arthur Weaver, 1989

arms, his faintly pendulous belly, and his bent knees all tend toward his shoes, which are ideally natty — solid as bricks, black and white, with baroque stitching, frilled kilties, and spikes as neat as alligator teeth. He looks at me almost with interest. His grass-green irises are tiny, whittled by years of concentrating on the ball. "Loosen up," he tells me. I love it, I clench with gratitude, when he deigns to be directive. "Take a few practice swings, Mr. Wallace. You looked like a rusty mechanical man on that one. Listen. Golf is an effortless game."

"Maybe I have no aptitude," I say, giggling, blushing, hoping to trap him with the humility bit.

He is not deflected. Stolidly he says, "Your swing is sweet. When it's there." Thus he uplifts me and crushes me from phrase to phrase. "You're blocking yourself out," he goes on. "You're not open to your own potential. You're not, as we say, *free.*"

"I know, I know. That's why I'm taking all these expensive lessons."

"Swing, Mr. Wallace. Show me your swing."

I swing, and feel the impurities like bubbles and warps in glass: hurried backswing, too much right hand at impact, failure to finish high.

The pro strips off his glove. "Come over to the eighteenth green." I think we are going to practice chipping (a restricted but relaxed pendulum motion) for the fiftieth time, but he says, "Lie down."

The green is firm yet springy. The grounds crew has done a fine job watering this summer, through all of the drought. Not since childhood have I lain this way, on sweet flat grass, looking up into a tree, branch above branch, each leaf distinct in its generic shape, as when, in elementary school, we used to press them between wax paper. The tree is a sugar maple. For all the times I have tried to hit around it, I never noticed its species before. In the fall, its dried-up leaves have to be brushed from the line of every putt. This spring, when the branches were tracery dusted with a golden budding, I punched a 9-iron right through the

crown and salvaged a double bogey.

Behind and above me, the pro's voice is mellower than I remember it, with a lulling grittiness, like undissolved sugar in tea. He says, "Mr. Wallace, tell me what you're thinking about when you freeze at the top of your backswing."

"I'm thinking about my shot. I see it sailing dead on the pin, hitting six feet short, taking a bite with lots of backspin, and dribbling into the cup. The crowd goes *ooh* and cheers."

"Who's in the crowd? Anybody you know personally?"

"No ... wait. There is somebody. My mother. She has one of those cardboard periscope things and shouts out, 'Gorgeous, Billy!'"

"She calls you Billy."

"That's my name, Dave. William, Willy, Billy, Bill. Let's cut out this Mr. Wallace routine. You call me Bill, I'll call you Dave." He is much easier to talk to, the pro, without the sight of his powerful passionless gloom, his hands (one bare, one gloved) making a mockery of the club's weight.

"Anybody else you know? Wife? Kids?"

"No, my wife's had to take the babysitter home. Most of the kids are at camp."

"What else do you see up there at the top of the backswing?"

"I see myself quitting lessons." It was out, *whiz,* before I had time to censor. Silence reigns in the leafy dome above me. A sparrow is hopping from branch to branch, like a pencil point going from number to number in those children's puzzles we all used to do.

At last the pro grunts, which, as we said, he never does. "The last time you were out, Mr. Wallace, what did you shoot?"

"You mean the last time I kept count?"

"Mm."

"A hundred eight. But that was with some lucky putts."

"Mm. Better stand up. Any prolonged pressure, the green may get a fungus. This bent grass is hell to maintain." When I stand, he studies me, chuckles, and says to an invisible attendant, "A hundred eight, with a hot putter

yet, and he wants to quit lessons."

I beg, "Not quit forever — just for a vacation. Let me play a few different courses. Get out into the world. Maybe even try a public course. God knows, even go to a driving range and whack out a bucket's worth. Learn to live with the game I've got. Enjoy life."

His noble impassivity is invested with a shimmering, twinkling humorousness; his leathery face softens toward a smile, and the trace of a dimple is discovered in his cheek. "Golf is life," he says softly, and his green eyes expand, "and life is lessons," and the humps of his brown muscles merge with the hillocks and swales of the course, whose red flags prick the farthest horizon, and whose dimmest sand traps are indistinguishable from galaxies. I see that he is right, as always, absolutely; there is no life, no world, beyond the golf course — just an infinite and terrible falling-off. "If I don't give *you* lessons," he is going on, "how will I pay for *my* lessons?"

"*You* take lessons?"

"Sure. I hook under pressure. Like Palmer. I'm too strong. Any rough on the left, there I am. You don't have that problem, with your nice pushy slice."

"You mean there's a sense," I ask, scarcely daring, "in which *you* need *me*?"

He puts his hand on my shoulder, the hand pale from wearing the glove, and I become a feather at the touch, all air and ease. "Mr. Wallace," he says, "I've learned a lot from your sweet swing. I hate it when, like now, the half hour's up."

"Next Tuesday, eleven-thirty?"

My pro nods solemnly. "We'll smooth out your chipping. Here in the shade."

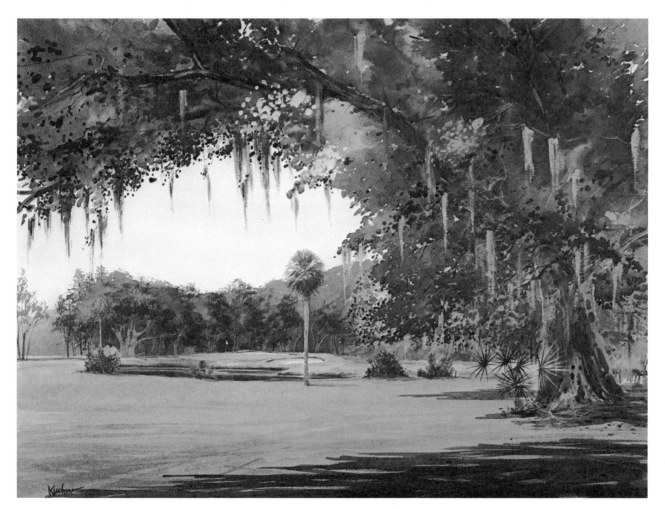

HOLE # 13, OCEAN GOLF COURSE, SEA PINES PLANTATION
by Paul Kuchno

DR. GOLF

by Judd Arnett

As promised (or threatened), your commentator put his poor, debilitated golf swing on a stretcher this past week end, stuck a lily in its palsied hand and hauled it out to the Pine Lake Country Club, where Dr. Elmer Prieskorn, the resident specialist, has been treating hooks, slices, shanks and chili-dips for 15 years.

In the great and vexing realm of golf, Dr. Prieskorn is to his profession what Dr. Benjamin Spock is to pediatrics. While others dash around the country in search of glory and loot, Dr. Elmer stays home and tends the store and administers to the needs of his members. He has probably looked down the throats of 5,000 lousy golf swings in his career, improving most and burying only a few. He is, in short, a patient man and a splendid teacher.

Your commentator went to him on Saturday and Sunday as the result of an experience in late March which has now become known as The Ordeal At Pinehurst.

That week in North Carolina became so full of frustration and anguish that on Thursday morning, upon donning his gear and contemplating the sun-bathed greens and fairways, an announcement was made: "Honest-to-Pete, I would rather go to work!" This so alarmed your commentator's companions — Monta Cox, Robert Hefty and Jerry Rideout — that they immediately applied artificial resuscitation and began offering torrents of solace and advice. Up to that point, they had been content to titter and take the money.

Mr. Hefty, who hits the ball like a shipwright driving home a cold rivet, was of the opinion that I was not playing the ball far enough forward. "You must position it opposite the little toe on your left foot," he said, "and that way you will hit on the upswing." I tried one from that stance and knocked it so far into the woods on the left that it was declared unplayable in Virginia.

Mr. Cox, who was last off the fairway in 1965 — he even misses 'em straight — then delivered a very learned lecture on the golf swing, pointing out that it is not a perfect arc, as commonly believed, but is, instead, flat on the bottom.

"The trouble with you," he said, "is that you swing in too much of a circle. As a result you strike the ball above the equator and hammer it into the ground. You gotta flatten out on the bottom, Arn, and then you will be right back in the old groove." I tried this, with amazing results; whereas I had been taking small divots, now I began digging trenches. For 18 holes I was a one-man excavating company, complete with steam shovel.

Which left it up to Mr. Rideout, about whom you should remember one thing: a few years ago he hit his irons lefthanded and his woods righthanded. Anyone who would take advice from a crazy, mixed-up guy like that has to be on the verge of complete collapse.

"Your principal difficulty," he said, "is that you are not taking the club back in one piece, so to speak. You have lost co-ordination, Arn. Your hands and arms are fighting each other and I don't think there is any hope for you. Maybe the best thing we can do is have a memorial service for your swing at the first tee and then you can come along and keep score, paying whoever wins the usual Nassau." As you can see, Mr. Rideout is all heart.

Well sir, I would take the persimmon in hand and stand there on the tee, knowing full well that disaster impended, and you could hear a rustling in the grass as the bugs, spiders, worms and crickets scurried for cover. "Grounder coming!" they would call to each other, galloping right and left, and they were oh, so right. But it would not be just an ordinary grounder, but a hooked grounder sizzling with enough top-spin to propel it into a stand of three or four hundred pine trees. Holy Toledo!

That, in brief, is what your commentator put on the doorstep of Dr. Elmer Prieskorn the past week-end, and he took one look at it, clapped hand to brow and called for oxygen. It was, he said later, a near thing ...

For what had happened was that in an effort to gain extra distance your commentator had fallen into a flat swing and a humped left wrist. The latter is a bit difficult to describe — but beware of it. For it brings the club face into the ball in a closed position and absolutely guarantees the dad-burndest knee-high hook you ever saw.

Convalescence will be long and painful, Dr. Prieskorn says, but the chances of survival are fair.

SEVE

by Lawrence N. Levy

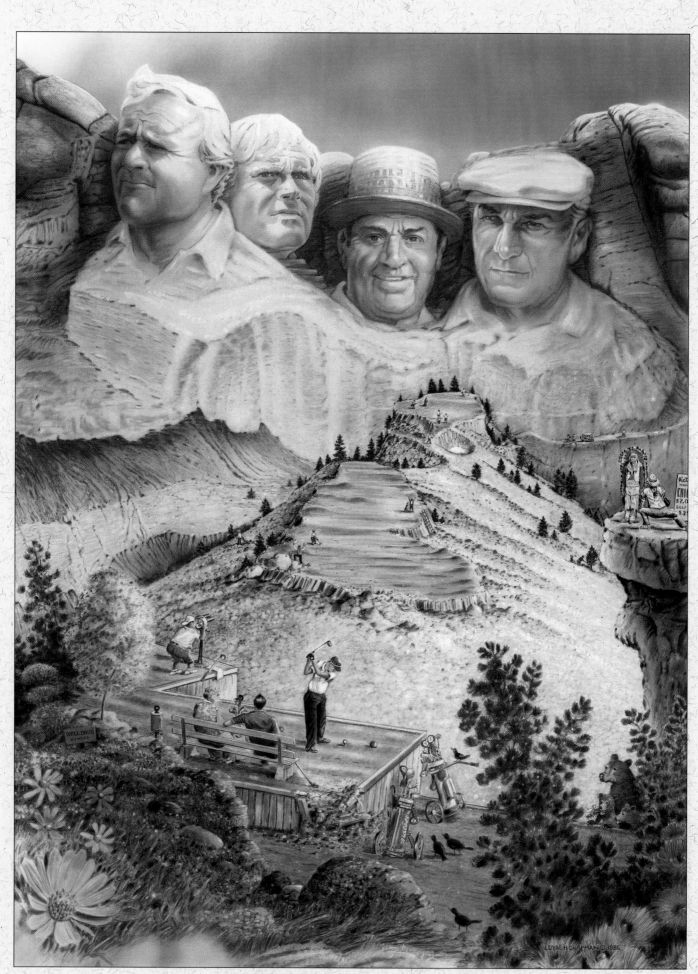

MOUNT RUSHMORE NATIONAL PUBLIC LINKS
by Loyal H. Chapman, 1986

WHIMSICAL

◆

GOLF-MANIA!

by A.S. Gardiner

Golf is an excellent form of recreation, but even its warmest advocates must admit that its devotees are somewhat trying when they get together in a mixed company and start talking of their recent achievements and misfortunes on the links. I have travelled in a railway carriage with three men who, to my knowledge, are atrociously bad players, but who have clamoured in competition for an hour at a stretch about clubs, bunkers, drives, and so forth. A couple of years ago I saw a man crossing Gracechurch Street at the Eastcheap end, and making an imitation golf drive with his umbrella, and this at midday. That must have been an uncommonly bad case, but there is no doubt that golf enthusiasts are too much inclined to fall into the temptation to think and talk of their favourite pastime without regard to their surroundings. Ruskin says that "the moment a man can really do his work he becomes speechless about it." Accepting this statement as a somewhat exaggerated representation of the truth, I suppose it has been my ill-fortune to meet only novices so far as golf is concerned.

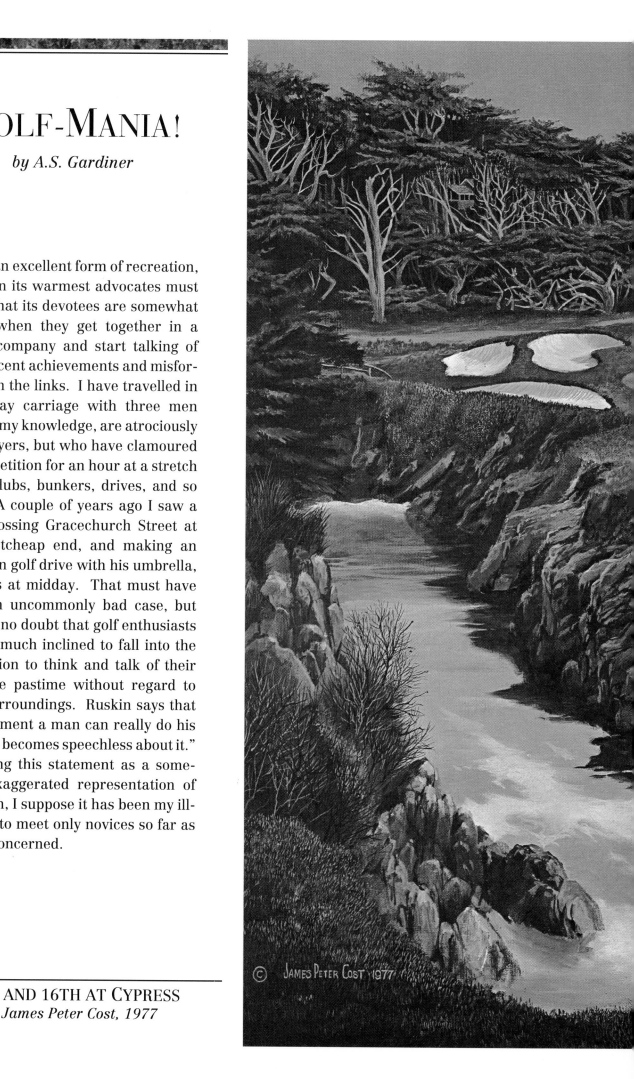

15TH AND 16TH AT CYPRESS
by James Peter Cost, 1977

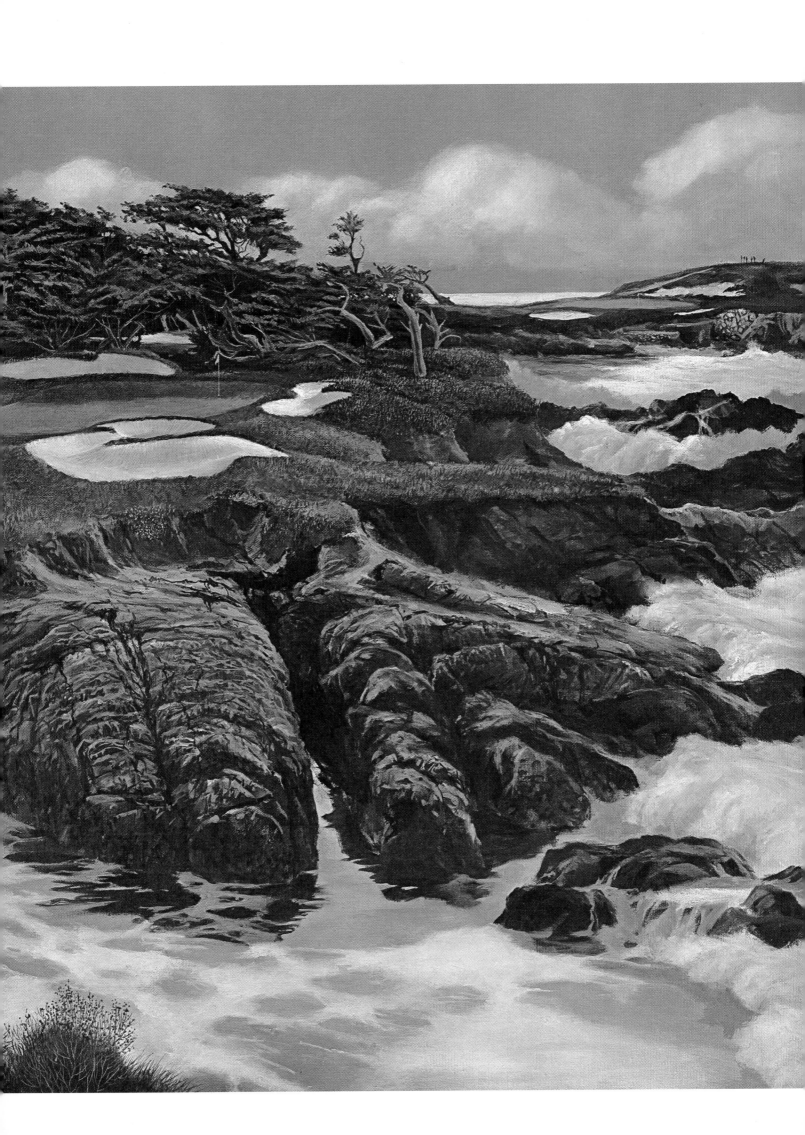

Concerning Curses

by Lord Balfour

Expletives more or less vigorous directed against himself, the ball, the club, the wind, the bunker, and the game, are the most usual safety-valve for the fury of the disappointed golfer. But bad language is fortunately much gone out of use; and in any case the resources of profanity are not inexhaustible. Deeds, not words, are required in extreme cases to meet the exigencies of the situation; and, as justice, prudence, and politeness all conspire to shield his opponent from physical violence, it is on the clubs that under these circumstances vengeance most commonly descends. Most players content themselves with simply breaking the offending weapon against the ground. But some persons there are whose thirst for revenge cannot be satisfied by any such rapid or simple process. I have been told of one gentleman who threw the offending club upon the ground, and then with his niblick proceeded to punish it with piecemeal destruction, breaking its shaft into small pieces very much as criminals used to be broken upon the wheel. Even this procedure seemed inadequate to one infuriated golfer of whom I have heard. A shaft, be it broken into ever so many fragments, can be replaced and the implement be as good as new. Nothing less than destroying both head and shaft can ensure its final disappearance from the world of golf. The club must not merely be broken, but must be destroyed, and from its hated remnants no new race must be permitted to arise for the torment and discomfiture of succeeding generations of golfers. This perfect consummation can, it is said, be attained by holding the club upright, the head resting on the ground, then placing one foot upon it and kicking it with the other, just at the point where head and shaft are bound together. By this simple expedient (which I respectfully commend to the attention of all short-tempered golfers) a "root and branch" policy may be effectually carried out by destroying at one stroke both the essential parts of the club.

Boyne Highlands, # 18
by Brian Morgan

THE GUEST

Anonymous

All his life, a dignified English barrister-widower with a considerable income had dreamed of playing Sandringham (one of Great Britain's really exclusive golf courses) and one day he made up his mind to chance it when he was travelling in the area. Although he was well aware that it was very exclusive, he asked at the desk if he might play the famous course. The Secretary inquired, "Member?"

"No, Sir."

"Guest of a member?"

"No, Sir."

"Sorry," the Secretary said.

As he turned to leave, the lawyer spotted a slightly familiar figure seated in the lounge, reading the Times. It was Lord Wellesby Parham. He approached and bowing low, said, "I beg your pardon, your Lordship, but my name is Higginbotham of the London law firm of Higginbotham, Willoughby and Barclay. I should like to ask a huge favor, really — if I might play this delightful course as your guest?"

His Lordship gave Higginbotham a long look, put down his paper and asked,

"Church?"

"Episcopalian, sir. And my late wife, Church of England."

"Education," the old gentleman asked.

"Eton, sir, and Oxford — magna cum laude."

"Athletics?"

"Rugby, sir, spot of tennis, and rowed number four oar on the crew that beat Cambridge."

"Military?"

"DCCE, sir, Coldstream Guards, Victoria Cross, Knight of the Garter."

"Campaigns?"

"Dunkirk, El Alamein, Normandy, sir."

"Languages?"

"Private tutor in French, fluent German and a bit of Greek."

His Lordship considered briefly, then nodded to the club Secretary and said ... "Nine Holes."

THE GOLFERS
by Charles Lees, 1850
(overleaf)

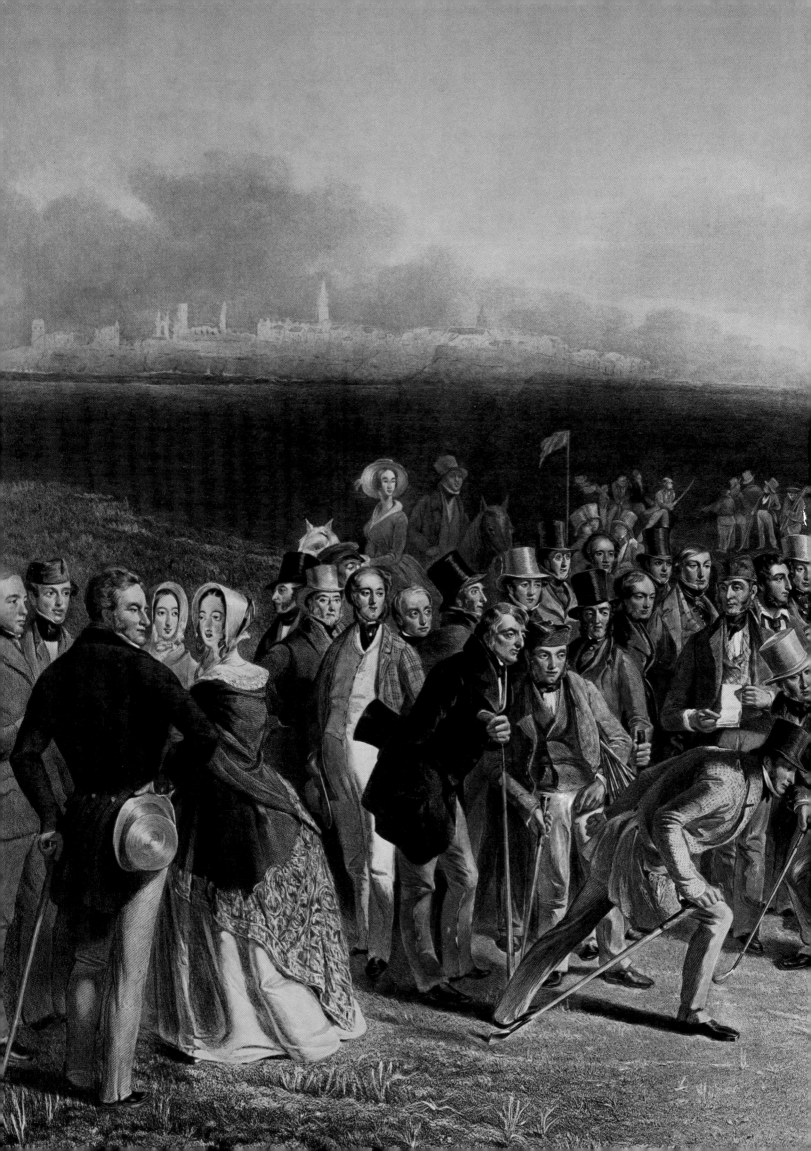

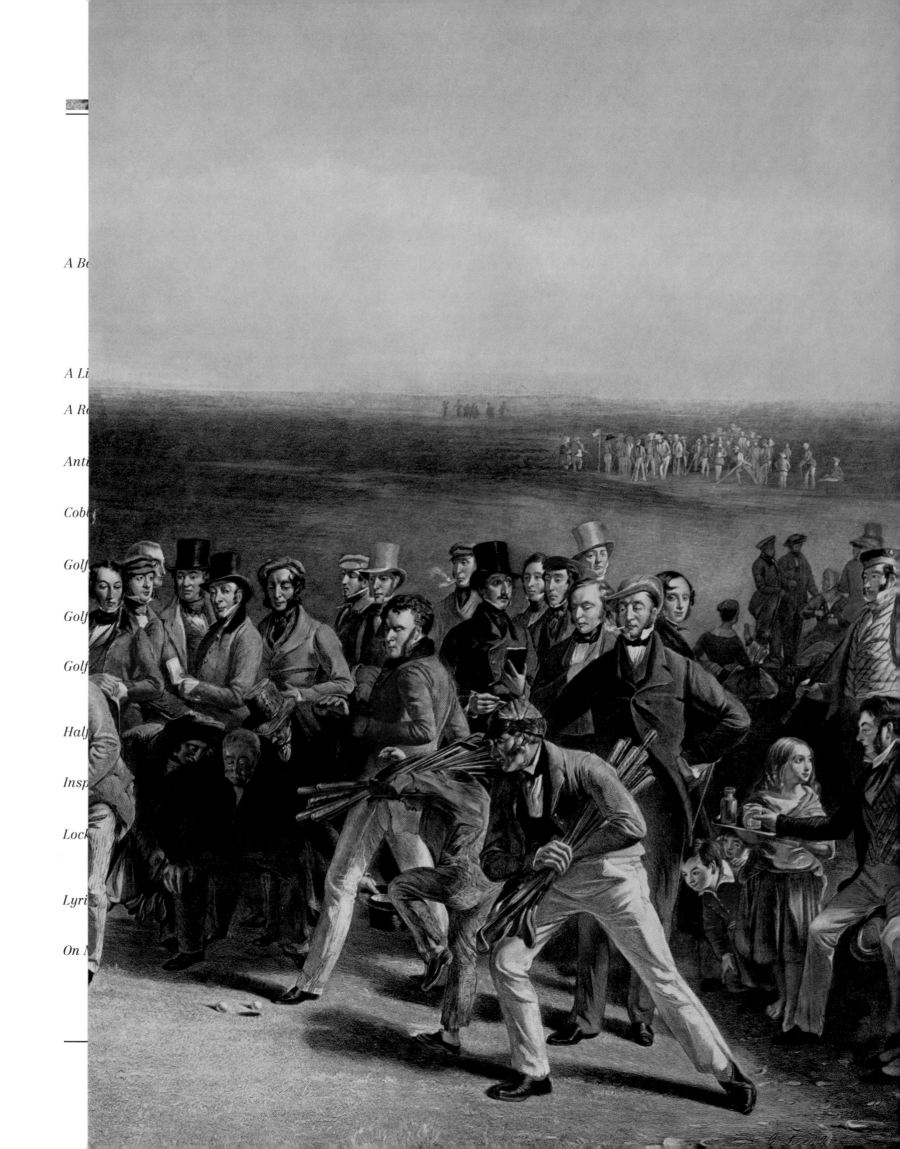

A Bo

A Li

A R

Anti

Cob

Golf

Golf

Golf

Half

Insp

Lock

Lyri

On

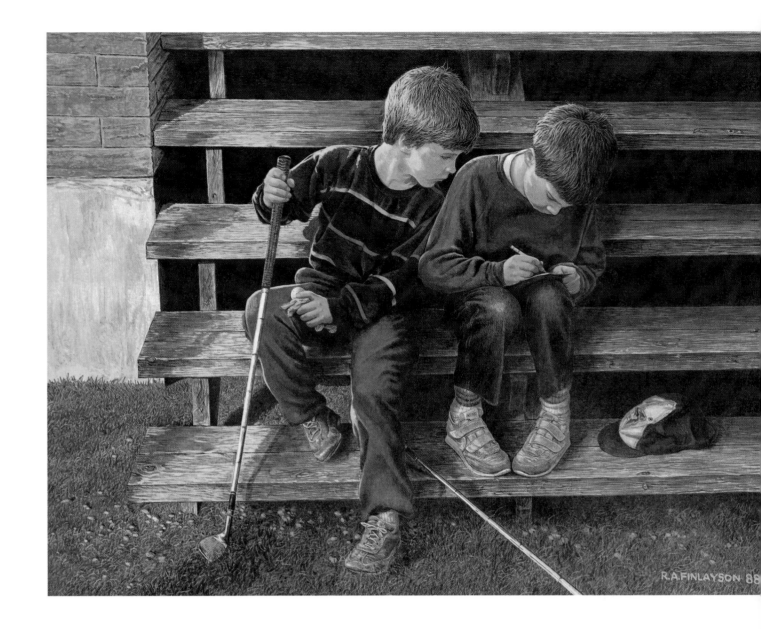

A

Abbot, L.F., 1790 (Mr. William Innes), 162
"A Brighter World," Jesse G. Clare, 193
A Cabinet Minister's Holiday (Artist Unknown), 176
"A Course to Try Men's Souls," Jospeh C. Dey, 1978, 90-93
"A Cure," Anonymous, 130
Adams, Douglas, (A Difficult Bunker), 122-123, (The Drive) 200-201
"Address to St. Andrews," Anonymous, 95
A Difficult Bunker, (Douglas Adams), 122-123
"A Dude Game?", Philadelphia Times, Feb. 24, 1889, 123
"Advice to Beginners," Horace G. Hutchinson, 216
"A Golf Song," Rose Champion de Crespigny, 37
"A Golfer's Wish," Edgar A. Guest, 191
"A Golfing Song," James Ballantine, 88
A Little Practice, (W. Dendy Sadler, 1915), 2
"An Ode to St. Andrew," W.A. Campbell, 94
Arnett, Judd, "Dr. Golf," 225
Augusta #11, (Mark King), 174-175
Augusta National #12 (Gordon Wheeler, 1989), 138
Autumn at Muirfield, (James Peter Cost, 1977), 15
Awarding the First USGA Trophy — 1895, (Leland Gustavson), 128
"A Woman's Way," A.W. Tillinghast, 1915, 134-137

B

Balfour, Lord, "Concerning Curses," 230
"Ballade of the Royal Game of Golf," Andrew Lang, 79
Ballantine, James, "A Golfing Song," 88
Barclay, R., "The Golfing Ghost," 173
Barkow, Al, "Hey, Flytrap," 71
Barton, Paul, (The Wave Hole #16), 155, (The Dragon Hole) 156, (The Mermaid Hole #11), 157
Batchelor, Gerald, 1914, "If the Beasts Played Golf," 31
Baxter, Graeme, 1988, (Old Course St. Andrews), 93 (The Gleneagles Hotel — Kings Course, Scotland), 153
Bensley, Mick, (The Home of Golf), 90
Bishop, Jim, "The Happy Hacker," 113-114
Bitting, W.C., "Golf Links," 16
Blair, John, (St. Andrews, 1891), 21
Bobby Jones, (Bob Crofut, 1988), 104
Boinet, Karen, (The Bag, 1987), 51, (Playing Through), 70, (Fair Play), 183
Bonnelle, Frank J., "Fascination," 69, "Silence at the Tee," 184, "The Village Golfer," 199
Boulder's Saguaro #9, (Jim Moriarty), 142-143
Boyne Highlands Heather #5, (Brian Morgan), 230
Boyne Highlands #18, (Brian Morgan), 230
Brock, Charles Edmond, (The Drive), 83
Brown, Michael, (Open Championship, St. Andrews), 94-95, (Untitled), 195
Browning, Robert, 1910, "My Better Self," 62, "Wordsworth Re-Worded," 106, "The Threesome," 133

C

Campbell, W.A., "An Ode to St. Andrew," 94
Cannes Travel Poster, (Artist Unknown), 145
Carey, Chip, (Sugarloaf #11), 208
Carmel Valley Ranch from the 13th (James Peter Cost, 1984), 150-151
Caught in the Rough, (Ken Smith), 31
Chapman, Loyal H., (Mt. Rushmore National Public Links), 226
Clare, Jesse G., "A Brighter World," 193
Collins, Audrey Diebel, "The Greater Joys," 144
"Concerning Curses," Lord Balfour, 230
Coop, Dr. Richard H., 1989, "Golf as Therapy," 214-215
Cortissoz, Royal, 1922, "On Dufferdom," 100-102, "On Making a Hole in One," 171-172, "On the Devil in Golf," 182-183

Cost, James Peter, (Autumn at Muirfield), 13, (8th Hole Pebble Beach), 29, (Carmel Valley Ranch from the 13th), 150-151, (15th and 16th at Cypress), 228-229
Crofut, Bob, 1988, (Bobby Jones), 104
"Crystal Among the Gems," Tom Stewart, 146-148
Crystal Downs #8, (Tom Doak), 148
Crystal Downs #13, (Tom Doak), 147
Curtis Strange, Open '88, (Lawrence N. Levy), 167
Cypress Pt. #16, (Jim Moriarty), 68

D

Dacey, Bob, 1987, (Invitational), 132, (Tournament), 188
de Crespigny, Rose Champion, "A Golf Song," 37
Dey, Joseph C., 1978, "A Course to Try Men's Souls," 90-93
Disgusted Caddie, (Norman Orr), 65
Doak, Tom, (Crystal Downs #13), 147, (Crystal Downs #8), 148, "Dr. Golf," Judd Arnett, 225
Dollman, J.C., 1896, (The Sabbath Breakers), 130-131
Duffer's Yet, (Artist Unknown), 100

E

Earle, L., (The Bogey Man), 67
8th Hole Pebble Beach, (James Peter Cost), 29
Elk River #8, (Brian Morgan), 25

F

Fair Play, (Karin Boinet), 183
"Fascination," Frank J. Bonnelle, 69
"Favete Linguis," Arnold Haultain, 43
Finlayson, R.A., 1988, (The Fishing Hole), 53, (That's 9 Not 10!), 236
15th and 16th at Cypress, (James Peter Cost), 228-229
Forbes, Bart (Untitled), 48
Forgan, David R., "Golf," 234
Fowler, Clement, 1913, (The Triumvirate), 17
Francis D. Ouimet Wins United States Open Title, 1913, (Leland Gustavson), 206-207
French Open, 1983, (Lawrence N. Levy), 33
Frost, A.B., (Untitled), 62, (Hooked), 115, (Good Form), 190, (Saturday Afternoon), 198
"Fun, Friends and Play," Tom Stewart, 1985, 52
Furmanski, Ralph, (Par Shooter), 42

G

Gardiner, A.S., "Golf-Mania!", 228
Ginger Beer, William Blake Lamond, 98
"Golden Rules of Golf," Anonymous, 206
"Golf," Anonymous, 28
"Golf," David R. Forgan, 234
"Golf," The Oxford Dictionary, 1814, 85
Golf, (Frank Gude, 1988), 54
Golf, (Lepas), 111
Golf, (Chuck Wilkinson), 136
"Golf as Therapy," Dr. Richard H. Coop, 1989, 214-215
"Golfer's Ballade for Autumn," Clinton Scollard, 209
Golf Boy, (C. Spiegle, 1900), 204
"Golfer's Hymn," E.W. Stansbury, 39
"Golf in the Kingdom," Michael Murphy, 160
"Golf Links," W.C. Bitting, 16
"Golf-Mania!", A.S. Gardiner, 228
Golf Player, (Frank Gude), 211
"Golf Prints: A Visual Link to the Traditions of the Royal and Ancient Game," John M. Olman, 80-82
"Golf: The Esperanto of Sport," Lorne Rubenstein, 32-35
Good Form, (A.B. Frost), 190
Grant of Glenmorrison, (R.R. McIan, 1847), 40

THAT'S 9 NOT 10!
by R.A. Finlayson, 1988

Gude, Frank, 1988, (Golf), 54, (Golf Player), 211
Guest, Edgar A., "A Golfer's Wish," 191
Gustavson, Leland, (The Old Apple Tree Gang, 1988), 106, (Awarding the First USGA Trophy — 1895), 128, (Robert Tyre Jones Jr., 1930), 184, (The First Clubhouse in America 1892), 192-193, (Francis D. Ouimet Wins United States Open Title, 1913), 206-207

H

Haultain, Arnold, ""The Mystery of Golf," 3, "Photo Essay," 22-23, Favete Linguis," 43, "The Drama of Golf," 72
Heather Hole, (Artist Unknown), 56-57
Heller, Steve, "The Player and the Giant," 109-112
"Hey, Flytrap," Al Barkow, 71
"Hiawatha on the Links," 96
Hogan, Chuck, 1987, "Where's This (Your) Game Going?", 166-168
Hole #13, Ocean Golf Course, Sea Pines Plantation, (Paul Kuchno), 223
Hooked, (A.B. Frost), 115
Horace Hutchinson, (Sir Leslie Ward), 81
Hoylake, (Sir Leslie Ward), 165
Humphrey, Maud, (One Putt), 196, (Ted), 89
Hutchinson, Horace G., "Advice to Beginners," 216

I

Ian Woosnam, (Lawrence N. Levy), 23
"If the Beasts Played Golf," Gerald Batchelor, 1914, 13
In Clover, (Artist Unknown), 39
"In Search of the Perfect Pro-Am," Ben Wright, 125-127
Invitational, (Bob Dacey, 1987), 133
Iona Golf & Grazing Grounds, (Jan Vandenbrink), 202
Irving, Minna, "The Golf Girl," 197

J

"Jinx's Office," A.W. Tillinghast, 194
Josset, Lawrence, (St. Andrews 1800), 84

K

"Keep the Rules and They Keep You," Colman McCarthy, 218-219
Keller, A.J., 1900, (Mixed Foursome), 7
King, Mark, (Augusta #11), 174-175
Kipling, Rudyard, "The Sages on the Links," 210-211
Kuchno, Paul, (Hole #13, Ocean Golf Course, Sea Pines Plantation), 223

L

Lamond, William Blake, (Ginger Beer), 98
Lang, Andrew, "Ballade of the Royal Game of Golf," 79
Lardner, Ring W., "The Golfer's Prayer," 207
Leach, Henry, "The Great Mystery," 64-65, "The Spirit of Hope," 149
Lees, Charles, 1850, (The Golfers), 230-231
Legends Remembered, (Kenneth Reed FRSA), 186-187
Lepas, (Golf), 111
Levy, Lawrence N., (Royal County Down), 22, (Ian Woosnam), 23, (French Open, 1983), 33, (Swiss Open, 1983), 34, (Spanish Open, 1987), 35, (Curtis Strange, Open '88), 167, (Seve), 224
Locker Room Ballads, "Theories," 195
"Lost Ball," Anonymous, 115

M

Mac Foozle, Chief of the Clan, (Artist Unknown), 100
"Making the Shot, Taking the Shot," Jim Moriarty, 141-142
March, Thomas, "The Story of a Tee-Club," 48-49

McCarthy, Colman, "Keep the Rules and They Keep You," 218-219
McIan, R.R., 1847, (Grant of Glenmorrison), 40
Mixed Foursome, (A.J. Keller, 1900), 7
Moore, Charles W., 1929, "The Mental Hazards of Golf," 179-181 "Why Does the Golfer 'Look Up?' ", 185
Morgan, Brian, (Treetops #6 Gaylord, MI), 4, (Teeth of the Dog #16), 22, (Elk River #8), 25, (Boyne Highlands Heather #5), 64, (Boyne Highlands #18), 230
Moriarty, Jim, (Strange, U.S. Open 1988), 23, (Untitled), 23, (Cypress Pt. #16), 68, (Turtle Point, #14), 97, (Pebble Beach, #7), 120-121, (Pine Valley #2), 140, (16th at Cypress), 141, "Making the Shot, Taking the Shot," 141-142, (Boulder's Saguaro #9), 142-143, (Sun Valley #7), 168-169
Morrisey, Tom, "Out of the Depths," 117-119
Morse, Tony, "Walking and Golf," 150-153
Moss, Donald, (The 15th at Oakmont), 72
Mr. William Innes, (L.F. Abbott, 1790), 162
Mt. Rushmore National Public Links, (Loyal H. Chapman), 224
Muirhead, Desmond, "On Creating Golf Holes," 154-157
Murphy, Michael, "The Game's Hidden But Accessible Meaning," 44-47, "Golf in the Kingdom," 160,
"My Better Self," Robert Browning, 1910, 62

N

Nowak, William A., 1988, "Par Four, Dogleg Left," 66

O

Obstacle Course, (Gary Patterson), 117
Old Course, St. Andrews, (Graeme W. Baxter, 1988), 93
Olman, John M., "Golf Prints: A Visual Link to the Traditions of the Royal and Ancient Game," 80-82
"On Creating Golf Holes," Desmond Muirhead, 154-157
"On Making a Hole in One," Royal Cortissoz, 1922, 171-172
"On the Devil in Golf," Royal Cortissoz, 1922, 182-183
One Putt, (Maud Humphrey), 196
Open Championship, St. Andrews, (Michael Brown, 1895), 94-95
Orr, Norman, (Disgusted Caddie), 65
"Out of the Depths," Tom Morrisey, 117-119

P

"Par Four, Dogleg Left," William A. Nowak, 1988, 66
Par Shooter, (Ralph Furmanski), 42
Patterson, Gary, (Obstacle Course), 117
Pebble Beach #7, (Jim Moriarty), 120-121
"Perfection," John Thomson, 200
"Photo Essay," Arnold Haultain, 22-23
Pine Valley #2, (Jim Moriarty), 140
Playing Through, (K. Boinet, 1986), 70
Poxon, Frank, "The Best Game," 38

R

Radler, Mil, (The "Postage Stamp") 160-161
Reed, Kenneth, FRSA, (Legends Remembered), 186-187
"Reflections," Anonymous, 202
Richards, F.T., 1901, (The Royal Game of Golf), 79
River Scene in Winter, (Aert Vander Neer), 76
Robert Tyre Jones, Jr., 1930, (Leland Gustavson), 184
Royal County Down, (Lawrence N. Levy), 22
Royal Lytham & St. Annes, (Bill Waugh, 1988), 172
Rubenstein, Lorne, "Golf: The Esperanto of Sport," 32-35

S

Sadler, W. Dendy, 1915, (The Stymie), 1, (A Little Practice), 2
St. Andrews, 1891, (John Blair), 21
St. Andrews, 1800, (Lawrence Josset), 84
Saturday Afternoon, (A.B. Frost), 198

Schon, Leslie, 1923, "A Vindication of the Theorist," 177-178
Scollard, Clinton, "Golfer's Ballade for Autumn," 209
Sentry World #6, (Artist Unknown), 22
Seve, (Lawrence N. Levy), 224
Shed, (Sunrise Golfer), 37
"Silence at the Tee," Frank J. Bonnelle, 184
Simpson, Sir W.G., 1887, "The Origin of Golf," 78,
 "The Praise of Golf," 24-27
16th at Cypress, (Jim Moriarty), 141
Smith, Carlyle, "The Secret of Golf," 164
Smith, Ken, (Caught in the Rough), 31
Smith, Linda Jane, (The Nineteenth Hole), 86-87
Spanish Open, 1987, (Lawrence N. Levy), 35
Spiegle, C., (Golf Boy), 204
Stansbury, E.W., "Golfer's Hymn," 39
Stewart, Tom, "Crystal Among the Gems," 146-148, "Fun,
 Friends and Play," 52
Strange, U.S. Open 1988, (Jim Moriarty), 23
Sugarloaf #11, (Chip Carey), 208
Sunrise Golfer, (Shed), 37
Sun Valley #7, (Jim Moriarty), 168-169
Swiss Open, 1983, (Lawrence N. Levy), 34

T

Taylor, Joshua, 1920, "The Song of the Iron," 50-51, "The Real
 Golfer," 103-105,
Ted, (Maud Humphrey, 1897), 89
Teeth of the Dog #16, (Brian Morgan), 22
That's 9 Not 10!, (R.A. Finlayson), 236
"Theories," Locker Room Ballads, 195
The Bag, (Karen Boinet, 1987), 51
The Ballesteros Hole, (W.K. Waugh, 1987), 217
"The Best Game," Frank Poxon, 1922, 38
The Bogey Man, (L. Earle), 67
"The Call of the Masters," Herbert Warren Wind, 1962,
 158-159
"The Conquering Hero," Gerald Batchelor, 1914, 129
The Dragon Hole, (Paul Barton), 156
"The Drama of Golf," Arnold Haultain, 72
The Drive, (Charles Edmond Brock), 83
The Drive, (Douglas Adams, 1893), 200-201
The 15th at Oakmont, (Donald Moss), 72
The First Clubhouse in America 1892, (Leland Gustavson),
 192-193
The Fishing Hole, (R.A. Finlayson, 1988), 53
The Flower Hole #16, (Margaret Tvedten, 1988), 127
"The Game's Hidden But Accessible Meaning,"
 Michael Murphy, 44-47
The Girl With a Golf Club, (Artist Unknown, 1595), 74
The Gleneagles Hotel – Kings Course, Scotland (Graeme W.
 Baxter, 1988), 153
"The Golf Girl," Minna Irving, 197
The Golfers, (Charles Lees, 1850), 230-231
"The Golfer's Garland," Anonymous, 76-77
"The Golfer's Prayer," Ring W. Lardner, 207
"The Golfing Ghost," R. Barclay, 173
"The Great Mystery," Henry Leach, 64-65
"The Greater Joys," Audrey Diebel Collins, 144
"The Guest," Anonymous, 231
"The Happy Hacker," Jim Bishop, 113-114
The Home of Golf, (Mick Bensley), 90
"The Joy of Golf," The Times of London, October 5, 1874, 20
"The Mental Hazards of Golf," Charles W. Moore, 1929, 179-
 181
The Mermaid Hole #11, (Paul Barton), 157
"The Mystery of Golf," Arnold Haultain, 3
The Nineteenth Hole, (Linda Jane Smith), 86-87
"The Object of the Game," Anonymous, 87
The Old Apple Tree Gang, 1888, (Leland Gustavson), 106
"The Origin of Golf," Sir W.G. Simpson, 1887, 78

The Oxford Dictionary, 1814, "Golf," 85
"The Player and The Giant," Steve Heller, 109-112
The "Postage Stamp," (Mil Radler), 160-161
"The Praise of Golf," Sir W.G. Simpson, 1887, 24-27
"The Pro," Anonymous, 217
"The Pro," John Updike, 221-223
"The Real Golfer," Joshua Taylor, 1920, 103-105
The Royal Game of Golf, (F.T. Richards, 1901), 79
The Sabbath Breakers, (J.C. Dollman, 1896), 130-131
"The Sages on the Links," Rudyard Kipling, 210-211
"The Secret of Golf," Carlyle Smith, 164
"The Song of the Iron," Joshua Taylor, 1920, 50-51
"The Soul of Golf," P.A. Vaile, 55
"The Spirit of Hope," Henry Leach, 149
"The Story of a Tee-Club," Thomas March, 48-49
The Stymie, (W. Dendy Sadler, 1915), 1
"The Threesome," Robert Browning, 1910, 132
The Triumvirate, (Clement Fowler, 1913), 17
The Two MacDonalds, (Artist Unknown), 77
"The Village Golfer," Frank J. Bonnelle, 199
The Wave Hole #16, (Paul Barton), 155
Thomson, John, "Perfection", 200
Tillinghast, A.W., 1915, "A Woman's Way," 134-137,
 "Jinx's Office," 194
Times of London, The, October 5, 1874, "The Joy of Golf," 20
Times, Philadelphia, Feb. 24, 1889, "A Dude Game?", 123
Tournament, (Bob Dacey), 188
Treetops #6 Gaylord, MI, (Brian Morgan),4
Turtle Point #14, (Jim Moriarty), 97
Tvedten, Margaret, 1988, (The Flower Hole #16), 127

U

Untitled, (Bart Forbes), 48
Updike, John, "The Pro," 221-223

V

Vaile, P.A., "The Soul of Golf," 55
Vandenbrink, Jan, (Iona Golf & Grazing Grounds), 202
Vander Neer, Aert, (River Scene in Winter), 76
Vaughan, Michael, (Untitled), 108, (Untitled), 170

W

"Walking and Golf," Tony Morse, 150-153
Ward, Sir Leslie, (Horace Hutchinson), 81, (Hoylake), 165
Waugh, Bill, (Royal Lytham & St. Annes), 172
Waugh, W.K., 1987, (The Ballesteros Hole), 217
Weaver, Arthur, 1987, ('Young Tom' Morris), 152, (Willie
 Park, Jr.), 221, Willie Park Sr., 212
Weaver, Gordon, "Zen Golf," 56-61
Wheeler, Gordon, 1989, (Augusta National #12), 138
Wilkinson, Chuck, (Golf), 136
Willie Park, Jr., (Arthur Weaver), 221
Willie Park Sr., (Arthur Weaver), 212
Wind, Herbert Warren, 1962, "The Call of the Masters,"
 158-159
"Wordsworth Re-Worded," Robert Browning, 1910, 106
Wright, Ben, "In Search of the Perfect Pro-Am," 125-127
Why Does the Golfer 'Look Up?' ", Charles W. Moore,
 1929, 185

Y

'Young Tom' Morris, (Arthur Weaver, 1987), 152

Z

"Zen Golf," Gordon Weaver, 56-61

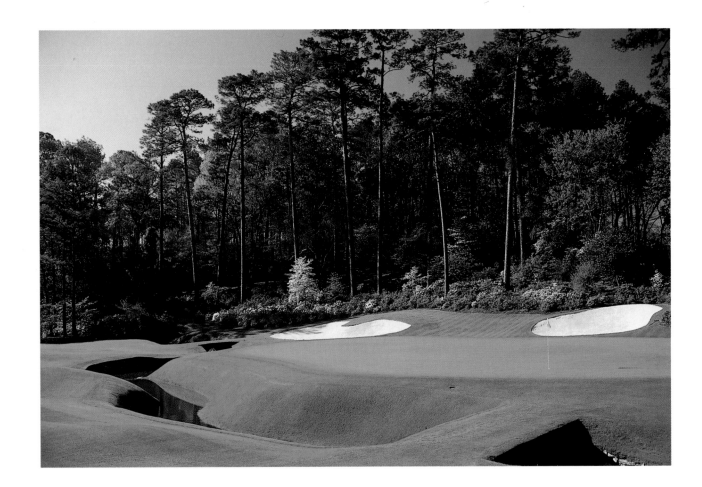

AUGUSTA NATIONAL #13
by Jim Moriarty